DREAMING ØF CINEMA

D1546831

FILM &CULTURE

John Belton, Editor

FILM & CULTURE
A series of Columbia University Press
Edited by John Belton

For the list of titles in this series see page 255.

DREAMING

ØF

CINEMA

SPECTATORSHIP,

SURREALISM,

& THE AGE OF

DIGITAL MEDIA

ADAM LOWENSTEIN

Columbia University Press

New York

COLUMBIA UNIVERSITY PRESS

Publishers Since 1893

New York Chichester, West Sussex

cup.columbia.edu

Library of Congress Cataloging-in-Publication Data

Lowenstein, Adam.

Dreaming of cinema : spectatorship, surrealism, and the age of digital media /
Adam Lowenstein.

pages cm. — (Film and culture)

Includes bibliographical references and index.

isbn 978-0-231-16656-0 (cloth : alk. paper) — isbn 978-0-231-16657-7 (pbk. : alk.
paper) — isbn 978-0-231-53848-0 (ebook)

1. Motion picture audiences. 2. Surrealism in motion pictures. I. Title.

PN1995.9.A8L69 2015

302.23'43—dc23 2014026068

Columbia University Press books are printed on permanent
and durable acid-free paper.

This book is printed on paper with recycled content.

Printed in the United States of America

COVER & INTERIOR DESIGN BY MARTIN N. HINZE

For Irina, as always
and for Simone, for the first time

Contents

Illustrations

Acknowledgments

The surrealists knew that we never truly dream alone, and so it is for this book as well. I cannot hope to include by name all of the people who helped me along the way during this book's long process of coming into being, but I am deeply grateful to all of the friends, family members, colleagues, and students who contributed their time, expertise, good will, and understanding while I was dreaming of cinema.

For acts of professional support both large and small, I thank Richard Allen, Dudley Andrew, Jonathan Arac, John Belton, Tim Corrigan, Peter Decherney, David Desser, Lucy Fischer, Jen Florian, Rosalind Galt, Lalitha Gopalan, Tom Gunning, Randall Halle, Adam Hart, E. Ann Kaplan, Jim Lastra, Colin MacCabe, Keiko McDonald, Jim Naremore, Bill Paul, Donald Richie, Matt Rockman, Karl Schoonover, Terry Smith, Rajiv Vrudhula, and Phil Watts. Years of delightful intellectual conversation (including that most precious kind of conversation, co-teaching) with Marcia Landy have left impressions all over this book.

Important institutional support came from the George A. and Eliza Gardner Howard Foundation, which provided a fellowship that allowed me time to pursue research for this book. At the University of Pittsburgh, I wish to thank the Department of English, Humanities Center, University Center for International Studies, Japan Council, Asian Studies Center, and Office of the Dean in the Kenneth P. Dietrich School of Arts and Sciences. In Tokyo, Yuka Sakano of the Kawakita Memorial Film Institute was invaluable as my point of contact with director Hideo Nakata and screenwriter Hiroshi Takahashi, both of whom made themselves available to me in remarkably generous ways. Kenjin Miwa and the staff at the National Museum of Modern Art in Tokyo were also very helpful.

ACKNOWLEDGMENTS · XII

Additional archival support came from Robert A. Haller at Anthology Film Archives in New York. Audiences at the Cinema Studies Colloquium (University of Pennsylvania), Department of Radio-TV-Film (University of Texas at Austin), Humanities Center Colloquium (University of Pittsburgh), Mass Culture Workshop (University of Chicago), Pittsburgh Film Colloquium (University of Pittsburgh), and the Society for Cinema and Media Studies Conference offered stimulating feedback on my work in progress. Earlier versions of some of the material included in this book have appeared in *Cinema Journal*, *Post Script*, and *Global Art Cinema: New Theories and Histories* (Oxford University Press); I am grateful for the permission of the publishers to draw on that material here. Thanks are due to the Artists Rights Society, Art Resource New York, the Museum of Modern Art, and the Smithsonian American Art Museum (Joseph Cornell Study Center) for aid in reproducing the images included in this book.

Working once again with the stellar team at Columbia University Press was just as pleasurable as the first time around, only this time I felt even more at home thanks to director Jennifer Crewe, series editor John Belton, assistant editor Kathryn Schell, production editor Roy Thomas, copy editor Joe Abbott, cover and interior designer Martin Hinze, and the anonymous readers of the manuscript.

It saddens me greatly that so many special friends and colleagues who contributed all sorts of inspiration while I worked on this project are no longer here to share the book. I will always hear their voices within these pages: Eric Clarke, Miriam Bratu Hansen, Keiko McDonald, Anil Ramayya, Donald Richie, Richard Tobias, Phil Watts, and my aunt Marion Sue Lane, whose love of writing about and caring for animals enriched my life and animated this book's fourth chapter.

First and last and always, I must thank my family for everything: Ed Lowenstein, Paula Friedman, Jane Lowenstein, and Noah Lowenstein. I dedicate this book to my wife Irina Reyn and our daughter Simone Lowenstein, with love. They remind me of the real in the surreal, as well as the surreal in the real, in just the right ways.

DREAMING ØF CINEMA

Introduction

Cinema as Digital Dream Machine

How can one grasp the present? Especially a present as fast and fleeting as our own, where new digital media technologies transform our modes of perception, awareness, and experience in dizzying ways? This book grows out of a desire to understand our present age of digital media, even as that era continues to metamorphose at a pace that stuns the imagination; there is something appropriate affectively, however misleading historically, in calling the digital era the age of "new media."[1]

My particular pathway into "new" (digital) media is through an "old" (analog) media form that clings to the present with remarkable tenacity: cinema. Whether we turn to Blu-ray discs or streaming video, fan-constructed movie websites or YouTube channels, the Internet Movie Database or film-oriented cell phone applications, digital 3-D or movie-

based video games, evidence abounds that here in the age of digital media, we still find ourselves dreaming of cinema—what cinema is, what cinema was, what cinema may become.[2] So simply dividing the media landscape into neatly periodized or technologized categories belonging to "old" media or "new" media clearly will not do. Is it possible, then, given cinema's ability to straddle old and new media, to consult the cinematic past in order to reckon with the digital present? I believe it is, and my own wish to think about the intersections between cinema and digital media led me back to an earlier generation of cinematic dreamers: the surrealists. Of course, surrealism is not the only possible bridge between the cinematic past and the digital present, but it strikes me as an especially rich and promising resource for several reasons.[3]

First of all, the surrealists' enthusiasm for cinema derived partially from their own excitement, beginning in the 1920s, with film as a new, quintessentially modern media form. The hopes and dreams of the surrealists for cinema's future, some prescient and others outlandish, can often remind us of today's sometimes wildly careening discourses surrounding digital media—the utopian or dystopian ways it has changed and will change our lives, its potential to make obsolete, superfluous, or barely recognizable so much that has gone before while it opens new horizons of information, expression, and communication. Surrealist fascination with cinema, like our own fascination with digital media, pivots on the technologically and culturally new. Cinema was new media for the surrealists just as surely as today's digital technologies are new media for us.

Second, a commonly perceived crisis for cinema in the age of digital media involves something the surrealists were also very attuned to (and suspicious of): cinema's nature as a realist medium. Today, many observers believe that cinema's foundational characteristics (based in analog technologies) as an "indexical" medium, with a privileged capacity to record and represent the real, are disappearing or altering fundamentally under the influence of new digital technologies.[4] So the specter of cinema's decline or even extinction in the digital era arrives as a crisis of realism—a crisis that surrealism is ideally equipped to engage because it never assumed cinema was a realist medium but rather a surrealist one. In this way, returning to surrealist conceptions of cinema enables us to move beyond the mirage of a digitally induced crisis of realism. Seeing through this mirage means rethinking cinema's relation to the real but not because digital media has changed everything. On the contrary, the

ascent of digital media invites us to recognize that cinema always was and continues to be a deeply surrealist medium rather than an inherently realist one. Coming to terms with this recognition drives this book's research, as it is one of the most pressing tasks of contemporary film theory.

Third, surrealism and digital media intersect at a point that also touches the heart of film theory, both classical and current: spectatorship, or the interaction that takes place between viewers and films. The surrealists were committed to ideas and practices focused on spectators doing things with films that were not anticipated or intended by the filmmakers, while today's digital media are often touted as changing passive viewers into active producers (or at least "prosumers") of the media they once could only consume. Despite pronounced political differences between surrealism's radical aims and digital media's often fervently capitalist guises and uses (differences I will return to later), I use this shared fascination with a "liberated" spectator to generate a surrealist-inspired critique of digital media's widely embraced progressive potential. This critique questions the common narrative of spectatorship in the digital era as one that moves from passivity to activity, from powerless viewer to powerful user.[5] That said, digital media is not the villain, and surrealism is not the hero, of this book; instead, I endeavor to place them in conversation, to seek out new ways to imagine spectatorship that unmoor and redistribute the conventional attributions of passivity and activity.

Fourth, the surrealists found in the cinema a dream machine, a vital collaborator for their explorations of the irrational, the hallucinatory, the unconscious. If Sigmund Freud and the surrealists ultimately parted ways over their respective desires to demystify and remystify the meaning of dreams, then my own attraction to surrealism for the purposes of this project is closer to Walter Benjamin's sense that surrealism offers a "dialectical optic that perceives the everyday as impenetrable, the impenetrable as everyday."[6] Benjamin's dialectical optic lends a politics of temporality to André Breton's belief in "the future resolution of these two states, dream and reality, which are seemingly so contradictory, into a kind of absolute reality, a *surreality*, if one may so speak."[7] Surreality, for Benjamin, carries the potential to awaken us from the false political and technological promises of present-day reality by juxtaposing them with the outmoded dreams of the past—a potential that this book attempts to foster and activate in its organization and selection of materials.

Dreaming of Cinema conjoins the surrealist past and the digital present, not to build a chronological narrative of cause-effect or even hidden influence but to underline the need for figurative juxtapositions of past and present in order to challenge commonplace rationalizations of what technological change means. To rationalize the transitions from celluloid to TV to VHS to DVD to Blu-ray to streaming video, for example, as a technological evolution that leaves the cinematic experience essentially unchanged provides only a certain kind of history about how and why cinema works. In this sort of history theatrical cinema remains safely detached from its home-delivery variants and those variants themselves cleanly separated from each other through a false sense of "more of the same"—the notion that their differences in form do not add up to differences in function when it comes to watching films. But how do such changes mold our imagination of cinema, our desire for cinema, our dreams about what cinema once was or might become? *Dreaming of Cinema* investigates technological change from *within* these questions of spectator-centered fantasy rather than outside them, relying on sparks of figurative possibility thrown off by the historically impossible collision of a surrealist past and a digital present to light the way.

Cinema, like dreams, blends the past and present, the impenetrable and the everyday, in ways that can freight the experience of spectatorship with perceptual and political awakening. Whether this awakening occurs, or how to measure it if and when it does, are questions impossible to settle with quantified answers. I do not interpret this fact as an excuse to abandon this line of inquiry but as the impetus to press on. *Dreaming of Cinema* takes seriously one of the primary missions of humanistic film studies scholarship, which is to provide theoretical accounts for acts of spectatorship that must be carefully historicized and contextualized but must also, ultimately, remain hypothetical. This is the spirit that animates this book—a spirit shared with much previous scholarship on film spectatorship. Labels that subdivide this work into categories like "feminist," "psychoanalytic," "cognitivist," "phenomenological," and so forth have their significance, of course, but the spirit of what I have called humanistic film studies scholarship cuts across these subdivisions despite (and often prior to) their differences.[8] I have certainly drawn inspiration from a vast array of these theoretical approaches to film spectatorship, and my hope for this book is that it can speak, in some way, to as many of these approaches as possible without subscribing to any one of them

entirely. Dreaming of cinema in the age of digital media, when cinema is never film alone or located only in movie theaters, makes theorizing cinematic spectatorship more paradoxical, but also more urgent, than ever before.[9]

Each chapter that follows investigates a different theoretical model of cinematic spectatorship in the digital era. These models incorporate key discourses and technologies belonging to the age of digital media in order to highlight their connections with and disconnections from surrealist theories and practices surrounding cinematic spectatorship. My goal is to stage strategic confrontations between surrealism and digital media organized by cinematic spectatorship, to generate new vantage points on spectatorship that invite us to wrestle with the digital present by returning to the surrealist past. *Strategic* is an important term to remember here, as this book does not provide comprehensive overviews of surrealism, digital media, or film theory on spectatorship but instead works selectively in the spaces between them so that we learn something new about cinematic spectatorship in the digital age. Another aspect of my strategy for engaging the present is to think history dialectically, in Benjamin's sense, by simultaneously looking "forward" (surrealism encounters digital media) as well as "backward" (digital media encounters surrealism). In the process I hope to give the conjunctures between surrealism/digital media, cinema/digital media, and cinema/surrealism a different sort of attention than they have previously received. This is not to say that my central terms have eluded scholarly analysis; indeed, *surrealism*, *digital media*, and *cinematic spectatorship* have each accrued mountains of scholarship that continue to grow steadily. But that scholarship tends to focus on one or two of the terms in isolation, very rarely considering all three together. That is precisely what this book sets out to do. I am dreaming of the present, of cinema in the age of digital media, by repositioning the cinematic dreams of the surrealist past. To what end? To catch a glimpse of an alternate future, one in which the irresistible but also irresolvable questions about cinema's identity in a digital or even postdigital age can be approached with different eyes, new dreams.

Chapter 1: "Enlarged Spectatorship." This chapter analyzes surrealism's influence on two figures central to realist film theory, André Bazin and Roland Barthes, to argue that their shared commitment to photographic realism is more accurately described as an investment in surrealism. This

revised take on Bazin and Barthes is established through an intellectual genealogy that connects them with surrealist "pope" André Breton, surrealist "apostate" Georges Bataille, and philosopher Jean-Paul Sartre (particularly his early work in phenomenology). This revised take is then tested against notions of cinema in the age of digital media by examining *The Sweet Hereafter* within an "intermediated" context: as a text that exists for spectators *between* the media forms of Russell Banks's 1991 source novel, Atom Egoyan's 1997 film adaptation, and New Line Home Video's 1998 DVD. My contention is not that *The Sweet Hereafter* is a surrealist novel or film but that the digital technologies of the DVD (loaded with a number of special features unavailable in the text's literary or cinematic incarnations) open up possibilities for spectatorship practices once considered surrealist. As a result the DVD "enlarges" (in the surrealist sense of expanded spectator interaction with the artwork beyond the bounds of the artwork itself) the film and novel by remapping relations between the literary and the cinematic.

Chapter 2: "Interactive Spectatorship." Much recent scholarship on video games insists that the "gamic action" provided by these games differs fundamentally from any sort of "interactivity" offered by older media forms like literature or cinema. Consequently, the "user" of new media stands very much apart from the "reader" or "spectator" of old media. But what is gained or lost by using "gamic action" to separate one kind of interactivity from another? This chapter argues that cinema, although not interactive in the same sense as video games, still offers a valuable model for theorizing interactivity as embodied stimulation—a model that helps us chart more specifically the kinds of interactivity that unite and divide new and old media. By examining David Cronenberg's *eXistenZ* (1999), a film explicitly engaged with questions of cinema and/ as digital gaming, I show how cinema still demonstrates the potential for embodied exchange and collaboration between artist and audience explored earlier by the surrealists through their use of games. The surrealist commitment to games involving embodiment emerges particularly clearly in Luis Buñuel and Salvador Dalí's landmark *Un chien andalou* (1929), with its famous images/enactments of assault on spectator vision. It can also be detected in the writings of the surrealist turned sociologist of games Roger Caillois, whose investigations of mimicry early and late in his career suggest how games can fuse surrealist theory and practice.

Chapter 3: "Globalized Spectatorship." Media theorist Marshall McLuhan's concept of a "global village" enabled by "electric media" has, after many years of disparagement as technological determinism, returned for reconsideration in certain discourses of digital media.[10] This chapter explores the possibilities and impossibilities of globalized spectatorship by investigating the complex media flows connecting recent extremely successful Japanese horror films and their U.S. remakes, all of which feature prominent displays of digital media technologies and surrealist aesthetics as central to their sources of horror. For example, in Nakata Hideo's *Ring* (1998) and Gore Verbinski's remake *The Ring* (2002), digital media's haunted aspects come forward through "cursed" videotapes that act like lethal computer viruses, while surrealism emerges in striking visual quotations of *Un chien andalou*. But surrealism's influence takes shape even more dramatically when consulting the fan-produced websites devoted to *Ring* in both its Japanese and U.S. versions, where snippets of footage in the American film are isolated for analysis in ways that invite comparison to surrealist artist Man Ray's "rayograph" experiments in photography, as well as atomic imagery from World War II. Tracing surrealism's role in these global "flows" and "contra-flows"[11] between Japan and the United States that characterize the digital era means studying the history of Japanese surrealism, with its vexed relation to both exposing and conceal-ing the nation's wartime experience. From artists like Okamoto Tarō to Murakami Takashi the legacy of Japanese surrealism constitutes a sort of mediated unconscious that organizes the possibilities for globalized spectatorship across *Ring* and *The Ring*. In this way surrealism provides the aesthetic and historical underpinnings for the treatment of digital media as a haunted form of globalization between past and present, remembering and forgetting, Japan and the United States.

Chapter 4: "Posthuman Spectatorship." An important discourse linked to the age of digital media is that of the "posthuman": a set of views that interpret humankind's increasingly embedded relationship with machines as having reached a point where, in N. Katherine Hayles's influential formulation, "there are no essential differences or absolute demarcations between bodily existence and computer simulation, cyber-netic mechanism and biological organism, robot teleology and human goals."[12] Digital media offer the human body at least the promise of certain prostheses, such as those associated with "virtual reality" technologies, that propel us toward the posthuman. But doesn't the prospect of post-

human spectatorship also inevitably raise questions concerning the significance of the apparently transcended "prehuman"—the animal? To trace the shadow of the animal in the posthuman is to refigure issues of embodiment described by Hayles through common imaginings of the posthuman as a disembodied, machine-enabled escape from the all-too-embodied human condition. What the surrealists pointed the way toward so profoundly is exactly what might complicate this dichotomy between the disembodied posthuman and the embodied human: restoring our sense of the human to its often repressed, hyperembodied animal origins. For the surrealists, seeing humanity truthfully often meant reckoning with its physical, material animality in ways others were loath to consider. Important aspects of this surrealist project can be detected in the writings of Bazin and Bataille, as well as in Buñuel's *Las Hurdes* (also known as *Land Without Bread*, 1933) and *Los olvidados* (1950), while its inversion can be found in contemporary digital phenomena such as the YouTube sensation surrounding Christian the lion (a lion who "remembers" his former human owners and greets them lovingly in the wild). I draw on the growing body of scholarship in animal studies to juxtapose the surrealist and new media accounts of human-animal relations, so that posthuman spectatorship rests on cinema's role in remapping the human within the frames of machine and animal, embodiment and disembodiment.

Chapter 5: "Collaborative Spectatorship." This chapter investigates the ramifications of digital technologies on the phenomenon of spectator fantasy concerning the film star, specifically as it overlaps with surrealist imaginings of the movie star. My primary cases are the American surrealist Joseph Cornell's meditation on the minor star Rose Hobart in his 1936 film of the same name, and a YouTube channel devoted to 1950s and 1960s film icon Rock Hudson. I focus particularly on those aspects of the Hudson channel that correspond to Cornell's ability to lift Hobart from her textual context and into the realm of spectator reappropriation, recalling also how Mark Rappaport's documentary *Rock Hudson's Home Movies* (1992) repurposed footage from Hudson's films to build a political commentary on Hudson's fate in the public sphere during and after his death from AIDS in 1985. But whereas Rappaport assembles a pointed critique of how Hudson's star image disavows queerness, the Hudson YouTube channel attempts to conceal or ignore any meaningful reckoning with Hudson's homosexuality (although the channel simultaneously invites us to revisit Hudson's strangest and most retrospectively

"confessional" film, *Seconds* [John Frankenheimer, 1966]). Cornell shows us a third way to imagine exchanges between audience and star, one I call "collaborative spectatorship," by revising surrealist conceptions of enlarged spectatorship and the misogyny and homophobia often typical of surrealism. Cornell's cinematic fantasy of Hobart, when placed alongside the digital fantasies of a Hudson YouTube channel, illuminates both the strengths and weaknesses of surrealism as a theoretical model for understanding cinematic spectatorship in the age of digital media.

Dreaming of Cinema concludes with a brief reflection on how questions of marking time characterize surrealism, digital media, and this book as a whole. Buñuel and Dalí's *L'âge d'or* (1930), once the acid sarcasm of its title becomes apparent, rails against the propensity to understand time through a series of linear, sequential events reducible to histories of dark or golden ages. This sentiment also pervades one of surrealism's most iconic images: Dalí's melting watches, found most famously in his painting *The Persistence of Memory* (1931). Christian Marclay's *The Clock* (2010), a twenty-four-hour film designed as an art installation, deploys digital assemblage to return cinematic time to us in ways both familiar and strange. By collating digital snippets of films that show or mention a specific minute in time and then matching that minute to the viewer's real-time experience of the film, Marclay offers cinematic spectatorship a decidedly digital sheen. What unites *L'âge d'or* and *The Clock* is a shared commitment to denaturalizing our experience of time. *L'âge d'or* uses the tools of cinema to explode time (disjunctive editing mocks time-space continuity), while *The Clock* uses the tools of digital media to memorialize cinematic time (digital compilation transforms the marking of time in cinema into an artwork in its own right). In *L'âge d'or* the spectator's conventional ideas about the "reality" of time wither under the onslaught of surrealism. In *The Clock* the "unreality" of cinematic time becomes the "reality" of lived time for the spectator. Despite pronounced differences in tone and politics regarding the address of the spectator, both films turn to cinematic spectatorship to unbalance (however harshly or gently) our experience of time. Taken together, they demonstrate how in 1930, as well as today, it is cinema that can teach us to question how "old" or "new" media lend meaning to the time in our lives.

Enlarged Spectatorship

From Realism to Surrealism: Bazin, Barthes,
and *The* (Digital) *Sweet Hereafter*

I n "The Myth of Total Cinema" (1946) film theorist André Bazin writes,
"Every new development added to the cinema must, paradoxically,
take it nearer and nearer to its origins. In short, cinema has not yet
been invented!"[1] In "The Third Meaning" (1970) cultural semiotician
Roland Barthes states, "Forced to develop in a civilization of the signi-
fied, it is not surprising that (despite the incalculable number of films
in the world) the filmic should still be rare . . . so much so that it could
be said that as yet the film does not exist."[2] Although Bazin's "cinema"
and Barthes's "filmic" are not equivalent terms, the similarities between
these declarations suggest the neglected trajectory in film theory this
chapter seeks to trace: pursuing surrealism's influence on Bazin and
Barthes in order to illuminate how their shared commitment to the
realism of the photographic image, so often misunderstood as a naively
literalist stance, is much more accurately described as an investment in

surrealism. In the chapter's second half this revised take on Bazin and Barthes will be tested against our current desire to understand cinema's role in the digital age of new media. By examining *The Sweet Hereafter* as an *intermediated* text characterized by modes of spectatorship brought to the fore in the new media era—that is, as a text that exists for spectators *between* the media forms of Russell Banks's 1991 source novel, Atom Egoyan's 1997 film adaptation, and New Line Home Video's 1998 DVD—I will attempt to demonstrate how today's possibilities for intermediated spectatorship demand that we revisit yesterday's surrealist visions of "enlarged" cinematic spectatorship.[3]

The notion of considering Bazin and Barthes together may seem a rather unpromising point of departure. After all, Bazin's passionate devotion to cinema characterizes his work as clearly as Barthes's ambivalent, self-described "resistance to film" (TM 66) marks his own. Although both men frequently ponder the nature of cinema by turning to related media forms for instructive comparisons, they tend to spin these comparisons (especially between photography and cinema) in very different directions. For example, in "Death Every Afternoon" (1949) Bazin asserts that "a photograph does not have the power of film; it can only represent someone dying or a corpse, not the elusive passage from one state to the other."[4] When Barthes begins his own meditation on the relays between photography, death, and mourning in *Camera Lucida* (1980), he admits, "I decided I liked Photography *in opposition* to the Cinema, from which I nonetheless failed to separate it."[5] Although Barthes does refer briefly to Bazin later in *Camera Lucida* (a reference to which I will return), the passing mention seems more puzzling than enlightening. As Colin MacCabe observes while comparing *Camera Lucida* with Bazin's "The Ontology of the Photographic Image" (1945), "Once one has noticed the parallels between Bazin's and Barthes's theses, it becomes absolutely extraordinary that Barthes makes no mention of Bazin in his bibliography." MacCabe concludes that Barthes's exclusion of Bazin indicates just how "immense" the differences that divide these two texts really are, however "striking" their similarities may appear to be.[6] But perhaps these similarities run even deeper than we imagined.

BAZIN, SARTRE, AND PHOTOGRAPHIC SURREALISM

Dudley Andrew has discovered persuasive evidence in Bazin's unpublished notes for how "The Ontology of the Photographic Image" was written in

direct response to Jean-Paul Sartre's *L'imaginaire* (1940), the very same book to which Barthes dedicates *Camera Lucida*.[7] Sartre, whose philosophy in 1940 was powerfully influenced by Edmund Husserl's transcendental phenomenology without having fully developed the existentialism that would structure his later work, devotes painstaking attention in *L'imaginaire* to distinguishing between perception and imagination. He describes *perception* as our sensual observation of an object in the world and *imagination* as our mental representation (or "quasi-observation")[8] of such an object. For Sartre perception and imagination must not be confused as interrelated points on a continuum of consciousness; instead, they are fundamentally different forms of consciousness. Sartre maintains that "we can never perceive a thought nor think a perception. They are radically distinct phenomena.... In a word, the object of perception constantly overflows consciousness; the object of an image [or imagination] is never anything more than the consciousness one has of it; it is defined by that consciousness: one can never learn from an image what one does not know already" (*TI* 8, 10). This stark division between perception and imagination leads Sartre to claim that the photograph has no privileged relation to reality or to perception, that it suffers from the same "essential poverty" (*TI* 9, 16) that afflicts all acts of imagination: the photograph can only reveal what the viewer has already brought to his or her encounter with it, so it cannot teach us anything we do not already know. As Sartre explains, "if that photo appears to me as the photo 'of Pierre,' if, in some way, I see Pierre behind it, it is necessary that the piece of card is animated with some help from me, giving it a meaning it did not yet have. If I see Pierre in the photo, *it is because I put him there*" (*TI* 19, Sartre's emphasis).

If Sartre provides the initial inspiration for both Bazin and Barthes in their work on the image, neither one ultimately agrees with Sartre's account of the photograph. For Bazin, what makes the photograph (and cinema, as a photographic medium) so important is its ability to conjoin those aspects of perception and imagination that Sartre divides. If Sartre's photograph excludes objective perception (or "observation") in favor of subjective imagination (or "quasi-observation"), then Bazin's photograph unites imagination's subjectivity with perception's objectivity. To quote the famous passage from "The Ontology of the Photographic Image":

> The aesthetic qualities of photography are to be sought in its
> power to lay bare the realities. It is not for me to separate off, in
> the complex fabric of the objective world, here a reflection on

a damp sidewalk, there the gesture of a child. Only the impassive lens, stripping its object of all those ways of seeing it, those piled-up preconceptions, that spiritual dust and grime with which my eyes have covered it, is able to present it in all its virginal purity to my attention and consequently to my love. By the power of photography, the natural image of a world that we neither know nor can know, nature at last does more than imitate art: she imitates the artist.[9]

Here Bazin ascribes to the photograph the very power that Sartre denies it: the power to reveal to the viewer something about the world that the viewer neither knows through imagination nor can know through perception. According to Bazin, the photograph captures, and allows us to glimpse, a reality that eludes both perception and imagination by uniting mechanical objectivity (which he describes as the "impassive" perception belonging to the camera, not to the viewer) with affective subjectivity (which he describes as the "love" of the viewer responding to this reality newly revealed through photography).[10] For Sartre, when one detects true "life" or "expression" in a photograph, it is due solely to the viewer's input (*TI* 17). For Bazin the photographic experience that reveals the world anew is forged between the camera's contribution and the viewer's contribution.

Bazin's sense of the photographic experience as a union of perception and imagination, of mechanical objectivity and affective subjectivity, mirrors André Breton's vision of a surrealist union between dream and reality in certain important respects. As I mentioned in my introduction, Breton's "Manifesto of Surrealism" includes the following formulation: "I believe in the future resolution of these two states, dream and reality, which are seemingly so contradictory, into a kind of absolute reality, a *surreality*, if one may so speak."[11] Although Breton's surreality incorporates a number of explicitly political dimensions that Bazin's photographic realism does not, both men aim to dissolve distinctions between objectivity and subjectivity, perception and imagination, nature and representation.[12] Indeed, in "The Ontology of the Photographic Image" Bazin turns to the case of surrealist photography to crystallize what he describes as photography's capacity to conjoin two different ambitions that have structured the history of Western painting: "pseudorealism" and "true realism." For Bazin "pseudorealism" (OP 12) manifests itself as

trompe l'oeil illusionism—a variety of visual deceptions that trick the eye into mistaking representation for reality. "Pseudorealism" is rooted in humanity's psychological need to duplicate the natural world through representation or to "have the last word in the argument with death by means of the form that endures" (OP 10), a psychological condition Bazin diagnoses as a "mummy complex" (OP 9) or a "resemblance complex" (OP 13). "True realism" (OP 12), in contrast, is rooted in the aesthetic rather than the psychological, in "the expression of spiritual reality wherein the symbol transcend[s] its model" (OP 11). In other words art that uncovers reality's hidden essence counts as "true realism" by elevating an aesthetic commitment to revealing essential reality above the psychological need for illusionism's duplication of superficial reality.

The surrealist, according to Bazin, marries psychological "pseudorealism" to aesthetic "true realism" by erasing "the logical distinction between what is imaginary and what is real" (OP 15). The evidence for this marriage can be seen in "the fact that surrealist painting combines tricks of visual deception [a hallmark of 'pseudorealism'] with meticulous attention to detail [a hallmark of 'true realism']" (OP 16). Bazin's very terms *pseudorealism* and *true realism* echo Sartre's distinction between perception's "observation" and imagination's "quasi-observation," but surrealism gives Bazin the means to interweave what Sartre separates—Bazin outlines those aspects of "pseudorealism" present in perception and "true realism" in imagination. The result is that Bazin's most complete formulation of realism in "The Ontology of the Photographic Image" emerges as a version of surrealism, where the rational and irrational meet, while Sartre's notion of reality is constituted by maintaining strict divisions between the levels of rational perception and "irrational" imagination.[13]

When Bazin claims that "a very faithful drawing may actually tell us more about the model but despite the promptings of our critical intelligence it will never have the irrational power of the photograph to bear away our faith" (OP 14), he revises Sartre's account of the photograph in order to argue that photographic media possess a special ability to "bear away our faith," to *combine* rational fact with irrational belief.[14] We will recall Sartre's insistence that "if I see Pierre in the photo, *it is because I put him there*." But Bazin maintains, in effect, that "seeing" Pierre in the fullness of reality is not simply an act of viewer imagination (putting Pierre in the photo) but of complicated collaboration between the mechanical objectivity of the photographic medium and the affective subjectivity of

the viewer's response to, and belief in, the photographic image. For Bazin it is the surrealists who truly grasp the unique potential of photographic media to stage an encounter between camera and viewer where the image of an object emerges in both its rational concreteness and its irrational essence. This is the object understood through the lens of what Breton refers to as surreality, or the resolution of dream and reality, and what Bazin refers to as factual hallucination, or the resolution of psychological "pseudorealism" and aesthetic "true realism." The surrealist, according to Bazin, insists on precisely that resolution of imagination and perception refused by Sartre—an insistence that "every image is to be seen as an object and every object as an image" (OP 15–16). Bazin continues, "Hence photography ranks high in the order of surrealist creativity because it produces an image that is a reality of nature, namely, an hallucination that is also a fact" (OP 16).[15]

Here Bazin attributes to surrealism an understanding of photography's most remarkable power—to present the world as a factual hallucination, as an irrational dream coextensive with rational reality. In other words Bazin sees photographic media as having privileged access to certain modes of surrealist revelation—modes that bridge the gap not only between Sartre's perception and imagination but also between unknowable nature and knowable representation. When Rosalind Krauss summarizes the "aesthetic of surrealism" as "an experience of reality transformed into representation,"[16] she helps shed light on what Bazin, himself a one-time "fanatic surrealist" and "energetic practitioner of automatic writing,"[17] may be after when he turns to surrealism near the end of "The Ontology of the Photographic Image." The experience of reality made photographic, in its capacity to merge the knowable and the unknowable by encompassing both mechanical objectivity and viewer subjectivity, takes shape for Bazin, finally, as a surrealist phenomenon. Just prior to concluding that "photography is clearly the most important event in the history of plastic arts" (OP 16), Bazin chooses to describe the photographic experience of reality in very particular terms: through surrealism's unmasking of reality as surreality.

This is not to say that every time Bazin speaks of "realism" in his work on the cinema, what he really means is "surrealism." This would be impossible, for "realism," as Bazin's central theoretical concept and critical standard, undergoes a number of significant transformations within and between his most important writings. But it is striking, especially given

the conventional interpretations of Bazin as primarily concerned with cinema's faithful (even indexical) reproduction of preexisting reality, how often Bazin's "realism" moves toward the territory of surrealism.[18]

Consider, for example, Bazin's profound admiration for surrealism's most important filmmaker, Luis Buñuel, whom he calls "one of the rare poets of the screen—perhaps its greatest."[19] Bazin insists that "Buñuel's surrealism is no more than a desire to reach the bases of reality; what does it matter if we lose our breath there like a diver weighted down with lead, who panics when he cannot feel sand underfoot?"[20] Or consider Bazin's enthusiasm for Federico Fellini's *Le notti di Cabiria* (1957), a film that transports us beyond the "boundaries of realism" through "'poetry' or 'surrealism' or 'magic'—whatever the term that expresses the hidden accord which things maintain with an invisible counterpart of which they are, so to speak, merely the adumbration." "One might say that Fellini is not opposed to realism," explains Bazin, "but rather that he achieves it surpassingly in a poetic reordering of the world."[21] Or consider Bazin's appreciation of Jean Painlevé, the surrealist master of the scientific documentary, whose films inspire Bazin to exclaim, "What brilliant choreographer, what delirious painter, what poet could have imagined these arrangements, these forms and images! The camera alone possesses the secret key to this universe where supreme beauty is identified at once with nature and chance: that is, with all that a certain traditional aesthetic considers the opposite of art. The surrealists alone foresaw the existence of this art that seeks in the most impersonal automatism of their imagination a secret factory of images."[22] Ultimately, then, Bazin must be understood not as the naive realist he is so often mistaken for but as a complex film theorist whose work reminds us of the realism within surrealism and reveals to us the surrealism within realism.

THROUGH THE LENS OF BARTHES'S *CAMERA LUCIDA*

Roland Barthes's own sense of experiencing the photographic image depends, like Bazin's, on a conception of photographic realism finally much closer to surrealism than to the faithful, indexical reproduction of preexisting reality. In *Camera Lucida* Barthes proclaims, "The realists, of whom I am one and of whom I was already one when I asserted the Photograph was an image without code—even if, obviously, certain codes do inflect our reading of it—the realists do not take the photograph for

a 'copy' of reality, but for an emanation of *past reality*: a *magic*, not an art" (*CL* 88). Steven Ungar, in an excellent study of Barthes's work on photography and film, identifies this moment in *Camera Lucida* as a retraction of Barthes's earlier position in "The Photographic Message" (1961) that the photographic image is a "message without a code,"[23] where indexical content trumps style so completely that photography must be seen as fundamentally different from what Barthes calls "the whole range of analogical reproductions of reality—drawings, painting, cinema, theater."[24] I would argue instead that this moment in *Camera Lucida* is closer to a retrenchment than a retraction of Barthes's earlier notion of photographic realism; it functions as a clarification that this realism was always closer to an affective "emanation" than to pure reproduction and thus also closer (at least indirectly) to Bazin's factual hallucination than to Sartre's essential poverty of the imagined image.[25] Barthes's definition of himself as a realist underlines his commitment to photography as a unique experience for the viewer that distinguishes it from any of the other arts—an experience ultimately linked more intimately to a surrealistic uncovering of reality than to a realistic reproduction of reality. When Barthes refers to the "special credibility of the photograph"[26] or how, in the photograph, "the power of authentication exceeds the power of representation" (*CL* 89), he points toward a surrealism of the photographic image that recalls Bazin's revision of Sartre: only a photograph holds the "irrational power" to "bear away our faith" (OP 14).

Of course, Barthes differs from Bazin by assigning this special power to the photograph alone rather than to the photograph and to the cinema, as Bazin does. But Barthes's investment in the extraordinary affect generated for the viewer by the photographic image mirrors Bazin's own, even if Barthes disagrees about which media possess this affective impact. Consider, for example, Barthes's well-known distinction in *Camera Lucida* between the *studium* and the *punctum*.[27] The *studium*, on one hand, includes those aspects of a photograph that arouse in the viewer "a kind of general, enthusiastic commitment . . . but without special acuity" (*CL* 26). It encompasses the historical, cultural, and political substance of the photograph and locks the viewer at the level of what Barthes calls "an *average* affect" (*CL* 26). The *punctum*, on the other hand, is that rare quality in certain photographs that bursts through the studium for the viewer. A photograph's punctum "rises from the scene, shoots out of it like an arrow, and pierces me" (*CL* 26). For Barthes the extraordinary, "wound-

ing" affect produced for the viewer by the punctum is as private, intimate, and untranslatable as the studium's "average" affect is public, social, and articulable. The stubbornly idiosyncratic nature of the punctum emerges most dramatically when Barthes refuses to reproduce the photograph that, for him, captures the punctum with the strongest intensity: a photograph of his own recently deceased mother as a young girl standing inside a glassed-in conservatory known as a Winter Garden. Barthes writes, "I cannot reproduce the Winter Garden Photograph. It exists only for me. For you, it would be nothing but an indifferent picture, one of the thousand manifestations of the 'ordinary.' . . . At most it would interest your *studium*: period, clothes, photogeny; but in it, for you, no wound" (*CL* 73).

The affective wound of the punctum crystallizes Barthes's attempt to recast Sartre's *L'imaginaire*. For Barthes the punctum is what Sartre's "classical phenomenology" would not speak about: "desire and mourning" (*CL* 21). If Bazin revised Sartre by bringing together in the photographic experience what Sartre separates as imagination and perception, then Barthes revises Sartre in a similar way—by giving the photograph the power to animate the viewer through the punctum, to show the viewer something he or she did not already imagine and to feel something he or she could not have accessed without the photograph. Barthes, like Bazin before him, also turns to surrealism to rework Sartre's sense of the image. When Barthes emphasizes the unpredictability of the punctum, the fact that it "shows no preference for morality or good taste" (*CL* 43), he echoes Breton's definitions of surrealism as existing "in the absence of any control exercised by reason, exempt from any aesthetic or moral concern" and of the surrealist image as a "spark" that arrives (quoting Baudelaire) "spontaneously, despotically."[28] Barthes also evokes the paradoxical quality of the surrealist "spark" to sketch the punctum's untranslatable effect on the viewer: "certain but unlocatable, it does not find its sign, its name; it is sharp and yet lands in a vague zone of myself; it is acute yet muffled, it cries out in silence. Odd contradiction: a floating flash. . . . Ultimately—or at the limit—in order to see a photograph well, it is best to look away or close your eyes" (*CL* 52–53).

Whereas Bazin argues that the reality revealed by the photograph is neither reducible to nor exhausted by the reality of our perception, Barthes states a similar formulation in even more provocative terms: *seeing* a photograph is not at all the same thing as *looking* at a photograph with one's eyes. The surreal essence of the photographic experience, whether

in terms of Bazin's factual hallucination or Barthes's "floating flash" of the punctum, expands relations between the viewer and the world. For Bazin the world reveals itself to the viewer through the photograph; for Barthes the viewer is revealed to him- or herself in the affect triggered by the photograph. In both cases the network of relations connecting the viewer and the world is enlarged; in the encounter between photograph and viewer some new form of knowledge, affect, sensation, or revelation is added to the world. For Bazin "photography actually contributes something to the order of natural creation instead of providing a substitute for it. The surrealists had an inkling of this when they looked to the photographic plate to provide them with their monstrosities and for this reason: the surrealist does not consider his aesthetic purpose and the mechanical effect of the image on our imaginations as things apart" (OP 15). For Barthes the punctum contains "a power of expansion" (CL 45) that causes the viewer to "add" to a photograph in much the same manner as the surrealists would "enlarge" their experience of certain films by generating fantasies of their own and discovering forms of "irrational knowledge" only suggested by the film itself. For example, Barthes describes how a photograph by André Kertész includes the punctum of a dirt road that causes him to reembody (rather than simply recall) his own personal encounter with central Europe: "I recognize, with my whole body, the straggling villages I passed through on my long-ago travels in Hungary and Rumania" (CL 45).

SURREALIST ENLARGEMENT

An earlier version of Barthes's photographic reembodiment appears in Jean Ferry's 1934 surrealist appreciation of King Kong (Merian C. Cooper and Ernest B. Schoedsack, 1933), where he describes how the film, not through intentional design but through "the involuntary liberation of elements in themselves heavy with oneiric power, with strangeness, and with the horrible," rekindles his own nightmares of being trapped in a room with a savage beast.[29] Ferry eloquently describes how the encounter between external film and internal fantasy creates an expanded text that exists in the surreal space between inside and outside, subjective and objective, film and spectator; he claims that in this sense King Kong corresponds "to all that we mean by the adjective 'poetic' and in which we had the temerity to hope the cinema would be its most fertile native soil."[30]

Ferry's account of *King Kong* as "poetic" grants the film an expansive power that very much resembles Barthes's punctum—indeed, Ferry exemplifies a long tradition of surrealist engagements with the cinema predicated on the concept of "enlarging" a film through a variety of methods.[31]

For instance, in "Data Toward the Irrational Enlargement of a Film: *The Shanghai Gesture*" (1951), a second-generation group of surrealists adapt "the experimental researches on the irrational knowledge of the object" undertaken by Breton and other first-generation surrealists in 1933.[32] The first-generation surrealists, in the journal *Le surréalisme au service de la révolution*, explored the "possibilities" of objects ranging from a crystal ball to the date AD 409 to a painting by Giorgio de Chirico by posing questions to each object and then answering them spontaneously. The group's collected responses were then analyzed to uncover facets of "irrational knowledge" concerning each object so that the object could then be rediscovered.[33]

The second-generation surrealists applied this method to a cinematic object, Josef von Sternberg's *The Shanghai Gesture* (1941). The questions posed to the film—"What ought to happen when Mother Gin-Sling comes down to the gaming room after the revolver shot?; At what moment should a snowfall take place?; How does Omar exist outside of the film?; What don't we see?"[34]—do indeed aim to "enlarge" it. They are questions that encourage a collision between the film itself and the fantasies of its viewers so that a new, enlarged text that belongs neither to the director alone nor to the audience alone comes into being. And the answers to these questions—for example, one surrealist replies that a snowfall "should happen upside down, from bottom to top, at the moment the women are hoisted up in their cages"[35]—anticipate Barthes's attempts to describe the punctum. Both Barthes and the surrealists tend to focus on a certain detail in the cinematic or photographic object that "pricks" them, unleashing a deeply felt but idiosyncratic "spark" or "floating flash" between object and viewer; the object becomes enlarged through the viewer's response to it. When Barthes, directly inspired by Bazin's concept of a "blind field" (more on this below), describes finding a photograph's punctum in the detail of a woman's necklace that allows her to have "a whole life external to her portrait" (*CL* 57), he echoes the description the second-generation surrealists provide for the irrational enlargement of a film: a "strategy of poetic thought" where the object, "freed of its rational characteristics, begins to assume the multiple reflections of the perceptible world, [and]

is set . . . in all the rings of reality."[36] So the enlarged film of the surrealists, like Barthes's expanded photograph, partakes of a reality beyond the rational (a surreality), where photographic objectivity and viewer subjectivity overlap and ignite each other.

For the surrealists this spark could sometimes be set alight by violating basic conventions of cinematic spectatorship, such as Breton's account of darting in and out of different movie screenings at random junctures, without any concern for selection, continuity, or narrative development. Breton, writing in 1951 about his filmgoing experiences some thirty-five years earlier, recalls appreciating "nothing so much as dropping into the cinema when whatever was playing was playing, at any point in the show, and leaving at the first hint of boredom—of surfeit—to rush off to another cinema."[37] Breton also describes how he and Jacques Vaché would "settle down to dinner" inside a movie theater, "opening cans, slicing bread, uncorking bottles, and talking in ordinary tones, as if around a table, to the great amazement of the spectators, who dared not say a word."[38] Breton's spectatorship practices can be seen as an adaptation and extension of the surrealist project of automatic writing, where instinct and chance are designed to trump conscious craft as the engines of artistic creation, but they also seem designed to maximize cinema's unique potential to energize viewer fantasies. For Breton the value of cinema lies in the disorienting power it provides the viewer to enlarge the film, to charge one's own fantasies (located on that surreal edge between waking and sleeping) through the battery that is the film—he says of his unorthodox filmgoing experiences that "I have never known anything more *magnetizing*. . . . The important thing is that one came out 'charged' for a few days."[39]

But this is where Barthes seems to part ways with the surrealists: he does not grant the cinema a punctum, a power of expansion. "Do I add to the images in movies? I don't think so; I don't have time: in front of the screen, I am not free to shut my eyes; otherwise, I would not discover the same image; I am constrained to a continuous voracity; a host of other qualities, but not *pensiveness*; whence the interest, for me, of the photogram" (*CL* 55). It is significant that at precisely this point in *Camera Lucida*, after Barthes refers indirectly to his own earlier study of photograms (film stills) in "The Third Meaning," that he makes his one explicit mention of Bazin. Barthes refers to Bazin's sense of the film screen "not [as] a frame but a hideout; the man or woman who emerges from

it continues living: a 'blind field' constantly doubles our partial vision" (*CL* 55–56). Barthes admits that this "blind field," where cinematic figures emerge from the screen as alive for the viewer, is "a power which at first glance the Photograph does not have" (*CL* 55). But he goes on to explain that the punctum allows certain photographs to create a "blind field" of their own and thus grant the photographed subjects a life beyond the borders of the photograph for the viewer. In other words the punctum animates the photograph with a cinematic power.

In this manner, Bazin helps Barthes come closer than he does anywhere else in *Camera Lucida* to overcoming the opposition between photography and cinema that characterizes the book[40]—an opposition that, in its own way, strains and limits Barthes as severely as the opposition between imagination and perception constricts Sartre. Bazin's thought, as we have seen, offers a way to mediate between Sartre's rigid distinctions; Bazin may have been able to provide a similar outlet for Barthes, but this is not the avenue Barthes chooses to pursue in *Camera Lucida*. To imagine what this path not taken may have looked like, and to continue pursuing the implications of surrealism for Barthes's work on the image, it is necessary to return to "The Third Meaning," an essay that not only prefigures *Camera Lucida* in many significant ways but also transcends it in others.[41]

BARTHES, BATAILLE, AND "THE THIRD MEANING"

"The Third Meaning," like *Camera Lucida* ten years later, was published in conjunction with the journal founded by Bazin, *Cahiers du cinéma*. In fact, "The Third Meaning" can be summarized, at one level, as Barthes's meditation on reading film journals like *Cahiers du cinéma* alongside seeing the films discussed within their pages. The journal's film stills are especially fascinating for Barthes.[42] The film still provides fleeting entry into what Barthes refers to as "the filmic," an elusive alternate text both attached to and distinct from the film itself. To read this alternate text called "the filmic" is to access the level of "obtuse meaning" or "third meaning," to move beyond the image's first level of explicit information and second level of implicit symbolism into a third-level realm where "language and metalanguage end" (TM 64).

The filmic, then, as the repository of third meaning, is "theoretically locatable but not describable" (TM 65). It is the photographic essence that

Barthes, in *Camera Lucida*, assigns to the photograph's punctum but not to the cinema. Yet in "The Third Meaning," when Barthes focuses on the presence of the filmic in stills taken from Sergei Eisenstein's *Battleship Potemkin* (1925) and *Ivan the Terrible* (1944/1946), he carefully distinguishes these stills from conventional photographs in that the stills depend on the "diegetic horizon" (TM 66) of the films to which they are connected.[43] He explains that "film and still find themselves in a palimpsest relationship without it being possible to say that one is *on top of* the other or that one is *extracted* from the other" (TM 67). Here Barthes dares to imagine photography and cinema interwoven in a manner *Camera Lucida* steadfastly resists, and in the process provides an inkling of what *Camera Lucida* may have become had Barthes allowed Bazin to move from its margins to its center. In light of Barthes's relation to the shared legacies of Bazin, Sartre, and surrealism his definition of the film still as the gateway to the filmic and to third meaning could be read as a variation on surrealist enlargements of cinema. Indeed, Barthes's contention that the film still "throws off the constraint of filmic time . . . [that continues] to form an obstacle to what might be called the adult birth of film" (TM 67) echoes Breton's own revolt against filmic time through his random entrances and exits from the movie theater, just as Barthes's designation of third meaning (anticipating his definition of the punctum) as "indifferent to moral or aesthetic categories" (TM 55) nearly duplicates Breton's aforementioned definition of surrealism as "exempt from any aesthetic or moral concern."[44]

But Barthes's sense of third meaning as akin to surrealist enlargement is indebted not only to Breton but also to another crucial surrealist thinker: Georges Bataille. Breton and Bataille are often considered polar opposites in their theoretical stances, owing to a series of vicious public condemnations of each other in 1930 over the spirit and direction of the surrealist movement. Although the caricatures of Breton as blindly romantic idealist and Bataille as hopelessly perverse materialist that emerged from these condemnations gesture toward major differences concerning the possibilities of surrealism as politics,[45] Barthes seems to grasp the complicated relationship between the two men as something closer to what Sarane Alexandrian has described as "closely united, like day and night, like conscious and unconscious."[46] Barthes, like Bataille, often qualifies his support for Breton's version of surrealism, but both return consistently to the framework of surrealism nonetheless.[47]

In "The Third Meaning" Barthes mentions Bataille's essay "The Big Toe" (1929) as situating for Barthes "one of the possible regions of [third] meaning" (TM 60). Bataille argues that "the big toe is the most *human* part of the human body."[48] The big toe's often grotesque and hilariously absurd appearance, its absolute necessity for standing upright and its inevitable filthiness and embarrassing inelegance, captures for Bataille the truth of the body that humankind so often wishes to shield itself from. "Since by its physical attitude the human race distances itself *as much as it can* from terrestrial mud," writes Bataille, "one can imagine that a toe, always more or less damaged and humiliating, is psychologically analogous to the brutal fall of a man—in other words, to death. The hideously cadaverous and at the same time loud and proud appearance of the big toe ... gives a very shrill expression to the disorder of the human body, that product of the violent discord of the organs."[49] Bataille insists on the centrality of the base and the excretory, particularly in relation to the human body, as the foundation for a surrealist assault on conventional reality and social order. This insistence is precisely what Breton loathed in Bataille—Breton himself favored notions of love and beauty as the proper revolutionary forces of surrealism—but it is this very same dimension of Bataille that Barthes finds fascinating.[50]

For Barthes, Bataille's characterization of the big toe taps into one key aspect of third meaning: "an eroticism which includes the contrary of the beautiful, as also what falls outside such contrariety, its limit—inversion, unease, and perhaps sadism" (TM 59). In other words the third meaning generated by the filmic may well ignite feelings of desire, sympathy, and sadness, but it may also stir darker regions of affect. If we consider the filmic's third meaning as a version of surrealist enlargements of the cinema, then the direction and effects of this enlargement remain unpredictable, even volatile. Third meaning resists control and intention—not only on the part of the filmmaker or the viewer but also in terms of medium specificity. Third meaning, like the film still itself, partakes of both photography and cinema but exceeds them both as well. Barthes discovers in the film still the traces of the filmic, "the fragment of a second text *whose existence never exceeds the fragment*" (TM 67)—a second text that cannot be contained entirely either by the film still (which captures only a shard of this second text) or by the film itself (which contributes the backdrop of the "diegetic horizon" [TM 66] for this second text but does not capture it in its own right). This second text,

in other words, carries the third meaning; it is a filmic text that exists *between* the film still and the film itself. The filmic, then, comes into being through an *intermediated* encounter between film and photography that the viewer modulates—where meaning is created in the space between the two media forms.

Barthes's sense of the filmic as intermediated may also owe something to Bataille's surrealist project. "The Big Toe" appeared originally in a 1929 issue of the surrealist journal *Documents*, a groundbreaking periodical edited primarily by Bataille (with the assistance of Michel Leiris) that harnessed the forces of surrealism to turn an anthropological eye inward, toward the familiar and the everyday.[51] *Documents* often employed striking juxtapositions of words and images to estrange the everyday, aiming to shock the established social order into a disturbing self-recognition; "The Big Toe" is no exception. Bataille's essay is accompanied by the surrealist photographer Jacques-André Boiffard's shots of human big toes, isolated and magnified in the style of scientific investigation. The captions of the photographs reinforce their clinical aspect: "Big toe, male subject, age 30" (fig. 1.1); "Big toe, female subject, age 24." But the effect of the photographs, within the context of *Documents* in general and Bataille's essay in particular, is a disorienting mixture of the aesthetic and the scientific, the grotesque and the beautiful, the familiar and the strange. Bataille's description of the big toe as "the most *human* part of the human body," with its attack on conventional notions of what constitutes the human, comes to life through these photographs. Boiffard's images and Bataille's words generate an intermediated meaning between writing and photography, one that speaks to the big toe's paradoxical status as the simultaneous shame and foundation of humanity.

The photographs, with their magnified intensity and stark framing against black backgrounds, reveal all of those bodily imperfections that Bataille associates with humiliation, absurdity, and the cadaverous: unsightly hairs sprout from the base of the toe; layers of wrinkled skin crowd the cuticle; the toenail is a mass of chaotic indentations and scars. The addition of nail polish to the female toe only adds to its corpselike appearance, calling to mind a bloody stain more than flattering ornamentation. But there is also a strong fascination at work here—we understand what Bataille means when he writes of the big toe's base seductiveness, its stunning capacity to unmask the human body surprisingly and truthfully, to see ourselves in a shocking new light. The photographs offer themselves

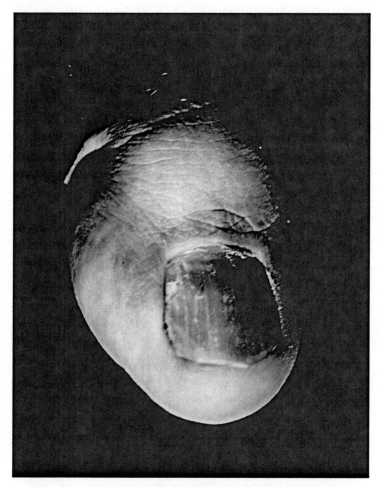

Figure 1.1 Jacques-André Boiffard (1902–61) © Copyright. *Big Toe, Male Subject, 30 Years Old* (1929). Gelatin silver print, 31 × 23.9 cm. Photo by Bertrand Prévost. Musée National d'Art Moderne, Centre Georges Pompidou, Paris. © CNAC/MNAM. Distributed by RMN-Grand Palais/ Art Resource, New York.

as glimpses not only of who we are but of an alien organism unknown to us, the subject of our scientific curiosity. Bataille concludes his essay by suggesting that when one considers the big toe, he or she must face "a return to reality . . . to the point of screaming, opening his eyes wide: opening them wide, then, before a big toe."[52] This reality is, of course, a surreality. It is the surreality made possible in the intermediated space

between word and photograph, where opening the eyes wide is not the same as reading an essay or seeing a photograph; instead, it is a moment of surrealist enlargement, when reality's meaning undergoes an expansion.

On one hand, Bazin, as we have seen, locates this expansion in the photographic experience that forms the basis of cinema. On the other hand, Barthes relegates this expansion to photography alone in *Camera Lucida* but maintains the possibility of cinema's access to "the filmic" in "The Third Meaning" via the intermediated network between film and still. Both critics turn first toward Sartre and then toward surrealism to map the conjunction of photorealism and the enlargement of reality. And both critics ultimately recognize that the forms of cinema they are describing, whether in terms of "total cinema" or "the filmic," have not yet been fully born.

Would Bazin and Barthes maintain the same positions today? Or has the computerized age of new media changed all of this? Has the ascension of the digital erased forever the possibilities of that cinematic experience imagined by Bazin and Barthes as the province of the future, or have new media finally brought this future into the present? In other words, what spaces does surrealist spectatorship occupy in the cinematic experience today? I would like to consider these questions through a case study of cinema in the context of new media, with a nonsurrealist film whose intermediated existence is nonetheless especially provocative in light of Bazin's and Barthes's engagements with surrealism: Atom Egoyan's *The Sweet Hereafter* (1997).

THE SWEET HEREAFTER AND CINEMA'S DIGITAL AFTERLIFE

One of the strengths of Lev Manovich's influential study *The Language of New Media* (2002) is its sensitivity in examining the continuities (rather than fetishizing the discontinuities) between new and old media. But when Manovich catalogs what he calls "the effects of computerization on cinema proper," he excludes "new distribution technologies" such as the DVD. For Manovich these digital technologies "will undoubtedly have an important effect on the economics of film production and distribution, [but] they do not appear to have a direct effect on film language."[53]

Does this assertion hold when we consider "film language" not only from the standpoint of production but of reception as well? I will argue that the DVD, once one of new media's most popular objects (at the height

of its appeal, its total annual sales outpaced theatrical ticket revenue for Hollywood feature films) but now overshadowed by Blu-ray discs and streaming video as cinema's state-of-the-art home delivery formats, does indeed offer the potential to change the practices of cinematic spectatorship and thus the texture of cinematic language. To pursue this claim, I will analyze *The Sweet Hereafter* in light of the preceding discussion of Bazin, Barthes, and surrealist enlargement—as an intermediated text located *between* its novel, film, and DVD incarnations. To consider *The Sweet Hereafter* as intermediated challenges us to extend the parameters of what we imagine constitutes "cinema proper."

I should emphasize at the outset that the manner in which I seek to explore *The Sweet Hereafter* as intermediated is not based on the assumption that all viewers, or even most viewers, will actually do the things this chapter hypothesizes as practices of spectatorship. Nor do I propose that *The Sweet Hereafter* constitutes an entirely conventional case of intermediation that can stand in easily for a majority of other examples. Instead, I want to describe a horizon of spectatorship possibilities, some closer to and some further from realization by present-day audiences. But all of these possibilities (and others) are certainly invited, in varying degrees, by interdependent media forms in the digital era, as well as anticipated by the surrealist aspects of cinematic experience described by Bazin and Barthes. I do not, however, wish to posit *The Sweet Hereafter* itself as belonging to a living legacy of surrealist cinema, the way one might argue that the work of directors such as David Cronenberg, David Lynch, Guy Maddin, or Jan Švankmajer does. I want to examine how intermediation shifts cinema's digital afterlife from the periphery to the center of potential cinematic experience and demands that we rethink how to draw the line between the languages of new media and old media, between contemporary spectatorship and surrealist spectatorship.

In both film and novel versions *The Sweet Hereafter* tells the story of a small town torn apart by a tragic school bus accident that kills many of the town's children. Although we are presented with events that occur both before and after the accident, the accident itself anchors the entire story by pulling every pretraumatic and posttraumatic moment toward it. But if the story appears to attach us to a particular event as the heart of its narrative, the intermediated context of *The Sweet Hereafter* suggests, at times, something very different: more of a radiation outward to multiple textualities and temporalities than a funneling inward to an originary

instant of narrative fact. But at other times this intermediated context only serves to constrain the possibilities of spectatorship presented to readers/viewers/users of *The Sweet Hereafter*. This movement between forces of textuality and temporality shapes the form and content of the novel, film, and DVD in complicated ways to which I will return shortly, but first we must consider the question of what exactly it means to delineate form and content in *The Sweet Hereafter*.

In a statement included on the DVD sleeve of *The Sweet Hereafter*, writer/director Atom Egoyan explains:

> When I was asked to prepare the "chapters" for this DVD edition ... I was faced with the unusual task of returning the project to its literary roots. Russell Banks's novel is divided into five chapters, each bearing the name of one of the main characters. My original wish was to be able to divide the film using the same organizing principle ... but this proved to be an awkward and highly contrived concept. More than any other stage in the making of this adaptation, this final gesture proved how far the novel had been deconstructed, only to be put back together again in a new and completely organic form.

Egoyan's observation about intermedia translation is characteristically perceptive—this is the director, after all, whose feature films from *Next of Kin* (1984) to the present have imaginatively dissected the psychological, social, and cultural impact of media technologies including cinema, video, photography, and sound recording.[54] But what does not ring quite true in Egoyan's statement, especially after sampling the special features bundled with *The Sweet Hereafter* in its DVD edition, is the claim that the theatrical film represents a "completely organic" creation utterly distinct from its novel and DVD versions.

The DVD special features include an audio commentary track with Egoyan and Banks, a videotaped panel discussion concerning the project featuring both the director and the author entitled "Before and After *The Sweet Hereafter*," a televised interview with Egoyan from *The Charlie Rose Show*, short interviews with most of the major cast members concerning their creative involvement on the film, and Kate Greenaway's illustrated version of Robert Browning's 1888 poem "The Pied Piper of Hamelin" (a crucial intertext for Egoyan's film that does not appear in Banks's

novel).[55] These features tend to highlight how much *The Sweet Hereafter* invites intermediated forms of spectatorship that blur boundaries between what constitutes "the novel," "the film," and "the DVD." Indeed, an intermediated understanding of *The Sweet Hereafter* evokes Bazin's prediction in "Adaptation, or the Cinema as Digest" (1948) that the "critic of the year 2050 would find not a novel out of which a play and a film had been 'made,' but rather a single work reflected through three art forms, an artistic pyramid with three sides, all equal in the eyes of the critic."[56]

In some ways Bazin's 2050 still seems a long way off. It is only very recently that film scholars have begun to question the conventional concepts of "fidelity" and "purity" that have contributed to what James Naremore describes as a condition whereby "the very subject of adaptation has constituted one of the more jejune areas of scholarly writing about the cinema."[57] Despite this influx of new scholarship that promises to reinvigorate the area of adaptation studies, Bazin's vision of a novel, play, and film comprising three equal sides of what critics will regard as a "single work" still reads more like science fiction than familiar critical practice. This circumstance is somewhat puzzling, because in many ways, Bazin's 2050 has arrived much sooner and with much more intensity than he ever dreamed. At this point in time Bazin's pyramid resembles at least a decahedron when we imagine today's single artworks composed not only of novel, play, and film versions but of television programs, video games, comic books, toys, novelizations, remakes, websites, pop songs, music videos, and any number of other media manifestations.

Given this multimedia cacophony, how do we discuss "cinema" today? Where is it located? In what guises? Such questions compel us to return to the attempts undertaken by both Bazin and Barthes to describe cinema in terms of the surrealism of the photographic image, where cinematic experience emerges as a dance between different media forms as well as between text and spectator.

EXPLORING INTERMEDIATION

To observe this dance unfold in *The Sweet Hereafter*, I want to examine how the novel, film, and DVD imagine, alone and together, the tragedy at the center of their narratives: the fatal school bus accident. In Banks's novel the accident has already occurred before the book begins. The novel's five chapters, each designated with the name of the character narrating the

chapter rather than numbered sequentially, relate events taking place both before and after the accident but always from the temporal perspective of the accident's aftermath and always in the first-person voice of that chapter's title character. The first chapter belongs to Dolores Driscoll, the kind and conscientious school bus driver who must live with the anguish of surviving a catastrophe that has taken the lives of so many of the children she has driven safely to school year in and year out. Her chapter begins and ends by describing the dog she believes she saw on the road the morning of the accident, the dog that caused her to swerve and the bus to plunge over the guardrail. Dolores describes this dog as something between an empirical fact and an enigmatic vision, an animal she begins by asserting she saw "for certain" but that she concludes was more likely "an optical illusion or a mirage, a sort of afterimage."[58] The fact that Banks, from the very beginning, employs photographic and cinematic metaphors to foreground questions about the nature of vision indicates how the intermediated context of *The Sweet Hereafter* exists not only *among* its three media forms but *within* each form as well.

In fact, when we move among the three forms of *The Sweet Hereafter*, those qualities in each form that may at first seem most specifically "literary," "cinematic," or "digital" come to feel forever reshuffled. When Banks reaches the point in Dolores's narration where she recounts the bus's chaotic descent from the roadway, he concludes her chapter and begins a new chapter narrated by Billy Ansel, the father of two children killed on the bus, who happens to be driving behind Dolores that morning and thus witnesses the accident firsthand. This apparent "cut" from Dolores's point of view on the accident to Billy's point of view actually comes to resemble, in light of Egoyan's film, something closer to a "dissolve," a smoothly shared transition between their two perspectives. And in light of the DVD audio commentary featuring both Egoyan and Banks, this same moment resists categorization into either Dolores's or Billy's point of view. The resulting constellation of resonances within and among the three forms of *The Sweet Hereafter* suggests what the horizon of intermediated spectatorship may potentially encompass, especially in terms of questions posed to the experience of vision as a matter of point of view.

To illustrate this intermediated network more fully and to weigh its implications for issues of spectatorship, I would like to analyze two different versions of the same brief sequence from Egoyan's film—a sequence that corresponds to this particular moment I have just described

in Banks's novel.[59] The first version of the sequence (which I will refer to as "clip 1") does not include the DVD audio commentary, while the second version ("clip 2") does.

Clip 1 begins by signaling its reliance on Dolores (Gabrielle Rose), as in the novel. It is her first-person voice-over that seems to authorize the images we see—her words reconstruct events from her morning bus route, and the images appear to illustrate her words. This sense of seeing what Dolores remembers is underlined by the fact that she is speaking to the lawyer Mitchell Stephens (Ian Holm), a man who, of course, wants Dolores to recall these events to the best of her ability. Although we do not catch a glimpse of Mitchell in this particular sequence, his presence in Dolores's home has been established earlier, and we are reminded of his proximity when Dolores interrupts her narrative to make asides about her perceptions of the boy Sean Walker (Devon Finn) and her bewilderment at the idea of having one of "those mornings," as Sean's mother, Risa (Alberta Watson), puts it to her. Egoyan cuts to Dolores in close-up for these asides, enacting a visual shift in time and space that reemphasizes her as the source in the present of these recalled images. The second close-up transforms, without a cut, into a tilt upward that moves from Dolores to the photographs of the school bus children on the wall behind her. Here the unusual camera movement within the frame, blurred focus, and eventual dissolve to the children on the bus that Dolores mentions in her last, choked words provide a number of conventional indicators of the cinematic flashback.

But why signal a flashback for Dolores when the point of view from her memory has already been established? The film seems to suggest, at least at first, that it is not necessarily the point of view that has now changed but that the affect of Dolores's memory has entered a different register. After all, she has now reached the point in her narrative where routine ends and trauma begins, so it makes sense that the dissolve fades to reveal the children on the bus in a slow tracking shot, as if Dolores is savoring one last, loving glimpse of the faces she will never see alive again. In fact, Egoyan cuts to a shot of Dolores at the wheel, looking toward the back of the bus through her mirror in a manner that seems to substantiate the rearview perspective and motion of the previous tracking shot (fig. 1.2).

As the sequence continues, however, this tracking shot begins to look less like a continuation of Dolores's perspective and more like a bridge

Figure 1.2 *The Sweet Hereafter* (Atom Egoyan, 1997): The school bus driver, Dolores (Gabrielle Rose), looks back.

to Billy's (Bruce Greenwood) point of view. Billy's two children stand at the very back of the bus, at the limit of Dolores's domain, but they are the center of Billy's field of vision as he waves to them from his pickup truck. The spatial smoothness of this transition between perspectives, which is only enhanced by the aerial shot that clearly locates Billy's truck behind Dolores's bus and the graphic match between shots of Billy's kids waving and Billy himself waving, works very differently than does the abrupt switch between chapters in Banks's novel. In the novel the unspeakable violence of the accident inhabits the blank space between the chapters as a radical discontinuity. In the film the accident emerges, with no diminishment of its horror, as a matter of shared experience, of relayed lines of perception between Dolores and Billy. When she can no longer see, he is able to see for her. Or, to put it in terms that deliberately mix media forms, the film presents a dissolve between points of view while the novel presents a cut.

But to think through *The Sweet Hereafter* as an intermediated text, and not merely a source novel and a film adaptation, means to trace these resonances between the forms in multiple directions. For example, the film's "dissolve" urges us to return to the novel's "cut," to search for a continuity we may have missed when reading. This continuity does indeed exist in Banks's novel but may become fully visible only in light of Egoyan's film. For what Dolores and Billy share in the novel is not the film's sense of intertwined vision but intertwined blindness. Dolores's mysterious "afterimage" of the dog that prevents her from seeing the road in front of her is echoed by Billy's admission that, at the same moment,

he was not truly looking at the bus in front of him but fantasizing about his lover, Risa Walker. To quote Billy's voice in the novel: "My truck was right behind the bus when it went over, and my body was driving my truck, and one hand was on the steering wheel and the other was waving at Jessica and Mason, who were aboard the bus and waving back at me from the rear window—but my eyes were looking at Risa Walker's breasts and belly and hips cast in a hazy neon glow through the slats of the venetian blind in Room 11 of the Bide-a-Wile."[60]

Billy's language, with its emphasis on visual fantasy and voyeuristic desire, evokes cinema and photography at least as powerfully as Dolores's language of "optical illusion" and "afterimage" to describe the dog on the road, but the film refuses to present, at least in any literal way, either of these two images. As a result, what *our* eyes see, as readers and viewers of *The Sweet Hereafter*, is an intermediated experience of vision itself that is not entirely reducible to novel or film but that exists between them. Indeed, perhaps the most provocative aspects of this intermediated experience of vision, of its possibilities and impossibilities, are only glimpsed after seeing and hearing the DVD.

THE DVD AS A "MUTATION OF READING"

In clip 2, which features DVD audio commentary from Egoyan and Banks over the images of clip 1, one of the most striking suggestions made by Egoyan in his commentary is that the moment I analyzed earlier as a "dissolve" in perspectives between Dolores and Billy actually represents the lawyer Mitchell Stephens "imagining" or "remembering" an event at which he was not present. Now the issue of vision grows even more complicated, moving beyond the novel's apparent "cut" and the film's apparent "dissolve" between points of view into a matter of memory itself as somehow exceeding first-person perspective or experience. These matters of vision and memory are at the heart of *The Sweet Hereafter* in both its novel and film forms, but to have the theme articulated in this way on the DVD, at this crucial juncture in the story, suggests that a vital aspect of what the novel and film propose about the relations of vision, memory, and experience may only come alive for spectators through an intermediated encounter with *The Sweet Hereafter*. As Banks points out in his commentary during clip 2, some readers who saw the film forged a retrospective memory of the book that did *not* include the incest contained

in both novel and film. What new memories, experiences, and visions of *The Sweet Hereafter* are opened up or shut down for viewers and readers through the DVD's digital interfaces?

One way to reply to such a question involves considering just what it means when Egoyan describes, in his audio commentary at the end of clip 2, the cut from the school bus sinking in icy water (fig. 1.3) to the peaceful shot of a family nestled in bed (fig. 1.4) as "shocking." For Egoyan the shock stems from the stark differences between the two images—the contrast between death at its most unrelenting and life at its most comforting. But shock arising from the collision of these two shots is only one sensation viewers experience at this moment. Another is a sense of recognition based on the *familiarity* of the image of the family. For it is this image that not only begins the film but that also adorns the promotional movie posters, the cover of the tie-in paperback edition, and the outer case of the DVD. This is a moving image that reminds us of its intermediated textuality, of the various double lives it leads as a still pressured to convey the substance of *The Sweet Hereafter* to the public. In this sense it is also an image that foregrounds Barthes's claim in "The Third Meaning" that the film still is not a random "sample" *from* the film but a significant "quotation" *of* the film (TM 67).

For Barthes the quotation represented by the film still is not merely an extract from the original film text; it signals an "other text" called the filmic, located between film and photograph, whose reading requires "a veritable mutation of reading and its object, text or film" (TM 68). Perhaps another way to describe this mutation would be the movement from the "readerly" to the "writerly" text articulated so influentially by Barthes in *S/Z* (1970), a study published the same year as "The Third Meaning." *S/Z*, a pioneering investigation into the nature of reading centered on a close analysis of Honoré de Balzac's short story "Sarrasine" (1830), posits the readerly text as the kind of literary text with which we are most familiar—a text that neatly separates the roles of the author as producer of the text and the reader as consumer of the text. In a writerly text, however, the reader is "no longer a consumer, but a producer of the text." A writerly text is very rarely an actual book or story but rather a certain quality (like the filmic) reached "by accident, fleetingly, obliquely in certain limit-works."[61] Barthes explains his "step-by-step" method of analyzing "Sarrasine" as a way of respecting the writerly, of resisting attempts to force the writerly text into the structured orders of interpretation char-

Figure 1.3 *The Sweet Hereafter*: The tragic school bus accident.

Figure 1.4 *The Sweet Hereafter*: An idyllic image of the family.

acteristic of the readerly text. Perhaps not surprisingly, he describes the "step-by-step" method through a metaphoric language of intermediation between cinema and literature that recalls "The Third Meaning" and its positioning between cinema and photography: the method is "never anything but the *decomposition* (in the cinematographic sense) of the work of reading: a *slow motion*, so to speak, neither wholly image nor wholly analysis."[62] And again, as in "The Third Meaning," Barthes's sense of intermediated meaning remains aligned with surrealism: Barthes's definition of the writerly, as well as his selection of "Sarrasine" as his chosen object of analysis, is inspired explicitly by Bataille. It is Bataille's selection of "Sarrasine" as one of those rare (writerly?) literary works that capture how "only suffocating, impossible trial provides the author with the means of attaining the distant vision the reader is seeking" that aids Barthes in choosing the text for *S/Z*.[63]

Does the audio commentary on *The Sweet Hereafter* DVD constitute a readerly or writerly addition to the cinematic text? If the writerly aims to disturb conventional structures of textual authority to make room for a reader who produces a text rather than simply consuming it, then the audio commentary seems to do just the opposite—it reasserts the author's voice, not the reader's, as producer of meaning. Or does it? In "The Death of the Author" (1968), an essay closely related to *S/Z*, Barthes traces those rare but significant moments in modern literature when the primacy of the author as locus of textual meaning has been challenged. One of these moments is surrealism. According to Barthes, surrealism "contributed to the desacralization of the image of the Author by ceaselessly recommending the abrupt disappointment of expectations of meaning (the famous surrealist 'jolt'), by entrusting the hand with the task of writing as quickly as possible what the head itself is unaware of (automatic writing), by accepting the principle and the experience of several people writing together."[64]

The audio commentary of *The Sweet Hereafter* may well deliver the voice of the author to the viewer directly, but it is the dual voice of Egoyan *and* Banks talking together. This voice, like the multiply authored surrealist projects referred to by Barthes, reminds us of authorship's plural rather than unified nature—it presents the authorship of *The Sweet Hereafter* as collaborative, as intermediated, and as an ongoing process of conversation. At times the substance of this conversation seems to exclude the viewer by positing Egoyan and Banks as the only true authors of *The Sweet Hereafter*, the only ones with the knowledge and authority to speak over its images. But at other times the commentary seems to invite viewers to imagine themselves as participants in the making of *The Sweet Hereafter*—perhaps not in the sense of cowriting the novel with Banks or codirecting the film with Egoyan but rather in the sense of shaping the digital afterlife of *The Sweet Hereafter* as an intermediated text irreducible to either pure literature or pure cinema. In other words *The Sweet Hereafter* DVD, as a new media text in its own right that is simultaneously dependent on the horizons of its literary and cinematic incarnations, contains at least the potential to move from readerly text to writerly text through strategies of viewer engagement not unlike those of surrealism.

Consider, for example, the moment when Egoyan, in his audio commentary near the film's conclusion, discusses what he finds most exciting about working in the medium of cinema.[65] He mentions film's ability

to generate spaces where viewers can "drift, creating their own strands of narrative." Shortly thereafter, Banks interrupts Egoyan to respond directly to the images onscreen. Banks notes how Egoyan's juxtaposition of two different gestures by Mitchell Stephens (first hiding his face in his hands in an outburst of grief, then donning his glasses to take in the unexpected presence of Dolores Driscoll, who is now working happily as an airport shuttle bus driver several years after the accident) gives the sense of movement from blindness to sight in terms of Mitchell's ability to perceive himself through the eyes of others. Egoyan calls Banks's reading "beautiful," particularly in how it captures that very sense of "drift" possible for the viewer, beyond and between the director's design of the film. Egoyan reveals that the first in the set of two gestures Banks responds to was not the result of his own planning but of the actor Ian Holm's suggestion during filming. In other words Banks, now functioning much more as the voice of a viewer than an author, unmasks the text as something more than a unilateral exchange between a director who produces meaning and a viewer who consumes it; Banks "drifts" with the film in ways that Egoyan could not anticipate.

Moments in the audio commentary such as this one, where Egoyan's authorial voice is interrupted by Banks's articulation of his experience as a spectator and Egoyan, in turn, admits the limitations of his own influence over the film's meaning and celebrates the film made by the viewer, invite a writerly engagement with *The Sweet Hereafter*. Granted, these "writerly" moments are the exception to the norm of a more "readerly" tone in the audio commentary, where Egoyan tends to dominate discussion with his own interpretations of the events onscreen. Still, these instants of the writerly do exist, and in certain ways the digital media format of the DVD makes room for viewers to extend such moments and create others on their own. For example, the scene index feature allows viewers to see the film as a series of twenty-one chapters, each with its own title and an accompanying still taken from that chapter. On one hand, the scene index allows Egoyan to impose his own version of the film's meaning on viewers by isolating and clarifying those elements in each chapter that are most crucial in shaping the desired viewer response to the film. So the introduction of the incestuous relationship between Nicole Burnell (Sarah Polley) and her father, Sam (Tom McCamus), is given in the chapter entitled "The Pied Piper" and its accompanying still of Nicole and Sam sharing a romantic kiss (fig. 1.5). This chapter's still mirrors two similar

Figure 1.5 *The Sweet Hereafter*: The DVD's chapter index feature.

stills in the scene index that also feature Nicole and Sam together, one for the chapter entitled "Fathers and Daughters" and the other for "Sam and Nicole." These chapter titles and their stills seem designed to counteract the confusion or denial on the part of some viewers, discussed by both Egoyan and Banks in the audio commentary, to understand this relationship as father-daughter incest.

On the other hand, the DVD includes a number of tools that could conceivably aid viewers in challenging Egoyan's interpretations or in pursuing readings of their own. For instance, although Egoyan asserts a number of times in his audio commentary how closely Robert Browning's "The Pied Piper of Hamelin" resembles the events portrayed in the film, studying the poem in the page-by-page illustrated format available on the DVD exposes viewers not only to the relevant passages quoted within the film but to the many passages absent from the film that may undermine Egoyan's assertion. Similarly, the brief interviews with cast members appended to their biographies and filmographies on the DVD sometimes highlight aspects of the characters they portray that Egoyan minimizes or inflects differently in his own commentary. But most important, by having Banks featured so prominently in both

the audio commentary and in the "Before and After *The Sweet Hereafter*" panel discussion, the DVD invites viewers to stage their own versions of *The Sweet Hereafter* as an intermediated encounter among novel, film, and DVD. Such encounters will utilize the literary, cinematic, and digital media incarnations of *The Sweet Hereafter* as launching pads, but the texts viewers create between these forms may conceivably have the potential to "enlarge" *The Sweet Hereafter*, in a variation on the surrealist sense of that term, as unexpected encounters in the borderlands traversing film and spectator. Of course, *The Sweet Hereafter* DVD encourages such encounters to occur in the realms of rational meaning and commodity consumption made most easily available by the DVD's design rather than within sur-reality. But lodged inside the networks of intermediation established by *The Sweet Hereafter* in its digital form reside tools for viewer-assembled texts that may well be marked by that "veritable mutation of reading and its object" that Barthes called "the filmic." Or perhaps these texts may move toward that impossible beginning/ending of cinema Bazin imagined as the myth of total cinema's fulfillment, when spectator desire for the ideal medium matches the actual medium's existing capabilities. But just what will these new, intermediated texts produced by viewers look like?

Subtitles: On the Foreignness of Film (2004), a book coedited by Egoyan and Ian Balfour, includes a chapter on *The Sweet Hereafter* coauthored by Egoyan and Banks that may begin to answer this question. The chapter opens with Egoyan's description of "two formative subtitles experiences."[66] One of these experiences involves Egoyan's accidental encounter with his own film as a viewer: while preparing for a lecture, Egoyan mistakenly accesses the DVD function that presents *The Sweet Hereafter* with English subtitles for the hearing impaired. This surprising experience of seeing the film from a new perspective inspires Egoyan to review the public-ity photographs taken by Johnnie Eisen during the film's production, particularly those portraits of actors posing in character and looking directly into the camera lens. Egoyan then sends these stills to Banks and asks him to subtitle them—to select passages from his source novel to accompany the stills. The chapter concludes with this series of publicity stills featuring Banks's subtitles, with notes that reproduce the longer passages from which Banks selected his shorter subtitles.

When Egoyan describes this striking gallery of stills as "subtitles to an alternate version of the film,"[67] one cannot help but hear the echoes of Bazin, Barthes, and, perhaps most of all, Breton. It was Breton, after all,

who valued cinema above all else for its *"power to disorient,"* for its "lyrical substance simply begging to be hauled in en masse, with the aid of chance."[68] In the end perhaps this alternate version of *The Sweet Hereafter*, discovered through a disorienting, chance encounter with digital media and assembled through intermediation, offers a surrealist glimpse of cinema's elusive "lyrical substance." Such glimpses may remind us of the surreal essence of cinema, even now (and especially now) that the very concept of what "cinema" was, is, and could be seems harder to define than ever before.

Interactive Spectatorship

Gaming, Mimicry, and Art Cinema: Between *Un chien andalou* and *eXistenZ*

How do we go about mapping the complex network of connections and disconnections between "old" media, such as cinema, and "new" media, such as video games? As increasing numbers of film and media studies scholars turn their attention to this question, the concept of "interactivity," or mutual exchange between text and audience, often defines its parameters. John Belton, for example, claims that the transition from analog to digital cinema in the theatrical context must be characterized as a "false revolution" because digital technologies have been used to simulate analog cinematic experiences rather than to provide interactive ones. For Peter Lunenfeld "interactive cinema" can be regarded most accurately as a "myth," a "doomed genre" enslaved to its hopelessly impractical, utopian aspirations. Marsha Kinder attempts to find a middle ground between demonizing interactivity as a "deceptive

fiction" and fetishizing interactivity as the "ultimate pleasure" promised by digital technology. With this goal in mind Kinder turns to Luis Buñuel's films as models for current digital experimentation with "interactive database narratives," which she defines as "narratives whose structure exposes the dual processes that lie at the heart of all stories and are crucial to language: the selection of particular data (characters, images, sounds, events) from a series of databases or paradigms, which are then combined to generate specific tales."[1]

Like Kinder, I believe that Buñuel's films (alongside the surrealist encounter with cinema more generally) provide important touchstones for today's task of charting the relations between old and new media along the axis of interactivity. I propose to shift the discussion, however, from an emphasis on narrative to the interrelated subjects of gaming and art cinema. Narrative is certainly important for many forms of new media, but it cannot claim the same kind of centrality for digital culture as gaming can, nor can gaming be reduced wholly to a narrative-oriented phenomenon, even if it usually involves some narrative structures. What is occluded in our understanding of new media when narrative is installed as the primary point of entry for analysis?[2] Art cinema, too, has been defined most influentially by considering narrative form first and foremost. When David Bordwell describes art cinema as a "distinct mode of film practice," his definition leans most heavily on those "loosenings" of classical narrative form that distinguish art cinema from mainstream popular cinema, on the one hand, and from more radically experimental "modernist cinema," on the other.[3] But do these distinctions, however useful for illuminating the particular narrative strategies of art cinema, end up overshadowing its other vital aspects?

For Bordwell the "intellectual presence" of art cinema during its heyday in the 1960s "effectively reinforced the old opposition between Hollywood (industry, collective creation, entertainment) and Europe (freedom from commerce, the creative genius, art)."[4] This dichotomy remains with us today at some intuitive level, but as Thomas Elsaesser and Rosalind Galt have argued persuasively, art cinema (particularly after 1989) situates itself toward the coordinates of "Hollywood," "Europe," "popular," and "avant-garde" in ways that the old oppositions fail to capture.[5] In this chapter I hope to contribute to art cinema's redefinition by juxtaposing two films whose relations to art cinema may at first seem tangential: Luis Buñuel and Salvador Dalí's *Un chien andalou* (1929) and

David Cronenberg's *eXistenZ* (1999). The former is a famous French film (made by two Spaniards) that is most often discussed as an avant-garde surrealist film rather than an art film. The latter is a sleeper Canadian film (produced with additional funding from Britain and France) that is most often mentioned as a science fiction film rather than an art film.

Nevertheless, Buñuel's associations with the avant-garde and popular genres such as melodrama, like Cronenberg's own associations with the avant-garde and popular genres such as horror and science fiction, have not diminished (in fact, have often enhanced) their status as *auteurs* whose bodies of work are now read most commonly through the authorship protocols belonging to art cinema.[6] Instructive parallels in the career arcs of these two directors become apparent when Buñuel's beginnings in avant-garde cinema (*Un chien andalou, L'âge d'or* [1930]) are juxtaposed with Cronenberg's (*Stereo* [1969], *Crimes of the Future* [1970]). Each man then endures a period outside major international recognition, only to resurface as an "art cinema director" (with Buñuel's *Los olvidados* [1950]) and a "horror film director" (with Cronenberg's *Shivers* [1975]). Later "rebirths" in each of the director's careers, whether Buñuel's from gritty art cinema realist in *Los olvidados* to flamboyant art cinema surrealist in *Belle de jour* (1967) through *That Obscure Object of Desire* (1977), or Cronenberg's from the horror provocateur of *Shivers* to the art cinema provocateur of *M. Butterfly* (1993) onward, highlight the continuity in their authorial signatures across categories of avant-garde film, genre film, and art film. I will contend that when *Un chien andalou* and *eXistenZ* are considered together around questions of gaming and interactivity, striking possibilities for understanding art cinema, spectatorship, and digital media beyond their conventional categorizations emerge. What finally binds these two films most powerfully is a shared commitment to a surrealist-inflected cinematic form perhaps most accurately described as interactive art cinema.

Whether in the form of video games played on home consoles and mobile devices or computer games played online with multiple participants, there is no doubt that gaming occupies a dynamic, popular, and lucrative space within the digital culture of new media. Indeed, scholarly studies of these games have begun to take shape as a field of their own, and Alexander R. Galloway's recent book *Gaming: Essays on Algorithmic Culture* represents an important moment in the development of video game studies.[7] Galloway attempts, with a compelling sense of ambition

and scope, to address both the unique specificities of video games and their shared traits with older media, particularly cinema. He begins by claiming, "If photographs are images, and films are moving images, then *video games are actions*."[8] As this statement suggests, Galloway frames video games within the contexts of earlier visual media, but he tends to highlight how video games depart from their antecedents in the realm of action. He resists the label "interactivity" to describe video games precisely because he feels it is too broad to capture the material specificity of "gamic action." For Galloway video games constitute an "active medium" due to a materiality that "moves and restructures itself—pixels turning on and off, bits shifting in hardware registers, disks spinning up and spinning down." So for him "interactivity" risks sliding into more abstract, less materialist notions that could apply just as easily to literature or film as to video games.[9] But what is gained or lost by using "gamic action" to separate one type of interactivity from another? Are video games always actions and never images? Are films always images and never actions?

I wish to reflect on the deployment of "interactivity" to control boundaries between cinema and video games at the level of spectatorship. I will argue that cinema, although not interactive in the same way as video games, still offers valuable models for theorizing gaming experiences linked to but not easily explained by standard notions of interactivity—models that may help us chart more effectively the kinds of spectator/player experiences that unite and divide "new" and "old" media. Furthermore, art cinema's reliance on particular relays of communication between author and audience lays a foundation for the cinematic interactivity recognizable in both *Un chien andalou* and *eXistenZ*. By examining *eXistenZ*, a film explicitly engaged with questions of cinema and video gaming, I will show how Cronenberg incorporates certain surrealist notions of gaming to demonstrate how video games and cinema intersect through forms of surrealist interactivity based on associative and embodied stimulation. But first it is necessary to explore the surrealist commitment to games as central to their theory and practice. This commitment emerges clearly in *Un chien andalou*, a film often referred to as marking the birth of cinematic surrealism.[10]

Buñuel famously insisted that *Un chien andalou* must be reckoned with at the level of the "irrational," where the film's images are "as mysterious to the two collaborators as to the spectator" and "NOTHING . . . SYMBOLIZES ANYTHING."[11] In other words, *Un chien andalou* aims to

replicate in the audience's reception certain antirational mechanisms built into the film's production. What Buñuel and Dalí did to uphold the film's commitment to the irrational was what the surrealists often did to preserve the elements of chance and accident in their automatic writing (spontaneous, uncensored free association) and other forms of antirational artistic creation: they played a game. During the writing process, Buñuel and Dalí collaborated by bouncing images off each other, with one man proposing an image (sometimes drawn from dreams) that the other would then question, elaborate on, and reject or accept in a continuing conversation designed to screen out everything that seemed tied to the rational and the explainable.[12] This game of images played between Buñuel and Dalí bears strong similarities to automatic writing but also to surrealist games such as the exquisite corpse, where players would collaborate on a drawing or poem by submitting individual parts toward a collective whole beyond the design of any single participant.[13] One key difference, however, is that the exquisite corpse games rarely took into account an audience outside the immediate circle of collaborators, while Buñuel and Dalí clearly imagined the spectator of their film as a third player in their game of images.[14] For Buñuel the aim of *Un chien andalou* was to "provoke in the spectator instinctive reactions of attraction and repulsion." Couldn't these instinctive reactions of attraction and repulsion in the spectator also describe the guidelines for the game of images played by Buñuel and Dalí, especially when their film sets out to be "as mysterious to the two collaborators as to the spectator"?[15] In this sense *Un chien andalou* takes shape as a game of images with at least three players and a duration that encompasses both production and reception. At the same time, my description of *Un chien andalou* as a game of images is intended to blur the boundaries between the film's avant-garde qualities, art cinema qualities, and popular film qualities. After all, surrealist cinema stands apart from other avant-garde film movements, such as Dada, for its investment in "the stories, the stars, the spectacular and the specular" that are more frequently associated (to varying degrees) with art cinema and popular cinema.[16]

Of course, if *Un chien andalou* functions as a game of images, this does not mean that all players participate in precisely the same way. It's not as if spectators have the privilege of speaking directly to Buñuel and Dalí as the two men did with each other during the writing of the film. But the trails through the film blazed by Buñuel and Dalí are based on a

chain of associated images (rather than conventional narrative or causal logic) that invite spectators to find their own associations, to take their own turn in the game of images. Indeed, the film presents a number of tropes familiar from popular romance narratives only to parody or obstruct their usual meanings—a game of critique built into the game of images that extends from narrative structures to social ones.[17] But with regard to narrative, Bordwell's characterization of typical audience engagement with art cinema as "play[ing] games with the narrator" applies remarkably well in this context.[18] For example, the notorious opening sequence of *Un chien andalou,* where a woman's eye is slit by a razor after a man witnesses a passing cloud "slicing" the moon, certainly includes associations apparent to the filmmakers that would be lost on most spectators: the origin of the film's title in an unpublished book of the same name written by Buñuel in 1927, or Buñuel's casting of himself as the man with the razor whose cigarette produces puffs of smoke graphically similar to the "slicing" clouds in the sky (fig. 2.1). These associations posit Buñuel as the film's primary author and active agent, the force that cuts the eyeball onscreen and cuts the film offscreen.[19] But the graphic associations between the similar shapes and movements of the razor across the man's thumb, the cloud across the moon, and the razor across the eye (along with the multiple verbal associations suggested by these images)[20] may well generate reactions for the spectator beyond the material contributed by Buñuel and Dalí (see figs. 2.2–2.4). For the spectator, encouraged additionally by the fantastic opening title "once upon a time . . . ," perhaps this man with the razor is driven to imagine a future crime based on a recent betrayal by a lover. Or this could be the anxious dream of a woman who has left her jealous lover and fears his retribution. Or this could be a film director's fantasy of punishment for an audience that refuses to "see." In other words the film's form as a chain of associated images solicits images from the spectator in turn, extending the game of the film's construction into the realm of its consumption.

Such games of association are also woven into the fabric of Cronenberg's *eXistenZ,* where the shuttling between cinema and video game opens a space for the spectator's participation that recalls the image games of *Un chien andalou.* For much of *eXistenZ* Ted Pikul (Jude Law) and Allegra Geller (Jennifer Jason Leigh) are playing game characters within the virtual reality video game, designed by Geller, called *eXistenZ.* At one point their characters arrive at a strange Chinese restaurant where they

Figure 2.1 *Un chien andalou* (Luis Buñuel, 1929): Luis Buñuel as the man who cuts.

Figure 2.2 *Un chien andalou:* The razor slices the thumb.

Figure 2.3 *Un chien andalou*: The cloud slices the moon.

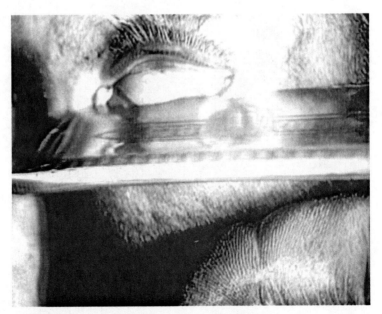

Figure 2.4 *Un chien andalou*: The razor slices the eye.

Figure 2.5 *eXistenZ* (David Cronenberg, 1999): Ted Pikul (Jude Law) turns the gun on Allegra Geller (Jennifer Jason Leigh).

are served a special platter composed of mutant reptiles and amphibians. Although both Pikul and Geller are disgusted by the sight of the platter, Pikul feels compelled to eat it based on what Geller explains is a "game urge," an action Pikul's game character was "born to do." As Pikul eats, he pieces together the discarded bones to assemble a gun that he then points at Geller, proclaiming, "Death to the demoness, Allegra Geller" (fig. 2.5). "That's not funny," Geller replies nervously. After an uncomfortable pause, Pikul apologizes and lowers the weapon.

At the heart of this scene are a series of tensions concerning agency that speak powerfully to the relations between cinema and gaming. Is Pikul playing the game, or is the game playing him when he cannot resist the urge to eat the special platter? Or when he constructs the gun? Or when he points the gun at Geller? The key that unlocks these questions is Pikul's statement, as he nears completion of the gun's assembly, that "this looks awfully familiar." The gun does indeed look familiar, and not just to Pikul. It is a weapon that viewers recognize as a duplicate of the one used earlier in the film during an assassination attempt on Geller. In that earlier sequence an assassin fires on Geller while issuing the exact same proclamation that Pikul does here, "Death to the demoness, Allegra Geller." The reproduction of the proclamation, as well as the gun itself, suggests that Pikul is caught inside the game's logic, forced to do what the game insists his character must do. Up until his withdrawal of the

gun, it seems that the game controls Pikul's mimicry of the assassin, just as the game controls his desire to eat the special platter.

This transfer of power from player to game simulates a common formal feature of video games called "cut-scenes." Cut-scenes are interludes in the gamic action where the player does not control what occurs onscreen but instead becomes a spectator to what the game itself presents. For Galloway, cut-scenes or "cinematic interludes" constitute a "grotesque fetishization of the game itself as machine" because "the machine is put at the service of cinema." He concludes that cut-scenes are ultimately "nongamic," that they can be explained best as "brought on by a nostalgia for previous media and a fear of the pure uniqueness of video gaming."[21] In Galloway's account cut-scenes signal a regression from video gaming's most interactive, noncinematic features and a return to cinema's older, more familiar forms of passive spectatorship. But what Cronenberg does by inserting this moment that resembles a cut-scene within *eXistenZ* is to invite spectator participation in a game of medium definition that recalls the game of images staged in *Un chien andalou*. Where Buñuel and Dalí encouraged spectators to contribute their own associations to the series of discontinuous images in their film, Cronenberg asks spectators to associate their experiences of cinema with their experiences of video gaming. To explore more thoroughly the intersections between Buñuel and Dalí's game of image association and Cronenberg's game of medium definition, I turn now to a theorist whose work straddles the realms of surrealism and the sociology of games: Roger Caillois.

ROGER CAILLOIS AND THE LURE OF MIMICRY

Roger Caillois (1913–78) has yet to receive the kind of scholarly attention accorded to his contemporary and sometime collaborator Georges Bataille, but his work illuminates the terrain shared by surrealism and gaming in unique and often extraordinary ways. Although Caillois was an official member of the Surrealist Group only between 1932 and 1934, he also participated briefly in or stood nearby the surrealist offshoot collectives Contre-Attaque (1935–36) and Acéphale (1936–37).[22] In addition he cofounded the famed College of Sociology with surrealist fellow travelers Bataille and Michel Leiris in 1937.[23] Still, Caillois's relation to surrealism was always a tense and difficult one, even if the movement's influence on him was profound and long-lasting. As late as 1975, Caillois

declared, "I have always been surrealist; what is more, I was surrealist before even becoming one."[24] Yet this declaration appears at the end of an essay, "Surrealism as a World of Signs," in which Caillois attacks surrealism for its fetishization of obscurity for its own sake, for its unwillingness to incorporate scientific rigor into its explorations of subjectivity, chance, and imagination.

In many ways "Surrealism as a World of Signs" recapitulates the reasons for Caillois's original break from the movement in 1934. "Above all, there were the Surrealist games, which were the real cause of my break with Surrealism," Caillois recalls in 1973.[25] He refers specifically to the game of the "irrational knowledge" questionnaires I described in chapter 1 (which Caillois dismisses as "*literary* . . . in the worst sense of the word"),[26] but his general unease with surrealism's refusal to embrace the scientific is perhaps most vividly captured in a famous incident dating from 1934. When Caillois and André Breton are faced with a new, strange object, in this case a Mexican jumping bean, Caillois's instinct is to slice it open to discover its inner workings. Breton refuses to allow such an action, claiming it would violate the mystery of the jumping bean and thus break the spell of the marvelous cast by its strangeness. Caillois laments Breton's rejection of what Caillois calls the "great game [*grand jeu*]" of charting the marvelous in a manner that "does not fear knowledge but, on the contrary, thrives on it."[27] For Caillois this Mexican jumping bean incident clinches his decision to leave the Surrealist Group; he cannot tolerate Breton's refusal to play the "great game" of interweaving knowledge and the marvelous, science and surrealism.

Caillois's entire career, in a certain sense, can be summed up in his continuing commitment to playing this "great game." In fact, the traces of his most famous essay written during his early years, "Mimicry and Legendary Psychasthenia" (1935), can be detected clearly in the most well-known book from his later period, *Man, Play and Games* (1958). In the space between these two seminal works Caillois stages the encounter between surrealism and games that will illuminate the exchanges between cinema, gaming, and surrealism present in *Un chien andalou* and *eXistenZ*.

"Mimicry and Legendary Psychasthenia" studies instances of mimicry in the animal kingdom (particularly among insects) to suggest that it is not, as is often assumed, a primarily defensive phenomenon. For Caillois imitative acts performed by animals are understood best not as camouflage that protects the organism but as a desire on the organism's

part for self-erasure, for a removal of the distinctions between itself and its surrounding environment. Caillois's mimicry is not an instinct for self-preservation but for self-abandonment, an often dangerous attraction toward "depersonalization through assimilation into space" that resembles the Freudian death drive. These aspects of self-erasure and depersonalization cause Caillois to align mimicry with psychasthenic psychology, or "disorder in the relationship between personality and space." The organism engaged in mimicry is seduced by "a veritable lure of space" where the organism "is no longer located at the origin of the coordinate system but is simply one point among many." In this state the organism "quite literally no longer knows what to do with itself."[28]

The desire to lose oneself, to become assimilated into the surrounding environment rather than control that environment, connects mimicry to certain aspects of game play. Indeed, Caillois's *Man, Play and Games* returns to "Mimicry and Legendary Psychasthenia" for some of its key theoretical components. Although the critical hindsight granted by more than two decades forces Caillois to distance himself from his earlier claims about mimicry's connections to the death drive and the spatial disorder of psychasthenia, he maintains that mimicry constitutes one of the four major classifications of human game play described in his sociological taxonomy of games. These four types of games are competition (*agôn*), chance (*alea*), vertigo (*ilinx*), and simulation (*mimicry*). Examples of *agôn* include "football, billiards, or chess"; of *alea*, "roulette or a lottery"; of *ilinx*, "a rapid whirling or falling movement, a state of dizziness and disorder." Games of *mimicry* simulate an imaginary universe, one where the player "forgets, disguises, or temporarily sheds his personality in order to feign another." So examples of mimicry include "theatrical presentations and dramatic interpretations" that Caillois labels "cultural forms found at the margins of the social order": carnival, theater, cinema.[29] For Caillois it is not only the film actor who participates in mimicry but also the film spectator. The actor, of course, pretends to be someone else during his performance. But spectators are also engaged in acts of imaginative imitation, forgetting themselves as they enter the film's world and identify with the film's characters or stars. Although Caillois considers this sort of identification to be a "degraded and diluted form of *mimicry*," he cannot deny its power to fascinate or its location at the center of modern society, "in a world in which sports and the movies are so dominant."[30]

When Caillois describes cinematic spectatorship's forms of identification as a "degraded and diluted" version of mimicry, his point of comparison is older rituals (often religious) that use masks, possession, and trance to access mimicry's roots in the realm of the sacred. The complicated category of the sacred anchors much of Caillois's work over the course of his long career, but perhaps most notably during his involvement with the College of Sociology in the late 1930s and in his book *Man and the Sacred* (first published in 1939, then revised in 1949). The revised edition of *Man and the Sacred* includes an appendix entitled "Play and the Sacred," which introduces the concerns taken up later in *Man, Play and Games*. "Play and the Sacred" argues against the sociologist Johan Huizinga's tendency in *Homo Ludens* (1938) to equate play and the sacred. Caillois contends that play and the sacred are opposites: play affords an active, controlling mastery over the profane realm of everyday life, while the sacred requires a tension-filled submission to forces that transcend the profane. So play and the sacred may ultimately mirror each other in their shared difference from the everyday, but the particular ways in which they differ from the profane are opposed. For Caillois modern society has lost touch with the sacred; he laments this passing of the sacred, especially the modern practice of ridiculing the sacred without replacing it.[31]

In *Man, Play and Games*, however, the eclipse of the sacred in the modern era is not primarily an event to be mourned but an occasion to recognize how crucial aspects of civilization depend on this eclipse: "If the decisive and difficult leap, or the narrow door that gives access to civilization and history (to progress and to a future), coincides with the substitution, as bases of collective existence, of the norms of *alea* and *agôn* for the prestige of *mimicry* and *ilinx*, it is certainly proper to investigate through what mysterious and improbable good fortune certain societies have succeeded in breaking the vicious circle of simulation and vertigo."[32] Theater and cinema, then, are domesticated remnants of the precivilized sacred, of mimicry's masked simulations, just as mountain climbing and skiing are domesticated remnants of ilinx's vertiginous trances.[33] This domestication and secularization of the sacred into games is necessary for a society's progress, even if the civilizing process dilutes and degrades the sacred.

Caillois's double-edged presentation of the sacred's relation to games responds to, without fully reconciling, the diverse theoretical

and historical contexts that have shaped his conceptions of surrealism, play, and mimicry. Claudine Frank argues that the years Caillois spent in Argentina during World War II (1939–45) enabled a "progressive intellectual, ideological, and cultural change, which left him a convert to 'civilization'—or to what he had previously sought to overturn and destroy."[34] In certain ways this observation seems accurate: the postwar Caillois of *Man, Play and Games* exhibits little of the tortured desire to embrace elitism or fascism itself as a weapon against fascist political forces (when faced with democracy's apparent impotence) that characterizes much work in the College of Sociology from 1937 to 1939 and informs Bataille's writing even earlier.[35] Still, the fact that Caillois retains the category of mimicry at all for his postwar study of games, considering the qualifications and exceptions this retention necessitates, suggests a remarkable continuity with his interwar, surrealist conception of mimicry and its decidedly ambivalent stance toward "progress" and "civilization."

Indeed, Bataille's influence seems to preside over both the interwar and postwar versions of mimicry for Caillois, particularly Bataille's essay "The Notion of Expenditure" (1933).[36] Bataille's interest in waste, destructiveness, and unproductive forms of economic activity can be detected in the turn from self-preservation to self-abandonment in "Mimicry and Legendary Psychasthenia," as well as in *Man, Play and Games*, where Caillois asserts that play is "an occasion of pure waste: waste of time, energy, ingenuity, skill, and often of money" and that this unproductive aspect of play, its separateness from "real life," is central to its social importance.[37] Caillois cites the Nazi rallies at Nuremberg alongside a 1957 riot by Swedish youth in Stockholm that "can probably be correlated with the popular success of such American films as *The Wild One* [Laslo Benedek, 1953]" as examples of the danger contained within mimicry and ilinx. He points to a simultaneous repulsion from and attraction toward mimicry by claiming these two events share a "magnetic power" able to "precipitate a crowd into a monstrous frenzy."[38] It seems as if the dangerous mimicry present in Nazi rallies, youth riots, and self-destructive animal behavior is finally not entirely separable from the progressive mimicry of films and "civilized" forms of simulation as play. Again, it is striking that Caillois uses the same term, *mimicry*, to cover both sorts of phenomena, no matter how significant their differences.

One crucial thread connecting dangerous mimicry and progressive mimicry for Caillois is embodiment.[39] In *Man, Play and Games* mimicry

becomes most dangerous when it is embodied in combination with ilinx: "the conjunction of mask and trance, in this dangerous domain where perception becomes distorted, is very frightening. It provokes such seizures and paroxysms that the real world is temporarily abolished in the mind that is hallucinated or possessed."[40] For Caillois the echoes of these "seizures and paroxysms" can be found at the fairground or amusement park, where mimicry and ilinx once again combine—only this time the potentially dangerous conjunction is domesticated by the civilized rules of play and games: "The disconcerting reflections that multiply and distort the shape of one's body, the hybrid fauna, legendary monsters, nightmarish detectives, the grafts of an accursed surgery, the sickly horror of embryonic gropings, larvae, vampires, automatons, and Martians (for everything that is strange or disturbing is of use here), supplement on another level the wholly physical thrill by which the vertiginous machines momentarily distort one's sensory stability."[41] The remnants of mask in the fun house, along with the remnants of trance on the roller coaster, still contain the traces of dangerous embodiment—note Caillois's emphasis on the "disconcerting," "nightmarish," "accursed," "sickly," "strange," "disturbing," and "distort[ing]." Given this unmistakably cinematic inventory of fairground attractions provided by Caillois, the question of cinema's own attractions arises. Do cinema's "attractions," as Tom Gunning calls them when he investigates film's origins in fairground aesthetics, also access the potential risks of embodiment?[42]

For the Caillois of *Man, Play and Games* the answer to this question is affirmative: the phenomenon of film stars as powerful "attractions" causes spectators to "live by them and in them, even to the extent that some are inconsolable when the stars die and refuse to survive them. These impassioned devotions exclude neither collective frenzy nor suicide waves."[43] But there are also tantalizing hints of possible responses to this question in "Mimicry and Legendary Psychasthenia," where Caillois sums up the depersonalizing assimilation into space characteristic of mimicry with the psychasthenic statement, "I know where I am, but I don't feel that I am where I am." This disconnect between knowing and feeling space, when "the subject crosses the boundary of his own skin and stands outside of his senses," could be one way of describing the multiple cognitive and affective investments of cinematic spectatorship.[44] Indeed, the psychoanalyst and sometime surrealist fellow traveler Jacques Lacan refers specifically to Caillois on mimicry in his own famous essay

"The Mirror Stage as Formative of the Function of the I as Revealed in Psychoanalytic Experience" (published in 1949 but based on an original version written in 1936), which was later adopted (however problematically) as a cornerstone text for psychoanalytic film theory of the 1970s and its influential formulations of spectatorship.[45]

For Lacan, Caillois's classification of mimicry as "an obsession with space in its derealizing effect" supports his own sense of how human mechanisms of identification cannot be reduced to comforting notions of adaptation and altruism but fall closer to aggression, fragmentation, and disintegration. Lacan is therefore sympathetic to interrogating those same restricted notions of rational, external reality as the basis for identification and for human knowledge that "the surrealists, in their restless way" recognized as limitations.[46] The intersection of Lacan's identification with Caillois's mimicry reveals a surrealist framework for understanding identification through the body rather than just the mind. When Lacan distills the function of the mirror stage, a developmental phase where the child recognizes its own reflection in the mirror for the first time, as a "drama" consisting of conflict between the inner world of the subject and the outer world of the social, he illustrates this drama through a fragmented body-image common in dreams: "It then appears in the form of disjointed limbs, or of those organs represented in exoscopy, growing wings and taking up arms for intestinal persecutions—the very same that the visionary Hieronymus Bosch has fixed, for all time, in painting, in their ascent from the fifteenth century to the imaginary zenith of modern man."[47]

Lacan's fragmented body shares with Caillois's mimicking body a radical blurring of boundaries between self and space that both men see reflected in the world of art. For Lacan it is Bosch's bodies that cross these lines. For Caillois it is "Salvador Dalí's paintings from around 1930," whose fantastic forms stem from "the mimetic assimilation of animate beings into the inanimate realm."[48] This transformation of animate into inanimate, subject into object, and body into space that Caillois locates in Dalí crystallizes the progressive potential of mimicry. "The inclination to imitate," explains Caillois, "remains quite strong in 'civilized' man, for it persists" in two related thought processes: "the subjective association of ideas," or "the chance or supposedly chance links between ideas," and "the objective association of phenomena," or "the causal links between phenomena." These associative thought processes of modern mimicry

may be understood as informing not only the metamorphoses captured in Dalí's paintings but also "the aesthetic instinct" writ large, which Caillois admits he has no problem reducing to "the tendency to become transformed into an object or space."[49]

In other words mimicry resides at the heart of artistic creativity for Caillois, especially as such creativity was defined by the surrealists as a matter of shocking or surprising *associations* between different images. Breton proclaims in his "Manifesto of Surrealism" that surrealist images emerge from "the fortuitous juxtaposition" of "two terms" from which "a particular light has sprung, *the light of the image,* to which we are infinitely sensitive. The value of the image depends upon the beauty of the spark obtained; it is, consequently, a function of the difference of potential between the two conductors."[50] As with many of Breton's proclamations, this influential definition of the surrealist image was one Caillois would eventually contest; he will claim that Breton's privileging of surprise for evaluating an image's "spark" misses the significance of the obvious, the evident, and the preparation of audience expectations.[51] Still, Caillois's alignment of mimicry with "the aesthetic instinct" and those associative processes of metamorphosis he detects in Dalí's paintings testifies to a surrealist understanding of mimicry's intersection with art—precisely the kind of intersection that later allows Caillois to describe progressive, "civilized" forms of mimicry as game alongside more dangerous forms of embodied mimicry as sacred in the cinema.

I would argue that it is not mere coincidence that one of Dalí's most famous paintings from the era Caillois mentions as evidence for mimicry in art, "around 1930," is entitled *The Lugubrious Game* (1929) nor that two of Dalí's most important artistic achievements of this period are not paintings at all but his contributions to the films *Un chien andalou* and *L'âge d'or.*[52] In short, Caillois's concepts of mimicry include as many distinctively cinematic dimensions as they do gaming dimensions, with surrealism and embodiment uniting the two. Armed with Caillois's mimicry as a theoretical framework, we are now prepared to return to the games of spectatorship played by *Un chien andalou* and *eXistenZ.*

MIMICRY OF THE BODY AND THE AUTHOR

Viewers of *eXistenZ* must grapple with the questions of just how gamic cinema can really be and just how cinematic video games can really be.

In one sense the previously described cut-scene moment in *eXistenZ* breaks the cinematic spell by simulating a video game mechanism and surrendering, at least momentarily, to the video game's rhythms of action. When Pikul imitates Geller's assassin by repeating his words and gestures, he embodies the lure of mimicry, with its seductive drive toward self-abandonment. Caillois depicts mimicry's self-abandonment as a blurring of distinctions between self and environment, body and space; in *eXistenZ* Pikul briefly surrenders his own will to the game's logic, releasing control over his own body to the game's commands about what his body should be doing within the space of the game.[53]

Pikul is initially apprehensive about accepting this form of self-abandonment, but Geller encourages him to enjoy it as one of gaming's pleasures; either way, he seems powerless to stop it. "I find this disgusting but I can't help myself," Pikul says as he feasts on the mutant amphibians. He adds, "I'm fighting it, but it isn't doing me any good." Nevertheless, he eats with lip-smacking relish and assembles the gun with eager precision. One of the pleasures provided by this scene is watching Pikul, who has always steadfastly resisted any "invasive" stimulation of his body, submit to an entirely different order of embodied behavior. As if to underline this transformation, Pikul insists that the teeth he removes from his mouth while eating—the gun's "bullets"—must belong to the game's version of his body, not his own "real" body (whose teeth are perfect). Just as Pikul's "game teeth" mimic bullets, so, too, does his "game body" mimic his "real body," thrusting him toward an embodied self-abandonment he has never permitted himself.

True to Caillois's interweaving of progressive, "civilized" mimicry with dangerous, more radically embodied forms of mimicry, *eXistenZ* never allows viewers to draw definitive lines between harmless "game" and threatening "reality," nor between video game characteristics commonly perceived as "interactive" and cinematic characteristics often understood as "passive." Does Pikul's submission to the game reveal the interactive potential of video games or their confinement to the mere shadow of interactivity? Does the viewer's spectatorship of Pikul's submission to the game reveal cinema's capability for delivering "active," embodied experience for audiences or for generating only "passive" forms of experience? And where do the pleasures for the viewer/player emerge in this constellation of links and disjunctions between cinema and video games?

The fact that Cronenberg, as always, channels such questions toward the body—both onscreen and offscreen—means that mimicry's embodied dimensions take center stage in *eXistenZ*. It is crucial that Pikul's disgust while eating is mirrored by the viewer's disgust at the sights and sounds of watching him eat, just as Pikul's self-abandoning pleasure while eating echoes the viewer's enjoyment of surrender to this spectacle ("I find this disgusting but I can't help myself"). Geller's reactions to Pikul also suggest a series of possible models for the viewer's own reactions: she cringes with visceral distaste as Pikul eats, smiles as he submits to the "game urge," reassures him that his responses are normal, and finally shrinks from him as he menaces her with the gun. Positing Pikul and Geller as the primary points of identification for viewer mimicry would support Caillois's later claims about the attachments viewers express toward film characters or stars, but focusing solely on this sort of identification may minimize Caillois's earlier arguments about mimicry as the lure of becoming space. Isn't it possible that viewers mimic not only Pikul and Geller but also the setting of the game itself? That viewers desire to get lost in the world of the game (or the film) in ways beside or beyond character or star identification? Cronenberg seems quite aware of this possibility—a lurid advertisement for a game glimpsed earlier in the film is called *Chinese Restaurant*, indicating that this scene's setting could be an attraction in itself.

Chinese Restaurant is not the only game on display in the "game emporium" explored by Pikul and Geller in *eXistenZ*. Other titles include *Hit by a Car* and *Viral Ecstasy*. Of course, these two game titles could serve as references to (or adaptations of) the Cronenberg films *Crash* (1996) and *Shivers*, respectively, highlighting the opportunities for mimicry of the author presented to the viewer/player of *eXistenZ*. Alongside desires to lose oneself within the film/game's characters or settings comes the desire to lose oneself within the author's imagination, to "play" in the Cronenberg universe. In other words, *eXistenZ* presents its invitation to interactivity through the reading strategies of art cinema, where the "competent viewer" searches the film for the author's "stylistic signatures."[54] Indeed, the proclamation "Death to the demoness, Allegra Geller" recalls a very similar proclamation from Cronenberg's *Videodrome* (1983), when Max Renn (James Woods) declares, "Death to Videodrome, long live The New Flesh." "Videodrome" and "The New Flesh," like "Cortical Systematics" and "The Realist Underground" in *eXistenZ*, refer to organi-

zations whose mixtures of corporate, revolutionary, technological, and ideological elements always remain shrouded in ambiguity. Renn, like Pikul, accompanies his statement by wielding a gun that is equal parts animate and inanimate matter. For Caillois, as we have seen, one way of defining mimicry in art is through the melding of the animate and the inanimate. The set of intertextual moves performed in *eXistenZ* joins its networks of mimicry at the levels of story, image, and affect (Pikul imitates Geller's assassin, bodies imitate machines, viewers feel as Pikul/Geller do) to networks of mimicry at the levels of art cinema authorship and spectatorship (Pikul imitates Renn, *eXistenZ* imitates *Videodrome*, viewers "play" across a number of Cronenberg films).

The specific type of play engaged in by viewers of *eXistenZ* will depend partly on their *auteurist* knowledge of Cronenberg's films, but no previous knowledge at all is required to sense the game of mimicry that occurs between Pikul and the assassin. And it is this mimicking of the assassin by Pikul that foreshadows the revelations of doubled identities that conclude the film, when many of the film's characters are unveiled as players testing a new game called *transCendenZ*; *eXistenZ* is consequently revealed as a gaming experience generated within *transCendenZ*. In one last burst of mimicry Pikul and Geller then assassinate the game designer of *transCendenZ*, declare "Death to *transCendenZ*!" and finally train their guns on the man who played the waiter they "killed" earlier in the *Chinese Restaurant* of *eXistenZ*. He pleads with them not to shoot him, then asks, "Are we still in the game?" Their silent reply is the final shot of the film: a straight-on, frontal view of Pikul and Geller, guns aimed, fingers on the trigger. Their weapons are pointed directly at this man but also at us, the audience (fig. 2.6).

When Buñuel attended the theatrical premiere of *Un chien andalou*, he carried stones in his pockets to hurl at the audience "in case of disaster." After hearing the applause that greeted the film's conclusion, Buñuel dropped the stones "discreetly, one by one, on the floor behind the screen."[55] But in the end perhaps Buñuel had not averted disaster. In a prefatory note to accompany the publication of *Un chien andalou*'s screenplay in a 1929 issue of the journal *La révolution surréaliste*, Buñuel complains, "A *box-office success*, that's what most people think who have seen the film. But what can I do about . . . this imbecilic crowd that has found *beautiful* or *poetic* that which, at heart, is nothing other than a desperate, impassioned call for murder?"[56] Buñuel's harsh words for his audience must be

Figure 2.6 *eXistenZ*: Pikul and Geller turn their guns on us.

contextualized with his need to please an extremely demanding Surrealist Group that often looked suspiciously on popular success, but still, one wonders whether he ultimately regretted his decision not to throw stones at his viewers. Buñuel echoes Breton's similarly provocative statement in the "Second Manifesto of Surrealism" (1929), published in the same issue of *La révolution surréaliste*: "The simplest surrealist act consists of dashing down into the street, pistol in hand, and firing blindly, as fast as you can pull the trigger, into the crowd. Anyone who, at least once in his life, has not dreamed of thus putting an end to the petty system of debasement and cretinization in effect has a well-defined place in that crowd, with his belly at barrel level."[57] Breton and Buñuel deliberately overstate their cases to achieve a scandalous effect, but one feels clearly their surrealist rage for change in both art and life, as well as how their public audience inspires not only a desire to create but also fear and contempt. They worry that they will not succeed in communicating their surrealist anger to their audience; they fear, in other words, the failure to accomplish interactivity.

The final shot of *eXistenZ* carries the weight of this same fear, with its realization that the games initiated between author and audience are at once deeply playful and deadly serious. One of the last statements made by Yevgeny Nourish (Don McKellar), the game designer of *transCendenZ*, prior to his assassination is that he was "disturbed" by the antigame theme that surfaced while playing *eXistenZ*. He comes to the uncomfort-

able conclusion that since the antigame theme could not have originated with him, it must have been devised by the players—the interactive audience. The danger posed to the author by the audience runs along both edges of interactivity: failed interactivity diminishes the effect of the artwork, but successful interactivity risks the audience's returning to the author with input he cannot process, with desires he cannot fulfill, with interpretations he did not foresee.

Cronenberg speaks about the origins of *eXistenZ* in the lethal fatwa issued when author Salman Rushdie was accused of blasphemy against Islam for his novel *The Satanic Verses*. The spark for the film, according to Cronenberg, grew out of "the question of a writer having to deal with what he has created, that what he creates becomes a living thing out in the world that can come back to haunt you in many ways or stalk you, [as] in the case of Rushdie."[58] This "living thing" that Cronenberg refers to is not a novel or film in isolation but the interactivity established between author, artwork, and audience. In Rushdie's case some extremist readers participated in such a fully interactive exchange with his work (or at least an imagined interactive exchange) that they called for the author's murder. The stones in Buñuel's pockets were carried by the director as a defensive measure against an audience the director feared might attack his film or perhaps even his body during the screening: "I was a nervous wreck. In fact, I hid behind the screen with the record player, alternating Argentinian tangos with *Tristan und Isolde*."[59] So for Buñuel the film screen is a site for interactivity—it simultaneously exposes him to and hides him from the audience, presenting the author as a silent, unseen presence, as well as an active "speaker" through the film's images and the accompanying musical selections.

What unites Buñuel, Rushdie, and Cronenberg is a powerful understanding of interactivity's pleasures and dangers, how the desire for an audience to be so deeply affected by your work that they mimic acts of authorship through active responses of their own may become realized as direct or indirect aggression toward the author. And the author, in turn, may wish to lash back at the audience—witness Buñuel's stones or Cronenberg's final, confrontational shot in *eXistenZ*. "Are we still in the game?" is a question that cannot be answered by anyone within *eXistenZ* because Cronenberg recognizes how it ultimately addresses the audience outside the film, the audience that makes or breaks the interactive loop. It is toward them (us) that the guns are pointed, just as it is they (us) that

have the power to hold the author at gunpoint over the work he has created. In this image we can detect signs of art cinema's transformation into interactive art cinema: the viewer's search for the author's "stylistic signatures" has become something simultaneously more of a (risky) game and less of a(n) (innocuous) game. And this is precisely the kind of game found within both *eXistenZ* and *Un chien andalou* in the shape of surrealist interactivity.

STORIES OF THE EYE: OBJECTS AND SPACE

Un chien andalou, like *eXistenZ*, foregrounds the volatile potential of interactivity by portraying mimicry as a matter of doubled selves, whether they are characters within the film or author-audience relations outside the film. In fact, the loose "story" of *Un chien andalou* unfolds as a series of linked contractions toward narrative elements and expansions toward nonnarrative elements because the expectations alerting viewers to who is who are raised but never fulfilled. To return to the film's previously described opening sequence, the man played by Buñuel who seems to slice a woman's eye is never seen again. The female victim, however, played by Simone Mareuil, reappears unharmed in the following sequence, which begins with the intertitle "eight years later." She sits in an apartment, inspecting a book intently. The content of the book is revealed as a reproduction of Vermeer's painting *The Lacemaker* (c. 1665), which depicts a woman devoting rapt concentration to her work as a seamstress. As soon as Vermeer's painting is unveiled as the object of the woman's attention, it is clear that her intensive study of the painting mimics the act of absorption conveyed by Vermeer's seamstress. This doubling between Mareuil and the seamstress recurs throughout the film across a number of different figures. The androgynous bicyclist, played by Pierre Batcheff, who distracts Mareuil from her book later reappears as the dark-suited man inside Mareuil's apartment who pursues her lustily. This dark-suited man will eventually revert to his androgynous form, only to be confronted by another double, a light-suited man (again played by Batcheff) who scolds the dark-suited man and tosses his feminine clothing out the window. The dark-suited man shoots the light-suited man with a pair of pistols; the victim's corpse is then carried away by a group of men in a forest setting. But a new suitor, yet another double for the dark-suited man (although this time not played by Batcheff), appears on

a beach, and he and Mareuil stroll the shore together affectionately. The film concludes, appropriately, with one last act of mimicry at the level of character substitution. Following the intertitle "in spring . . . ," a couple is shown buried chest-deep in the sand, unmoving and apparently dead. The woman is identifiable as Mareuil, but it is difficult to tell whether her partner is the dark-suited man, the light-suited man, or the lover on the beach.[60] Here, as throughout the film, identity and narrative slip as one character mimics another.

Un chien andalou pursues the lure of mimicry not only through doubled characters but also as a chain of associated images that imitate each other formally. The film's opening sequence, as I have argued above, relies on a number of graphically matched images and movements rather than narrative causality for connections between the shots. This practice of graphic matching continues throughout the film. In fact, the initial connection between the film's first and second sequences is not the presence of Mareuil but the graphically similar patterns of diagonal stripes that appear on both the tie of the man with the razor and the rectangular box carried by the androgynous bicyclist. When this box is opened by Mareuil, its contents include a tie with similar diagonal stripes. When the dark-suited man appears in Mareuil's apartment, his presence initiates a return to the circular imagery presented in the film's opening sequence when the thumb, moon, and eye are matched. Ants emerge from a circular hole in his hand, and then, in a series of dissolves: a patch of armpit hair that resembles the shape of the swarming ants around the circular hand hole; a circular sea urchin whose spiky surface resembles the strands of hair; and a circular iris framing an overhead shot of a person with a cane prodding a severed hand.

The spectacle of the severed hand brings Un chien andalou "full circle" in a number of different ways. First, this hand that is literally cut off from the body literalizes film language by evoking the earlier close-up of the dark-suited man's hand, when the framing distance of the shot figuratively "cuts off" the man's hand from the rest of his body. This literalization of film language across the body repeats the film's opening sequence, when film editing, or "cutting," results in the literal cutting of an eye. Second, the chain of associated circular images that appeared initially in the film's opening sequence (thumb, moon, eye) now comes "full circle" spatially, narratively, and thematically by presenting this second chain of associated circular images (hole in hand, hair in armpit,

sea urchin, round-shaped iris) as the shared vision of Mareuil and the dark-suited man. They stare down together from the apartment window at the severed hand in the street as the series of dissolves concludes, just as they stared together at the ants streaming from the dark-suited man's hand when the series of dissolves began. Their collective point of view organizes space (eventually "rationalizing" the overhead angle after a crowd assembles—forming yet another circle—around the severed hand), narrative (providing the continuity of return to the same apartment with the same characters), and theme (the act of seeing as the film's subject and object of attention).

The look down into the street at the severed hand also integrates the mimicry of graphic matching with the mimicry of character doubling, merging (and ultimately replacing) the psychological interiority of character identity with the spatial exteriority of formal surfaces. In a cinematic enactment of Caillois's mimicry as self-abandonment and becoming space, *Un chien andalou* substitutes spatial association for psychological depth. Mareuil and the dark-suited man witness together a chain of circular images that culminates with an iris surrounding the person whose cane jabs at the disembodied hand. Additional shots reveal this person as an androgyne, a woman whose masculine features (including a tie) compete with her feminine ones (including women's shoes). So this androgyne with the cane becomes yet another double for the dark-suited man, who appeared earlier as the androgynous bicyclist glimpsed from this same vantage point at the window by Mareuil. This doubling is further bolstered when a policeman places the severed hand inside the same rectangular box with diagonal stripes originally carried by the bicyclist and then gives the box to the androgyne with a cane. When the crowd encircles this androgyne, film language is again made literal flesh as the iris becomes a physical ring of bodies. And we are again returned to the film's opening sequence not just through the graphic similarity between the circular crowd and the eye but through bodily violence. Just as the eye slicing closed the film's opening sequence, here the death of the androgyne by collision with an automobile ends this one. Although the intertitle "about three in the morning . . . ," which marks the official end of this second sequence and the beginning of the third, does not appear until slightly later, the death of the androgyne generates the sexually aggressive frenzy in the dark-suited man that motivates the remainder of the second sequence. This frenzy, which causes the dark-suited man

to fondle Mareuil and to chase her around the apartment, subsides only when Mareuil traps his grasping, ant-infested hand in the door ("severing" the hand once more), and he reverts to the form of the androgynous bicyclist. This transformation brings the sequence to its official conclusion by highlighting the doubled identities of the two androgynes. They share the motif of the severed hand, while the death of one ultimately provides the energy necessary for the "rebirth" of the other.

Mimicry, whether in terms of character doubling or graphic matching, functions as a spectatorial game of spatial assimilation in *Un chien andalou*. The chains of associated circular or diagonal images, like the series of characters that substitute for each other, frustrate narrative logic and instead invite viewers to experience mimicry as Caillois's "lure of space." If mimicry's attraction involves, as Caillois claims, a "depersonalization through assimilation into space," then *Un chien andalou* makes room for such assimilation on the part of viewers by refusing to let conventional character development or linear narrative override the lure of becoming space.[61] It is the transformation of objects in space that compels the film's viewers; the film's "story" revolves not so much around characters and narrative as objects and spaces. In fact, Roland Barthes's description of Bataille's surrealist pornographic novel *Story of the Eye* (1928) as a story not about characters but about an object—the eye—could apply equally well to *Un chien andalou*. They are both stories of the eye, where the "story" is not a narrative in the traditional sense but an account of how the eye passes "from image to image, so that its story is that of a migration, the cycle of avatars it traverses far from its original being." In Bataille's novel the eye "migrates" toward metaphorically similar "globular" objects such as eggs and bull testicles while becoming metonymically exchanged with a second metaphoric chain of "moist" objects such as tears, milk, egg yolk, semen, and urine.[62] Likewise, the sliced eye in *Un chien andalou* emerges as the most striking component in a metaphoric chain of circular objects such as thumb, moon, hand hole, and sea urchin, as well as a metonymic switch point for other chains of objects like the diagonally striped tie and box.[63]

When Barthes, whose investments in surrealism and Bataille were explored in chapter 1, describes the migration of objects in *Story of the Eye* as traversing a "cycle of avatars," he inadvertently touches on a term that will become central to video games years later: the avatar.[64] In video games the avatar is the figure standing in for the player within the video game's world. In *eXistenZ* the avatars for Pikul and Geller mimic their

actual bodies so closely that the two forms are virtually indistinguishable; changes in clothing and hairstyle, for example, are relatively minor when compared with the fact that Jude Law and Jennifer Jason Leigh portray both the players "outside" the game and the avatars "inside" the game. Indeed, the avatars allow the players to assimilate into the space of the game in a manner that Cronenberg compares with the workings of film language on the perceptions of film spectators. When Pikul and Geller first enter the *eXistenZ* game together, the transition from "real" world to "game" world is articulated within the film through a classic film editing mechanism: the eyeline match. Pikul's look upward is matched to a shot of a game character walking down a flight of stairs, making the traversal between worlds a seamless one. Pikul is so stunned by the nature of the transition that his avatar comments to Geller's avatar, "That was beautiful." Pikul's avatar then feels his own body and face, checking to make sure he is "all there" within the game's space. "I feel just like me," he comments. Then he asks Geller's avatar, "Is that kind of transition, that kind of smooth interlacing from place to place . . . ?" As he trails off, Geller's avatar answers, "It depends on the style of game. You can get jagged, brutal cuts, slow fades, shimmering little morphs."

Geller's inventory of cinematic editing devices, which merges the analog era of "cuts" and "fades" with the digital era of "morphs" as easily as it blends the realms of cinema and video games, calls attention to how *eXistenZ* invites viewers to assimilate into space along lines tested in *Un chien andalou*. Buñuel, from the slicing of the eye via graphic matching to the severing of the hand via close-up to the shaping of the crowd via iris, converts film language into body language. One effect of this embodying process is a sense of assimilation into space within the film and outside it—film language becomes spatialized as embodied objects, while film viewers follow the "migrations" of these objects in space rather than a "story." At times viewers mimic the space inhabited by these embodied objects so closely that they "feel" the objects at the level of the body. It is physically difficult to watch the slicing of the eye, to resist closing one's own eyes in queasy discomfort. Lesser but still pronounced jolts of embodiment accompany the spectacles of ants crawling out of a wound in a palm and a cane prodding the soft flesh of a severed hand. These spectacular objects migrate not only from one object form to another but also from screen space to viewer space through bodily sensation.

Cronenberg, too, invests his cinematic/gamic objects with embodied dimensions that meld the space of the film with the space of the viewer. To play the *eXistenZ* game requires jacking one's nervous system into a "game pod," a hybrid animal-machine composed of living tissue and electronic circuits. A "bioport" drilled into the spine of the player's body allows an "umby cord," a combination of an umbilical cord and a power cable, to connect the game pod to the player. The mixtures of animate and inanimate matter that characterize the hardware of *eXistenZ* (game pod, bioport, umby cord) recall Caillois's sense of mimetic assimilation into space as a metamorphosis "of animate beings into the inanimate realm."[65] But in *eXistenZ* the metamorphosis occurs in two directions simultaneously: animate matter becomes inanimate (bodies mimic machines) as inanimate matter becomes animate (machines mimic bodies). Still, Caillois's characterization of mimicry as becoming space is upheld in *eXistenZ* as persuasively as it is in *Un chien andalou*. Cronenberg's moaning game pods, infected bioports, and bleeding umby cords are the progeny of Buñuel's sliced eye and severed hand: embodied objects that generate visceral responses from embodied viewers. These objects and the sensations they provoke close the space between screen and viewer, often in shockingly immediate ways. The winces offscreen that accompany the images of a sliced eye or a bleeding umby cord onscreen testify to the powers of spatial assimilation enacted in these films. Their interactive dimensions finally belong to the surrealist realms of mimicry and games, to the transformations of space performed within the film and encouraged in viewer perceptions of the film. Becoming space in these films as an act of spectatorship contains both assaultive components (attacks on viewer sensibilities through mimicked sensation) and reactive components (erasures of viewer subjectivities through mimicked spatial assimilation).[66]

This sort of surrealist interactivity, with its emphasis on becoming space, is different from but not unrelated to the action-based interactivity often used to describe video games. If we return now to Galloway's definitions of cinema as "moving images" and video games as "actions," we can see more clearly how his deployment of these definitions to separate cinema and video games misses the potential intersections between surrealist interactivity and action-based interactivity. For Galloway the rise of video games as a prominent feature of digital culture means that "what used to be primarily the domain of eyes and looking is now more

likely that of muscles and doing, *thumbs*, to be sure, and what used to be the act of reading is now the act of doing."[67] Of course, cinema as eyes and looking contrasted with video games as bodies and doing obscures how the varieties of onscreen and offscreen mimicry in films from *Un chien andalou* to *eXistenZ* constitute forms of interactivity that resist eye/body and looking/doing distinctions.[68] And it is precisely through resistance to these distinctions that the games played in these films emerge as deeply playful and deadly serious. In these games the spectator's very senses and sensibilities are the ultimate stakes.

TIME, SURREALIST INTERACTIVITY, CURATORIAL CINEMA

The account of surrealist interactivity presented in this chapter leans heavily on formulations of space. But what of time? Does surrealist interactivity take place in time as well as space?

If we return once more to the opening of *Un chien andalou* and reinspect the man with the razor played by Buñuel, we will notice that one more object must be added to the chain of associated circular images that includes thumb, moon, and eye: a watch. As Buñuel sharpens his razor and peers at the sky from his balcony, he wears a watch on his left wrist. But during the slashing of the eye, the watch is missing. The absence of the watch and sudden appearance of a tie with diagonal stripes suggests that the eye slashing, although spatially continuous with previous shots through graphically matched images and movements, may not be temporally continuous.[69] This impression of temporal discontinuity builds on the film's opening title, "once upon a time . . ." and is further supported by the intertitle that follows the eye slashing: "eight years later." But soon the viewer realizes that each of the film's intertitles holds out only the mirage of temporal orientation. The film's subsequent intertitles, "about three in the morning . . . ," "sixteen years before," and "in spring . . . ," all refer to time but in ways that do not aid at all in ordering the film's images chronologically. The intertitles present a parody of temporal structure, just as the film's loose "story" presents a parody of a romantic affair. It's as if Buñuel provides hints of familiar conventions, whether in terms of chronology or narrative, only to underline how inadequate these conventions are when viewers face the film itself.

And yet the emphasis on mimicry in *Un chien andalou* that I have described as surrealist interactivity does not simply abandon order,

convention, or narrative. The chains of associated objects and their migrations offer alternate forms of structure for spectators to experiment with as they make their way through the film. When the object of the watch, which disappeared during the eye slashing, reappears during the film's closing moments, it reminds viewers that these alternate forms of structure pertain to time as well as space. The watch rematerializes on the wrist of Mareuil's seashore lover, who gives her an initially chilly reception by confronting her accusingly with the sight of the watch.[70] In a striking close-up Mareuil's face occupies the left side of the screen while the lover's hand, wrist, and watch fill the right (fig. 2.7). This frame composition echoes the earlier eye slashing because we again witness a close-up shared by Mareuil's face and a man's hand; only this time the watch is present, and she lowers his hand (fig. 2.8). The substitution of the watch for the razor as the central object in the frame presents a spatial discontinuity with the eye slashing, but Mareuil's action of lowering the lover's hand suggests a certain sense of temporal continuity, as if she remembers or anticipates the figurative action of the eye slashing and chooses to defuse its violence now. The subsequent shots of Mareuil and her lover bolster this impression of remembering the past or anticipating the future in order to choose a different course of action: they come across the diagonally striped box (now broken) and the feminine clothing of the bicyclist as they stroll the shore, and discard them indifferently after a brief survey. For the couple these once powerful objects no longer carry the same significance; time has revealed the objects as only one way of organizing space, not the only way. In other words the film offers spectators multiple temporal pathways to follow, as well as multiple spatial associations to connect. In this sense the "misleading" intertitles may also be interpreted as temporal markers of an alternate kind: invitations to spectators to organize and reorganize the film's chronology.

Even the final shot of *Un chien andalou*, a grim tableau where time seems to stand still, features more than enough ambiguity to make the film's final title, "The End," seem just as malleable as the previous intertitles. Who is the male figure buried in the sand beside Mareuil? Why is her gaze directed upward and his downward? Where should we, the spectators, direct our gaze? One possible way of addressing this last question, Buñuel seems to suggest, is a matter of time as much as space. Viewers are encouraged by the film's evocation of (but resistance to) conventional chronology to revisit the film and seek out alternate

Figure 2.7 *Un chien andalou*: The woman (Simone Mareuil), the lover, and the watch.

Figure 2.8 *Un chien andalou*: The woman, the razor, and the eye.

chronologies, to assemble different versions of *Un chien andalou* the way a participant in an exquisite corpse game might contribute different sorts of words or images depending on the round that shift the game's outcome.

The final line of dialogue in *eXistenZ*, "Are we still in the game?" functions as a similar invitation for viewers to revisit the film and reorganize its spatial and temporal dimensions, this time along lines of "inside the game" and "outside the game." And as in *Un chien andalou*, these alternate chronologies offer something closer to a series of possible permutations than to a "correct" version of the film's events—permutations that suggest the games played by the film can and should be continued by viewers after the lights have come up. In this way *Un chien andalou* may be seen as a precursor to the kinds of "puzzle films" once considered squarely within art cinema traditions but whose popularity has increased significantly with the advent of new media and moved into the mainstream—films with tricky, sometimes labyrinthine spatial and temporal structures that encourage multiple viewings in the quest for solutions to the film's puzzles.[71] Puzzle films like David Fincher's *The Game* (1997) and *Fight Club* (1999) or Christopher Nolan's *Memento* (2000), *The Prestige* (2006), and *Inception* (2010), like *eXistenZ* itself, are constructed with an acute awareness of the computerized technologies, particularly the DVD, that their viewers understand as familiar tools for navigating and reexperiencing a film. Surfing through the chapters of a DVD to reorganize a film's chronology is certainly something the puzzle films expect their viewers to do physically as part of the film's afterlife, but the films are also constructed in such a way that they invite viewers to perform similar functions mentally during the theatrical screening as well. This aesthetic of reorganization and revisiting is a prominent feature of cinema in the age of digital media, but it is also a crucial component of surrealist interactivity.

As I pointed out in chapter 1, this is not to say that DVDs cannot also work to limit viewer engagement with a film, to restrict the range of possible interpretations available to viewers. Nor would I claim that puzzle films constitute an inherently adventurous and challenging refiguration of cinematic spectatorship practices; quite often the puzzles reveal a renewed investment in standard narrative devices rather than a questioning of them.[72] But the proposition presented to film viewers by the DVD is finally not unlike the proposition presented to visitors of a museum: they can be guided to varying degrees, by design or against

design, by the author-curator. Within the limits of the institutions of the cinema and the museum (institutions, it must be noted, that are undergoing a rich cross-pollination in the new media era),[73] some author-curators welcome a wider range of interactive possibilities, some less. The same can be said for the viewer-visitor. Still, these convergences of the author with the curator and the viewer with the visitor suggest additional possibilities for imagining a viewer-curator and an author-visitor at the crossroads of art cinema, surrealism, and digital media—a crossroads where interactive art cinema meets curatorial cinema.

A number of the projects Cronenberg has pursued in the wake of *eXistenZ* stand at this crossroads. These projects include *Spider* (2002) and *A History of Violence* (2005), two films that play authorship games with Cronenberg's *The Brood* (1979) and *The Dead Zone* (1983), respectively, in much the same manner as *eXistenZ* does with *Videodrome*—games, in other words, that present authorship as a search term for cinema in a new media landscape where the author and viewer curate a digital database that includes the present film's relation to the author's previous films.[74] And then there is *Camera* (2000), Cronenberg's poignant short film that could be summarized as an encounter between old and new media under the sign of art cinema as film festival cinema (filmed in digital video with the exception of the 35 mm final shot and produced to celebrate the twenty-fifth anniversary of the Toronto International Film Festival). Like *eXistenZ*, *Camera* shares an intimate relation with *Videodrome* and its concerns with interactive media, new and old: it stars Les Carlson, a featured cast member of *Videodrome*, and the film itself can now be found, appropriately enough, on the special edition DVD of *Videodrome* issued by the Criterion Collection.

More recently, Cronenberg guest-curated the exhibition *Andy Warhol/ Supernova: Stars, Deaths, and Disasters, 1962–1964* at the Art Gallery of Ontario (Toronto) in 2006. Cronenberg's revision, condensation, and extension of an important Warhol exhibition that originated at the Walker Art Center (Minneapolis) is a remarkable double illumination: it shows us Warhol through Cronenberg as well as Cronenberg through Warhol, expanding our sense of both artists simultaneously.[75] Central to achieving this feat is Cronenberg's audio commentary, which accompanies the exhibition in a manner similar to the director's commentary feature included on many DVDs. But the museum context, with its presentation of art through physical spaces to be navigated, endows this commentary with specific

curatorial qualities that can sometimes be suggested only latently (if at all) on a DVD. What emerges from the exhibition's implicit attempt to resituate Cronenberg's films through Warhol's art (something the poster ads for the exhibition make use of, asking visitors whether *Crash, The Dead Zone,* and *A History of Violence* are really Cronenberg films or Warhol themes) is another version of the interactivity that characterizes *eXistenZ.* In other words, Cronenberg's use of museum curating to remap his own work helps illuminate new media's capacity to search, index, juxtapose, and rearrange cinema—to present cinema as a shared curatorial project between author and spectator. In a way, Warhol's explicit rerouting of photographs from magazines in his paintings mirrors the implicit rerouting of Cronenberg's films through this exhibition: the original artifacts are lifted into new contexts and transformed, their "intended" and "correct" meanings splintered into a series of constellations that then must be negotiated between artist and audience. This recontextualizing move, so often associated with digital media, is also, of course, a hallmark of Dada and surrealism.

Un chien andalou can also be located within a trajectory of curatorial acts. Not long before making the film, Buñuel traveled from Paris to Madrid as the curator of a film program he presented at the request of a lecture society at his alma mater, the Residencia de estudiantes. According to Buñuel his program included "René Clair's *Entr'acte* [1924], the dream sequence from [Jean] Renoir's *La fille de l'eau* [1925], [Alberto] Cavalcanti's *Rien que les heures* [1926]." When Buñuel realized how "aristocratic" his audience was, he was tempted to "announce a menstruation contest and award prizes after the lecture."[76] Almost twenty years later, in 1947, Buñuel again contributed curatorial material to a film program, this time for an avant-garde film exhibition held at the San Francisco Museum of Art entitled *Art in Cinema.*[77] Although the exhibition was not of his own design, Buñuel's written contribution, "Notes on the Making of *Un chien andalou,*" recalls his earlier Madrid film program by framing *Un chien andalou* with the contemporary avant-garde cinema of its day, including the work of Clair and Cavalcanti. For Buñuel (at least from the vantage point of 1947) *Un chien andalou* "represents a violent reaction against" this contemporary avant-garde cinema addressed "to the reason of the spectator." His collaboration with Dalí, in contrast, functions on a "purely irrational" level, where the images "are as mysterious and inexplicable to the two collaborators as to the spectator."[78] To place *Un*

chien andalou between these two curatorial acts is to remind ourselves that Buñuel always imagined the film as an alternative to avant-garde cinema, as a volatile engagement with spectators trained by the conventions of earlier avant-garde films as well as popular romance narratives. Again, we might well dub this alternative "interactive art cinema."

When Buñuel insists, nearly two decades after the production of *Un chien andalou*, on the mystery of its images for those who made the film and for those who watch it, he highlights his commitment to surrealist interactivity as ongoing in time as well as space. The games of mimicry and image association played by the film become enhanced, over time, through the curatorial lens of authorship. From the age of new media looking backward, Buñuel's "Notes on the Making of *Un chien andalou*" reads like excerpts from a DVD audio commentary by the director. But chances are that if Buñuel had lived to see the digital era, the encounters between old and new media he would stage might be closer to something like Cronenberg's curating of Warhol, or perhaps even a video game not unlike the one imagined in *eXistenZ*.[79] After all, when Cronenberg was invited to help curate a film retrospective at the 1983 Toronto International Film Festival (then the Festival of Festivals), one of the cradles of art cinema, under the theme *Science Fiction Revisited*, he said the retrospective could also be called *A Revisionist View of the History of Film*. Cronenberg's selections included the following titles: *L'âge d'or* and *Un chien andalou*.[80]

Globalized Spectatorship

Ring Around the Superflat Global Village: J-Horror Between Japan and America

In the electric age, when our central nervous system is techno-
logically extended to involve us in the whole of mankind and to
incorporate the whole of mankind in us, we necessarily partici-
pate, in depth, in the consequences of our every action. It is no
longer possible to adopt the aloof and dissociated role of the
literate Westerner.... As electrically contracted, the globe is no
more than a village.

MARSHALL McLUHAN, *Understanding Media*

The world of the future might be like Japan is today—superflat.
Society, customs, art, culture: all are extremely two-dimensional.
It is particularly apparent in the arts that this sensibility has
been flowing steadily beneath the surface of Japanese history.
Today the sensibility is most present in Japanese games and
anime, which have become powerful parts of world culture. One
way to imagine superflatness is to think of the moment when,
in creating a desktop graphic for your computer, you merge a
number of distinct layers into one.... The feeling I get is a sense
of reality that is very nearly a physical sensation.

MURAKAMI TAKASHI, "The Superflat Manifesto"[1]

I s the world round or flat in the age of new media? Is it closer to the
"global village" envisioned by the Canadian media theorist Marshall
McLuhan in 1964 or the "superflat" Japan described by the Japa-
nese artist Murakami Takashi in 2000? This chapter investigates how
discourses of globalization function in the digital era by turning to the
remarkably popular phenomenon of Japanese horror films in the 1990s
and 2000s (a renaissance commonly referred to collectively as "J-Hor-
ror") and their American remakes. I will argue that these extraordinary

interchanges between East and West at the levels of genre, culture, and economics demand that we rethink what characterizes "dominant" and "subaltern" global media flows. In other words, I want to suggest that the networks established between these Japanese and American horror films present us with a haunted-house version of McLuhan's global village, one where Murakami's superflat Japan stages globalization as an unsettled and unsettling confrontation between histories and technologies, past and present, remembering and forgetting. At the crux of this confrontation stands surrealism, functioning within globalization's mediated unconscious.

Discussions of cinema in the age of new media have focused increasingly on issues of *globalization*, an umbrella term that tends to incorporate trends often more accurately described as transnational or international.[2] Still, the existence of computerized, digitized means of production and distribution have altered our conventional sense of "world cinema"—our awareness of it and desire for it—even if many of the obstacles to making and seeing films from off the beaten path (whether geographically or aesthetically) remain firmly in place or have grown even more daunting in the digital era, at least in the theatrical context.[3] At this point most scholars agree that globalization is synonymous with neither cultural standardization nor cultural diversification in any absolute sense. Instead, concepts such as "dominant global flows" and "subaltern contra-flows"[4] emerge to describe a worldwide media economy that is becoming "more diverse through standardization and more standardized through diversification."[5]

According to Arjun Appadurai, the key to defining what makes globalization "strikingly new" in the past century or so is "a technological explosion, largely in the domain of transportation and information, that makes the interactions of a print-dominated world seem as hard-won and as easily erased as the print revolution made earlier forms of cultural traffic appear."[6] For Appadurai the centrality of media such as cinema, television, and computers to the new global cultural economy demands that we shift our understanding of globalization from standard center-periphery models, where concepts such as Americanization have explained how the center dominates the periphery, to a more "disjunctive" sense of globalization. In disjunctive globalization, global flows move in multiple, uneven, and idiosyncratic directions simultaneously, not just from the center to the periphery. "The complexity of the current global

economy," concludes Appadurai, "has to do with certain fundamental disjunctures between economy, culture, and politics that we have only begun to theorize."[7]

What does the case of J-Horror films such as *Ring* (Nakata Hideo, 1998),[8] *Kairo* (Kurosawa Kiyoshi, 2001), *Honogurai mizu no soko kara* (Nakata Hideo, 2002), *Ju-On* (Shimizu Takashi, 2003), and *Chakushin ari* (Miike Takashi, 2004), along with their respective American remakes *The Ring* (Gore Verbinski, 2002), *Pulse* (Jim Sonzero, 2006), *Dark Water* (Walter Salles, 2005), *The Grudge* (Takashi Shimizu, 2004), and *One Missed Call* (Eric Valette, 2008), have to tell us about this new global terrain? In this chapter I will limit my discussion to Nakata's *Ring* and Verbinski's *The Ring*, but I believe many of my observations can be extended to the other J-Horror films as well, including the many sequels, prequels, and offshoots attached to them.

A *RING* OF MEDIATED GLOBALIZATION

Ring, based on a 1991 novel of the same name by Suzuki Koji and adapted for the screen by Takahashi Hiroshi, tells the story of a curse originating with a murdered girl named Sadako (Inou Rie). From beyond the grave Sadako wreaks revenge on the world for her death by channeling her fearsome psychic powers into disturbing, mysterious images transmitted first by television and then by videotape. These images will kill whoever watches them precisely one week after first seeing them, unless the viewer succeeds in expanding the curse's "ring" by copying the deadly videotape and exposing a new victim to Sadako's images. The film follows the efforts of the reporter Asakawa (Matsushima Nanako) and her psychically gifted ex-husband, Ryuji (Sanada Hiroyuki), to interpret the images on the videotape. Understanding Sadako's images is a matter of life and death, as they have both been exposed to the curse along with their young son, Yoichi (Otaka Rikiya).

The film begins with a sequence that immediately locates viewers within the discursive realm of mediated globalization. *Ring*'s first images present a dark sea that disintegrates into televisual static before resolving into the broadcast of a Japanese baseball game. By juxtaposing the sea, Japan's ancient natural barrier to global trade, with television, a modern media platform for globalization and an example of Japan's worldwide success in the electronics industry, *Ring* establishes the connections and

the tensions between modern and premodern, domestic and global that will haunt the entire film. The fact that the televisual signal takes shape as a game of Japanese baseball locates these connections and tensions specifically within global coordinates designated by Japan and the United States. Baseball, America's "national pastime," first appeared in Japan in the 1870s and has since become a significant example of the cultural and economic ties linking the two countries, with players and business passing between Japan and America in both directions.[9]

The two Japanese teenagers Masami (Sato Hitomi) and Tomoko (Takeuchi Yuko) do not watch the game with any sort of focused attention, but the mise-en-scène suggests that they do not need to: the global flows that characterize Japanese baseball have already spilled onto their clothing and surroundings. American brand names such as Pro-Keds, Ritz, and Planters can be detected among the Japanese dolls, books, and magazines that fill Tomoko's home, adding to the impression generated by the televised baseball game that the mediated terrain we have entered is globalized; it is marked by cultural disjunctures enabled by media technology, where there are no definitive means to distinguish the purely Japanese from the purely American. When Masami tells Tomoko about a legend she has heard that involves a cursed videotape, an ominous phone call, and then death for the viewer one week later, Tomoko admits that she watched a strange videotape herself almost exactly one week before. When the phone rings, its piercing tones terrify both girls—is it the enactment of the curse?

The caller turns out to be Tomoko's mother, telling her daughter that the baseball game she is attending has gone into extra innings so she will be late coming home. The relief the two girls feel when they learn the caller's identity does not entirely reassure the viewer, because we already feel caught in a claustrophobic media web. Is the game on television the same one Tomoko's mother attends? Is the legend of the cursed videotape told by Masami the same one experienced by Tomoko? Can the phone that carries Tomoko's mother's voice also carry the power of the curse? In each case a technological medium (television, videotape, telephone) offers the promise of shared experience while simultaneously conveying the threat of suffocation and infection. Indeed, soon after Tomoko hangs up the phone, the television in the adjoining room switches on to the baseball game of its own accord, making the sounds and images that should comfort us through their familiarity and their association

Figure 3.1 *Ring* (Nakata Hideo, 1998): Tomoko's (Takeuchi Yuko) death as photographic negative.

with Tomoko's mother seem uncanny.[10] Even though Tomoko then turns off the television, it is ultimately the television that turns off Tomoko; something unseen emerges from the television to claim her, and her dying scream is captured in a frozen, black-and-white image that resembles a photographic negative (fig. 3.1).[11]

The conversion of Tomoko into a kind of photograph completes the equation suggested throughout the entire opening sequence: death = becoming mediated. The photograph, like the television, videotape, and telephone, exceeds its everyday function as communicator between people over time and space. These media, all so central to processes of globalization, establish a deadly "ring" of mediation that consumes people rather than connects them. The ring tightens the world around media users, instead of expanding it, to the point where finally there is no more media user; there is only the media itself. In this ring of mediation McLuhan's global village comes to life in nightmare form: the technologies that promise to erase boundaries between people scattered across the globe fulfill their promise—only too much so. It is not just the boundaries that are erased but the people themselves as well.

So where is cinema in this ring of mediation? Is *Ring* simply another example in a long line of films stretching from cinema's beginnings to its present that express technophobia toward rival media while consolidating film's own status as a medium to be trusted?[12] I believe the intertextual and international language of the horror genre functions to implicate

cinema within this haunted ring of mediation rather than to exonerate it. If *Ring*'s opening sequence teems with images that wed mediation to globalization, particularly in relation to Japan and America, then its generic references weave another layer in this tapestry of images. The themes of curses and ghosts reach back to Japanese folklore, as well as to a rich Japanese cinematic tradition that includes films such as *Ugetsu monogatari* (*Ugetsu*, Mizoguchi Kenji, 1953), *Tokaido Yotsuya kaidan* (*Ghost Story of Yotsuya*, Nakagawa Nobuo, 1959), *Kwaidan* (Kobayashi Masaki, 1964), and *Onibaba* (Shindo Kaneto, 1964).[13] At the same time, the trope of a haunted television is familiar from North American horror films such as *Poltergeist* (Tobe Hooper, 1982), the threatening telephone call from *When a Stranger Calls* (Fred Walton, 1979) and *Scream* (Wes Craven, 1996), and the "living" videotape from *Videodrome* (David Cronenberg, 1983).[14] Indeed, my interviews with Nakata Hideo and Takahashi Hiroshi (which I will return to throughout this chapter) reveal an extraordinarily diverse array of films and directors that influenced their work on *Ring*: *The Haunting* (Robert Wise, 1963), *The Innocents* (Jack Clayton, 1961), *The Texas Chainsaw Massacre* (Tobe Hooper, 1974), *The Evil Dead* (Sam Raimi, 1983), Sergei Eisenstein, Joseph Losey, Nakagawa Nobuo, and Luis Buñuel.[15] In short, *Ring* presents cinema alongside the photograph, television, telephone, and videotape as media haunted by globalization.

In terms of the particular globalization effects that Murakami dubs "superflatness," where a number of different cultural layers are merged into one and the rest of the world comes to resemble Japan more and more, *Ring* and its American remake together provide a vividly "superflat" global portrait: a simultaneously "Japanized" America and "Americanized" Japan that belongs to both nations but is not fully locatable in either. If globalization's disjunctures emanate largely from media technologies, then the mediated networks between these films could connect a series of images that exceed the conscious intentions of their Japanese or American filmmakers. Appadurai reminds us of how difficult it is to map globalization's disjunctures, especially since the coordinates of center and periphery no longer anchor us as they used to. He points out how one symptom of globalization is that "the past is now not a land to return to in a simple politics of memory. It has become a synchronic warehouse of cultural scenarios."[16]

The mediated unconscious is one way to imagine these conditions of globalization: media technologies crisscross at such rapid speeds, in such

unpredictable directions, that images once consciously relegated to the particular past of a specific nation now materialize as the unconscious visual present of another nation, or between nations. These images belong to the domain of globalized mediation, where histories, aesthetics, and politics may take shape visually as an expression of a mediated unconscious. Murakami's superflatness, like the mediated unconscious, is an attempt to map globalization in new ways, with new cultural coordinates. But both models, like McLuhan's global village before them, risk collapse into an ahistorical fantasy realm where new technology is fetishized and political conflict is minimized. One vital aspect of Murakami's project that resists such collapse comes into focus when it is juxtaposed with the mediated unconscious: its kinship with surrealism. In a major 2005 exhibition of postwar Japanese popular culture (*anime*, *manga*, film, television, toys, figurines) as/through contemporary Japanese art curated by Murakami, history comes to the fore with the aid of surrealism in order to expand the superflat project. By turning to this exhibition, entitled *Little Boy: The Arts of Japan's Exploding Subculture* (held at the Japan Society Gallery in New York), we move toward a theoretical framework that can situate the mediated globalization of *Ring* and its remake alongside surrealism and history.

THE *LITTLE BOY* OF HISTORY

In the exhibition catalog Murakami calls *Little Boy* the third and final chapter in his "*Superflat* Trilogy," a series of exhibitions and accompanying publications commencing with *Superflat* in 2000 and continuing with *Coloriage* in 2002. According to Murakami, the superflat project grew out of a desire to define postwar Japanese art and culture: "Postwar Japan was given life and nurtured by America. We were shown that the true meaning of life is meaninglessness, and were taught to live without thought. Our society and hierarchies were dismantled. We were forced into a system that does not produce 'adults.' The collapse of the bubble economy was the predetermined outcome of a poker game only America could win. Father America is now beginning to withdraw, and its child, Japan, is beginning to develop on its own."[17]

In this passage from the *Little Boy* catalog, where Murakami quotes his own 1999 essay "Greetings, You Are Alive: Tokyo Pop Manifesto," he suggests that one way to interpret the term *little boy* is as a metaphor for

postwar Japan, with America as a father figure. But, of course, "little boy" also calls to mind the codename for the atomic bomb detonated over Hiroshima on August 6, 1945—a connotation highlighted by the exhibition's use of "exploding" in its subtitle.

As one becomes more fully acquainted with the exhibition, "little boy" and "exploding subculture" take on additional meanings. The opening plate in *Little Boy*'s catalog is a photograph of the Japanese surrealist artist Okamoto Tarō posing in front of his gigantic sculpture *Tower of the Sun* (1969), the centerpiece of the 1970 World's Fair (*Expo '70*) held in Osaka. The text that accompanies this photograph, in both Japanese and English, is a signature phrase of Okamoto's: "Art is explosion!"[18] Murakami's decision to foreground Okamoto in this way, as a sort of guiding spirit who presides over *Little Boy*, underlines how the exhibition's context takes shape at the crossroads of globalization (the World's Fair), surrealism (Okamoto), and history (the "explosion" of art inseparable from World War II's atomic explosions).

Another "little boy" who stands at this crossroads is the *otaku*, a diehard fan (almost always male) devoted to Japanese anime, manga, and other "lower" forms of Japanese popular culture. The culture of the otaku is the "subculture" referred to in *Little Boy*'s subtitle, and a conversation between Murakami and two experts on the otaku phenomenon, Okada Toshio and Morikawa Kaichirō, is included in the catalog.[19] Although opinions vary widely on exactly how to define *otaku* and what stands inside and outside this subculture, one might say that generally *otaku* has undergone a transformation from a largely negative designation to a somewhat positive, even respectable one. The negativity encompasses connotations of social ineptitude, regressive immaturity, and nonproductivity, while the positive aspects touch on authentic art, international influence, commercial success, and cultural power. Murakami's art is itself an important example of how the materials of formerly denigrated otaku culture can be reworked as critically and financially successful contemporary art—even if Murakami describes himself as having "failed to become an *otaku*."[20]

The lucrative export business and international acclaim generated by Japanese anime, manga, video games, and other popular culture objects, including horror films (to the point where many Western fans proudly identify themselves as otaku), figures centrally in Japan's transition from economic superpower to "cultural superpower" in the recessionary 1990s.[21]

In fact, the bursting of the Japanese bubble economy in the early 1990s has been understood as "epochal,"[22] as a moment when "the image of Japan, built up over decades, as a nation of unending economic expansion" crumbles so seriously that what is signaled socially and culturally may be nothing less than "the long-deferred end of the postwar."[23] Certainly this is how Murakami sees the "superflat" context of his own work, if we recall how he traces his project to an era marked by "the collapse of the bubble economy," as well as the ascension of "Japanese games and *anime*, which have become powerful parts of world culture."[24] In other words, Murakami's superflat project materializes at a time when Japan's long postwar, with its emphasis on economic growth as a guarantee of an endless present that affords precious little opportunity to reflect on the wartime past, gives way to a prolonged economic downturn that challenges Japan to rethink its relation to the past, present, and future under the banner of globalization.

I do not wish to refer to this recessionary era as "post-postwar," with its suggestion that World War II and its aftermath are somehow transcended during this time; in fact, as J. Victor Koschmann observes, "deeply rooted in the culture of Japan's recession of the 1990s are insistent issues of Japanese war responsibility and compensation. . . . In the course of the decade, significant connections have emerged between issues of war guilt and the question of Japanese nationalism."[25] Indeed, the global success of Japanese popular culture, "as one of the few bright spots in the nation's bleak economic landscape since the 1990s," has resulted in domestic political use of "the emergent image of 'cool' Japan abroad in order to boost the sagging national self-confidence."[26] The Japanese right has sought to capitalize on this circumstance in a number of ways, including advocating less "masochistic" portrayals of wartime Japanese history. The history textbook revision efforts associated with noted manga creator Kobayashi Yoshinori, "honorary director" of the Japanese Society for History Textbook Reform, have been incisively summarized by Marilyn Ivy: "only by justifying the war—and by sharing out atrocity under erasure—can Japan revivify its moribund national body." Ivy points out how this textbook revision strategy depends on the logic of "no worse than," where Japanese war crimes are "no worse than" those committed by other nations and therefore "the fact that monstrosity is shared, that it is international, should pay for its erasure: we are *not* monsters."[27]

At some level Murakami seems to sense the nationalist dangers produced at this intersection of Japan's economic fall and cultural rise—the globalized intersection where his superflat project resides. He concludes his summary of the "*Superflat* Trilogy" in the *Little Boy* catalog with words that seem designed to counter, or at least provide an alternative to, the kind of conservative history textbook reform underwritten by Kobayashi: "We are deformed monsters. We were discriminated against as 'less than human' in the eyes of the 'humans' of the West.... The *Superflat* project is our 'Monster Manifesto,' and now more than ever, we must pride ourselves on our art, the work of monsters.... Only by knowing the meaning of history can we sense that we are alive now."[28] Murakami's formulations are not free from nationalist sentiment, nor do *Little Boy*'s accounts of World War II ever really move beyond Japanese atomic victimhood. But by embracing "monstrosity" rather than denying it, Murakami opens a window for negotiating "the meaning of history" that Kobayashi closes. Chief among the elements passing through this open window is surrealism.

EXPLOSIVE SURREALISM

To return to where *Little Boy* begins: Okamoto's phrase "Art is explosion!" was made famous when the surrealist artist appeared in a popular Japanese television commercial for Hitachi Maxell videocassettes. The catalog description of *Little Boy*'s opening plate dedicated to Okamoto (an entry edited by Murakami) draws attention to this fact, as well as to how Okamoto's artistic sensibility was formed during the years he spent in France (1928–40) as an associate of the surrealists and related figures, including Georges Bataille.[29] This is not the first time surrealism has been on Murakami's mind, as one of his own series of paintings produced in 1999 bears the title *PO + KU Surrealism*.[30] By beginning with Okamoto, *Little Boy* foregrounds the junctures of surrealism and electronic media, of Japanese art and Japanese commerce, of globalization and history. These are the same junctures crucial for understanding Nakata's *Ring*, Verbinski's *The Ring*, and the forces of mediated globalization that traverse the two films.

Indeed, there are certain ways in which the cursed videocassettes of *Ring*, imprinted with Sadako's surrealist-style series of discontinuous images that document a monstrous crime committed in the past, perform a nightmare version not only of McLuhan's global village but

also of Okamoto's Hitachi Maxell videocassettes. In *Ring* the "explosion" of "art" crystallized by surrealist-style images transmitted by videotape means that a haunted past has come to claim lives in the present. By having its curse recorded and played on videotape, *Ring* also allegorically suggests that the electronic products that epitomized Japan's economic strength in the 1980s, such as televisions, VCRs, and videocassettes, no longer "work" in the recessionary 1990s. What used to bring prosperity now brings death; what used to safeguard a never-ending present now insists on returning to a repressed past.

Again, I am not suggesting that Nakata and Takahashi consciously intended to present the media technologies that saturate *Ring* as signs of the contemporary recession or a revisiting of the wartime past. But the film's fascination with media indicates powerful connections to globalization's mediated unconscious. For Takahashi one of *Ring*'s influences was his own earlier experience with what we might call in retrospect an instance of the mediated unconscious:

World War II is very important to me, even though I did not live through it myself. In the 1960s, my generation watched a lot of special-effects-filled Japanese TV dramas that were made by people who experienced the war. These TV programs were not pro-war or anti-war, but the things that the people who made them saw during the war were reflected in the programs themselves, often in quite horrifying ways. These programs were science fiction, like *The Outer Limits*. But while watching them, you could still feel a sense of guilt about the war behind them. And that feeling is quite important when it comes to making horror films.[31]

Takahashi's associations with television as a conduit between the trauma of the past and the life of the present gains a striking analogue in *Ring* through Sadako's deadly videotaped images, which always appear on television screens or monitors.[32] Television's role as a passageway connecting past and present becomes terrifyingly literalized during the film's climax, as Sadako lurches out of the TV screen to kill Ryuji in his apartment (fig. 3.2). Although Sadako's images begin as surrealist-style abstractions, they are eventually translated as clues that help uncover her hidden murder many years earlier. And in the end these images are

Figure 3.2 *Ring*: Sadako (Inou Rie) emerges from the television screen.

transformed into a manifestation of Sadako herself—equal parts ghostly and material, recorded videotape and live television, then and now.

It is important to recognize how *Ring* connects the "then" of World War II to the "now" of Japan's 1990s recession. For Takahashi memories of World War II, like Sadako herself, came through the television. Another traumatic televisual image that makes its way onto Sadako's videotape in allegorical form is the figure of Miyazaki Tsutomu. When Miyazaki was arrested in 1989 and convicted for kidnapping, murdering, and partially devouring four young girls, TV footage depicted him pointing to the site where he committed his crimes, with a white jacket over his head to conceal his identity. The image of a pointing, hooded figure also appears on Sadako's videotape (fig. 3.3), an intentional allusion on the part of Takahashi and Nakata that gains additional force when one considers Miyazaki's title in the Japanese news media as "The *Otaku* Murderer." In addition to the corpses of the girls he killed, police discovered thousands of videotapes in Miyazaki's possession associated with the otaku subculture, namely "his collection of *anime* and horror films."[33]

As Nakata explains:

> Takahashi and I spent a night going over a detailed description of each shot [on Sadako's videotape], and he recalled some weird images from *manga* as well as of the child killer Miyazaki, who was . . . my age. When he was taken to the crime scene, he was asked where he killed the girls. He pointed to the ground, like this [gesturing with one arm outstretched], and on his head was

Figure 3.3 *Ring*: The hooded figure from Sadako's cursed videotape.

a white jacket. It was not exactly the same in the film, but that image itself impressed me and Takahashi when we were watching the news. It was . . . an eerie, haunting image.[34]

Takahashi concurs: "My generation was very much influenced by the horrible case of Miyazaki Tsutomu. . . . That crime, for my generation, had a deep impact."[35] The generation-defining aspect of Miyazaki's crimes for both Takahashi (born in 1959) and Nakata (born in 1961) places Miyazaki alongside the recession, even though his arrest predates the bursting of the bubble economy. The fact that Miyazaki's presence finds its way into *Ring* nearly ten years later supports this connection, as does Takahashi's belief that, at least in retrospect, Miyazaki must be understood in conjunction with the traumatic national events of 1995 (also the fiftieth anniversary of the end of World War II) that helped make J-Horror possible commercially:

> The crucial year for J-Horror was 1995. Up until then we were not having much success producing these films. But after 1995 everything went more smoothly. 1995 was the year of the Kōbe earthquake and of the Aum Shinrikyō sarin gas subway attacks in Tokyo. So for us 1995 is a very memorable year in terrible ways. . . . The J-Horror group [Takahashi, Nakata, director Kurosawa Kiyoshi, director Tsuruta Norio, and screenwriter Konaka Chiaki] already understood that the world was changing in the 1980s, with Miyazaki and the fall of the Berlin Wall. Then there

was the dissolution of Nikkatsu Studios in 1993 or so. But after Aum especially, Japanese people had to face a new reality, where impossible things can become very possible. Even Japanese film studios, who do not tend to accept change, had to face this.[36]

To summarize: Miyazaki's identity as "The *Otaku* Murderer" has, over time, made him a generational icon for Japan's recessionary era—the disturbing face of Japan's transition from economic to cultural (otaku-linked) superpower. When Takahashi maps Miyazaki onto events coinciding with the heart of the recession (the Kōbe earthquake, Aum Shinrikyō)[37] and massive changes in the Japanese film industry (the collapse of Nikkatsu, the birth of J-Horror),[38] he maps the relations that combine to forge a "new reality" for Japan. And it is this map that can be glimpsed in the images on Sadako's videotape.

According to Nakata, Takahashi came up with a "genius" formulation that guided them in the visual realization of Sadako's images: "We should try to make images like those in a blind person's dream." But even though Nakata and Takahashi discussed their desire before filming to steer clear of images that might seem too obviously "surrealist," Nakata admits, "Actually, a blind man's dream and surrealist artists' paintings and movies are kind of similar things."[39] In both *Ring* and *Little Boy* the specter of history touches on the intertwined legacies of World War II, surrealism, and the recession. The art historian Sawaragi Noi develops one strand of these legacies in his contribution to the *Little Boy* catalog, an essay that claims contemporary Japanese Neo Pop art like Murakami's, with its foundations in postwar Japanese popular culture, affords an invaluable opportunity to reassess the connections between Japanese art and World War II. For Sawaragi, Japanese Neo Pop "has re-imagined Japan's gravely distorted history, which the nation chose to embrace at the very beginning of its postwar life by repressing memories of violence and averting its eyes from reality." Even if Murakami's generation of artists vacillate "between the desire to escape from historical self-withdrawal and to revert to it," Sawaragi asserts that Japanese Neo Pop's fascination with postwar Japanese popular culture demonstrates an engagement with World War II missing (or erased) from more canonical Japanese art.[40]

For example, Sawaragi finds Japanese Neo Pop's embrace of World War II–themed anime, model kits, television programs, and films such as *Gojira* (*Godzilla*, Honda Ishiro, 1954) in stark opposition to Japan's

continuing reluctance to exhibit "war paintings" dating from World War II by a number of important Japanese artists. These war paintings depict Japanese military campaigns for propaganda purposes and were commissioned by the Japanese government during the war. Although these paintings were confiscated by U.S. authorities at the war's end, they were returned to Japan in 1970 as an "indefinite loan" and have yet to be exhibited together as a whole for the public. The National Museum of Modern Art, Tokyo, at which the collection of 153 surviving war paintings is deposited, usually displays only three at any one time in its gallery.[41] As Sawaragi concludes, "an important chapter of Japanese modern art history thus remains unwritten."[42]

Among the prominent artists who made war paintings was the surrealist pioneer Fukuzawa Ichiro. Prior to obliging the government's request for war paintings, Fukuzawa, along with the surrealist poet-critic Takiguchi Shūzō, was arrested in 1941 "under suspicion of collaboration with international communism."[43] After undergoing several months of criminal investigation and detention, Fukuzawa and Takiguchi were released but remained under surveillance. Fukuzawa was forced to recant publicly his ties to surrealism;[44] later, he began work on war paintings. Not surprisingly, Fukuzawa's attitude toward his war paintings was deeply ambivalent; one pupil "recalls that Fukuzawa kept his war paintings down in the cellar in order to avoid looking at them."[45] After the war Fukuzawa helped found a left-wing artists' group, Nihon Bijutsukai (Japan Artists' Association), that in 1947 accused the nonsurrealist artist Fujita Tsuguharu of war crimes for his war paintings. As a result Fujita left Japan in 1949 and lived the rest of his life in exile.[46] The Fujita incident, when juxtaposed with Fukuzawa's own persecution by the government before the war and contribution to war paintings during it, helps to indicate the painful reasons why the intersections between surrealism and World War II have remained in the shadows of postwar Japan for so long: surrealism's relation to the war has never been settled. In the context of postwar Japan, surrealism will always be haunted by World War II.

In this light Murakami and Japanese Neo Pop can be read as mobilizing surrealism to capitalize (however unconsciously or incompletely) on this haunting, to restore evaded memories of World War II by looking toward an art movement already freighted with its own unresolved sense of war responsibility. *Ring* must be seen in the same light. Indeed, Suzuki's source novel locates the origins of its deadly curse in the immediate

aftermath of World War II. Sadako's mother, Shizuko, first manifests her own supernatural abilities in 1946, when she dives into the sea to recover the statue of a Buddhist ascetic and mystic dumped into the ocean by American occupation forces. According to a friend of Shizuko's, it is only after this incident that Shizuko begins experiencing "searing pains in her head, accompanied by visions of things she'd never seen before flashing across her mind's eye."[47] Shizuko's visions predict the future, but it is her daughter Sadako's images drawn from the *past* that lend these "visions of things" inherited from her mother the intensified potency of a lethal curse.[48]

Nakata and Takahashi omit this episode from their film, but Takahashi explains how World War II informed his personal sense of horror that he brought to his work on *Ring*: "Two things are especially important. One is an event that is similar to the Holocaust where Japanese soldiers in China, since called the '731 troops,' performed scientific experiments on Chinese and Russian prisoners. That was very horrifying to learn about, even though it was not officially admitted. The second is the fact that Japan lost the war. But also the huge air raid on Tokyo and the atomic bombs dropped on Hiroshima and Nagasaki."[49] Indeed, Takahashi's previous collaboration with Nakata on the horror film *Joyūrei* (*Ghost Actress*, also known as *Don't Look Up*, 1996) includes an important plot strand involving World War II that prefigures certain aspects of *Ring*. In *Ghost Actress* a film being shot in the present is set in the Japanese countryside during World War II. The shooting of this film within the film becomes haunted when old film footage from a cursed production is accidentally spliced in with the new footage, resulting in disorder and death on the set. Just as the curse in *Ghost Actress* transmits itself from old film to new film, so, too, does the curse in *Ring* travel from past to present via videotape and television. The haunted vortex between past and present contains World War II explicitly in *Ghost Actress*, while it remains implicit in *Ring*. Still, the atmosphere of dread created by a hidden, violent past hanging over a cursed present and delivered by media technology runs continuously between the two films. In fact, early on in *Ring* a coworker mentions to Asakawa the case of "a star who killed herself, and people saw her ghost on TV"—a case, in other words, that melds the curses of *Ghost Actress* and *Ring*.

The language for the past generated by Sadako's images in *Ring* is both surrealist and cinematic. In fact, when Suzuki summarizes the series of discontinuous sounds and images included on the cursed videotape,

he breaks them down into a kind of sequence analysis of a surrealist film, with twelve "scenes" of varying duration that can be labeled either "real" or "abstract."[50] In this sense Suzuki's novel already gestures toward cinematic surrealism to describe its cursed images from the past. Nakata and Takahashi will complete the circle by bringing Sadako's surrealist images to cinematic life. In many ways the images in this sequence are the heart of the film. Nakata explains:

> I worked with my director of photography on making it hard to tell which direction the light was coming from in that sequence. I wanted the light to look flat, so distinctions between dark and light should be kind of vague. And of course we tweaked the quality of the images, because we shot on 35 mm and then worked again and again to lose the color digitally, and at the end we copied the images onto VHS a few times to degrade them. After we spent more than 24 hours on it, the images still had some color in them. So the producer Takashige Ichise came to me and said, "This is not good enough. We should do it again." And I agreed. A lot of time, perhaps even 48 hours, was put into that sequence.[51]

Nakata first presents Sadako's images as seven discontinuous scenes:

1. From below, we observe a man's face peering down into a well as clouds pass by above him (fig. 3.4).
2. A woman brushes her hair in an oval mirror; an identical mirror appears and disappears quickly on the opposite side of the frame, offering us a glimpse of a white-robed figure with long black hair (Sadako); the original mirror returns, with the woman turning to the right as if to look for the now absent Sadako.
3. An assortment of written Japanese characters swim around a page, sometimes jostling each other and spelling out *eruption*.
4. A group of people stumble and crawl along the ground, some moving forward and others backward.
5. A hooded figure points to the left, the sea behind him (fig. 3.3).
6. An extreme close-up of an eye with the written character *sada* ("chaste") appearing in its pupil; the eye blinks twice (fig. 3.5).
7. An exterior shot of a well in a forest (fig. 3.6).

Figure 3.4 *Ring*: A man, a well, and clouds from Sadako's videotape.

Figure 3.5 *Ring*: Sadako's eye from Sadako's videotape.

Figure 3.6 *Ring*: The well in the forest from Sadako's videotape.

A number of striking parallels unite Sadako's images with those of the most famous surrealist film, Buñuel and Dalí's *Un chien andalou*. The notorious opening sequence of *Un chien andalou* (described more fully in chapter 2), where a woman's eye is slit by a razor after a man witnesses a passing cloud "slicing" the moon, echoes throughout this sequence in *Ring*. Similarities include not just the shared visual elements of eyes and clouds but the associational connections between images based on graphic matching (rather than conventional narrative logic): *Un chien andalou*'s series of rhyming shapes and movements of the razor across the man's thumb, the cloud across the moon, and the razor across the eye recur in *Ring*'s rhyming circular shapes of the well and the mirror (scenes 1 and 2) and the eye and the well (scenes 6 and 7). In addition the rhyme between the movements of the written Japanese characters as they "crawl" across the page (scene 3) and the people as they crawl along the ground (scene 4) recalls the ants crawling out of a wound in a hand featured in *Un chien andalou* (and a visual motif in Dalí's paintings as well).

The resemblances between the two films are not entirely accidental. Takahashi names Buñuel alongside Fritz Lang as "the directors who I was influenced by the most,"[52] and Nakata acknowledges that prior to filming *Ring*, "I actually watched *Un chien andalou* a few times, so there could have been some kind of influence there." He adds, "We all knew that [the influence of surrealism] was inevitable. For example, there was that shot of a huge eye [in *Ring*]. . . . Of course, a filmgoer would say, 'OK, here's a Luis Buñuel sequence.' But actually, Takahashi and I tried our best to avoid that kind of surrealistic feeling. But because you cannot rationalize each shot on the videotape in the beginning, what does each image mean? They're very weird, impressionistic, and surrealistic images."[53]

What Nakata refers to as the "inevitable" influence of surrealism on *Ring*, despite attempts to sidestep it, certainly informs similarities between the surrealist structure of Sadako's images and those of *Un chien andalou*. But this is not enough to call *Ring* a surrealist film in the same way we call *Un chien andalou* a surrealist film. *Ring* is still essentially a narrative film and *Un chien andalou* a nonnarrative one, even if the increased emphasis on narrative explanation in Verbinski's *The Ring* points toward some significant departures from Hollywood narrative conventions in *Ring* (and J-Horror in general). As Takahashi explains concerning his adaptation of *Ring* to the screen, "The huge difference between the novel and the film is that the novel is a detective story. To

make the film less of a detective story, I made [Ryuji] a psychic so that he doesn't need to be as much of a detective. Like Eisenstein, I don't want to focus on explaining the narrative details. If I just followed the detective story, that would require a lot of narrative explanation." In relation to Eisenstein, Takahashi adds, "One of the models for J-Horror is to shoot things that are both probable and supernatural. It's not as interesting if the subject matter is only realistic or only fantastic. To combine the two in a way that has the most impact, it is very effective to use a disjunctive method, the way Eisenstein did."[54]

Takahashi's application of Eisenstein's disjunctions might finally be closer to Buñuel than to Eisenstein himself, but still, it is hard to imagine Takahashi or Nakata speaking about *Ring* the way Buñuel spoke about his collaboration with Dalí. For Buñuel, as we will recall, *Un chien andalou*'s images are "as mysterious to the two collaborators as to the spectator" and "NOTHING . . . SYMBOLIZES ANYTHING."[55] By the end of *Ring* the overall mystery presented by Sadako's images has been deciphered, and we know, for the most part, what each image symbolizes. Even before Sadako's images have been investigated, dissected, and translated into narrative meaning, the "blinking" mirrors of scene 2 (as they appear and disappear) and the blinking eye of scene 6 provide a visual bridge between the sequence's first two scenes and last two scenes in such a manner (forming a "ring" around the sequence as a whole) that a prevailing sense of order emerges. This is not to say that *Un chien andalou* is pure disorder—indeed, it is quite typical of surrealism in that it depends on references to a number of recognizable narrative conventions and genres, even if it ultimately parodies, critiques, or subverts them—but its investment in "answers" is far less pronounced than *Ring*'s, as my analysis in chapter 2 demonstrates.

The surrealist aspects of *Ring*, however, are not limited to the "film-within-a-film" constituted by Sadako's images. Sadako's ghost, which becomes more and more corporeal as the film unfolds, moves in twisted, erratic spasms that unmistakably evoke the grotesque body movements made famous by *ankoku butoh* (dance of utter darkness), an avant-garde Japanese dance form originating with Hijikata Tatsumi and Ohno Kazuo. Indeed, Nakata cast an actress trained in this dance form to play Sadako. Ankoku butoh, often shortened to simply *butoh*, was first performed in 1959 and remains influential to this day.[56] But Hijikata's most active period was during the 1960s, when his surrealist-associated inspirations

included Antonin Artaud and Takiguchi Shūzō, and butoh "tried to distort, warp, and torture the body in order to keep the self in a constant state of fragmentation."[57] At the climax of *Ring*, when Sadako emerges from the well and crawls through the television screen, her unnerving movements recall those of butoh performance, and her appearance bears an uncanny resemblance to Hijikata himself in the 1960s.[58]

Sadako's body, through the aid of subtle visual effects (Nakata filmed backward movement by the actress and then presented it as forward motion), simulates the painful, often spastic gestures of butoh, where themes of bodily metamorphosis depend on shocking embodiments of violence, deformity, and disease. As Sadako metamorphoses from the mediated to the corporeal, from a ghost in the past to a body in the present, she gives shape to the twin legacies of surrealism and globalization I have argued for as profoundly intertwined in *Ring*'s expression of the mediated unconscious. To understand Sadako's monstrosity, one must ultimately reckon with her as a media virus—a virus neither wholly Japanese nor wholly American but shared between Nakata's *Ring* and Verbinski's *The Ring* in such a way that surrealist vocabularies of assaultive and assaulted vision enable us to see a superflat global village mediated by the horrors of history. To see Sadako more fully in this light, we must observe what becomes of her in Hollywood.

THE RING BETWEEN JAPAN AND AMERICA

Of course, the very existence of Gore Verbinski's *The Ring*, the American remake of Nakata's *Ring*, extends the intertextual and transnational network of mediated globalization established by Nakata's film.[59] But the fact that Verbinski and his screenwriter, Ehren Kruger, choose to follow Nakata and Takahashi so closely in many important respects gives the remake an enhanced sense of mediated uncanniness, as if it were the ghost of a ghost created by globalization. For example, even before the film begins, the production company logo of DreamWorks Pictures flickers with the televisual static effect familiar from Nakata's film, minus the logo's traditional color scheme and theme music. The result is that the DreamWorks logo, with its iconic American connotations attached to production partner Steven Spielberg, shows signs that it has become possessed by a Japanese media infection—which, of course, it has. *The Ring* reveals America imitating Japan, in effect turning the tables on the

conventional, defensive stereotype that Japan's technological success depends on copying America's innovations, not originating its own. But then again, in the uneven logic of globalized economics, DreamWorks can afford to risk a playful acknowledgment of this debt to Japan; it is they who bought American distribution rights to Nakata's film on DVD, even bestowing the artificially "Japanized" title *Ringu* on Nakata's film, so that for most American audiences it is the DreamWorks logo that precedes both versions of *Ring*. In this manner DreamWorks stakes a claim to "owning" the franchise in both its Japanese and American variations. This is a claim bolstered by the absence of Nakata and Takahashi's names from the credits of *The Ring*, as well as by the decision to employ Nakata as the director of *The Ring Two* (2005), a Hollywood sequel to Verbinski's remake again produced by DreamWorks.

But determining "ownership" of the *Ring* phenomenon becomes a slippery business when one moves from economic to cultural and historical concerns. We have already seen how *Ring* reached out to at least as many American film traditions as Japanese ones and how the transnational influences of globalization and surrealism shaped the film. Turning to *The Ring* necessitates consideration once again of globalization's mediated unconscious, but from a different vantage point. In *Ring* the mediated unconscious could be detected in images that resonate with Japan's experiences of World War II and the recessionary 1990s refracted through surrealism. In *The Ring* this template transforms so that the mediated unconscious breaks through in images linked to America's experiences with the atomic bombing of Japan during World War II.[60] Once again, I am not claiming that *The Ring* is consciously designed as an atomic allegory for World War II. I am arguing that the technologized global flows that brought this American remake of a Japanese horror film into existence had to incorporate and update, by unconscious necessity, precisely those histories, aesthetics, and politics I discussed in relation to *Ring*'s exploration of the mediated unconscious. So perhaps it is not surprising to learn that between *Ring* and *The Ring*, between Japan and America, we can also find surrealism—a context I will return to later in the chapter.

In a brilliant study of postwar Japanese visual culture, Akira Mizuta Lippit traces how "the atomic radiation that ended the war in Japan unleashed an excess visuality that threatened the material and conceptual dimensions of human interiority and exteriority." Lippit is not the only one to suggest that "since 1945, the destruction of visual order by

the atomic light and force has haunted Japanese visual culture," but his original syntheses of technologies as diverse as X-rays and atomic radiation with films as varied as Teshigahara Hiroshi's *Suna no onna* (*Woman in the Dunes*, 1964) and Kurosawa Kiyoshi's *Cure* (1997) lends their intersections a new level of complexity.[61] Lippit's notion of "excess visuality" and its disruption of borders between the visible and the invisible, like my own sense of the mediated unconscious, provides tools for investigating how cinema captures and expresses the impact of different technologies by means of its optical surfaces rather than only its explicit narratives or implicit themes. In my analysis that follows, I will investigate manifestations of excess visuality in *The Ring* as a bridge to the film's interface with the mediated unconscious. As we will see, it is not only *Japanese* visual culture that has been haunted by the atomic bomb.[62] That said, any attempt to neatly disentangle purely Japanese from purely American cinematic engagements with the atomic bomb is as futile as explaining the destruction at Hiroshima and Nagasaki in exclusively Japanese or exclusively American terms.[63] Even a cursory glance at the history of the most popular and durable cinematic icon of the atomic bombings, Gojira/ Godzilla, discloses a powerful shared legacy between (and beyond) the two nations.[64] But the case of *Ring* and *The Ring* presents this exchange with a new set of coordinates, where the forces of globalization and surrealism chart the shared histories of World War II in novel ways.

 The Ring is set in America's Pacific Northwest, where the newspaper reporter Rachel Keller (Naomi Watts) struggles to penetrate the mystery of the videotaped curse of Samara (Daveigh Chase) after her niece falls victim to it. Keller's investigation takes her from Seattle to two remote areas of Washington State, Shelter Mountain and Moesko Island. Each new revelation about the curse's origins comes at the expense of time ticking away for Rachel herself; her psychic son, Aidan (David Dorfman); and her ex, Noah (Martin Henderson), all of whom have only seven days left to live after watching Samara's videotape. When Rachel learns that Samara was the child of Anna Morgan (Shannon Cochran) and Richard Morgan (Brian Cox), a couple whose happiness as successful horse breeders was offset by their inability to conceive, she hopes that uncovering this family's secret history can counteract the curse. But in the end she discovers that Samara's death sentence can only be avoided by copying her videotape and showing it to a new victim. This knowledge comes in time to save herself and Aidan but not Noah.

Figure 3.7 *The Ring* (Gore Verbinski, 2002): The "burning" tree—a red Japanese maple.

When Rachel plays Samara's videotape for the first time, something extraordinary happens at the level of visuality in *The Ring*. In a film almost completely devoid of bright sunshine, a blazing sunset suddenly washes over the cabin where Rachel prepares to play the tape, drenching the location in such intensely bright light that the red leaves on a nearby tree seem to burn under the illumination (fig. 3.7). The light pierces the cabin's interior, bathing the scene of Rachel's viewing in a fiery crimson glow. When the videotape ends, the sun has set and the overcast sky returns. Only now, it is raining.

In this sequence, like several others in *The Ring*, the ghosts haunting the film are not limited to Samara or Sadako but extend to those technological and historical substrates that conjoin *Ring* and *The Ring*. Here, through the circulation of visuality I have described as globalization's mediated unconscious, the scorching light that momentarily consumes the cabin evokes an atomic blast. In these images the atomic bomb meets the TV and the VCR as technological agents of globalization, just as Japan in 1945 meets present-day America as intertwined historical moments. This connotation may not have been intended by Verbinski, but it is there nonetheless, in the images themselves and in the contexts that ground them. It is revealing that the tree selected to "burn" in this sequence is a red Japanese maple, an image that gains significance later as a tree on fire glimpsed on Samara's videotape, and then as an etching literally burned into a wall through Samara's psychic power. The tree's identity as a red Japanese maple is never mentioned in the film itself, but new media's

contribution to global flows means that it is not only botanists who will eventually catch the reference.

THE RING ONLINE

On websites devoted to the *Ring* phenomenon in all its forms, production details such as the red Japanese maple are eagerly communicated and discussed by fans and filmmakers alike. I am not suggesting that such websites articulate the same kinds of theoretical and historical claims I am making here, but their in-depth devotion to issues concerning each film's production, the narrative significance of particular images, and comparisons between the Japanese and American versions of the *Ring* phenomenon certainly provide an impressive set of tools that certain viewers might use to interpret the films along similar lines. These tools come in a variety of forms, such as articles, reviews, interviews, and online discussions involving viewers all over the world. The sheer diversity of these forms and the mountain of information they present is often difficult to organize in the manner of a streamlined argument, but the information itself is remarkably detailed and easily navigated. For example, in an article on the production of *The Ring* included on the website *Curse of the Ring*, we learn that

> the primary exception to the film's subdued color scheme was
> a fiery red Japanese maple seen in the cursed video and acting
> almost as a signpost along the way. "The tree is a focal point
> of the movie. It kind of unifies the different elements—every-
> thing always seems to come back to that tree," offers [production
> designer Tom] Duffield. . . . The red maple was also one of the
> designer's homages to the story's Japanese origins. Others
> that might be picked out include an American version of a
> sliding luminous door, and a Japanese wall hanging seen at
> the Morgan ranch.[65]

Granted, there are a number of analytic steps separating the presentation of this information from a reckoning with the mediated unconscious. But the fact remains that this article, as part of a website produced by, geared toward, and accessible to everyday (albeit English-speaking and Internet-savvy) viewers the world over, raises concerns like the visual significance of the red Japanese maple, its status as a "focal point" of the

film, and its presence as one of a series of images that connect the film's Japanese and American dimensions. How exactly viewers might use such information is difficult to determine, but one possibility is that they could return to *The Ring* with new eyes.[66] How might knowledge about the red Japanese maple guide viewers toward the atomic connotations of the film's related imagery of burning and scarring? Could the website help viewers establish a sort of connective tissue between images like the red Japanese maple aflame, Rachel's arm scarred from the burning touch of Samara's ghost, and the rain that falls so often in the film (recalling the black rain of atomic fallout, a connotation heightened when the rain pours down following the "atomic" sunset)? Or might viewers abandon such readings after the website classifies the burning tree as an "abstract" image, distinct from the "concrete" images on the videotape that can be explained as tangible emblems belonging to the film's story arc?[67] In either case, the website can only be regarded as one element among many others that might factor in matters of spectatorship—it cannot stand alone in relation to these questions.

Still, the very existence of *Curse of the Ring* and the ambitious range of its engagements with the entire *Ring* phenomenon is rather exceptional, since ultimately very few films inspire this kind of detailed online analysis. Then there is the plot of *The Ring*, which is about the very kind of technological deconstruction of an analog medium that viewers are invited to perform themselves through the website. Rachel uses techniques that we associate with the digital era (searching the Internet, freezing and printing images, taking digital photographs) to decipher the videotape's images, while the website is built around the desire of viewers to participate in a similar sort of process—using new media to decipher the film's images. This unusual sort of mirroring between the film and the website thrusts the website forward when considering issues of spectatorship, so even if the website refrains from engaging the history of World War II explicitly, its treatment of history merits further exploration.

One section of *Curse of the Ring* covers the topic of the "factual basis of *The Ring*."[68] Here, users of the website can read an illustrated article on Fukurai Tomokichi, a Japanese psychology professor who published a book in 1913 that was later expanded and translated into English as *Clairvoyance and Thoughtography* (1931). In this book Fukurai reports on his experiments with a number of mediums between 1910 and 1928, leading him to conclude "that clairvoyance is a fact, and that thoughtography [the ability to imprint thoughts on a photographic surface through psychic

means] is also a fact."[69] Fukurai's evidence of clairvoyance comes from mediums who can "read" letters on hidden sheets of paper controlled by the professor, while his claims for thoughtography rest with mediums who can imprint their "thoughts" directly on photographic plates, without the aid of a camera. The website does not pass any judgment on the scientific worth of these experiments, but it does point out that two of Fukurai's subjects are named Shizuko and Sadako. Like the character of Sadako's mother in Suzuki's novel and Nakata's film who bears the same first name, Fukurai's Shizuko commits suicide after she is accused of fraud for her demonstrations of clairvoyance. What the website does not mention is that Fukurai's Sadako also bears some striking resemblances to her fictional counterpart, although she is in no way related to Shizuko. According to Fukurai, Sadako manifests multiple personalities, including one who calls himself a "long-nosed goblin."[70] In novel and film one of the messages embedded on Sadako's videotape is "frolic in brine, goblins be thine," a reference to the centrality of water to her origins. Fukurai's Sadako also exhibits some talent in thoughtography, which of course takes on much greater proportions in the film through the cursed videotape. *The Ring* dispenses with any substantial account of Samara's mother as clairvoyant, but it extends significantly Samara's abilities in thoughtography. Again, the website's inclusion of Fukurai offers information that could aid viewers in anchoring the film's representation of thoughtography to history, even if it is not directly tied to the history of World War II (in fact, the website's section on the factual basis for En no Ozunu, the Buddhist ascetic whose statue ignites Shizuko's psychic powers in Suzuki's novel, fails to mention the context of the American occupation that I described earlier in this chapter).[71] But there are other, indirect routes to this history that the website evokes implicitly. Through a link to a related website, *Curse of the Ring* offers galleries of Samara's videotape and prevideotape instances of thoughtography, all of which appear briefly in *The Ring*. What one already senses while watching the film is only strengthened by perusing these images online: that behind thoughtography stands surrealism.

FROM THOUGHTOGRAPHY TO RAYOGRAPHY

Curse of the Ring links to a website called *Inteferon's Viral Vestibule*, which describes itself as "a gift to the fans of Sadamara. It does not pretend to be a comprehensive *Ring* site—instead the emphasis is on analysis aids

such as movie graphics and technical info."[72] The use of the term "Sada-mara" to refer to both Sadako and Samara reinforces the organizational premise of *Curse of the Ring*: that *Ring* and *The Ring* are so deeply intertwined that analysis of one necessitates consultation of the other. Among the "analysis aids" offered by *Inteferon's Viral Vestibule* is an image gallery entitled "X-ray images," which collects the examples of thoughtography created by Samara in *The Ring* prior to the cursed videotape. In the film these images are glimpsed briefly when Noah reads through the medical records of Anna Morgan and Samara at the psychiatric hospital where Samara once stayed. On the website the images can be studied as a series of thumbnails side by side, each of which can be magnified by clicking on it. Even though each image comes with a makeshift title coined by the website that ostensibly describes the objects one sees in them ("rocking horse waves," "needles doll mask"), the titles do not fully capture the strangeness of the images, nor does the classification of "X-ray" really suit them.[73] A better term would be *rayograph*.

Rayographs were the name the artist and photographer Man Ray, a close associate of the Surrealist Group, gave to images he created through a process he described as "cameraless" photography.[74] Rayographs were constructed by placing objects directly on photosensitive paper, expos-ing the paper and the objects to the light for a few seconds, and then completing developing as one would with conventional photographs. The results were images simultaneously concrete and dreamlike, where the outlines of recognizable objects gave way to slightly distorted, stark white silhouettes that contrasted sharply against a black background. They were photographic but not photorealistic. In short, they were surrealistic.

Although Man Ray (born Emmanuel Radnitzky) made his first rayographs in late 1921 or early 1922, their significance came both earlier and later. By 1921 the American Man Ray had moved to Paris and become deeply involved with the Dadaists there. According to Man Ray, the first person to observe his rayographs was the leading Dadaist Tristan Tzara, who was very enthusiastic and told him that the rayographs were "far superior to similar attempts . . . made a few years ago by Christian Schad, an early Dadaist."[75] The fact that Man Ray discovered rayography when and how he did, alongside Dada and well before André Breton brought surrealism into official existence in 1924, has led a number of art historians to distance Man Ray from surrealism.[76] I disagree with this view and would argue instead, as Rosalind Krauss has done, that Man

Ray's work not only constitutes some of surrealist photography's most important achievements but that photography itself has for too long remained "the great unknown, undervalued aspect of surrealist practice" instead of being recognized as "the *great* production of the movement."[77] I would amend Krauss only by adding that cinema has received even less attention than photography in most studies of surrealism and that it is cinema, in conjunction with photography, that deserves a place at the heart of surrealism's accomplishments.

It is difficult, however, to claim that Man Ray's own films are the equal of his photography when it comes to surrealist power. Man Ray himself admits that making films never excited him the way his photographs and other artwork did, that he "had no desire to become a successful director."[78] In fact, Man Ray's preference for photography over cinema prefigures strikingly the stance of Roland Barthes that I described in chapter 1: "A book, a painting, a sculpture, a drawing, a photograph, and any concrete object are always at one's disposition, to be appreciated or ignored, whereas a spectacle before an assemblage insists on the general attention, limited to its period of presentation. . . . I prefer the permanent immobility of a static work which allows me to make my deductions at my leisure, without being distracted by attending circumstances."[79]

For Man Ray, as for Barthes, this preference did not translate into an aversion to watching films or to mining the surrealist territory between photography and cinema. Since Man Ray welcomed technological innovations in film, from sound to color to 3-D, and "even hoped for the addition of the sensations of warmth, cold, taste, and smell," one can imagine him embracing the capabilities of a website to provide a "photographic" experience of "cinema."[80] But he never could have imagined how *The Ring*, with the aid of the Internet, would refigure rayography as thoughtography.

Verbinski has said that one of the qualities that drew him to *The Ring* was its mixture of high-culture and low-culture characteristics: "It's a simple premise but not exactly a 'studio picture.' I think that is what interested DreamWorks as well. It's both pulp and avant-garde."[81] This awareness of the film's intersections with the avant-garde may not have extended to deliberately orchestrated citations of surrealism, but there is no doubt that when *The Ring* wades into avant-garde terrain, the specter of surrealism almost always materializes in some shape or form. Samara's thoughtography is a prime example. When Noah flips through Samara's medical records, he discovers a file containing several sheets of

film that he holds up to the light to study (they also reappear later on an old videotape where Samara is interviewed by a doctor at the hospital who conducts thoughtography experiments with her). What we see on these sheets of film—distorted white silhouettes of objects staged against black backgrounds—often looks remarkably similar to rayographs. Indeed, the gallery of Samara's thoughtography displayed in *Inteferon's Viral Vestibule* includes one image, dubbed "Comb Tree Woman," that closely resembles one of Man Ray's first published rayographs, an untitled image that also prominently features a comb (figs. 3.8, 3.9).[82] "Comb Tree Woman" is not one of the four thoughtographs Noah inspects in *The Ring*, but it is one of several additional thoughtographs included in a compilation of deleted footage available on the DVD of *The Ring*. Another one of these deleted thoughtographs, "Hairbrush," bears a strong similarity to one of Man Ray's most famous images, the sculpture entitled *Cadeau* (*Gift*, 1921), which takes the shape of an iron outfitted with a row of upturned nails for "teeth."[83] Like *Gift*, "Hairbrush" confronts its audience by transforming a mundane household object, emphasizing the rows of bristles as "teeth" facing directly, menacingly outward.

Figure 3.8 *The Ring*: Samara's thoughtograph *Comb Tree Woman*, featured as an online image and DVD extra.

Figure 3.9 Man Ray, untitled rayograph: comb, straight razor
blade, needle and other forms (1922). © Artists Rights Society (ARS),
New York. Gelatin silver print. 22.4 × 17.5 cm (8 13/16 × 6 7/8 in.).
Metropolitan Museum of Art, Ford Motor Company Collection, Gift
of Ford Motor Company and John C. Waddell, 1987 (1987.1100.294).
Copy Photograph © Metropolitan Museum of Art, New York. Image
copyright © Metropolitan Museum of Art. Image Source: Art Resource,
New York. © 2013 Man Ray Trust/Artists Rights Society (ARS), New
York/ADAGP, Paris.

The new media platforms connected to *The Ring*, whether the DVD or the website, highlight particular affinities with Man Ray's work, but the thoughtography featured in the film itself still evokes enough visual aspects of rayography for surrealism to hang heavily in the air surrounding Samara. The fact that *The Ring* refers to Samara's images not as thoughtography but as "projected thermography" pushes these images toward a conjuncture between surrealism's rayography and World War II's atomic radiation. Thermography, a method for measuring heat emissions from the body by capturing them photographically, is a term that unites the film's images of thoughtography with those reminiscent of the atomic bombings. As I mentioned earlier, Samara's ghost burns Rachel's arm, and Samara herself burns an etching of the red Japanese maple into the wood of the Morgan family barn, where she lives temporarily. Anna and Samara's first psychologist, Dr. Grasnik (Jane Alexander), speaks to Rachel about how "Anna said she'd been seeing things, horrible things, like they'd been *burned* inside her. That it only happened around Samara, that the girl put them there." And when Rachel returns to the cabin at Shelter Mountain near the end of the film as the curse threatens to overtake her, she reminds Noah that seven days earlier, "the sun came through the leaves and lit them up like it was on fire. Right at sunset. Right when I watched the tape."

One of Samara's thoughtographs, or projected thermographs, shows this tree, the red Japanese maple, in silhouette. Her cursed videotape shows it again; only this time it is on fire. The film suggests that this tree's significance pertains to its status as one of the last things Samara sees before a desperate Anna chokes her and pushes her into a well at Shelter Mountain. This is the same well on top of which the cabin in which Rachel first watches the tape was constructed—this is where Samara died. It is the film's "ground zero," a label whose atomic connotations are underlined visually when a spilled set of marbles collect as if drawn by magnetism, or radiation, to the very spot in the cabin beneath which the well is buried. In this manner the visual images of the burning red Japanese maple move beyond their strictly "narrative" function and into the realm of history, mapped by the mediated unconscious.

On the occasion of a 1963 retrospective exhibition, Man Ray described his rayographs in this way: "Like the undisturbed ashes of an object consumed by flames, these images are oxidized residues fixed by light and chemical elements of an experience."[84] Man Ray's description

seems haunted by the atomic bomb, even if the rayographs he refers to were created prior to 1945. The image of atomic shadows, those horrifying burns left behind on pavement and buildings when human bodies were incinerated by the atomic blasts at Hiroshima and Nagasaki, seem apparent in his words, even if they are only implied unintentionally. It is also important to note that Man Ray continued making rayographs later in his career. The only rayograph included as an illustration in his 1963 autobiography, *Self Portrait*, was one he created in 1946. Among the objects used in this particular rayograph is a wire basket whose silhouette is uncannily reminiscent of Niels Bohr's popular "planetary model" of the atom, with a dense central nucleus composed of protons and neutrons surrounded by rings of circling electrons (fig. 3.10).[85] A deliberate atomic reference? Probably not, especially if we take Man Ray at his word when he insists that objects were selected for his rayographs, at least initially, by "taking whatever objects came to hand."[86] Nor is there any attempt in Man Ray's rayographs to tell a story the way there is in Samara's thoughtographs, where most objects are meant to be "translated" as symbols

Figure 3.10 Man Ray, untitled rayograph (1946). Reproduced in Man Ray, *Self Portrait*. © 2013 Man Ray Trust/Artists Rights Society (ARS), New York/ADAGP, Paris.

of Samara's own experiences. But the overlapping of rayography and thoughtography made possible by *The Ring* in its globalized, mediated dimensions gives Man Ray's images, like Verbinski's, a visuality that precedes and exceeds them.

Man Ray's account of creating rayographs by randomly choosing objects close at hand is a variation on Breton's surrealist practice of automatic writing. Indeed, Breton's landmark accomplishment in automatic writing, the book *Les champs magnétiques* (*The Magnetic Fields*) he coauthored with Philippe Soupault in 1920, was later designated by Breton (in retrospect) as the first surrealist text. It is this book that Man Ray nods to in the title of his first published collection of rayography, *Delicious Fields* (1922). This is not the first or last time Man Ray and Breton would inspire each other. In *Surrealism and Painting* (1928), an influential book expanded in later editions but originally composed largely of earlier writings published in the journal *La révolution surréaliste*, Breton praises Man Ray for how he has "applied himself vigorously to the task of stripping [photography] of its positive nature, of forcing it to abandon its arrogant air and pretentious claims." Breton continues: "The photographic print, considered in isolation, is certainly permeated with an emotive value that makes it a supremely precious article of exchange (and when will all the books that are worth anything stop being illustrated with drawings and appear only with photographs?); nevertheless, despite the fact that it is endowed with a special power of suggestion, it is not in the final analysis the *faithful* image that we aim to retain of something that will soon be gone forever."[87]

What Breton sees as the promise of photography, in the context of Man Ray's work, is the surrealist potential of the photographic image later articulated in strikingly similar terms by André Bazin, as I discussed in chapter 1: the surrealist photograph's power stems from but also reaches beyond its "faithful" reproduction of the world. Breton would put into practice his preference for photographs over drawings in his own books *Nadja* (1928) and *L'amour fou* (1937). In the first case he employed Man Ray's assistant, Jacques-André Boiffard, and in the second Brassaï and Man Ray himself. But as Breton's comments in *Surrealism and Painting* suggest, he is both impressed by and wary of photography.[88] As befits a champion of automatism in surrealist artistic production, he is drawn to photography's "emotive value" and "special power of suggestion" but distrustful of photography's "arrogant air and pretentious claims" that

seem inherent in its "positive nature"—its assumption that it can somehow authentically reproduce the world it records. This ambivalence toward photography does not prevent Breton from stating, in an earlier article, that automatic writing is "nothing less than thought photography."[89] Breton's formulation of automatic writing as thought photography, when considered alongside the intersections between thoughtography, rayography, and thermography presented in *The Ring*, brings us nearly full circle. We can now return to where we began, with the place of *The Ring* in a superflat global village.

COMPLETING *THE RING*

Samara's thoughtographs literalize Breton's sense of automatic writing as a form of thought photography. In a videotaped interview a psychologist asks Samara how she made the thoughtographs. She replies, "I don't make them. I see them. Then they just are." For Breton automatism is "one of surrealism's two great directions. . . . Any form of expression in which automatism does not at least advance *under cover* runs a grave risk of moving out of the surrealist orbit." The second "great direction" of surrealism Breton mentions beside automatism turns out to be not so great after all: "The other road available to surrealism to reach its objective . . . *trompe l'oeil* . . . has been proved by experience to be far less reliable and even presents very real risks of the traveler losing his way altogether."[90] Breton's elevation of automatism above *trompe l'oeil* replays his double-edged characterization of photography in *Surrealism and Painting* as valuable in its "special power of suggestion" (photography's good automatism) but suspicious in its "positive nature" (photography's bad automatism). A similar distinction will be voiced by Bazin in "The Ontology of the Photographic Image" when he differentiates between a "true realism" that uncovers reality's hidden essence and the "pseudorealism" of *trompe l'oeil* illusionism that merely imitates reality's surface appearances. For Bazin, as I explained in chapter I, surrealist photography holds a privileged place in his argument because of its ability to wed "true realism" and "pseudorealism," to produce "an hallucination that is also a fact." Bazin does not mention Man Ray by name, but it is likely he has Man Ray in mind when he notes how the surrealists "looked to the photographic plate to provide them with their monstrosities."[91]

Bazin's use of the term *monstrosities* is worth pausing over. By turning to surrealist photography, he suggests that there is something monstrous in the photographic image inseparable from its revelatory potential, its ability to present "the objective world . . . in all its virginal purity to my attention and consequently to my love."[92] Surrealist photography's factual hallucination is both revelatory and monstrous. It enables us to see in a new way, but that new vision passes through the monstrous, as well as the redemptive. What would Bazin have made of those peculiar photographs at the heart of both *Ring* and *The Ring*, the ones that show people who have been exposed to the cursed videotape as deformed and distorted? (fig. 3.11). These are photographs that "know" something the people pictured inside them do not: that something about them has changed since watching the videotape, something invisible to the naked eye but visible in a photograph. And this "something" is both revelatory and monstrous. It is a surreality.

Nakata reveals that he and Takahashi studied examples of spirit photography during preproduction on *Ring*, which in turn influenced the look of the film's distorted photographs: "There were also certain ghost photos we investigated, where there was something like white cloth over the face of just one person. It was a happy photograph, but one person's face was covered with something that looked like cloth. Looking at the photograph gave off a very weird feeling."[93] As Tom Gunning has argued, spirit photography's often undervalued role in the creation and reception of photography from its beginnings in the nineteenth century through

Figure 3.11 *Ring*: Photographs of the cursed appear distorted.

the early twentieth century reminds us that "if photography emerged as the material support for a new positivism, it was also experienced as an uncanny phenomenon, one which seemed to undermine the unique identity of objects and people, endlessly reproducing the appearances of objects, creating a parallel world of phantasmatic doubles alongside the concrete world of the senses verified by positivism."[94] Gunning's description of photography's ghostly underside could be extended from spirit photography to surrealist photography to digital photography. In each of these cases, albeit through very different means and often with very different aims, photography's positivism collides with its monstrosity. The photograph may well be a record, but it is also a ghost. Spirit photography's phantasms, surrealist photography's rayographs, and digital photography's photoshopped images all draw attention to this fact. In *Surrealism and Painting*, immediately before Breton begins discussing Man Ray, he quotes the "immortal propositions" of the Spanish writer and mystic Ramon Llull, who once said, "A ghost is an abstract resemblance of things through the imagination."[95] Substitute "photograph" for "ghost" and Breton's sense of photography's promise remains intact.

So if photography and cinema, following Breton and Bazin, contain a sort of monstrosity, a ghostly underbelly, then what exactly do we see when modes of vision such as surrealism spotlight this monstrosity? In the Japanese and American versions of *Ring*, the distorted faces in the photographs of those cursed by the videotape evoke the horror of what we cannot see with our eyes but exists nevertheless—like history in the present or radiation in the past. Indeed, the brief glimpses of these photographs in each film, with their warping of facial features, bear more than a passing resemblance to human deformities and wounds inflicted by the atomic bomb. But viewers need not make this explicit connection to become deeply unsettled by these images. For they invite us to see in a disturbing way, where vision's human and mechanical components, along with its evidentiary and ghostly dimensions, blur together to show us things we would rather not see, or remember.

One of the relatively few images to appear on the cursed videotapes in both films is the extreme close-up of an eye. For Nakata, as we learned, this eye inevitably recalls *Un chien andalou*. The eye in Verbinski's film is even closer to Buñuel's eye in certain respects: it is a horse's eye, while Buñuel, as many cinephiles know, used a calf's eye in his film. In fact, the Internet Movie Database entry for *The Ring*, in its "movie connections/

references" subheading, lists *Un chien andalou* as one of the film's citations.[96] But in neither version of *Ring* is this eye slit, as it is in Buñuel's film. Yet perhaps the *Ring* films still make Buñuel's archetypal surrealist gesture through other means. The demand for viewers to see beyond routine vision, to assault their very senses into this recognition, may not occur fully in either version of *Ring*. But in the space between the two films, in the overlaid images and histories that reside within globalization's mediated unconscious, a variation on the sliced eye is performed. If Buñuel's eye conveyed to an audience how painful and necessary seeing anew can be, then the two *Ring* films offer their own account of photographic vision's monstrosity. Reckoning with *Ring* between Japan and America is to see the relations between media technologies, traumatic histories, and surrealist iconographies in ways that alter our conventional sense of what it means to see "globally." Is it any wonder that Murakami's conception of a superflat Japan, an attempt in its own right to re-view McLuhan's global village, coincides with the moment of the *Ring* films? Or that Murakami calls his superflat project a "Monster Manifesto" geared to convey both the monstrousness of the past and the idea "that only by knowing the meaning of history can we sense that we are alive now"?[97] What the *Ring* films tell us is that seeing, in the surrealist sense of a quite literal eye-opening, is a powerful method for knowing the meaning of history. In a globalized age of new media, Sadako and Samara collaborate to repossess the surrealist and historical potential of Okamoto's dictum: "Art is explosion!"

Posthuman Spectatorship

The Animal in You(Tube): From *Los olvidados* to "Christian the Lion"

I n previous chapters I have tracked the ways cinema's transforma-
tions in the age of new media become attached to concepts such as
intermediation, interactivity, and globalization. All of these concepts
have attracted well-deserved attention within film studies, but another
discourse that has flourished in the digital era has generated compara-
tively little conversation: posthumanism. According to N. Katherine
Hayles's influential definition, "in the posthuman, there are no essen-
tial differences or absolute demarcations between bodily existence and
computer simulation, cybernetic mechanism and biological organism,
robot teleology and human goals." Hayles is rightly suspicious of how
posthuman thought tends to valorize disembodied information systems
at the expense of human embodiment and all its complex particulari-
ties: "Embodiment has been systematically downplayed or erased in the

cybernetic construction of the posthuman in ways that have not occurred in other critiques of the liberal humanist subject, especially in feminist and postcolonial theories." She admits that her "nightmare" is "a culture of posthumans who regard their bodies as fashion accessories rather than the ground of being," but she also holds out a "dream" of the posthuman "that embraces the possibilities of information technologies without being seduced by fantasies of unlimited power and disembodied immortality."[1]

One of the remarkable aspects of Hayles's work is her commitment to placing scientific and literary texts in conversation with each other, as mutually illuminating discourses. Yet for Hayles, the "nightmare" (disembodied) posthuman often traces its origins to post–World War II cybernetics, the science of systems of control and communication in living organisms and machines, while the "dream" (embodied) posthuman tends to appear in conjunction with science fiction literature, such as the novels of Philip K. Dick. Cinema is nowhere to be found in Hayles's study, despite the fact that science fiction films (including adaptations of Dick's work like *Blade Runner* [Ridley Scott, 1982]) have powerfully shaped popular conceptions of the posthuman for more than a century. Indeed, it is doubtful that the most iconic posthuman figure, the cyborg, would have nearly the theoretical and cultural resonance it does today without science fiction cinema's long line of fantastic life forms. So where is film in the dream and nightmare mappings of the posthuman?

I do not wish to answer this question by following the route that seems most obvious: building on Hayles by examining those science fiction films that offer representations of posthuman beings.[2] Instead, I want to think through cinema's relation to the posthuman by turning not to the cyborg but to the animal. My contention is that if posthumanism, as Hayles claims, becomes most problematic when it veers toward disembodiment, then there is much to learn about the posthuman from the animal, that most thoroughly embodied "prehuman." It might even be the case that, as Cary Wolfe argues, posthumanism should be regarded first and foremost as a "mode of thought" that engages "the problem of anthropocentrism and speciesism and how practices of thinking and reading must change in light of their critique."[3] So if the issue of embodiment—whether embraced or resisted, animalized or mechanized—is at the heart of posthumanism, then cinema's virtual and material essences, its simultaneous presence and absence, its mechanical technologies so often mobilized to simulate or extend human perception, offer rich soil

for growing the theoretical implications of the posthuman. Conversely, discourses of the posthuman may also help bring more precision to our understanding of cinematic spectatorship in a digital era.

At this point I would like to present two different examples of what I will be referring to as posthuman spectatorship. In other words, I will compare two cases that outline the hypothetical possibilities of interactions between viewers and film-related media at the intersection of cinema and the posthuman. The first example comes from YouTube, a website that launched in 2005 and has since become the most well-known hub for short videos on the Internet.[4] In April 2008 a two-minute video entitled "Christian the Lion" was posted on YouTube and caused such a sensation that it was later broadcast on popular U.S. television talk shows such as *The View* and *The Today Show* and inspired a tie-in book publication. The second example is *Los olvidados* [*The Forgotten Ones*, 1950], Luis Buñuel's celebrated return to the main stage of international cinema after nearly two decades of invisibility (but not inactivity) following his surrealist masterworks *Un chien andalou* (1929), *L'âge d'or* (1930), and *Las Hurdes* [*Land Without Bread*, 1933]. I will argue that the digital posthumanism of "Christian the Lion" can be strategically challenged by returning to *Los olvidados*'s surrealist posthumanism, resulting in an illumination of the possibilities for posthuman spectatorship.

"CHRISTIAN THE LION"

"Christian the Lion" tells the true story of two men who buy a lion cub named Christian as a pet. Although they love him dearly, they realize they must release him into the wild once he grows too big for them to handle. The video focuses on their reunion in the wild one year later. They are told Christian will not be able to remember them, but when the parties do meet, Christian embraces them with a stunning round of joyful hugs that they return just as enthusiastically (fig. 4.1).[5]

The emotional appeal of "Christian the Lion" is easy to understand but quite complex in its construction. The video foregrounds its "true memory" status by beginning with black and white photographs that show Christian the cub at home with his owners, engaging in playful antics like making a mess of dresser drawers and climbing on top of a television set. The transition from still photographs to color film footage of the reunion does not feel like a departure from the "true memory"

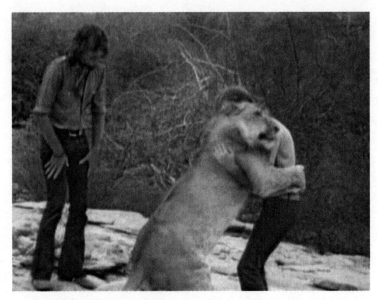

Figure 4.1 "Christian the Lion" (2008): Christian's joyful reunion with his human owners.

tone, since this footage is washed-out and obviously dated, much like a scrapbook would be. Superimposed titles relate the story's outlines during the photograph segment but disappear during most of the filmed reunion so that its immediacy stands out. The soundtrack consists of the rock band Aerosmith's ballad "I Don't Want to Miss a Thing" (1998), a song that highlights themes of love, loss, and the need for physical contact:

> Even when I dream of you
> The sweetest dream would never do
> I'd still miss you, babe
> And I don't want to miss a thing.

When the screen goes black, a final title appears: "You got this video from someone who loves you. Send it to someone you love."

Like many other YouTube videos, "Christian the Lion" is a product assembled from found footage. In fact, the video consists of material posted on YouTube as early as 2006; it is not the first YouTube version of Christian's story, but it is the most popular (viewed more than seventeen million times by 2012). Many of the video's photographs can

be found in the book *A Lion Called Christian*, a memoir by the cub's two owners, Anthony "Ace" Bourke and John Rendall, first published in 1971 (reprinted in 2009 following the video's YouTube exposure).[6] The filmed reunion is excerpted from the documentary *The Lion at World's End* (Bill Travers and James Hill, 1971), a chronicle of Christian's story starring Bill Travers and Virginia McKenna, the actors featured in an earlier, Academy Award–winning film about lions called *Born Free* (James Hill, 1966). In *Born Free* Travers and McKenna play George and Joy Adamson, whose real-life experiences with lions in Africa were the subject of Joy Adamson's best-selling 1960 book of the same name—the basis for the film. The Aerosmith ballad originally appeared on the soundtrack of *Armageddon* (Michael Bay, 1998), a Hollywood disaster/action blockbuster that carries familial connotations since it stars (among others) Liv Tyler, the daughter of Aerosmith's lead singer Steven Tyler.

None of the above information on the sources of "Christian the Lion" appears within the video itself. This is also typical of YouTube's format. What does appear are a plethora of posted responses from viewers, both in words and in images. These responses include revisions and updates of the original video, so that multiple alternate versions of "Christian the Lion" coexist alongside it on YouTube. Text responses include discussions of the video's authenticity (this video must be staged; no, this video is real) and its emotional impact (this video made me cry; you are foolish if this video made you cry).

Although it is impossible to provide any comprehensive sense of the text responses to "Christian the Lion" (as of 2012, there were more than sixteen thousand), it is clear that many users gravitate toward issues of anthropomorphism and cross-species feeling in their reactions to the video. One user writes, "Consider my heart touched. I'm crying that changed my perception of what bonds can be held with those who love each other." Another writes, "After this—who will say that animals have no soul?!!" Historian of science Lorraine Daston argues that current prevailing attitudes toward anthropomorphism (at least among intellectuals) as an impossibility, as something taken seriously only by the childish, is dependent on formulations of perspective as sensory experience, subjectivity, and sympathy that arose only in the eighteenth century. In medieval times angelology posited the study of nonhuman angelic intelligences in ways not dependent on these formulations, where what we now regard as commonsense demarcations between subjectiv-

ity and objectivity had not yet taken hold. By contrast, post-Darwinian comparative psychologists of the nineteenth century adopted subjectivity and sensory experience as central terms, therefore placing the emphasis on individuals rather than kinds, on the impossibility of knowing any kind but your own. For Daston, reconsidering anthropomorphism today should not entail dismissing or simplifying real otherness but searching instead for a way to connect across species lines that moves beyond the sentiment, "What is it like to be an X?"[7]

Daston's concerns fall squarely within the posthuman realm, but she does not use that term. Even Donna J. Haraway, perhaps the leading theorist of the posthuman in both its cyborg and animal forms (her work is at the center of burgeoning multidisciplinary developments in animal studies), feels uncomfortable with the "posthuman" label.[8] Despite the fact that her pioneering book *When Species Meet* (2008) appears in a series called "Posthumanities," Haraway states explicitly her preference for "companion species" over "posthuman" as her foundational concept. *Companion species* encompasses a biological perspective that posits all creatures as made up of their relationships with other creatures rather than a series of solitary species identities that do not touch: "The shape and temporality of life on earth are more like a liquid-crystal consortium folding on itself again and again than a well-branched tree. Ordinary identities emerge and are rightly cherished, but they remain always a relational web opening to non-Euclidean pasts, presents, and futures." For Haraway *companion species* resists the dangers surrounding notions of posthumanism that threaten to repeat humanism's errors. If humanism often tended to drift toward racism and the exclusion of otherness, then posthumanism risks a similar fate in its desire to transcend the human, to leave the problems of defining the human behind. As Haraway puts it, "I never wanted to be posthuman, or posthumanist, any more than I wanted to be postfeminist. For one thing, urgent work still needs to be done in reference to those who must inhabit the troubled categories of woman and human, properly pluralized, reformulated, and brought into constitutive intersection with other asymmetrical differences. Fundamentally, however, it is the patterns of relationality . . . that need rethinking, not getting beyond one troubled category for a worse one even more likely to go postal."[9]

I agree. My own investment in the posthuman is more strategic than doctrinaire. Posthumanism, for better or worse, collects around itself the

discourses (including those of Daston and Haraway) that I wish to project onto cinematic spectatorship's digital present and surrealist past. In other words, I am not a posthumanist, but I am committed to understanding the implications of the posthuman in this context. Alongside Hayles's embodiment I believe Daston's alternative anthropomorphism and Haraway's relationality offer valuable ways to proceed with analyzing "Christian the Lion" as an instance of digital, posthumanized spectatorship.

At first glance "Christian the Lion" appears to support the companion species model. Humans and animals connect across species lines, blurring the boundaries between properly "human" and "animal" capacities for memory, love, affection. But if it is the patterns of relationality between organisms that Haraway wishes to recast with the notion of companion species, does "Christian the Lion" achieve this? Not when it slides into old-fashioned anthropomorphism—Christian acts like humans or at least mimics the very best interpersonal impulses in humans. Christian gains legitimacy not as an animal on his own terms but for imitating admirable human behavior.

Yet "Christian the Lion" also presents a case where Haraway's web of relationality between species becomes a World Wide Web of relationality. Perhaps the technological format of YouTube offers possibilities for users to feel the posthuman, in an embodied sense, that exceeds the capacity of "Christian the Lion" to show the posthuman as anything other than anthropomorphism? Yes, in terms of sheer emotional involvement (including crying), but the direction of this emotional involvement seems geared more toward reinforcing old patterns of anthropomorphic relationality than establishing new ones. The video's end title underlines the lesson of "Christian the Lion" as one of human love, not interspecies relationality. In fact, the version of "Christian the Lion" that aired on *The View* uses a new end title that makes this stance even clearer: "Love knows no limits and true friendships last a lifetime. Get back in touch with someone today. You'll be glad you did."[10]

Of course, it's one thing for a video to provide a lesson but quite another for the spectator to swallow it whole. Even if there is evidence at the textual level that "Christian the Lion" channels its emotional power into shoring up anthropomorphism rather than questioning it, emotion and YouTube are both notoriously unruly elements that may mutate in surprising ways through those experiencing them. Browsing through the videos that YouTube flags as related to "Christian the Lion" reveals

earnest, detailed information about contributing to lion conservation causes, opportunities to learn more background by accessing the films and book on which the video was based, exposure to current interviews with Bourke and Rendall, as well as all sorts of witty and half-witty parodies that sometimes turn the video's lesson on its head (Christian mauling his owners, for instance). So there are certainly avenues of interactivity open to spectators of "Christian the Lion" that do not siphon all feeling into anthropomorphic life lessons, but judging from the overwhelming invective aimed at one of the parodies by angered users, these avenues may not be as well-traveled.

The parody, "Christian the Lion Owners—SHOCKING REAL Story," shows two actors masquerading as Bourke and Rendall, speaking about their "real" reunion with Christian. In this reunion (complete with footage from "Christian the Lion" but now in slow motion and narrated/interpreted to very different effect), Christian attacks his owners and urinates and defecates on them. One spectator writes to the creators of the parody, "ive never been mad wid a youtube vidieo but you 2 have just done it. how on earth can you make a joke out ov something so amazing like this." Another writes, "If you laughed at this FAKE video then your just a fucking cunt. So i could care less if you died!!!" The parody had only some 330,000 views as of 2009 (compared to twelve million for "Christian the Lion"), and its overall user rating was just 1.49 (compared to 5.0 out of a possible 5.0 for "Christian the Lion").[11]

Anger over the parody's perceived betrayal of what is true and real in "Christian the Lion" highlights important problems in the potential of the digital posthuman to refigure animal-human relationality for its viewers. The need for the real as images transparently faithful to concrete reality and aligned with comforting anthropomorphic beliefs trumps the challenge of accommodating what Haraway calls "the contagions and infections that wound the primary narcissism of those who still dream of human exceptionalism."[12] Although "Christian the Lion" is just one case of the digital posthuman, its status as one of the twenty most popular videos of all time within the sprawling "Pets and Animals" category of YouTube content (the category itself testifies to the centrality of animals on YouTube) gives some outline of its broader significance. In fact, the very first video ever posted on YouTube (on April 23, 2005), "Me at the Zoo," shows a young man (YouTube cofounder Jawed Karim) standing and speaking in front of the elephants at the San Diego Zoo.[13] So from

the very beginnings of this posthuman-era technology, the desire for the animal to make it real announces itself. To consider this desire from another vantage point, one where the real encounters its interrogators, we must turn to the surrealist posthuman.

LOS OLVIDADOS

Luis Buñuel, cinema's foremost surrealist, started out as an entomologist. Or at least this was his initial ambition when he left his parents' home in Zaragoza, Spain, to study at the Residencia de estudiantes in Madrid in 1917. Pressed by his father to decide on a sensible course of study, Buñuel chose entomology because "all living creatures fascinate me.... I'm passionate about insects. You can find all of Shakespeare and de Sade in the lives of insects."[14] By the time Buñuel left the Residencia de estudiantes for Paris in 1924, he had traded in entomology for philosophy and literature, but his films reveal a continuing enthrallment with animals.

This is particularly true of his first three films, those made in closest connection with the surrealist movement that would shape his entire career. The ants and donkeys of *Un chien andalou* (along with an actual calf's eye that stands in for a human eye during the infamous slashing that opens the film); the scorpions and cow of *L'âge d'or*; the goats, mosquitoes, pigs, bees, rooster, and donkeys of *Las Hurdes*—these are some of the creatures at the heart of Buñuel's first and most overtly surrealist films. In truth, animal imagery and surrealism are two of the most powerful connecting threads over three films that sometimes seem to share little in common in terms of style, tone, and subject matter. *Las Hurdes*, in particular, as a documentary on an impoverished region of Spain, might seem at first glance to have few commonalities with the more flamboyant, dreamlike surrealism of *Un chien andalou* and *L'âge d'or*. But as Buñuel explains, *Las Hurdes* "was very different and yet, nevertheless, it was a twin. To me, it seemed very much like my other films. Of course, the difference was that this film was based on a concrete reality. But it was an exceptional reality, one that stimulated the imagination. Furthermore, the film coincided with the social concerns of the surrealist movement, which were very intense at that time."[15]

It should not be surprising, then, that when Buñuel returns to surrealism's "exceptional reality" as it intersects with the "concrete reality" and "social concerns" of Mexico City in *Los olvidados*, animals

play a central role. Of course, the conventional narrative of Buñuel's "return" that has him disappearing between 1933 and 1950 only to pick up where he left off is not at all accurate. He spent time working in various film-related capacities in Spain, Paris, New York, and Hollywood, but in terms of directing, he spent the most productive years of that period in Mexico beginning in 1946, making commercial studio films that solidified his standing in the Mexican film industry and opened the doors to *Los olvidados*.[16] Still, for most of the international film world the arrival of *Los olvidados* appeared as it did for André Bazin: "And the miracle took place: eighteen years later and five thousand kilometers away, it is still the same, the inimitable Buñuel, a message which remains faithful to *L'âge d'or* and [*Las Hurdes*], a film which lashes the mind like a red-hot iron and leaves one's conscience no opportunity for rest."[17] At the 1951 Cannes Film Festival *Los olvidados* earned Buñuel a Best Director prize.

Los olvidados, a fiction film about the experiences of poor street kids in contemporary Mexico City, incorporates many of the ethnographic impulses that marked the documentary *Las Hurdes*. Indeed, Buñuel devoted several months to social research as preparation for shooting the film. He walked the slums of Mexico City, photographed what he saw, interviewed the people he met, consulted with the Department of Social Services, studied hundreds of children's case files, and tracked down newspaper accounts of the sorts of young lives he wished to chronicle.[18] In the film, Pedro (Alfonso Mejía) struggles with his mother, Marta (Estela Inda), who resents him because of his conception during a rape by an absent father, and his friend Jaibo (Roberto Cobo), who lures Pedro toward crime and murder. Ojitos (Mario Ramírez), an Indian abandoned by his father, earns the affection of Meche (Alma Delia Fuentes), a young girl who must fend off the sexual advances of Jaibo and Ojitos's cruel guardian, the blind street musician Don Carmelo (Miguel Inclán). Pedro attempts to better himself, first by getting a job, then by turning over a new leaf at the reformatory where his mother sends him, but his association with Jaibo (whom he has witnessed in the act of killing their friend Julián [Javier Amézcua]) spoils these plans. At the film's end Jaibo kills Pedro, the police kill Jaibo, Ojitos wanders alone, and Meche helps carry Pedro's hidden corpse past his worried mother (who now, too late, wishes to reconcile with her son) and into a garbage heap where the body is dispatched.

Buñuel anticipated—and received—a harsh reaction to *Los olvidados* in Mexico. Mark Polizzotti summarizes the "public and critical response" as ranging "from indignation to indifference," with the "most extreme

elements" calling "for Buñuel's expulsion as an undesirable alien." The film was "pulled from circulation after only three days" and would have to await rediscovery at Cannes before achieving any success in Mexico.[19] Even many of Buñuel's friends among the artists and intellectuals in Mexico scorned the film.[20] The major exception was author Octavio Paz, who worked hard officially (as secretary to the Mexican ambassador in France) and unofficially (as a contributor to and chief organizer behind a printed program celebrating the film distributed at Cannes) to rescue *Los olvidados* from obscurity.[21]

The initial negative reception accorded *Los olvidados* in Mexico is less remarkable than the lengths to which Buñuel went to avoid, or at least soften, that reaction. He filmed an alternate "happy" ending, in which Pedro survives and returns to the reformatory, that was not used, as well as an opening prologue that was included.[22] Some critics have assumed that this prologue was forced on Buñuel by his producer, but the director maintains that "it was my idea, so that the film could be shown."[23]

The prologue appears directly after the opening credits, which include the assertion that "this film is based completely upon true facts of life. All the characters are real" alongside a list of education and social services professionals consulted during production. Images of New York, Paris, and London fill the screen while a narrator discusses how all of these "great modern cities" contain unclean, malnourished, uneducated children poised to become future criminals. "Mexico, the great modern city, is no exception to this universal rule," intones the narrator as dissolves between New York, Paris, and London give way to views of Mexico City. The narrator warns that this film is "not optimistic," that it "leaves the solution up to society's progressive forces."

One can hardly imagine a more emphatically humanist framing of the social issues informing *Los olvidados*. Mexico City is just one modern city among others, all afflicted with the same "universal" problem that can only be addressed by vague "progressive forces" belonging to a "society" that is apparently as universal as the problem itself. The dissolves between the different cities (rather than cuts), along with the preference for images of architectural icons such as the Eiffel Tower and Big Ben (rather than people), buttress the humanist message of equivalence and its detached viewpoint outside and above any cultural specificity.

The shock for the viewer as *Los olvidados* exits the prologue and enters the film proper is heightened, not tempered, by the humanist introduction. An establishing long shot of a barren city courtyard maintains a

comfortable spatial distance from the hollering boys within it, beyond the ramshackle wall that occupies the frame's foreground. But this illusion of clinical, literally walled-off detachment shatters when the nature of the children's game becomes clear: this is a bullfight, and we are immediately implicated by watching from a position where spectators at the ring would sit. As Buñuel cuts to closer views of the action, we realize that this bullfight includes no bull—only a child acting as a bull. A close-up of the bull-child emphasizes his grotesque appearance, particularly his missing teeth and buckteeth. He clenches his fists and snorts (fig. 4.2). But just as we cringe with disgust or sigh with pity at this in-your-face image of the bull-child, eager to return to that seat in the "stands" outside the "ring" or perhaps even to the god's-eye view of the prologue, Buñuel transports us even closer—behind the bull-child's eyes. In a striking point-of-view shot, the bull-child charges another boy's jacket, and we experience the charge from the bull-child's perspective.

Even when the bullfight disintegrates into drinking, smoking, and talking, it is difficult to shake the discomfort generated by Buñuel's rapid modulation of social, cultural, and affective distance for the spectator during the first minutes of *Los olvidados*. The humanist promises of the prologue have been broken in so many ways. First of all, the bullfight as

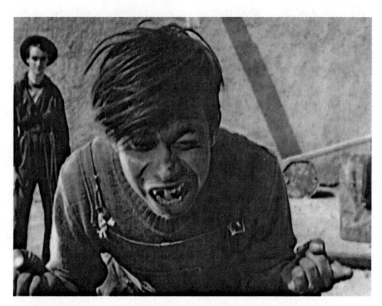

Figure 4.2 *Los olvidados* (Luis Buñuel, 1950): The child as animal.

point of entry suggests that Mexico City is *not* just like New York, Paris, and London, for bullfighting is as alien to those cities as it is centrally identified with Mexico (via the legacy of Spanish occupation). Indeed, the largest bullring in the world, Plaza Mexico, had opened in Mexico City just four years earlier. Second, the humanist perspective presented in the prologue's words and images, from outside and above, converts quickly to one from inside and below. We are spectators at the bullfight; then we are face-to-face with the bull-child; then we are the bull-child.

The fact that we see through the eyes of a bull-child (rather than a bull) as part of a sequence of pronounced point-of-view shifts is crucial for understanding Buñuel's contribution to a surrealist posthumanism in *Los olvidados*. Rather than resorting to anthropomorphism's humanizing of the animal, Buñuel chooses to animalize the human with the bull-child. Of course, animalizing the human in the context of poor street kids all too likely to be dismissed as inferior "animals" by a middle-class public runs the high risk of abetting reactionary, even fascistic, politics. But Buñuel weighs this risk against the equally dangerous yet less offensive tactic of humanism's simultaneous ennobling and generalizing of the downtrodden, where "universal" problems afflict a pitiable but faceless people. As James Lastra has observed, this is just the sort of ethical calculation Buñuel makes in his representation of the poor Hurdanos in *Las Hurdes*: "Given a choice between elevating the Hurdanos in an apotheosis of the 'truly human' and a fascist debasement of them as societal waste, Buñuel adopts *and* rejects both in a gesture that avoids both their appropriation and their demonization."[24]

In comparison to *Las Hurdes*, *Los olvidados* may seem almost restrained in the arc of its swinging pendulum between elevation and demonization. Yet Buñuel is engaging different genres with different conventions in these two films. *Las Hurdes* addresses itself to the ethnographic documentary, whereas *Los olvidados* speaks to the social-problem fiction film and the disadvantaged child subgenre in particular. This subgenre was very popular at the time in Mexican cinema, but Buñuel certainly had in mind also earlier models from other countries, such as Russia's *The Road to Life* (Nikolai Ekk, 1931) and Italy's *Shoeshine* (Vittorio De Sica, 1946).[25] So Buñuel was fully aware of how this subgenre not only tends to elevate its subjects but how "realism" tends to be deployed as the aesthetic strategy that makes this elevation possible. Instead, he offsets elevation with demonization and realism with surrealism, all

under the umbrella of an animal-human relationality I believe we can refer to as posthuman.

The bull-child of *Los olvidados*'s opening is far from an isolated figure in the film. His counterparts come in a constantly metamorphosing array of slippages, confrontations, and reversals between humans and animals. For example, when the gang of street kids moves on from simulating a bullfight to the attempted robbery of Don Carmelo, a skirmish ensues where the boys assault Carmelo, and he responds by lashing out with his nail-tipped cane, cursing them as "dogs" and "chickens." The spectator does not know where to turn during this conflict—the boys act cruelly toward a blind beggar, but Carmelo has already pontificated about his admiration for the loathsome dictator Porfirio Díaz and wounded one of the boys with his cane. What's more, the boys bait and tease Carmelo as if this assault were an extension of the earlier bullfight (Pedro even employs his jacket as an improvised cape), suggesting that they see their actions as just another harmless game.

The sequence ends with the boys fleeing and Carmelo left staring sightlessly at an actual chicken (fig. 4.3). The soundtrack provides a mocking sting, as if the chicken is laughing at Carmelo. But Buñuel

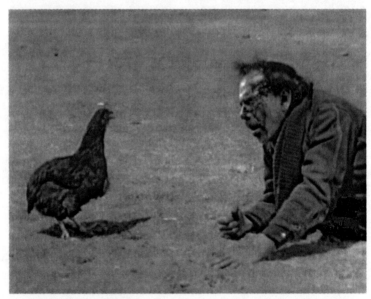

Figure 4.3 *Los olvidados*: Don Carmelo (Miguel Inclán) shares the frame with a chicken.

Figure 4.4 *Los olvidados*: Egg on the lens.

then zooms in on the chicken, leaving Carmelo completely outside the frame. The close-up of the chicken forces spectators to reconsider how they have used designations of "animal" and "human" to make their way through this disturbing sequence. Has Carmelo dehumanized the boys by calling them "chickens"? Have the boys acted like cowardly "chickens" by attacking a blind man and then running away? Is the chicken "mocking" Carmelo in an anthropomorphic jest (as the soundtrack suggests), or is the chicken to be understood as a sign of surreality's eruption into a world where the distinctions between figurative animals and literal animals fall away (as the zoom and lingering close-up suggests)?[26] After all, Carmelo cannot see the chicken he stares at, nor can the boys who have left the scene. The close-up is for us, the spectators.

One final detail: the close-up of the chicken dissolves to reveal the image of another chicken. This one is cradled lovingly by Pedro in a barn attached to his mother's home. He reaches beneath the chicken and smiles at the egg he uncovers, but his joy is cut short by the return of his mother and younger siblings. Pedro's mother inverts the "miracle" of life represented by the egg-laying chicken by guarding and nourishing her "eggs" (Pedro's siblings) while cruelly denying Pedro the same treatment. Once again, any easy symbolic reading or even affective valence attached

to the chicken in the previous sequence is instantly complicated by this new one (a cinematic "double" via the dissolve), and Buñuel has just begun. Chickens will resurface again and again throughout the film (along with dogs), climaxing in an extraordinary moment at the reformatory where an enraged Pedro bludgeons several chickens to death after hurling an egg directly at the camera. As the lens drips with the broken egg, we can no longer see (fig. 4.4). Or perhaps, Buñuel seems to intimate, we can no longer see the way we are accustomed to seeing, where our sense of animal-human relationality supports a humanist worldview with which we are familiar. As Buñuel reminds us here in such a flagrantly surrealist manner, the animal is not just in the lens; it's on the lens. It is part of our perceptual apparatus as spectators, intrinsic to a way of seeing that *Los olvidados* seeks to change.

POSTHUMAN SPECTATORSHIP: DIGITAL AND/OR SURREALIST

Buñuel's surrealist posthumanism offers important possibilities for reframing the digital posthumanism of "Christian the Lion" along the axis of spectatorship. Whereas the realism of "Christian the Lion" emphasizes humanist and anthropomorphic interpretations of animal-human relationality, *Los olvidados* animalizes the human not to reproduce humanism's abstraction or realism's elevation or demonization of its subject matter, but to embrace surrealism's challenge to animal-human relationality and its role in ordering social reality. In this sense *Los olvidados* appears to come closer than "Christian the Lion" to fulfilling Haraway's vision of companion species, with its insistence on interspecies relationships beyond anthropomorphism as the ground of being. I will now return to Haraway's formulations in order to reflect on my comparisons between the posthumanisms of "Christian the Lion" and *Los olvidados*.

Although visual media exist only on the margins of Haraway's *When Species Meet*, it is worth noting that Haraway mentions how the surrealist documentary filmmaker Jean Painlevé's work can guide viewers to "the join of touch and vision" occasionally present in *Crittercam*, a 2004 National Geographic Channel television series.[27] The advertised premise of *Crittercam* is that special digital cameras attached to the bodies of wild animals will allow spectators to experience the environment precisely as an animal does. Haraway rightly critiques the absurdity of this premise, where *Crittercam*'s animals are "presented as makers of home movies

that report on the actual state of things without human interference or even human presence." But she asserts that Painlevé's surrealist accounts of underwater organisms help to illuminate what is most promising in *Crittercam*'s footage, what exceeds the show's premise: "The cuts are fast; the visual fields, littered; the size scales of things and critters in relation to the human body, rapidly switched. . . . Never is *Crittercam*'s audience allowed to imagine *visually* or *haptically* the absence of physicality and crowded presences, no matter what the voice-over says." For Haraway the sheer physicality of the *Crittercam* footage dispels the illusion of the show's premise: these are not purely movies made by animals but rather movies that remind spectators of the interdependence of humans and animals for their visual and haptic properties, their materialist (and indirectly surrealist) "join of touch and vision." The camera, contra the premise of *Crittercam*, does not become some "mentalistic, dematerializing black box."[28] Instead, the camera as material site of mediation between animal and human occupies the foreground of the spectator's embodied experience of the footage. Despite these moments of embodied effectiveness, what frustrates Haraway about *Crittercam* is not just the naiveté of its advertised premise but ultimately its inability to provide something implicit in that premise: animal experience and agency on its own terms. *Crittercam* is still a "colonial" project for Haraway, one that finally subordinates animal experience to human experience despite complicated forms of enmeshment.[29]

It is possible to detect a similar frustration in Haraway's accounts of poststructuralist thinkers who have taken up the question of the animal. She admires Jacques Derrida's willingness to speculate on the philosophical implications of an encounter between himself and the cat that stares back at his naked body, but she laments Derrida's failure to imagine this encounter beyond human shame, his refusal to include an animal acknowledged as "mutually responsive." Gilles Deleuze and Félix Guattari's notion of "becoming-animal" receives harsher criticism from Haraway; she sees in it "little but the two writers' scorn for all that is mundane and ordinary and the profound absence of curiosity about or respect for and with actual animals."[30] Part of Haraway's disappointment with Derrida and Deleuze and Guattari surely stems from her deeper investment than theirs in concerns more closely associated with animal rights or animal liberation.[31] However, I wish to explore Haraway's insistence on the "mundane and ordinary," which for her is epitomized

by the touch exchanged between herself and her pet dog: "My premise is that touch ramifies and shapes accountability. Accountability, caring for, being affected, and entering into ethical responsibility are not ethical abstractions; these mundane, prosaic things are the result of having truck with each other."[32] In this account Deleuze and Guattari (and Derrida, to a lesser extent) prefer abstraction to touch, the sublime idea of the animal to the mundane existing animal, the extraordinary to the ordinary.

But what does it mean for Haraway to characterize "touch" primarily as a matter of direct physical contact, the kind that occurs between humans and their pets? One advantage to this approach is taking seriously an entire realm of relationships that Deleuze and Guattari dismiss when they assert that *"anyone who likes cats or dogs is a fool."*[33] For Deleuze and Guattari human-pet relationships can only prop up the sort of regressive, narcissistic, fixed identities that they believe psychoanalysis depends on and that they aim to replace with an alternative notion of being as becoming, of identity as a series of deterritorializing transformations always in flux. I think Haraway is correct to call Deleuze and Guattari on their reductive portrayal of human-pet relations, but her decision to locate her critique in the realm of touch, of actual animals meeting actual humans, minimizes those technologically mediated but also affective and embodied aspects of "touch" I have described here as posthuman spectatorship. Indeed, Deleuze and Guattari's first example of "becoming-animal" comes from cinema: *Willard* (Daniel Mann, 1971), a horror film about a young male loner named Willard (Bruce Davison) who befriends a pack of rats, has them carry out his bidding, but then falls victim to their murderous revenge when he betrays their trust. For Deleuze and Guattari, Willard functions as an example of "becoming-rat." His being is not fixed through human or animal identities but instead circulates as a series of "impersonal affects, an alternate current that disrupts signifying projects as well as subjective feelings."[34]

Deleuze and Guattari offer impersonal affects involving the human and the animal without resting subjectively in either; they take shape as cinema. Haraway offers personal affects that belong to both human and animal subjectivities; they take shape as the touch between human and animal. But can cinema or new media "touch" as well? Can they address and move the spectator in ways that might complicate this duality between the virtual-impersonal and the actual-personal? To answer these questions, we must return to two of the surrealist-influenced theorists who opened this book's investigations: André Bazin and Georges Bataille.

BAZIN, BATAILLE, AND ANIMAL SPECTACLE

Bazin's essay "Death Every Afternoon" (1949) and Bataille's novel *Story of the Eye* (1928) share with *Los olvidados* a fascination with the bullfight. "Death Every Afternoon" analyzes Pierre Braunberger's documentary *The Bullfight* (*La course de taureaux*, 1949), which features voice-over commentary written by the surrealist Michel Leiris. *Story of the Eye* features a harrowing bullfight scene where a matador's eye is enucleated by the horns of a charging bull—imagery that anticipates *Un chien andalou*, a film that Bataille would later praise in his essay "Eye" (1929). Bazin, whose love of animals was as well-known as Bataille's affection for bullfights, nevertheless detects in *The Bullfight* an ability to capture "the essence of the spectacle, the mystical triad of animal, man, and crowd" along with its "metaphysical kernel: death."[35] Bataille, too, highlights "the utter nearness of death" in bullfighting, an intimacy that takes on sexualized feeling for spectators: "When the bull makes its quick, brutal thrusts over and over again into the matador's cape, barely grazing the erect line of the body, any spectator has that feeling of total and repeated lunging typical of the game of coitus. The utter nearness of death is also felt in the same way."[36] Bazin and Bataille differ in many aspects of their accounts of bullfighting, but their shared sense of the bullfight's power for spectators, its connection to a reckoning with mortality that binds human and animal, sheds light on the "touch" of posthuman spectatorship in *Los olvidados*.

For Bazin *The Bullfight* illustrates cinema's capacity to reveal both the sacred and the obscene qualities of sex and death in the realm of representation. The key is film's access to repetition: "I cannot repeat a single moment of my life, but cinema can repeat any one of these moments indefinitely before my eyes. . . . Like death, love must be experienced and cannot be represented (it is not called the little death for nothing) without violating its nature. This violation is called obscenity."[37] So cinema's ability to record and repeat any moment in life, including the sacred moments of sex and death, gives the medium a strong potential for the obscene. But this potential for the obscene can also heighten the spectator's sense of the sacred: "The representation on screen of a bull being put to death (which presupposes that the man has risked death) is in principle as moving as the spectacle of the real instant it reproduces. In a certain sense, it is even more moving because it magnifies the quality of the original moment through the contrast of its repetition."[38]

In *The Bullfight*, footage of the death of the famous matador Manolette in the bullring is suggested by Bazin to be both obscene ("the representation of a real death is also an obscenity.... We do not die twice") and sacred (the cinematic repetition of this death "confers on it an additional solemnity. The cinema has given the death of Manolette a material eternity").[39] Bazin's formulation of cinema's privileged relation to the apparently impossible, a simultaneous obscene/sacred, material/eternal, echoes his earlier description in "The Ontology of the Photographic Image" (1945) of surrealist photography as fact/hallucination. Indeed, Bazin's sense of surrealism as the conjuncture of subjectivity and objectivity, where "every image is to be seen as an object and every object as an image,"[40] seems to inform his understanding of the moment of death as well: "For every creature, death is the unique moment par excellence.... It marks the frontier between the duration of consciousness and the objective time of things."[41] For Bazin filmic time makes the moment of death, the transition from subjective consciousness to objective thingness, recordable and repeatable. Cinema thus lends death itself a surrealist cast, a unique/repeated and individual/communal quality. Thanks to film, Manolette does not die once in the bullring but every afternoon in front of the audience viewing *The Bullfight*.

A deep sense of risk anchors Bazin's understanding of cinema's surrealist character, its capacity to juxtapose the impossible and the possible. On the one hand, obscenity always looms, with its violations of the true nature of experience and reality. On the other hand, the possibility of revelation, of seeing in a new way that expands viewer perceptions of experience and reality, also remains present. For Bazin, perhaps the most important variable for calculating how this risk inherent in the cinematic image gets managed is the feeling of the spectator. Film has the power to break down barriers between the observer and the world, to add or detract from the spectator's sense of the world. The spectator's feelings provide the evidence for whether or not the cinematic gamble with representation has paid off. "I have never been to a bullfight," Bazin admits, "and it would be ridiculous of me to claim that the film lets me feel the same emotions, but I do claim that it gives me its essential quality, its metaphysical kernel: death. The tragic ballet of the bullfight turns around the presence and permanent possibility of death (that of the animal and the man).... The toreador plays for his life, like the trapeze artist without a net."[42] The fact that Bazin specifies the nature of cinematic risk here as

death's possibility for both man and animal, a possibility felt emotionally by the spectator, underlines how central human-animal relationships are to his formulations. Consulting some of Bazin's other writings helps to substantiate this claim.

Serge Daney points out that what is crucial for Bazin in cinema is the relation between heterogeneous elements within the frame, a relation of sharing and risk based on film's ability to respect reality's spatial and temporal unity. Daney claims that this relation becomes clearest in Bazin's writings during the moment when animals and humans come together within the frame under the possibility of death.[43] In "The Virtues and Limitations of Montage" (1953/1957), for example, Bazin claims that *Where No Vultures Fly* (Harry Watt, 1951), an "otherwise mediocre" film that dramatizes a family's attempts to establish a game reserve in South Africa (and thus a notable precursor to *Born Free* and "Christian the Lion"), contains "one unforgettable sequence": a wandering young boy picks up a lion cub and walks back toward his parents' camp, unaware that the cub's protective mother is following behind him and preparing to spring. "Then suddenly, to our horror, the director abandons his montage of separate shots that kept the protagonists apart and gives us instead parents, child, and lioness all in the same full shot."[44] The shot ends when the parents succeed in instructing the boy to put down the cub, which the lioness then carries away, averting any further danger.

Bazin's fascination with this moment stems from the director's decision to establish a particular form of relationality between human and animal, one freighted with the risk of death. The director accomplishes this by forgoing editing, which keeps the humans and animals safely apart in separate shots, in favor of capturing human and animal together within a single shot. For Bazin this single shot "carries us at once to the heights of cinematographic emotion." This sense of extreme spectator affect is not based on exposing the filmed actors to actual physical risk. Bazin acknowledges that the shot could only have been made possible through the use of a "half tamed" lioness, that "the question is not whether the child really ran the risk it seemed to run but that the episode was shot with due respect for its spatial unity."[45] So the risk conveyed through this respect for spatial unity does not depend on an actor actually being threatened by an animal outside the film but on *spectator perception* of the *relationality* between human and animal together within the film frame. If we miss this distinction, it is easy to misunderstand Bazin (as he has often been

misunderstood) as calling for a cinema without editing. Instead, Bazin calls for a cinema that solicits a particular form of involvement from its spectators, one that encourages a reckoning with reality as equal parts document and revelation—the factual hallucination of surrealism. This is what Bazin's respect for spatial unity revolves around. It is not an edict against editing but a commitment to provide the spectator with a certain cinematic experience—one that is sometimes most effectively conveyed through the absence of editing but not always.

In this light Bazin's self-proclaimed "law of aesthetics" emerges not as a banishment of editing (montage) but as a safeguard for spectator experience pertaining to relationality: "'When the essence of a scene demands the simultaneous presence of two or more factors in the action, montage is ruled out.' It can reclaim its right to be used, however, whenever the import of the action no longer depends on physical contiguity even though this may be implied."[46] Again, when this physical contiguity involves risk shared between human and animal, the stakes for the spectator are particularly high. But it is the communication to the spectator of a relationality between human and animal that is most crucial, not the presence or absence of editing.

Bazin's "Cruelty and Love in *Los olvidados*" (1951) grapples with the same questions of risk and relationality that characterize "Death Every Afternoon" and "The Virtues and Limitations of Montage." Once again the animal and surrealism are central: Bazin argues for a powerful continuity among Buñuel's films by noting the shocking images of dead donkeys in both *Un chien andalou* and *Las Hurdes*. For Bazin the presence of the donkeys testifies to how the "objectivity" of *Las Hurdes* does not constitute a rejection of the "fantasy" of *Un chien andalou* but rather indicates two different syntheses of subjectivity and objectivity that work toward the same surrealist ends. These goals are shared by *L'âge d'or* and *Los olvidados*, and Bazin once again characterizes the goals in terms of a risky spectator address that unites all four films: a surrealist aesthetic that "lashes the mind like a red-hot iron and leaves one's conscience no opportunity for rest," causing us to "lose our breath . . . like a diver weighted down with lead, who panics when he cannot feel sand underfoot."[47]

Where Bazin falls short in his account of *Los olvidados* is when he attempts to convert what he calls Buñuel's "cruelty," the threat he poses to the spectator, into "love," an apology for liberal humanism: "Because [*Los olvidados*] evades nothing, concedes nothing, and dares to dissect reality with surgical obscenity, it can rediscover man in all his greatness

and force us, by a sort of Pascalian dialectic, into love and admiration. Paradoxically, the main feeling which emanates from . . . *Los olvidados* is one of the unshakable dignity of mankind."[48] Here, Bazin's need to recuperate *Los olvidados* for humanism obscures what I have described as Buñuel's surrealist posthumanism, the sort of risky relationality between humans and animals that Bazin captures so well in "Death Every Afternoon." It's as if Bazin, after so carefully and eloquently capturing the stakes of Buñuel's surrealism as a form of risky spectatorship, retreats to the vantage point of the humanist prologue in *Los olvidados*. It is Bataille who helps us see what Bazin misses in the film.

Bataille's bullfight in *Story of the Eye* is more graphic and grisly than Buñuel's in *Los olvidados*, but they both emphasize how the bullfight's power of spectacle can break down barriers between viewer and viewed, between human and animal relations. Bataille's bullfight generates a frenzied eroticism that results in a simultaneous orgasm for the textual spectator and death for the textual matador. The eruption of raw, animal-like spectator affect into the deadly encounter between human and animal underlines the significance of Bataille's shocking imagery; what is at stake here is a new way of seeing, one that demands a sort of destruction of the eye that Bataille literalizes when the matador's eye meets the horns of the bull. Buñuel, too, performs a similarly literalized demand for new, embodied vision on the part of the spectator when the razor meets the eyeball in *Un chien andalou*. Both Bataille and Buñuel will modulate and expand their calls for new forms of vision from their audiences over the course of their careers, but their insistence on surrealist-inflected, post-humanized approaches to this project will remain. Witness, for example, the broken chicken egg on the camera lens in *Los olvidados*.

With Bataille the matter becomes somewhat more complicated. As I explained in chapter 1, Bataille is most often seen as an enemy combatant of surrealism rather than a surrealist himself. It is true that Bataille's critiques of surrealism are often harsh and that he was never really inside the movement, but his devotion to constructing alternative takes on surrealism, or reformulating surrealist concerns, is absolutely central to his thought. Nowhere is this clearer than in his turn toward surrealism after World War II, a time when most commentators were turning their backs on surrealism. Although Bataille never published during his lifetime the book on surrealism that he began writing after the war, many of its components appeared in article form between 1945 and 1951 and have been posthumously collected as *The Absence of Myth: Writings on Surrealism*.

These writings, and their intersection with other projects Bataille pursued in the wake of the war, provide a means of drawing out the theoretical implications of Buñuel's surrealist posthumanism.

In *The Absence of Myth* Bataille is drawn to certain forms of vision and consciousness lodged within surrealism's impossibilities and contradictions. He finds the movement's convictions compelling despite its own limitations and missteps, and he admits that his own awkward, disillusioned, jealous history with the movement fails to diminish its power.[49] He claims that surrealism, like all myths, is most valuable in its waning or death—that is when we can see it most clearly (*AM* 48). The death of surrealism as a movement during the postwar period leaves room for a *"great surrealism"* to begin, one that extends beyond "the few people closely connected with André Breton" (*AM* 51, 55). So for Bataille "surrealism is not dead" (*AM* 52). One of its lasting contributions, in art and politics, is a "language beyond things," where we do not consider ourselves and others as objects or abstractions (*AM* 182, 25).

There is evidence in *The Absence of Myth* that this surrealist "language beyond things" can be understood as a form of posthuman relationality. For example, in a study of Jacques Prévert's poetry that links Prévert's articulation of a sort of "language beyond things" to his exposure to surrealism (*AM* 141), Bataille provides the example of a horse's death as an analogy for how poetry can accomplish a particular kind of awakening in the reader: "To kill the horse is to suppress it as a distinct object: the horse which dies is no longer . . . something distinct from me. The suppression of this object by its death is the suppression of a barrier between 'the animal' and myself: it becomes the same thing as I am, a presence on the edge of absence. Distinct *subjects* and *objects* no longer exist. . . . The awakening of the sensibility, the passage from the sphere of intelligible (and usable) objects to excessive intensity, is the destruction of the object as such" (*AM* 150).

For Bataille the "destruction of the object as such" precipitates an awakening in the reader to "the world of the instant," where subject and object distinctions fall away (*AM* 150). But this poetic awakening is not equivalent to, nor does it require, the object's actual physical death. As he explains, "In the world of the instant nothing is dead, absolutely nothing, even if the infinite pressure of death alone has the power to burst in with a single leap. Nothing is dead, nothing can be. No more difference, no calculation to make" (*AM* 150). The awakening occurs at the level of the reader's sensibility, his or her awareness, not in the literal

realm of the killing of animals (although Bataille, here and elsewhere, is powerfully attracted to the act of sacrifice, he puts it aside now as a "misguided zeal" [AM 150]).[50]

Bataille characterizes this awakening in terms borrowed from the surrealist poet Paul Éluard: poetry can "bestow sight" and "*open eyes*" rather than impart knowledge and meaning in the manner of prosaic language (*AM* 137). Sight, for Bataille, is the realm of "excessive intensity," of feeling rather than knowing. But feeling and knowing need not be mutually exclusive when it comes to poetry and its "unrestrained" (language-based) access to the power of death, its ability "to render palpable, and as intensely as possible, the content of the present moment" (*AM* 149). Poetry, that vehicle of sight, can accomplish the destruction of the object while simultaneously being "used to display knowledge" (*AM* 150). This possibility of seeing-feeling (sensibility) becoming a form of knowing-understanding (awareness) is precisely what Bataille means when he describes poetry's power to awaken readers to "the world of the instant" under "the infinite pressure of death" (*AM* 150). The specter of death is the force that tears down boundaries between subject and object, knowing and feeling, human and animal. And here is where Bataille's sense of risk for the reader goes beyond Bazin's for the spectator: the recognition of death's uselessness, intensity, and horror is not a force to be redeemed as humanism. Instead, this force enables a terrifying kind of posthuman vision, one where the full horror of blurring the lines between "human" subjects and "animal" objects comes alive. Seeing in this way is indeed an awakening but not in the ultimately comforting humanist sense of that term. When sight is bestowed, when eyes are opened, posthuman awakening sustains rather than relieves the nightmare of losing the self.

Film does not play a central role in *The Absence of Myth*, although one must assume that Bataille's consideration of Prévert as the exemplar of a poetic "destruction of the object as such" takes into account, if only implicitly, Prévert's significant involvement with the cinema as a screenwriter (most famously in his collaborations with director Marcel Carné).[51] In fact, there is a striking consistency between Bataille's characterization of Prévert's poetry and its impact on the reader (bestowing sight through the destruction of the object as such, generating an awakening to loss of self under the infinite pressure of death) and his earlier description of *Un chien andalou* and its effect on spectators. In "Eye" Bataille writes that *Un chien andalou* penetrates

so far into horror that the spectators are caught up as directly as they are in adventure films. Caught up and even precisely caught by the throat, and without artifice; do these spectators know, in fact, where they—the authors of this film, or people like them—will stop? If Buñuel himself, after the filming of the slit-open eye, remained sick for a week (he, moreover, had to film the scene of the asses' cadavers in a pestilential atmosphere), how then can one not see to what extent horror becomes fascinating, how it alone is brutal enough to break everything that stifles?[52]

Here the risk to the spectator and the filmmaker alike travels to extremes outside the purview of humanism. The threat of the image does not stop: it goes for the throat, it sickens as it fascinates, it insists on horror as the condition for an awakening beyond "everything that stifles" (such as conventional designations of subject and object). So we can understand how Bataille's poetic awakening to the destruction of the object and his cinematic awakening to horror are two versions of the same surrealist desire to "bestow sight" on the reader or spectator. In the case of *Un chien andalou* the safety of subject/object distinctions disintegrates for the spectator through risky, throat-grabbing exposure to death and horror that combines feeling and knowing. The awakening for the spectator that results is one where "human" subjects (the slit-open eye/I) and "animal" objects (the asses' cadavers) are no longer felt or known as separated—a posthuman awakening.

THE (IM)POSSIBILITIES OF POSTHUMAN AWAKENING

Now that Bazin and Bataille have helped me to clarify the risks of posthuman spectatorship in its surrealist dimensions, I would like to conclude by returning briefly to "Christian the Lion" and *Los olvidados*. How do these two texts honor or evade the possibilities of what I have called, through Bazin and Bataille, a posthuman awakening for spectators?

As I explained earlier, "Christian the Lion" works hard to lessen the risks associated with posthuman spectatorship. Two of the video's strategies in this regard can now be seen more clearly: its repression of death and its investment in a continuous past, present, and future rather than an urgent, unique present. The video's emotional power stems largely from the relief experienced by spectators when the possibilities of danger and

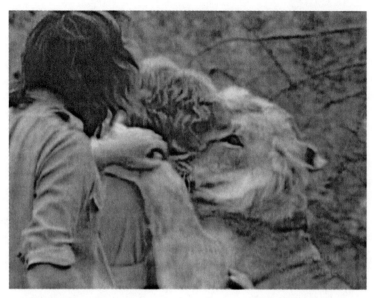

Figure 4.5 "Christian the Lion": Christian's nuzzling remains playful, not dangerous.

death are revealed to be love and affection. Christian seems to approach Bourke and Rendall somewhat warily at first—the lion and the men initially occupy separate shots, with cuts back and forth as Christian slowly crosses the space that separates them. Even though Bourke and Rendall do not seem at all fearful in these shots (they are smiling and eager to greet Christian), the suspense present in Bazin's previously mentioned description of a similar sequence in *Where No Vultures Fly* remains. Christian is, after all, a wild predator in a wild environment. Will he attack his former owners?

When the men and the lion finally do share the same shot, Bazin is channeled once again. The reunion transpires chiefly in a single uninterrupted take that lasts more than twenty seconds, nearly one-fifth of the video's total running time. But where Bazin insisted on spatial unity as a matter of conveying to spectators a risky relationality between humans and animals, "Christian the Lion" evokes that risk only to reassure us that there was never really any risk at all. Christian's leaps and nuzzling may at first simulate the look of an attack, but these actions are instantly tamed as play (fig. 4.5). Death is avoided in Bazin's example as well, but the difference is that what lingers in Bazin's case is the risk of death com-

municated to spectators as the governing form of relationality between the lion and the humans. In "Christian the Lion" what lingers for spectators is not risk but safety, the conviction that what we have witnessed is the survival of conventional subject/object distinctions (owner and pet) rather than the interrogation of those distinctions. Death's possibility is repressed, not embraced.

Indeed, "Christian the Lion" departs significantly from the documentary that serves as its source by erasing a series of deaths, both human and animal, that make this reunion possible. *The Lion at World's End* devotes considerable attention to chronicling the process of Christian's transition from domestic to wild habitats. This process includes the deaths of Boy and Katania, two half-domesticated lions used to ease Christian back into the wild, as well as one of George Adamson's human assistants, whom Boy kills. The absence of these deaths from "Christian the Lion" helps to betray the likelihood that spectators will enter what Bataille calls "the world of the instant," born under "the infinite pressure of death" (*AM* 150). Bataille's pairing of death and the "instant" of the present moment resembles Bazin's call for a cinematic respect for spatial unity (which is also a temporal unity, as disparate elements share the same space at the same time), but Bataille, as we have seen, pushes Bazin's call beyond its humanist framework. This is territory that "Christian the Lion" refuses to explore by preferring the past and the future over the present as its dominant temporalities.

Even though the undeniable center of "Christian the Lion" is its reunion shot, a moment located very much in a cinematic present, the video's bookend sequences highlight the past and future, respectively. The opening "scrapbook" photographs of Christian's childhood portray a frozen black-and-white past, while the closing intertitle, "Send it to someone you love," gestures toward a future in which the video is shared with other spectators. These bookends provide an additional bulwark against death. Death is not only absent in the present, but the possibility of its eruption is smoothed over by a past and future that make death seem irrelevant. Christian's story gains humanized meaning by lending it a familiar narrative arc, one that deemphasizes the urgency of the present by embedding Christian in an idyllic past (adorable domesticity) that extends into the present (memories of that domesticity honored via regained contact) and the future (the "lesson" apparent in this domesticity forever passed on to countless YouTube viewers). Questions about when

or where this story takes place, how the reunion came to be, or what the consequences of the reunion were for the men and the lion receive no attention in the video. These are questions that would raise the specter of death by establishing historical and causal specificity to the past, present, and future, giving each of those temporalities a particular set of stakes rather than a continuous flow.

This undifferentiated flow of time characterizes not only "Christian the Lion" but YouTube as a medium. The YouTube viewer accesses the tiny slices of time captured in each video (most last only a few minutes) in a way that might seem to grant the present tense of each video a genuine immediacy, but that immediacy is sapped by the context of YouTube as a whole. Each video is part of an endless present, a seemingly infinite plenitude of images where the instantly available, minimally historicized moments in each video lose much of their specific urgency and resonance. This is not to say that individual YouTube videos cannot capture significant historical incidents, provide instances of powerful fascination, or operate as valuable pedagogical tools, but the net effect of encountering YouTube as a medium often feels as if each video matters less given the multitude of other videos crowding it willy-nilly. Using YouTube may activate a certain sense of curiosity from spectators but probably not the kind of disorientation that André Breton mentions in connection with a surrealist activity that may at first seem quite like browsing YouTube videos: jumping randomly from one movie screening to another at irregular intervals.

As I explained in chapter 1, Breton's cinematic sampling utilizes "chance" to capture film's "*power to disorient*" the spectator.[53] One might be tempted to describe the act of using YouTube in a similar way—watching video after video in near-random fashion, abandoning one for another in rapid succession, always seeking a new image before boredom sets in. But what Breton designates as most important in his cinematic sampling is its potential to "magnetize" the spectator's own fantasies so that the viewer emerges from the cinema "'charged' for a few days." The spectator invests in the film in such a manner that its effects linger, evidence that the viewer "passes through a critical point as captivating and imperceptible as that uniting waking and sleeping." YouTube, however receptive to chance, cannot easily generate the sort of spectator investment that Breton characterizes as cinema's surrealist potential.[54] As "Christian the Lion" suggests, YouTube may well be capable of touching viewers emo-

tionally and encouraging them to share favorite videos with others, but the risks to the spectator carried by this touch are minimized. The sort of dreamlike captivation Breton speaks of, or what Bataille describes as film spectators being "caught by the throat," is mitigated in "Christian the Lion" through its sanitized vision of posthuman relationality. Looking at the conclusion of *Los olvidados* offers a very different realization of the surrealist potential for posthuman awakening in the spectator.

Los olvidados ends with the deaths of Pedro and Jaibo, two characters that spectators have invested significant energy in over the course of the film. The shock of their fates comes not only from the savage violence of their deaths but from how Buñuel maps their deaths onto images of posthuman relationality that catch the spectator "by the throat" in Bataille's sense—with a horror "brutal enough to break everything that stifles."[55] Pedro dies during a fight with Jaibo in the barn owned by Meche's family. Buñuel's use of this setting foregrounds the presence of donkeys and chickens, to the point that these animals become vital components of the scene's action and meaning. The squawking of the chickens alerts Jaibo to Pedro's proximity, a donkey later appears at Meche's window as if to "tell" her that something is wrong in the barn, and finally a chicken traipses over Pedro's corpse as if to confirm that he is really dead. Images such as these highlight the base "animality" of Jaibo and Pedro's lethal struggle, but they also lend flashes of "humanity" to the animals surrounding that struggle; it is they who "speak" about what happens between the two boys.

This blending of human subject/objects and animal object/subjects generates an opening to Bataille's "world of the instant" for the spectator. Under the "infinite pressure of death" Pedro's past and future, his identities as a mind that thinks and a body that feels, his alternation between "human" desires and "animal" materiality, become condensed in one horrific, violent moment of absolute presence (*AM* 150). Jaibo clubs Pedro to death through gestures identical to those that Pedro witnessed when Jaibo killed Julián, as well as those that Pedro used himself when killing the chickens at the reformatory. In addition, the blood on Pedro's face recalls the blood on Julián's face that appeared earlier in Pedro's famous dream sequence—a dream that begins with the sight and sound of chickens before narrowing in on themes of guilt over Julián's death and desire for his mother. Pedro's dream offers the spectator privileged access to his subjectivity, his inner "humanity." When Buñuel evokes that

Figure 4.6 *Los olvidados*: Jaibo (Roberto Cobo) shares the frame with a dog.

dream now, during a time when Pedro's body gets reduced to its bare materiality (Meche and her grandfather eventually load the corpse on a donkey and dump it as garbage), the spectator must join Pedro's subjective "humanity" to his material "animality." The funneling of Pedro's entire being into this one deadly instant sets up the spectator for a potentially shattering confrontation with posthuman relationality—one that hits home even more profoundly when paired with Jaibo's death.

Jaibo's demise occurs shortly after Pedro's, when the police catch up with him and shoot him in the back. As Jaibo expires, he is granted a brief dream sequence. Although his dream is not nearly as flamboyant as Pedro's, its echoes of Pedro's dream and the fact that it comes so near the end of the film give it a powerful impact. Jaibo dreams of a dog coming toward him, just as Pedro's dream opened with the presence of chickens. The image of the dog is superimposed over Jaibo's face so that he and the dog must literally share the frame, each dissolving into the other (fig. 4.6); chicken squawks and falling feathers saturate Pedro's dream in a similar manner. Disembodied voices speak in Jaibo's dream, like Pedro's and his mother's voices punctuated his. Among the voices in Jaibo's dream is Pedro's, warning him that the "mangy dog" is approaching.

But perhaps the most striking visual continuity between the two dreams is Jaibo's slow-motion turning of his head back and forth, a gesture that mirrors the movement of Julián's head in Pedro's dream—blood stains the faces of both Julián and Jaibo in these moments.

These multiple points of intersection between the dreams of Pedro and Jaibo suggest one shared subjectivity between them rather than two different ones. The centrality of animals to both dreams similarly insists that spectators should not read these dreams solely in terms of individually psychologized interiority but rather as the merging of subjective "humanity" and objective "animality." In other words, these dreams that transpire during "sleep" for the characters (whether rest or death) invite posthuman awakening in the spectator—a recognition of Bataille's "world of the instant" (*AM* 150). Indeed, Jaibo's dream ends in death, a moment Buñuel captures cinematically through a freeze-frame. In the stillness of Jaibo's face death's horror and power "render palpable, and as intensely as possible, the content of the present moment" (*AM* 149). And what comes forward for spectators in this moment of absolute presence, frozen in time and space, is a vision of posthuman relationality that *Los olvidados* has insisted on from the very beginning. The bull-child of the film's opening meets his partner in Jaibo's dog-man, images that catch spectators "by the throat" and invite them to see what "Christian the Lion" strives to erase: animals and humans as companion species joined not by reassuring anthropomorphism but by the risk, horror, and death tied to truly losing hold on one's sense of self.

That this gift of posthuman awakening for spectators is more apparent in the surrealist cinema of *Los olvidados* than in the YouTube video "Christian the Lion" does not mean necessarily that film and digital media have unequal access to the possibilities of posthuman spectatorship. But it does mean that we cannot simply understand posthumanism as something that moves inexorably from human to machine, from body to virtuality, from analog to digital. It must also move from human to animal and back again, toward that surrealist bestowing of sight where we can see the mutually constitutive animal-human.

Collaborative Spectatorship

The Surrealism of the Stars: From *Rose Hobart* to *Mrs. Rock Hudson*

L ong before YouTube made fan-produced digital videos devoted to favorite movie stars a staple of the twenty-first-century media landscape, the American artist Joseph Cornell (1903–72) created a film whose mesmerizing power seems to anticipate and complicate YouTube simultaneously: *Rose Hobart* (1936). Cornell constructed his film, named for the movie actress who inspired it, by reassembling a B-grade jungle adventure melodrama starring Hobart called *East of Borneo* (George Melford, 1931). In *East of Borneo* the intrepid Linda Randolph (Hobart) travels into the savage tropical wilderness to find her estranged, alcoholic husband, Allan Clark (Charles Bickford), and escape the clutches of the sophisticated yet ruthless prince of Marudu (George Renavent). In *Rose Hobart* Cornell selects particular scenes from *East of Borneo*, reedits and reorders them, slows down the projection speed, removes the film's

dialogue and sound, adds a new soundtrack featuring Brazilian samba music, intercuts images from other sources alongside the *East of Borneo* material, and inserts a dark blue filter to lend the black-and-white footage a new tinted color. The result is an astonishing nineteen-minute work (distilled from *East of Borneo*'s seventy-five minutes) that stands out today even beside Cornell's more famous, intricately crafted box constructions that have made him a major figure in the art world.[1]

In this chapter I will argue that *Rose Hobart* can be understood most accurately as an invitation to a particular kind of collaborative spectatorship that surrealism often strived for and that digital media continues to struggle with. In fact, *Rose Hobart* was so ahead of its time that its significance for us today may reside primarily in its ability to critique certain blind spots in how surrealism, as well as new media, deals with homophobic and misogynist fantasy, especially as those fantasies seep into constructions of movie stars by media spectators. The first half of the chapter focuses on *Rose Hobart* and Cornell's relation to surrealism, while the second half explores the legacy of Cornell's film in the digital era through a YouTube channel devoted to Hollywood star Rock Hudson. Throughout, my analysis is driven by an investigation of what I am calling "collaborative spectatorship": a network of fantasy negotiated between media artist, media audience, and media text so that these relations are expanded beyond the surrealist sense of enlargement described in chapter 1.

JOSEPH CORNELL AND *ROSE HOBART*: QUESTIONS OF SURREALISM

Rose Hobart premiered in December 1936 at the Julien Levy Gallery in New York, one of the first and most important sites for surrealist art exhibitions in America. Cornell's art had been appearing at the gallery since 1932, when Levy included examples of Cornell's art objects and collages in his groundbreaking survey exhibition *Surréalisme*.[2] What should have been a welcoming reception environment for *Rose Hobart* became a hostile one when a member of the audience loudly denounced the film and threatened Cornell; that viewer was none other than Salvador Dalí. Dalí's ferocious reaction prompted his wife, Gala, to apologize to Cornell and explain that her husband felt Cornell had somehow plagiarized ideas Dalí had thought about but never acted upon. This episode deeply affected Cornell, an unusually sensitive and contemplative man by nature, and has been

attributed to shaping Cornell's hesitation to exhibit his films afterward.[3]

The most obvious way to read the ill-fated premiere of *Rose Hobart* is as an unfortunate but not uncommon instance of acting-out by Dalí, an artist whose genius often competed with his own erratic, grandstanding, and self-serving behavior. But is it possible that Dalí was on to something? Not so much that Cornell was reading his mind and stealing his ideas, but that Cornell had tapped an important vein of surrealist creativity and accomplished what Dalí wished he had done himself?[4] In other words, perhaps Cornell ignited Dalí's rage because here in the Levy Gallery, the point of entry for surrealism in America, Cornell proved himself to be not simply indebted to surrealism but a significant innovator of surrealism. I will argue that Cornell's major contribution to surrealism was a particular type of collaborative spectatorship that challenges surrealist attributions of creativity and agency to artist, artwork, and audience. Various forms of collaborative spectatorship have figured in all of this book's previous chapters, as the desire to break down barriers between artist and audience, producer and consumer, has drawn us to the crossroads of surrealism and new media again and again. The difference that Cornell's case of collaborative spectatorship makes is its ability to highlight the limitations of both surrealist and digital versions of creative agency—how the liberation of observer into participant, viewer into user, may not be so liberating after all. When compared with Cornell's stunningly generous invitations to collaborative spectatorship, many surrealist and digital notions of collaboration between artist and audience start to feel like false or qualified gestures. But first Cornell's relation to surrealism requires exploration and explanation.

Despite the facts that Max Ernst's collages were one of Cornell's earliest inspirations, that his unrealized surrealist film scenario *Monsieur Phot* (1933) was published alongside the scenarios for *Un chien andalou* and *L'âge d'or* in Julien Levy's landmark compendium *Surrealism* (1936), that he met and corresponded with a number of surrealist artists over many years, and that surrealism exercised a powerful influence on him throughout his career, one of Cornell's most frequently mentioned comments on surrealism emphasizes his desire to distance himself from the movement. Cornell, writing in a 1936 letter to Alfred H. Barr Jr. as he was being presented as a surrealist artist in Barr's exhibition *Fantastic Art, Dada, Surrealism* at the Museum of Modern Art, stated, "I do not share in the subconscious and dream theories of the surrealists. While fervently

admiring much of their work, I have never been an official surrealist, and I believe that surrealism has healthier possibilities than have been developed."[5] This statement certainly gestures toward some of the ways in which the artist departed from prevailing surrealist sensibilities. Cornell maintained a serious, lifelong connection to Christian Science that began with a personal healing experience in 1925.[6] His devotion to the beliefs of Christian Science, of course, conflicted with surrealism's strident anticlericalism, as well as many aspects of surrealist fascination with the darker sides of human (un)consciousness and sexuality—hence Cornell's preference for the "healthier possibilities" of surrealism. But to use such statements, whether implicitly or explicitly, as a means simply to divorce Cornell's work from surrealism obscures much more than it illuminates.

To take a recent example, Michael Richardson's decision to demote Cornell's films in general and *Rose Hobart* in particular from the center of surrealist cinema minimizes precisely those aspects of *Rose Hobart* that broaden the horizons of what a surrealist collaborative spectatorship could be. For Richardson *Rose Hobart* belongs to the ranks of those films made "within the surrealist milieu during the twenties and thirties" that have "been subject to an overload of critical attention hardly justified by the films themselves," which are often "little more than home movies . . . now having only a historical interest." Although Richardson admits that *Rose Hobart* "has a genuinely oneiric and unsettling quality," Cornell's "cinematic imagination" remains ultimately "unfulfilled." *Rose Hobart*, in Richardson's account, fails to live up to its critical designation as an avant-garde film that rejects "Hollywood production methods" because "Cornell himself almost certainly considered it to be a homage to its star," and therefore the film "cannot be seen as an artist's triumph over the vulgarity of Hollywood." Even when Richardson recognizes, somewhat grudgingly, that *Rose Hobart* functions as a surrealist enlargement of *East of Borneo*, he asserts that Cornell's film "enlarges the original without annulling it"; as a result Cornell "fails" when it comes to "taking a trashy Hollywood film and turning it into 'art.'"[7] Richardson's conviction that true surrealism must not be tainted by the vulgarity of Hollywood, that it must make its allegiance to art (the superiority of the artist) over trash (the inferiority of mass culture) crystal clear, disqualifies *Rose Hobart* from consideration as a significant surrealist achievement. What Richardson overlooks in his dismissal of *Rose Hobart*'s importance for

surrealist cinema is its ability to invite spectators not only to enlarge *East of Borneo* along surrealist lines but to transform that enlargement into a dynamic collaboration with both Cornell and Hobart's image. This communion between viewer, artist, and star goes far beyond homage, into a new conceptualization of how the labor and magic of cinematic spectatorship is shared.

Cornell paves the way for surrealist enlargement in *Rose Hobart* by shrinking *East of Borneo*. By removing or lessening *East of Borneo*'s dialogue, sound, narrative, lighting contrast, and projection speed, Cornell opens up space for spectators to insert their own associations and fantasies. This creative space for the viewer is carefully cultivated and preserved even when Cornell adds to *East of Borneo*. For example, the opening shot of *Rose Hobart* shows a crowd of people looking up at the sky while gazing through special shielding eyewear (fig. 5.1); they seem to be observing an eclipse (a suggestion the film will later confirm). This shot, like several others in *Rose Hobart*, does not appear in *East of Borneo*. But this first shot is unique among Cornell's added images from other sources in that it depicts human beings rather than natural elements or inanimate objects. These spectators of an eclipse are the only people in *Rose Hobart* who are

Figure 5.1 *Rose Hobart* (Joseph Cornell, 1936): Stargazers look upward in the film's opening shot.

not movie characters from *East of Borneo*, so they beckon toward us and begin to mirror us, the spectators watching the film. Like us, they are stargazers; only they look to the sky while we look to the screen. They are protected from the blinding rays of the sun by the mediation of the eyeglasses, while we are shielded from the overwhelming stimulation tied to *East of Borneo*'s sights, sounds, and stories through Cornell's artistic shrinkage. In both cases a mediating agent enables viewers to see in a new way, to enlarge their vision. For viewers of an eclipse the usually invisible or blinding sights of earth's relation to the heavens become briefly visible through the mediation of protective eyewear. For viewers of *Rose Hobart* the spectator's standard or predetermined relation to the movie star becomes negotiable through the mediation of Cornell's reassembly of *East of Borneo*. Cornell, a passionate and knowledgeable astronomy enthusiast as well as an inveterate film buff and film collector, presents these two types of revelatory vision as one and the same in *Rose Hobart*. Cornell's film insists that to truly see the stars, whether in the sky or on the screen, we require the collaboration of a mediating force.

P. Adams Sitney, who has contributed some of the most important critical commentary on Cornell's films, notes astutely the centrality of mediation as a theme in Cornell's work. But for Sitney, Cornell's mediators are figures that come between the artist and the camera, "through whose consciousness these camera movements might be experienced."[8] Where Sitney sees mediation in Cornell's films primarily as a matter of cinematic stand-ins that simulate the filmmaker's "consciousness," I see mediation instantiated as a series of collaborative relays between filmmaker, film, and viewer that unmoor "consciousness" from the filmmaker or his stand-in alone. Although the many shots and cuts in *Rose Hobart* motivated by the star's arresting gaze do indeed suggest a perceptual doubling between the star and the filmmaker (with the relays between Hobart's looks and Cornell's edits organizing the film along parallel lines), it is important to remember that the very first look in *Rose Hobart* belongs to the crowd staring upward. And it is this look that overlays the film as a whole, for as Kirsten Hoving observes, Cornell's use of a dark blue filter throughout the film constantly reminds us that "solar eclipses must be viewed under special conditions, through a darkened glass." Cornell's filter repeats this "precaution for the film's audience," aligning the crowd of the opening shot with the spectators of *Rose Hobart* from beginning to end.[9]

Rose Hobart concludes with two answers to the question posed in

the opening shot of the crowd: What are these people looking at? The first answer is conveyed through a shot not included in *East of Borneo*: footage of an actual solar eclipse. The second answer is a shot from *East of Borneo*: Hobart at her most glamorous, in a jewel-studded evening dress and exquisite dangling earrings, but physically restrained on either side by the prince's guards and with her gaze directed downward, eyes closed (fig. 5.2). So the crowd stares at the brilliance of the sun and the star; in both cases the crowd's vision is protected and enlarged through mediating forces. The moon's passing shadow allows a rare glimpse of the sun, while Hobart's forced stillness, closed eyes, and downward glance offer an unusually candid, nonposing portrait of the star. In these images consciousness is no longer the exclusive province of Cornell or his stand-in, Hobart. Instead, it is the crowd's yearning look upward that is fulfilled through the sun brought "down to earth" by the eclipse and the star brought "down to earth" by her literal look downward. *Rose Hobart* begins with a crowd of earthbound spectators looking up, needing special technology to protect their eyes from the brilliance of what they wish to see; it ends with the heavenly objects of their gaze coming down to meet them in mediated form.

Nestled between the two concluding shots of *Rose Hobart* is another

Figure 5.2 *Rose Hobart*: In the film's closing shot Rose Hobart gazes downward.

of Cornell's additions to *East of Borneo*: a beautiful slow-motion image of a spherical object falling into a pool of water, the ripples from the splash catching glints of the light above (fig. 5.3). Sitney interprets this image as the culmination of the "new plot" Cornell grafts onto *East of Borneo*, a story that revolves around a "solar disaster" when the eclipse causes the sun (represented by the descending spherical object) to fall from the sky into the water. I agree with Sitney that this narrative of "the sun poked out of the sky" is one possibility for an "imaginary film" that viewers of *Rose Hobart* could conceivably construct.[10] But in keeping with Cornell's particular investments in collaborative spectatorship, I believe *Rose Hobart*'s address of the spectator is less about disastrous events than miraculous ones.

Sitney supports his sense of *Rose Hobart*'s ending as apocalyptic by asserting that Cornell's film "hyperbolically enlarges the catastrophe that terminated *East of Borneo*." At the conclusion of *East of Borneo* Linda's attempted murder of the prince sets off a volcanic eruption that swallows both the prince and his entire kingdom, with Linda and Allan barely escaping but now romantically reunited. Sitney claims that Cornell drains the volcano of its "destructive force" in order to substitute the far more "dreadful consequences of a world which has lost its sun"—the

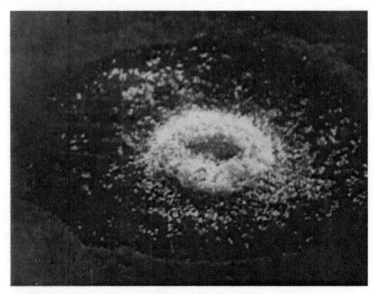

Figure 5.3 *Rose Hobart*: A spherical object falls into a pool of water.

solar disaster dwarfs the volcanic disaster because the latter is realized through cheap, literalizing special effects while the former is "left to our imagination."[11] It is important to note how Sitney's conviction that Cornell "enlarges" *East of Borneo* in this way is not ultimately a matter of surrealist enlargement, where paths through a film that differ radically from what was originally intended become possible. Instead, Sitney limits the imagination of *Rose Hobart*'s creator and spectator to more or less repeating *East of Borneo*'s ending (solar disaster replaces volcanic disaster) rather than transforming it. Yet the invitation to collaborative spectatorship that Cornell offers in *Rose Hobart* points to precisely this kind of surrealist metamorphosis.

For example, Cornell reimagines one of the most shocking scenes in *East of Borneo*—Linda sets free an adorable pet monkey only to watch it die seconds later in the jaws of a hungry tiger—as a moment of love and generosity, not folly and death. In *Rose Hobart* this encounter between Linda and the monkey recurs but without its tragic outcome. Instead, we see only the affection Linda lavishes on the monkey and her kind gesture of liberation, not its deadly price. Cornell manipulates the footage in such a way that Linda appears to spot the monkey first not as the captive pet of a native tradesman, as she does in *East of Borneo*, but as a wild monkey who eludes the threat of the tiger by seeking Linda out in his own playful way; the monkey eventually hitches a ride with the tradesman to meet her. So, in the end, the narrative meaning of this episode in *East of Borneo* is jettisoned altogether in *Rose Hobart*. The same goes for the presence of the prince and Allan in Cornell's film; one would be hard pressed to detect definitive signs in *Rose Hobart* of the prince's villainy or Allan's heroism, let alone the nature of the competition between them for Linda, just as one would have an equally difficult time missing these foundational narrative elements in *East of Borneo*. In fact, the prince occupies so much more screen time than Allan in *Rose Hobart* (and Linda so much more than the two of them combined) that it is quite impossible to divine the workings of *East of Borneo*'s central love triangle from Cornell's film alone. Changes such as these highlight how far Cornell goes to enlarge *East of Borneo* in a surrealist sense; he is simply not attached to *East of Borneo*'s narrative structures, even to reverse or subvert them. *East of Borneo* is a launching pad for collaboration between filmmaker and spectator, not a master text that demands rigorous cross-checking and comparison. Cornell's film, after all, is called *Rose Hobart*, not *Linda Randolph*. Its investment

in *East of Borneo* revolves around its images rather than its narrative, its potential to activate fantasy rather than to reflect the consequences of fidelity to (or sabotage of) the original's story. In other words, Cornell does not so much rewrite *East of Borneo*, which is what Sitney suggests when he maps Cornell's solar disaster onto *East of Borneo*'s volcanic disaster, as transform it into a meeting place for surrealist exchange between filmmaker and spectator.

At the heart of this exchange is a communion between spectator and star mediated by Cornell's film. This new set of relations between spectator and star points toward the revelation of a new world discovered when a star "falls" far enough to truly acknowledge the spectator, not the catastrophe of a world lost when its sun falls from the sky. *Rose Hobart*'s eclipse does not destroy vision; it brings a new way of seeing into being by fulfilling the desire for spectatorship conveyed in the film's very first shot. In the film's final three-shot sequence (described earlier), the boundary between earthbound spectator and heavenly star dissolves. The second of these three shots, the sphere falling into water, had already appeared once before near the film's beginning. In that first occurrence of the shot, Hobart shrugs off the significance of the falling sphere by shaking her head, smiling to herself, and turning her eyes skyward rather than continuing to stare down toward the pool. What she sees when she looks up is an image of clouds moving across a sky also dotted by the tops of palm trees, one of several natural landscape shots that Cornell inserts throughout the film amidst the footage drawn from *East of Borneo*. What these added landscape shots share is a focus on the aerial view—usually palm trees framed to emphasize their great height but also images of the sun obscured by clouds. The combined effect of these shots solidifies an impression of *Rose Hobart* forever straining skyward. So in the film's final shot, when Hobart finally looks down, without any attempt to dismiss or minimize her attention, there is a sense of relief, discovery, recognition. Her expression may seem sad and her posture forcibly restrained, but alongside the refreshing candidness of this shot that I mentioned earlier there is also an earnestness about looking down that is new to the film; indeed, since Hobart's eyes wind up closed in this final shot, her earnest look downward is coupled with a searching look inward. It is as if Hobart finally looked down and recognized herself in that crowd gazing upward in the film's opening shot (and they in her) so that the distance between what lies above and below collapses at long last. An enlarged, surrealist

collaboration among the star, spectator, and filmmaker opens up as these two gazes meet through Cornell's mediation—spectator becomes star becomes filmmaker becomes spectator in an ecstatic blurring between objects and agents of fantasy.

A prominent detail in the final shot of *Rose Hobart* reinforces an ecstatic, rather than disastrous, interpretation of the eclipse in which Hobart participates: her head is positioned so that only one of her opulent dangling earrings is visible, and since the shape of her earring forms a graphic match with the sun, moon, and falling sphere, a surrealist visual logic suggests that the falling sphere may be her "missing" earring, as well as the sun and the moon. A striking sequence earlier in the film bolsters this interpretation. Individual shots of the prince and Hobart sipping wine from ornate glasses cuts to a close-up (one of Cornell's inserts) of a similar glass, with the circular lip of the glass surrounding a spherical object first floating and then sinking in the glass's liquid. The suspicious expressions of the prince and Hobart in these shots initially suggests the possibility that the mysterious object in the wine glass may be poison, but this isolated interpretation alters as the film continues and its visual logic of graphic matching becomes clearer. By the time *Rose Hobart* concludes, the visual similarities and repetitive movements that unite the falling sphere, sun, moon, and dangling ear- ring claim the wine glass and the sinking object within it as well; all of these objects are difficult to narrativize or even identify on their own, but together they visualize the film's fascination with the exchange between high and low, the recognition between gazes from above and beneath, the communion of star and spectator. The glass is filmed in a high-angle close-up and placed between shots of Hobart that simulate eyeline matches between her gaze and the glass, emphasizing the same tension between a perspective from above and an object below (or vice versa) that characterizes the film as a whole. When this tension is finally released in the last sequence of *Rose Hobart*, the ecstatic implications of how earthly objects (the glass, the earring) can transform into heavenly objects (the sun, the moon) or even mysterious objects caught somewhere in between (the falling sphere in the pool, the sinking sphere in the glass) are unmistakable. The fluid metamorphoses linking these graphically matched objects mirror and amplify the collaborative roles of spectator, star, and filmmaker that structure the film.

I have called the particular visual logic of graphic matching at

work in *Rose Hobart* surrealist in order to underline its kinship with and distance from a film that almost certainly inspired it: *Un chien andalou*.[12] The echoes of *Un chien andalou*'s moon sliced by a cloud as a graphic match for an eye sliced by a razor reverberate in *Rose Hobart*'s solar eclipse and the chain of visually associated images linked by Hobart's gaze and Cornell's editing. I described in chapter 2 the graphic matching of *Un chien andalou* in terms of gaming, as a component of the film's desire to solicit active participation from its audience. But *Un chien andalou*'s relation to its audience, as I explained then, is ambivalent and volatile; its desire for spectator participation is laced with fear, rage, and even contempt. *Rose Hobart*, in contrast, approaches its spectator with gentle, respectful invitations to collaborate.

Compare *Un chien andalou*'s opening assault on the eye with *Rose Hobart*'s opening image of spectators looking skyward, their eyes shielded. *Un chien andalou* never relinquishes the aura of violence around its relation to the spectator—whether rooted in aggression or defensiveness (recall Buñuel clenching stones behind the screen to hurl at what he fears will be a hostile audience during the film's debut, as well as his later description of the appreciative audience as "imbecilic"), this film never lets us forget that it is willing to slash our eyeballs to make us see the way it wants us to. *Rose Hobart* is equally but oppositely committed to nurturing the spectator's vision, to engineering a gradual integration of the spectator's gaze with that of the star and the filmmaker that relies on slow repetition rather than shocking suddenness. *Un chien andalou* begins by pretending to soothe its viewers ("once upon a time") only to inflict an attack on their vision; the film ends with a savage perversion of "happily ever after." *Rose Hobart*'s happy ending is neither formulaic nor naive but earned painstakingly through subtle modulations of how the spectator, star, and filmmaker contribute to making meaning from the film. Cornell concludes *Rose Hobart* not by annihilating or belittling the audience's desire to "see the stars" but by honoring it and bringing it to fruition. Both films offer startling, even revolutionary, ways for their spectators to participate in the experience of watching them, but *Rose Hobart* allows the spectator inside that experience with a trust and an intimacy that *Un chien andalou* never dares to explore. So perhaps Dalí's jealous rage, his refusal to collaborate as a spectator of *Rose Hobart*, should ultimately alert us to that film's success as surrealism rather than its failure.

THE GIFT OF COLLABORATION

One way that *Rose Hobart* invites an intimate form of collaboration from the spectator is through its status as a gift. Dickran Tashjian has made a persuasive case for locating gift-giving at the center of Cornell's art. He documents how a remarkable number of Cornell's artworks were conceived as gifts to particular individuals, with gifting occupying a vital role in Cornell's creative process because "thinking about the recipient ... kept his project alive." For Cornell, imagining himself as a donor, his art as a gift, and his audience as a recipient meant approaching artistic creation as a matter of collaborative spectatorship—what Tashjian calls joining "donor and recipient together in mutual desire."[13] The true complexity of Cornell's approach to gifting starts to emerge when one realizes his recipients ranged from close personal friends to long-dead stars he had never known, from individuals who could and did accept his gifts to those who would never be able to acknowledge them. Even when the recipients of his gifts were good friends or creative partners, the ritual of gifting was always central to the way Cornell conceived of and practiced his art. In fact, *Rose Hobart* is an exception to the rule that governs most of Cornell's films: not only do they invite collaboration with the spectator, but they are executed as creative collaborations with other artists (most notably Stan Brakhage, Rudy Burckhardt, and Larry Jordan) that Cornell arranges as a kind of gift-giving process. In this exchange Cornell makes a gift of his ideas and visions, then trusts his collaborator to film and edit them in a way that is true to the spirit of the gift.[14] At the same time, it was not uncommon for Cornell to present gifts of his artwork or artifacts from his personal collection to people with whom he was not directly acquainted but who had earned his admiration in some way.[15]

So *Rose Hobart* was probably imagined as a gift to Hobart herself (although not likely intended to ever actually be given to her),[16] just as Cornell would later construct artwork inspired by stars such as Lauren Bacall, Deanna Durbin, Jeanne Eagels, Greta Garbo, Jennifer Jones, Hedy Lamarr, and Jackie Lane.[17] But to reduce the film to mere homage is to ignore the other recipients of the gift that is *Rose Hobart*: the spectator and the filmmaker. When one of Hobart's earrings "disappears" in the film's final shot, it "reappears" as a gift from Hobart to the spectator. The missing earring, in the shape of the falling sphere, comes "down to earth" along with Hobart's gaze to meet the yearning crowd below. Of course,

this gift exchanged between star and spectator, established by cinematic connections uniting the film's first and last shots, only comes into being through Cornell's editing. His orchestration of the visual relationships in the film permits him to inhabit the looks of both star and spectator, to cast himself in both roles, as well as to play matchmaker between them.

But the film, as brilliantly and meticulously assembled as it is, does not feel like the work of a mastermind smoothly manipulating the audience at each turn to follow the path he demands. As Sitney notes, "The editing of *Rose Hobart* creates a double impression: it presents the aspect of a randomly broken, oddly scrambled, and hastily repaired feature film that no longer makes sense; yet at the same time, each of its curiously reset fractures astonishes us with new meaning." I agree with Sitney's assertion that "only a collector of films could have made this kind of montage," an editing style that seems to highlight rather than conceal those "accidents" that happen when "one owns a print of a film and shows it repeatedly": "passages are damaged and strange ellipses occur in their repair."[18] So Cornell presents himself not so much as a filmmaker achieving perfection as a film collector wrestling with imperfection—another way Cornell fashions the film as a gift coming not from above (the artist superior to both star and spectator) but from below or beside (the artist indistinguishable from the starry-eyed spectator). Selecting *East of Borneo* as *Rose Hobart*'s source material (rather than other films featuring Hobart) emphasizes Cornell's modesty, his proximity to the spectator instead of the director; as Annette Michelson observes, the fact that *East of Borneo* already contains a significant amount of stock footage (mostly of wild animals) makes Cornell's film an act of "generational montage"; Cornell becomes just one more compiler in a cycle of compilation already set in motion by *East of Borneo* itself.[19]

By foregrounding Cornell's role as film collector rather than film director in this way, *Rose Hobart* finds yet another means to become a gift that transcends distinctions between donor and recipient, creator and spectator, star and editor. When the film ends with the sphere splashing down into the pool, it is not just the falling motion that animates the frame; it is also the ripples in the water that radiate from the point of impact. As these ripples transform the water's surface (an instant, we should recall, that Cornell deems important enough to present in slow motion on two separate occasions), an ecstatic visualization of the film's desire

to merge filmmaker, star, and spectator materializes. In the convulsing movement of the water we temporarily lose sight of surface and depth, action and reaction. As the light from above glimmers majestically in the rippling water below, it is impossible to say just where the great beauty in this image originates. From above? From below? From the force that has brought them together? In each case a gift has been received from elsewhere and given in turn.

Cornell's gifts, like much of his work, were subject to revision by the artist over time. In the case of *Rose Hobart* Cornell returned to the film more than three decades later and experimented with altering the color of its tinting.[20] He also considered changing the film's title to *Tristes tropiques* after coming across Susan Sontag's 1965 book review of Maurice Nadeau's newly translated *A History of Surrealism* (1944). *Tristes tropiques* was a title Cornell associated with Sontag (rather than Claude Lévi-Strauss) because he encountered it while reading her criticism.[21] Sontag's review of Nadeau moved the artist in powerful ways; it "rekindled Cornell's memories of André Breton," whom he had met in New York in 1941, and inspired him to create new collages featuring Breton. He gave one of these to Sontag as a gift.[22]

This afterlife of *Rose Hobart*, with its connections to Sontag, Breton, and Nadeau, testifies to how Cornell's approaches to gifting and surrealism are inextricable. Cornell's sense of collaboration between the artist-donor and spectator-recipient, mediated by unlikely associations that bridge time and space, manages to honor the disorienting "spark" of surrealism while dismantling the divide that often separates surrealist artists from their audience. By incorporating Sontag, Breton, and Nadeau within a creative process that equates art and gift, Cornell enlarges *Rose Hobart* by expanding his circle of collaborators. In her review of *A History of Surrealism* that registered so deeply with Cornell, Sontag argues that surrealism should be valued above all "in its complexities and contradictions," as it "continues both to abolish itself and to generate new and flexible modes of consciousness that are alive and questioning, not merely resentful or exhibitionistic."[23] With *Rose Hobart* Cornell enacts this evolving version of surrealism through the gift of collaboration. It's as if that crowd in the opening shot of his film was imagined as a site of infinite possibility, always ready to welcome new members searching for a new experience of vision.

Cornell's reliance on the friendly gestures of gifting for his mode of collaborative spectatorship does not mean that *Rose Hobart* lacks a critical edge. The film's commitment to androgynous, gender-bending imagery and themes, a hallmark of Cornell's work, proffers a sharp critique of common surrealist stances toward female and queer sexuality. Cornell was a lifelong bachelor who lived most of his adult life under the same roof as his mother and invalid brother in Queens, New York; his romantic involvements with women were often awkward at best and tragic at worst.[24] Yet in his art he was powerfully inspired by the work of a number of female artists associated with surrealism, including Léonor Fini, Lee Miller, and Dorothea Tanning. He never met Fini, but he collaborated with Miller (most notably on a strikingly androgynous photographic self-portrait shot by Miller) and maintained a rich, mutually supportive correspondence with Tanning.[25] Cornell's high regard for the art created by these women was rather unusual, since they existed on the outskirts of surrealism despite how closely intertwined their lives often were with those of their much more famous male counterparts (Tanning, for example, was married to Max Ernst). As Rudolf Kuenzli summarizes in blunt but compelling fashion, "The surrealist movement . . . was a men's club. The surrealists lived in their own masculine world, with their eyes closed, the better to construct their male phantasms of the feminine. They did not see woman as a subject, but as a projection, an object of their own dreams of femininity."[26] Some critics have seen *Rose Hobart* as participating in just this sort of standard surrealist misogyny. For example, Jodi Hauptman claims that Cornell converts Hobart into "the hysterical body of the woman" familiar from other surrealist artists' objectifications of women as hysterics. According to Hauptman, when Cornell strips narrative and sound from *East of Borneo*, he "forces Hobart's body to act as a voice. . . . Such a collapse of distance between feelings and expression, body and mind, is another indicator of hysteria."[27]

What gets lost in Hauptman's account is what I described earlier as the stunning power of Hobart's gaze in Cornell's film, how it organizes the film's editing to an extraordinary degree. *Rose Hobart* is not so much a record of Cornell's objectification of the star's image as his communion with it. Her looks and his edits fuse as the film unfolds, as do their bodies. The very first glimpse of Hobart in Cornell's film shows her clothed in a

shapeless bathrobe, her body hidden beneath it as the prince escorts her away. The next view of her heightens the gender ambiguity of this initial image: she wears a man's safari gear, complete with jacket, pants, boots, and tie (fig. 5.4). The film goes on to provide shifting images of Hobart in a number of different outfits, ranging from the masculine safari suit to the feminine evening dress. Cornell cuts back and forth between these outfits, making Hobart chameleonlike as she slips in and out of clothing as easily and mysteriously as she alters her gender. In one moment she wakes from sleep and pulls aside the bedcovers to reveal that she is wearing the masculine safari suit. At another moment she sheds her sexless bathrobe to reveal the dress she is wearing underneath it. As Deborah Solomon points out, even Rose Hobart's name "connotes sexual uncertainty": beyond the conjuncture of the feminine first name and masculine last name, there is the echo of Rrose Sélavy, Marcel Duchamp's female alter ego who appeared in photographs played by a cross-dressed Duchamp in the early 1920s. Cornell had met Duchamp at the Levy Gallery in 1933 and greatly admired his work, so Solomon argues that it is "not farfetched to see Cornell's *Rose Hobart* as a valentine to Duchamp."[28]

But what sort of valentine? Dickran Tashjian has explained how the surrealist fascination with gender bending, captured memorably in André

Figure 5.4 *Rose Hobart*: A masculine image of Rose Hobart.

Breton's quip, "I wish I could change my sex as often as I change my shirt," also had clear limitations. Breton "openly opposed homosexuality" and "once threatened to walk out of a meeting called to discuss sex when the inquiry broached the topic."[29] Although Duchamp was never an official member of the Surrealist Group, his connections to surrealism were substantial enough for Tashjian to consider his Rrose Sélavy photographs (taken by Man Ray) under the umbrella of surrealist-related "transgender coupling."[30] For Tashjian, "Duchamp's continued association with Rrose in a series of exchanges decisively transformed her portrait into his self-portrait." So Rrose Sélavy was never really about anyone but Duchamp; I do not think the same can be said for *Rose Hobart* and Cornell. If anything, Cornell's film reverses the spirit of Duchamp's use of Rrose. Duchamp's Rrose exists as an inside joke that, once made public (a transition Duchamp completed by 1925), generates the effect Tashjian describes: "We can no longer see Rrose . . . without seeing Duchamp. Knowledge has become vision."[31] Cornell's Rose is less a product of artist-centered display than spectator-oriented collaboration, a process that serves to recharge the mysterious eroticism surrounding relations between the star, artist, and audience rather than demystifying or ridiculing them as Duchamp does. "Rrose Sélavy" obviously plays on "eros, c'est la vie"; nothing could be further from the erotics of looking that convulses *Rose Hobart*.

The erotics of *Rose Hobart* become clearer by turning to another film-related work by Cornell. In *Enchanted Wanderer: Excerpt from a Journey Album for Hedy Lamarr* (1941), Cornell writes of how watching Lamarr perform in contemporary films transports him back to a magical, bygone era of silent cinema (fig. 5.5).[32] Lamarr harnesses "the profound and suggestive power of the silent film to evoke an ideal world of beauty, to release unsuspected floods of music from the gaze of a human countenance in its prison of silver light." The particular kind of beauty Cornell discovers in Lamarr is androgynous: "She has carried a masculine name in one picture, worn masculine garb in another, and with her hair worn shoulder length and gentle features like those portraits of Renaissance youths she has slipped effortlessly into the role of a painter herself . . . *le chasseur d'images*."[33]

In this passage, taken from the final, impressionistic section of *Enchanted Wanderer*, Cornell employs a literary style reminiscent of surrealist automatic writing to evoke the "unsuspected floods of music" that Lamarr's visage stirs in him. The passage provides an illuminating

View Page 3

"ENCHANTED WANDERER"

★ Excerpt from a Journey Album for Hedy Lamarr ★

By
JOSEPH CORNELL

Figure 5.5 Joseph Cornell, *Enchanted Wanderer: Excerpt from a Journey Album for Hedy Lamarr* (1941). Photomontage with text reproduced in *View* (Dec. 1941–Jan. 1942). Joseph Cornell Study Center, Smithsonian American Art Museum, Gift of Mr. and Mrs. John A. Benton.

summary, in Cornell's own words, of the aesthetics and erotics that mark *Rose Hobart* as much as *Enchanted Wanderer*. Hobart and Lamarr metamorphose not only from feminine to masculine but from object to subject, other to self. First through a name, then through clothing, then through the body, and finally through performance, Hobart and Lamarr leave behind the distinctions that separate feminine from masculine and star from artist. When Hobart's gaze fuses with Cornell's edits, or when Lamarr's screen role as a painter (a "hunter of images") fuses with Cornell's artistic role as a collagist, the ecstatic communion of star and artist also becomes an erotic one.

Cornell calls Lamarr an "enchanted wanderer," but it is in her beauty's impact on the artist-spectator that the real enchanted wandering occurs. By watching Lamarr, Cornell "wanders" in time (the present becomes the past of silent cinema), as well as through his reawakened senses. As in *Rose Hobart*, sound film becomes silent so that the accompaniment of "floods of music" divorced from the original film can be heard; Cornell even appends a note to the end of *Enchanted Wanderer* to explain that its title comes from a biography of the musician Carl Maria von Weber, composer of a "musical signature of the Enchanted Wanderer."[34] So this enchanted wandering ends up being another way to describe the collaborative spectatorship that Cornell cultivates between himself, his art, and his audience. It is fitting that the image Cornell assembles to anchor the words of *Enchanted Wanderer* is a collage of Lamarr's face with a painted portrait of one of those "Renaissance youths" Cornell mentions: like *Rose Hobart* this is an idealizing and androgynously erotic tribute to the star but also a transformation of the star by the artist that invites further collaborative "wandering" from the spectator. In Cornell's androgynous image of Lamarr she stares directly at the spectator; we look at her looking at us in a relay of gazes familiar from *Rose Hobart*. Where will her gaze take us? Where will our gaze take her?

EXIT *ROSE HOBART*, ENTER *MRS. ROCK HUDSON*

If Dalí had lived to see the age of new media, it is almost certain he would have resented Cornell even more than he already did for creating *Rose Hobart*. For digital culture's obsessive fascination with stars more often conjures a world invented by *Rose Hobart*, not *Un chien andalou* or *L'âge d'or*. The Internet is littered with websites and digital videos developed

by fans as tributes to favorite stars. No matter how indirectly or unconsciously (or elegantly or clumsily) related, these digital star tributes are the children of *Rose Hobart*. But in what ways do the children resemble or differ from their parent? To think through the legacies of Cornell's collaborative spectatorship in the digital age, I will examine closely one case (among a virtually infinite range of possibilities) of a digital star tribute: a YouTube channel called *Mrs. Rock Hudson LOVES Mr. Rock Hudson!!!* (shortened to *Mrs. Rock Hudson* hereafter).[35] I have chosen this case because I believe it speaks particularly powerfully to the issues of feminine and queer spectatorship I have highlighted in my account of Cornell's critique of surrealism.

Rock Hudson's name is much more recognizable today than Rose Hobart's, for several reasons. First, Hobart never reached the pinnacles of popularity Hudson enjoyed as a Hollywood idol in the 1950s and 1960s, when he specialized in torrid melodramas and light romantic comedies.[36] Second, Hudson's HIV infection and death from AIDS in 1985 gave him a new, perhaps even more high-profile, identity in the public eye: the closeted homosexual who made a career out of playing ultraheterosexual, "naturally" masculine roles now became the face of a "gay disease."[37] As Richard Dyer notes when surveying the public reaction to the revelation of Hudson's homosexuality, there was a common feeling that "it is surprising to think that Rock Hudson was gay, that there was a contrast between how he seemed on screen or in public appearances and how he was in private, that there was nothing gay about Rock as performer or image."[38]

Mrs. Rock Hudson, a YouTube channel established in 2008, dedicates itself to only one half of the split identity Dyer describes as surrounding Hudson after his coming out of the closet. On *Mrs. Rock Hudson* it is as if Hudson's heterosexuality never came into question. In this sense it is the flipside of Mark Rappaport's important independent film *Rock Hudson's Home Movies* (1992), which reintroduces Hudson's films in light of his homosexuality and cleverly argues that the "surprise" so many people felt about Hudson's coming out was unwarranted; the films were already larded with involuntary gay innuendo we were too oblivious to notice.[39] The creator of *Mrs. Rock Hudson*, whose screen name is MrsRockHudson, skillfully utilizes the resources of a YouTube channel to assemble her own version of the star. A YouTube channel incorporates aspects of the television channel (a space to broadcast your own digital videos as "shows"); the cable television channel (You Tube users can "subscribe" to

your channel); the social networking website (one can become a "friend" of the channel, like a Facebook "friend" or a Twitter "follower," while the channel itself can mimic some of the functions of a Facebook page: the creator's biographical information can be displayed, and an area is available for comments by friends and strangers that the public can see and join as an online conversation); the email program (one can send a message directly to the channel creator, so long as you subscribe to You-Tube or Google mail); the Internet search engine (the channel's posted videos appear as hits when a user conducts a general search of all of YouTube and includes search terms applicable to the channel); the repertory movie theater (the creator is the curator of his or her own collection of short videos, both self-made and those culled from elsewhere); the online media database (like the Internet Movie Database, the channel can provide production information about the films referenced on the channel); and the museum/archive/library/classroom (the channel can supply educational, research-based pathways through its subject matter).

Among the short video films included on *Mrs. Rock Hudson* is "Rock, Kiss Me," a two-minute compilation of kissing scenes edited together from an array of Hudson's films. "Rock, Kiss Me" shares a number of formal resemblances with *Rose Hobart*. Both films abandon the narrative contexts of the source material for their clips, add a new musical soundtrack that erases the original one, and focus on particular gestures made by the star—for Cornell it is Hobart's stares; for MrsRockHudson it is Hudson's kisses. Although "Rock, Kiss Me" does not demonstrate the same meticulous attention to visual detail and the rhythms of montage that *Rose Hobart* does, its selections and edits are not without a grasp of graphic matching or matching on action as methods to segue gracefully between the clips. But does "Rock, Kiss Me" invite the spectator to collaborate with the artist and star as *Rose Hobart* does?

Yes and no. "Rock, Kiss Me" lacks the footage so crucial to Cornell's film that originates from non-Hobart sources, and its presentation foregrounds MrsRockHudson herself in a way Cornell's film does not. Most notably, MrsRockHudson includes a short written introduction under the information tab attached to the video: "Mr. LUSCIOUS LIPS Rock Hudson puts those perfectly shaped, full, soft, kissable lips to w-o-r-k in this super cute-marvelous medley. 'Mrs. Rock Hudson' would like to receive all of these HOT smooches!!! Caution, I repeat, ooooooh these smooches are HOT!!! :-) :-) Forever my valentine Mr. Rock Hudson!!!

:-):-)." Cornell's ardor for Hobart can certainly be felt in his film, but it is never spelled out along these lines. As a result Cornell leaves more room for the spectator and MrsRockHudson less.

However, the comments of viewers who have posted reactions to "Rock, Kiss Me" suggest that even if MrsRockHudson is front and center with her own interpretation of the video and the heterosexual desires behind it, the "other" Rock Hudson is never far away. One viewer writes, "man EVERY time i see this guy in movies especially with these beautiful women i just cant help but feel sad that he was gay, on the outside he was such a man and could have made some woman very happy. what a cryin shame." Another adds, "yeAah! kiss rock, but in the straight way." The homophobic overtones in these comments become much more blatant and vicious in the comments of several other viewers posted elsewhere on the channel—a reminder of just how deep homophobia runs even today. But what I wish to focus on here is how there is more room for the spectator to make his or her own meaning on *Mrs. Rock Hudson* than it might appear initially.

A closer look at "Rock, Kiss Me" and its context within the channel as a whole indicates that the room for collaborative spectatorship may come in unexpected forms. "Rock, Kiss Me" begins with the sole clip left with its original soundtrack intact. In a scene from *The Tarnished Angels* (Douglas Sirk, 1958), Hudson looks longingly at a woman played by Dorothy Malone and tells her, "A few more drinks and I'd tell you how much I'm going to miss you." In an equally smoldering tone, she responds, "Tell me. Please tell me. I've forgotten how it feels to be missed." He then reaches for her, embraces her, and kisses her. The fact that this clip is the only one in "Rock, Kiss Me" with dialogue encourages spectators to meditate on its possible connotations. Since Hudson chooses to "tell" Malone of his desire for her with a passionate kiss rather than explanatory words, a crucial emphasis is placed on Hudson's physical gestures in the clips that follow. It's as if his kisses must tell us the truth of what he cannot say in words. His admission that he has been drinking strengthens this notion that there is something within Hudson that torments him, that he burns to express but cannot. In *Rock Hudson's Home Movies* it is his homosexuality, his true "private" self forced to hide in the margins of his "public" film performances. In "Rock, Kiss Me" it is his heterosexuality, his desire for women who he imagines cannot or will not return his love—another variation on the "love that dare not speak its name" theme that preoccu-

pied so many of the films he starred in (both melodramas and comedies) before it overtook the story of his identity as a closeted gay man acting as a heterosexual leading man. MrsRockHudson uses "Rock, Kiss Me" to cast herself as one (or all) of these women who know the "true" Hudson and can release him from his inner torment into outward expressions of love. Her Rock Hudson is her "valentine," the star who burns for her.

The reference to drinking in "Rock, Kiss Me," specifically in its associations with pent-up desire, gets amplified in one of the most popular videos on *Mrs. Rock Hudson*. "A Very Drunk Rock Hudson" is a seven-minute excerpt from *Seconds* (John Frankenheimer, 1966) where Hudson's behavior at a party becomes increasingly embarrassing and unhinged as he slips ever deeper into a drunken stupor. *Seconds* is one of Hudson's strangest and most atypical films, a grim, claustrophobic psychological thriller laced with horror and science fiction elements that bombed at the box office after being savaged by most critics when it premiered at the Cannes Film Festival.[40] Based on a 1963 novel by David Ely and adapted by Lewis John Carlino, *Seconds* tells the story of Arthur Hamilton, a successful middle-aged banker whose life has settled into a monotonous routine of dull work and passionless marriage. Hamilton is contacted by a mysterious underground company that offers him the chance to exchange his drab life for a reborn existence (via a staged death and radical plastic surgery) as a young, handsome, single man. When Hamilton, played by John Randolph, agrees to pay for this opportunity to live as a "second," he reemerges as a new man named Antiochus "Tony" Wilson, played by Hudson. Unfortunately, the conflict between the inner Arthur Hamilton and the outer Tony Wilson dooms this new life to miserable failure. When Wilson returns to the company to request yet another life, the company sends him back to the surgery ward—but this time to murder him and use his corpse as the alibi for another client's rebirth as a second.

"A Very Drunk Rock Hudson" had amassed nearly thirty-two thousand views as of 2011, making it second only to "Sexy Rock Hudson Taking a Shower!!!" (with almost thirty-three thousand views) as the most popular video on *Mrs. Rock Hudson*. As a point of comparison, "Rock, Kiss Me" had accumulated roughly nine thousand views. "A Very Drunk Rock Hudson" comes from the juncture in *Seconds* when the Hamilton-Wilson meld begins coming apart and sliding toward doom. It does include a kiss between Hudson and Salome Jens (playing a woman planted by

the company to nurture him), but for the most part it is true to the tone of *Seconds* as a whole: uncomfortable and anguished. Why would this sequence, and this film, garner so much attention from spectators on *Mrs. Rock Hudson*? The viewer comments attached to "A Very Drunk Rock Hudson" begin to provide some answers. One thread in the comments is a debate about whether Hudson is actually drunk in this scene or if he is only acting. MrsRockHudson herself admits that when she first watched the clip she mistook it for footage produced by "just a camera following him in his home" and only later discovered that *Seconds* was the source. But she goes on to defend the documentary nature of the images (and her choice of title for the video) by guiding viewers to John Frankenheimer's director's commentary on the *Seconds* DVD. There, Frankenheimer relates how Hudson consumed alcohol before shooting this scene in order to heighten the realism of his performance, an idea hatched by Frankenheimer but "endorsed" by Hudson.[41] MrsRockHudson glosses this anecdote by asserting that Hudson "wanted to do a great job for the movie; he wanted to branch out from the romantic comedies the typecasting studio had him doing." Her observation (which is supported by the scholarship on *Seconds*)[42] leads to another thread in the viewer comments: why *Seconds* is a special film in Hudson's career. One viewer writes, "I think this is rocks best performance brilliant but sadly overlooked." Another adds, "This movie deserved an Academy Award for Rock Hudson." Yet another writes, "This was a very meaningful role for Hudson, and his performance throughout is excellent."

So at least part of the popularity of "A Very Drunk Rock Hudson" and *Seconds* on *Mrs. Rock Hudson* circles back to Dyer's sense of Hudson's post-1985 split identity in the public eye: he appears to be one person on the outside and another on the inside. This conflict between Hudson's split selves is uncannily anticipated by the story line of *Seconds*, so in retrospect the film becomes a sort of veiled confession from Hudson to his audience. "This is who I really am," he seems to whisper to the spectator through his tortured portrayal of a man who quite literally cannot live in his own skin.[43] Hudson's turning to drink to drown the pain of his impossibly split identity, of desires that cannot be articulated, only underlines the poignancy of his situation. The centrality of alcohol to the opening of "Rock, Kiss Me" and the entirety of "A Very Drunk Rock Hudson" serves to "prove" the fantasy that the public Hudson onscreen can grant us access to the private Hudson offscreen: the "real" Hudson

can be glimpsed when his guard is lowered (actually or fictionally) by alcohol, his "true" self momentarily laid bare.

Dyer argues that the media blitz surrounding Hudson after the exposure of his HIV infection and subsequent death from AIDS was not simply a matter of finally lending AIDS victims a "human" face and signaling a turning point in public sympathy for those who suffer from the disease. The media coverage also included a pronounced dark side, which Dyer refers to as a fixation on "the Dorian Gray syndrome"—"a way of constructing queer identity as a devotion to an exquisite surface (queens are so good-looking, so fastidious, so stylish, so amusing) masking a depraved reality (unnatural, promiscuous and repulsive sex acts)." Such media coverage may have "boosted fund-raising [and] made people realize that 'nice people' get AIDS, [but] it was also used to reinforce venerable myths about queers."[44] Reading Hudson as a Dorian Gray figure allows homophobic viewers, threatened by the revelation of such a shocking disparity between Hudson's onscreen image and his offscreen life, to exercise a punishing mastery over a star who has "betrayed" them. Viewers angered and made vulnerable by "buying" Hudson's star persona not as mere public performance but as a reflection of his private self now have the opportunity to reassert their dominance over him, to regain control over how distinctions between a star's public surface and private interior are made legible and used.[45] Through the lens of the Dorian Gray syndrome, homophobic viewers can express their own fantasies about knowing the "real" Hudson—fantasies with shared roots but opposite sentiments from those who admire *Seconds* on *Mrs. Rock Hudson*. For example, consider this viewer comment posted to the discussion of "A Very Drunk Rock Hudson": "If he wanted to break out from being typecast, why didn't he play the part of a sexual pervert who really liked men instead of women?" In an even less subtle mode, another viewer participating in this conversation addresses Hudson directly: "Roast in hell AIDS ridden faggot."

Years before YouTube, *Rock Hudson's Home Movies* set out to question precisely this sort of homophobic reliance on the Dorian Gray syndrome to read Hudson's star image. In Rappaport's film the clips compiled from Hudson's onscreen career share time with a narrator posing as Hudson himself (played by actor Eric Farr) and speaking from beyond the grave about the films that made him famous. Rappaport's Hudson is open, candid, and humorous about the disjunctures between his public

and private selves. In fact, he claims that his "secret" was never really hidden at all, that "it was all up there" on the screen for those who could allow themselves to see it. *Rock Hudson's Home Movies*, in other words, leads viewers through a reading of Hudson's films animated not by the punishing impulses of the Dorian Gray syndrome but by the strategic tactics of camp.

Space does not permit a detailed exploration of just how complex and ambitious the critical discourse surrounding camp has become since Susan Sontag's pioneering 1964 essay "Notes on 'Camp.'" Sontag's essay was collected in her landmark volume of cultural criticism *Against Interpretation*, the very same book that Cornell consulted when he considered changing the title of *Rose Hobart* to *Tristes tropiques*.[46] Sontag's definition of camp as "*one* way of seeing the world as an aesthetic phenomenon ... not in terms of beauty, but in terms of the degree of artifice, of stylization" has more or less persisted, while her assertion that "the Camp sensibility is disengaged, depoliticized—or at least apolitical" has been vigorously refuted, especially in relation to camp's use by the queer community.[47] For example, when Richard Dyer claims in *Heavenly Bodies* that a camp reading of stars allows one to enjoy stars "not for any supposed inner essence revealed but for the way they jump through the hoops of social convention," he suggests that camp readings avoid or resist the trap that so many star readings (including those of Hudson's admirers and haters on *Mrs. Rock Hudson*) fall into: the desire to know the true, inner, private self beneath the false, outer, public self. This desire seeks to confirm conventional notions of the private self as personhood's genuine source and thus certify the private as the authentic repository of identity. Camp, on the other hand, celebrates the public surface of the star on its own terms and consequently opens the possibility of regarding the private self as an illusory attempt to minimize or erase the social from formulations of personhood. As Dyer so eloquently puts it, seeing stars by way of camp means "seeing them as appearance, as image, in no way asking them to be what they are, really."[48]

In this sense a camp reading of Hudson's post-1985 star image, such as that provided by *Rock Hudson's Home Movies*, contests the reading of Hudson presented by the Dorian Gray syndrome. But are these two readings really as diametrically opposed as they may first appear? Although one is punishing and the other playful, both ultimately depend on exercising certain forms of mastery over Hudson's image. Both read-

ings force Hudson's image to speak a particular truth, to surrender the image's capacity for ambiguity and for collaboration with the spectator in favor of a knowing monologue delivered by the all-powerful spectator to the unmasked, powerless image. Granted, *Rock Hudson's Home Movies* complicates the sense of mastery by presenting an unlikely stand-in Hudson who is not only undead but who never comes close to approximating Hudson's physical likeness in the projections behind him, despite attempts to replicate his clothing and hairstyle. Still, the presence of this narrator discourages viewers from doing precisely what Rappaport says was the initial inspiration behind the film: talking back to the screen.[49] There's no need for any such talking back on the part of spectators because the narrator, Hudson "himself," is doing it for them.

Watching *Seconds* retrospectively is a particularly disturbing experience because the film so thoroughly undermines viewer attempts to master Hudson's image. *Seconds* insists on foregrounding the power of Hudson's image that both Dorian Gray readings and camp readings, despite their very different motivations, act to domesticate or deny. The power of the images in *Seconds* derives not only from the bravura experimental cinematography of James Wong Howe, and the relentlessly suffocating atmosphere crafted by Frankenheimer, but from the interaction between Hudson's star text and the narrative itself. The film's story of a man whose body, however beautiful, imprisons and terrifies him achieves unnerving parallels with Hudson's own predicament as an actor—a typecast "beefcake" valued primarily for his body, as well as a closeted gay man obliged to perform the masculine ideal of "natural" heterosexuality until AIDS makes even this kind of performance impossible. These parallels are too intimate, too poignant, and too tragic for the knowing appropriations of either Dorian Gray or camp readings to master—hence the unlikely fascination with *Seconds* on *Mrs. Rock Hudson*, the sense that this film offers us something extraordinarily meaningful about the "real" Hudson. But when *Mrs. Rock Hudson* sends viewers back to *Seconds*, what lies in wait for them is a film that exceeds the sort of experience promised on the YouTube channel. Yes, *Seconds* retrospectively fulfills the fantasy that we can know the "real" Hudson, but it does so in such a dark, painful way that the knowledge we thought we craved turns out to taste poisonous.

Witness, for example, the shattering conclusion of *Seconds*, when Hudson's character learns that he is being wheeled to the operating

room not to begin a new life but to be killed. The excruciating anguish conveyed by Hudson in this scene is almost too vivid to watch. He erupts in desperate fear and anger before collapsing into catatonic resignation as he realizes he is trapped, not just on the gurney to which he is tied but within a body that he has never had the chance to inhabit as his own. Hudson's series of twisting, tortured spasms against the gurney's restraints and the gag choking his screams, chillingly complemented by Frankenheimer's claustrophobic jump cuts and wide-angle close-ups, transforms the smooth, attractive physicality that made Hudson a star into its nightmare double: the body as prison (fig. 5.6). This scene, when viewed retrospectively, inevitably evokes the unmaking of Hudson's star body associated with his death from AIDS. Yet the undeniable physical strength of Hudson raging against the straps that bind him, the sheer vitality of his struggle, contradicts the Dorian Gray narrative that charts Hudson's degeneration from robust star to wasted homosexual.[50]

It is also telling to watch how hard a sequence toward the end of *Rock Hudson's Home Movies* must work to place a palatable camp spin on the conclusion of *Seconds*, even while Rappaport stages a valiant deconstruction of the Dorian Gray syndrome. *Rock Hudson's Home Movies* uses the ending of *Seconds* to convey Hudson's strength and pain in a manner that challenges the simplistic Dorian Gray dichotomies, but at the same time, Rappaport must tamp down the disturbing power of *Seconds*. He

Figure 5.6 *Seconds* (John Frankenheimer, 1966): Tony Wilson (Rock Hudson) struggles in the prison of his body.

weakens the film's impact by interrupting it, interspersing dialogue, music, and images from other sources that encourage us to imagine death as a redemptive journey "from darkness to light" (as Hudson's own voice, lifted from another film, reassures us; soon the inspirational strains of "The Battle Hymn of the Republic" can be heard). This journey ends with Hudson living on as a cinematic legend, forever young, rather than dying as he does onscreen in *Seconds*, beneath the blinding surgical lamps of the operating table, or as he did in his final days offscreen, surrounded by the harsh flashbulbs of the mass media eager to document his demise from AIDS.

If Cornell designed *Rose Hobart* to strengthen the strangeness of *East of Borneo*, to enhance its latent possibilities for collaborative spectatorship, then both *Mrs. Rock Hudson* and *Rock Hudson's Home Movies* expend significant energy in the opposite direction when it comes to *Seconds*. The potential for collaborative spectatorship offered by *Seconds*, especially in relation to a retrospective critique of fantasy constructions of the "real" Rock Hudson (whether homophobic or not), proves too potent for either MrsRockHudson or Rappaport to control fully. In this sense it is *Seconds* itself (rather than Rappaport's film or MrsRockHudson's YouTube channel) that comes closest to mirroring *Rose Hobart*'s stance against surrealism's homophobic and misogynist impulses, but only in the retrospective dimension of spectatorship enabled partially by Rappaport and more comprehensively by MrsRockHudson. In other words, *Rose Hobart* depends on *East of Borneo* for the raw material that initiates its process of collaborative spectatorship, but *Mrs. Rock Hudson* and *Rock Hudson's Home Movies* cannot afford to depend on *Seconds* in the same way; *Seconds* exceeds them. Still, the ability of *Seconds* to exceed the spectatorship frameworks offered by these post-1985 platforms is intimately linked to the accessibility of the platforms themselves; without them the haunting afterlife of *Seconds* and its implications for collaborative spectatorship would remain largely undiscovered by viewers. *Rose Hobart* does not *need* viewers to return to *East of Borneo* to "get" Cornell's film, nor does Cornell encourage them to do so. Similarly, *Rock Hudson's Home Movies* provides no systematic key to the films it raids for clips, nor does it emphasize an attitude that viewers *should* return to these movies; Rappaport's film, complete with its own "Rock Hudson" speaking over the clips in first-person, conveys the idea that *this* is the last word on these

movies. *Mrs. Rock Hudson*, by contrast, persistently opens avenues for guiding viewers *back* to the films it features, not least by fostering online discussions where (as we have seen) the titles and production histories of the films are routinely raised. In short, *Rose Hobart* and *Rock Hudson's Home Movies* may offer spectatorship possibilities that anticipate the age of new media, but *Mrs. Rock Hudson*'s inhabitation of the digital era gives it a different relation to the source films on which it draws; it has a more pronounced capability to send spectators back to these films, to move the collaboration between audience and film beyond the confines of just one media platform.

In this context it seems important to mention that "A Very Drunk Rock Hudson" is not the only excerpt from *Seconds* that appears on *Mrs. Rock Hudson*. The other is a very short video (less than one minute long) entitled "Director John Frankenheimer Comments on Rock Hudson's Beauty." It consists of a brief but pivotal sequence copied from the DVD of *Seconds*, along with Frankenheimer's audio commentary. The sequence is the "reveal," the moment Arthur Hamilton (and the audience) sees his "second" face for the first time: the face, of course, belongs to Hudson. As Frankenheimer points out, this image of Hudson was deliberately "beat up" through strategic lighting and makeup design, so that the white hair of his "old" life and the scars of the surgery stand out. This was no easy task, according to the director: "To have Rock Hudson look badly at that time in his life was one of the great achievements in cinema, let me tell you. Because no one was better-looking than Rock Hudson." MrsRockHudson amplifies Frankenheimer's words in her own viewer comment posting: "Even with the dyed hair and scars, his BEAUTY shines through OOOOOH LA LA his beautifully shaped lips, gorgeous adorable eyes, I could go on and on Rock should have absolutely gotten an Oscar for this role. (((Look at the 1 tear come down his face as he wipes it!!! Just a small example of his GREAT acting throughout this ENTIRE movie!!!!)))."

As attentive as MrsRockHudson is to the details of this sequence, she misses several telling ones. First, Hudson's face is revealed initially as a fractured reflection in three adjoining mirrors—a shot whose importance Frankenheimer indicates by mentioning how difficult it was to compose (fig. 5.7). The connotations are clear: the "real" Hudson is not a matter of a single self but multiple, split selves. Second, Hudson's tear may not be what MrsRockHudson interprets it to be; she writes that what we see is

Hudson feeling "shocked by his own beauty." Instead, it could be a mournful recognition of all that has been lost in a life erased, perhaps even a kind of disgust for how inappropriate his new appearance is when it comes to communicating how desolate he feels. In an extended close-up Hudson first seems surprised by his reflection, then eager to draw closer to it, then somewhat repulsed as he bows his head and closes his eyes. The vivid series of expressions to which Hudson gives life during this close-up highlights how this sequence is not only about beauty but also its price, not only about the "real" Rock Hudson but also the complicated set of performed personae that combine to construct the star image of "Rock Hudson." If viewers return to the *Seconds* DVD themselves—an action implicit in the first viewer comment posted to this video, which asks, "What movie is that from?"—they will find that this sequence includes a reaction to the "reveal" that deepens the ambivalence surrounding it. The first voice we hear once Hudson's bandages are removed is that of the Old Man (Will Geer), the shadowy yet paternal chief executive of the corporation that creates "seconds." Before we can see Hudson's face for ourselves, the Old Man surveys his appearance and congratulates the surgeon on his handiwork, calling it "a masterpiece."

This jarring observation, with its unmistakable position on beauty as a constructed object rather than a natural quality (something detachable from Hudson's person, not inherent to it), underlines how difficult it is to reconcile MrsRockHudson's take on Hudson's beauty with that of

Figure 5.7 *Seconds*: The new self as split selves.

Seconds. But it is precisely this valuable difficulty, one that structures the collaboration between the spectator and *Seconds* around Hudson's star image, that is in many ways made possible for viewers in the digital age by platforms such as *Mrs. Rock Hudson*. MrsRockHudson may not have intended to provide spectators with the tools to challenge homophobic reactions to Hudson's star image, but just as surely as Cornell's invitation to collaborative spectatorship interrogates surrealist homophobia and misogyny, so, too, does *Mrs. Rock Hudson* contain the seeds of critique. In this way the digital afterlife for *Seconds* may prove even more unexpected than the strange, cultish existence the film has led since 1966—an existence Frankenheimer summarizes as being "the only film I know that went from failure to classic—without ever being a success."[51]

What *Rose Hobart* and *Mrs. Rock Hudson* share, aside from the potential to critique homophobic or misogynist blind spots in the cultures of surrealism or stardom on which they border, are invitations to collaborative spectatorship that André Breton (if he were capable of overcoming his own homophobia and misogyny) might have filed under one of his favorite concepts: crossing the bridge. For Breton this idea captured something essential about surrealism's ability to travel between the land of day (rationality, the everyday, politics) and the land of night (irrationality, the marvelous, dreams). He saw this "journey" undertaken in an extraordinary way in the early paintings of Giorgio de Chirico, so he applied this phrase to him: "When he reached the other side of the bridge the ghosts came to meet him."[52] Crossing such a bridge also speaks to the nature of collaborative spectatorship, as embodied by *Rose Hobart* and *Mrs. Rock Hudson*: an opportunity for the media producer, the media consumer, and the media text to reach out across the spaces that divide them, to enlarge their relations to each other in ways that bring the ghosts of fantasy to light. Whether this opportunity is capitalized on or not is a more uncertain, elusive matter. There will always be those spectators (along with those artists and artworks) who, like Dalí at the premiere of *Rose Hobart* or the "haters" that post vicious comments to *Mrs. Rock Hudson*, refuse or reverse the invitation to collaboration and stay on one side of the bridge. But for those who dare to cross over, an illumination awaits that may well transform how the realms of day and night are perceived. That this illumination is in no small part a cinematic one is borne out by the source of Breton's beloved phrase: it is an intertitle featured in F. W.

Murnau's haunting silent film *Nosferatu* (1922) that must, according to Breton, "send shivers down the spines of the spectators of that marvelous film."[53] Breton borrowed the intertitle and transplanted it to his own discussion of surrealist painting, in an act of enlargement that should feel familiar to us after considering the collaborative spectatorship modes belonging to *Rose Hobart* and *Mrs. Rock Hudson*.

Afterword

Marking Cinematic Time

By chance, I had my first opportunity to experience Christian Marclay's *The Clock* (2010) just as I was completing *Dreaming of Cinema*. *The Clock* is a remarkable twenty-four-hour film presented as an art installation, composed entirely of fragments culled from the history of cinema and television that refer to particular minutes in time. Marclay orchestrates these cinematic minutes to correspond exactly to the time the viewer watches *The Clock*. So when it is noon and you are watching *The Clock*, you are watching footage from films that take place at noon or mention the time 12:00 noon. Then 12:01. Then 12:02 . . .

The Clock struck me right away as intimately linked to the concerns of this book, without being obviously surrealist or flamboyantly digital at its core—although it is both surreal and digitized in certain significant ways that I will explain later. What I believe makes *The Clock* worth reflecting

on here at the end of *Dreaming of Cinema* is its implications for theorizing cinematic spectatorship. To watch *The Clock* is to dream of cinema as a matter of marking time, and this book has endeavored to frame cinematic spectatorship as an experience that holds the potential to recast our relation to time. Whether stretching *The Sweet Hereafter* beyond its celluloid incarnation to include its literary and digital variants as one conjoined act of enlarged spectatorship; or blurring the lines between cinematic and gamic interactivity in *Un chien andalou* and *eXistenZ*; or tracking a mediated unconscious at work in the globalized exchanges between the Japanese *Ring* and its U.S. remake; or formulating notions of posthuman spectatorship between *Los olvidados* and the YouTube video "Christian the Lion"; or framing *Rose Hobart*'s invitations to collaboration with the viewer beside those issued by the YouTube channel *Mrs. Rock Hudson*; in all of these cases cinematic spectatorship has been theorized outside the bounds of cinema as a technologically delimited platform (film, projection, theater) and a temporally delimited experience (time spent viewing the film in a movie theater). By calling each of these instances an example of *cinematic* spectatorship, I am deliberately refiguring and expanding what we mean by *cinema*.

In order to imagine what cinematic spectatorship means in the age of new media, *Dreaming of Cinema* has juxtaposed the surrealist past and the digital present. The book's guiding principle has been inspired by Walter Benjamin, who understood that staging strategic collisions between the past and present allows us to "blast open the continuum of history" and seize the past within the present "as an image which flashes up at the instant when it can be recognized and is never seen again."[1] Our sense of history, of what constitutes the past and present (along with what remains available to shape the future), can very easily fall under the sway of beliefs and habits that freeze the past, instrumentalize the present, and drain the future. Instead, Benjamin wished to keep the past alive for the struggles of the present and the promise of the future through a risky, disorienting, but ultimately illuminating "blast" or "flash."

Benjamin, himself deeply affected by the spirit of surrealism, formulates his flash of historical consciousness along lines that recall the surrealist "spark," a shocking union of two disparate images that come together at the crossroads of dream and reality. *Dreaming of Cinema*'s methodology has attempted to integrate Benjamin's flash and surrealism's spark by arguing that to see cinematic spectatorship as it exists now

requires balancing two things: a sense of what cinema always was (a surrealist medium, not a realist one) and a sense of what cinema sometimes seems to be moving toward but may never become (an entirely digital domain). To strike this balance requires imagining cinema, as well as the history it influences and is influenced by, beyond linear, cause-effect logic (as Benjamin teaches) but without abandoning our critical responsibility to the aesthetic and cultural contexts of those objects that carry history within them (as Benjamin insists).

But how exactly do we, as cinematic spectators embedded in history, live with and through cinema? By marking time. That is the answer *The Clock* presents to us, because seeing *The Clock* invites an encounter with cinema's special relation to the time in our lives. Even in a film that doggedly calls attention to each minute of its duration, watching *The Clock* was, at least for me, an almost hypnotically effortless experience. The time slips by quickly, easily, nearly without conscious recognition, as if I were, well, watching a good movie. And here the surrealist ghost in the machine that is *The Clock* reveals itself: this ultraliteral rationalization of the cinema, where cinematic time is yoked relentlessly to real time, ends up remystifying cinema rather than demystifying it. After a brief initial period spent trying to identify the film being sampled, or the actors appearing, or even the presence of the watch or clock that tells us the minute we are in (cinematically and live), I surrendered to a soothing familiarity with the language of cinema itself. All of those gestures, situations, actions, urgencies, and excesses that allow us to inhabit these images so immediately, pleasurably, and immersively turn out to have lives of their own, independent from knowing their source or larger narrative significance. *The Clock* is of course the product of digital video, even if its painstaking three-year assembly involved such analog technologies as hired teams of film buffs scouring their favorite genres for appropriate sequences to submit to Marclay for digital editing.[2] But, more important, it is a digital dream of cinema made real—as if the entire history of the medium were made into a single searchable database. Yet the effect of this digital dream's actualization on the spectator is not realist but surrealist. Converting cinematic time into real time does not boil down cinema to a realist substrate; rather, it highlights cinema's surreal essence. I believe that watching *The Clock* drew me closer to, not further away from, what it must have felt like for André Breton to dart in and out of movie theaters at random in his quest for a surrealist charge from the cinematic image.

At least to a certain degree. The terms I have used to describe my impressions of *The Clock*, such as *soothing* and *familiar*, are not terms often used to describe surrealism, and for good reason. In this regard *The Clock* is no more of a surrealist film than *The Sweet Hereafter*.[3] But as far as the experience of spectatorship is concerned, *The Clock* offers something well worth regarding alongside surrealism, just as seeing *The Sweet Hereafter* as a digital instance of surrealist enlargement does. At the heart of these two viewing experiences, like all the examples of spectatorship analyzed in this book, are shifts in our perception of cinematic time's relation to lived time. I believe these shifts, although far from being identical in every case, can be usefully grouped under the category of the surreal. After all, it is not just clever marketing that has made Salvador Dalí's melting watches, depicted most famously in his painting *The Persistence of Memory* (1931), one of the most iconic surrealist images (fig. A.1). Surrealism's disorientations are not just about unhinging our sense of space but also our sense of time. *The Persistence of Memory* accomplishes this by turning the everyday instruments on which we depend for measuring time into soft, malleable forms rather than hard, precise ones. *The Clock* also accomplishes something like this by shackling cinematic time to lived time. But perhaps the greatest surrealist assault on our routine perceptions of time, especially as those perceptions are channeled through cinema, is the film Dalí collaborated on with Luis Buñuel shortly before painting *The Persistence of Memory*: *L'âge d'or* (1930). In fact, the stark mountainous landscape of Cap de Creus, the Catalan peninsula near where Dalí was born and where Buñuel shot the opening scenes of *L'âge d'or*, can be detected in the background of *The Persistence of Memory*.

L'âge d'or was a much more strained and distant act of collaboration between Buñuel and Dalí than *Un chien andalou* had been just one year earlier, but Paul Hammond has argued convincingly that Buñuel's film displays evidence of significant input not only from Dalí but from a wide range of the surrealist movement's members.[4] Even more so than *Un chien andalou*, which was made under the influence of surrealism but prior to Buñuel and Dalí becoming members of the Surrealist Group, *L'âge d'or* functions as a cinematic statement of surrealist principles. And one principle that occupies the film's forefront right from the start is a ferocious attack on linear time as the trustworthy keeper of social, historical, and moral order.

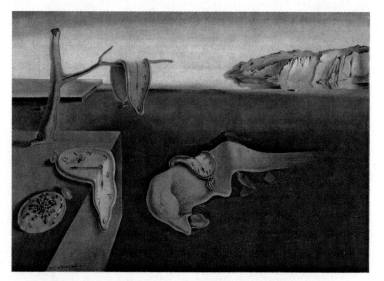

Figure A.1 Salvador Dalí (1904–89) © Artists Rights Society (ARS), New York. *The Persistence of Memory* (1931). Oil on canvas, 9½ × 13 in. (24.1 × 33 cm). Given anonymously. © Salvador Dalí, Gala-Salvador Dalí Foundation/Artists Rights Society (ARS), New York, 2013. Museum of Modern Art, New York. Digital Image © Museum of Modern Art/Licensed by SCALA/Art Resource, New York.

Rather than present us with the splendors of what the film's title seems to promise, a "golden age" where a civilization stands at the apex of its achievements so that we can look back nostalgically or look forward idealistically, *L'âge d'or* begins with a sequence quite literally out of time. The film opens by detailing the fearsome biology and behavior of scorpions in the tone of a scientific documentary—which is exactly what it is. Buñuel lifted footage as well as intertitles from an existing popular science documentary, overlaid a classical music soundtrack, and then re-presented it as the opening of his own film.[5] The scorpions come from the primordial time of the natural world, not some golden age of human invention, and their savage attacks on each other and a rat who falls victim to their poisonous sting suggests that we are far removed from any kind of ideally civilized era (the lush classical score, which accompanies much of *L'âge d'or*, only heightens the ironic clash between the film's title and images). But the scorpions also come from cinematic

time; they are already part of cinema's inventory of images even before they are incorporated into *L'âge d'or*. Like *The Clock*, the opening of *L'âge d'or* defines cinematic time as a matter of recollected images, not original ones. Unlike *The Clock*, with its meticulously engineered structure, the beginning of *L'âge d'or* parades its determination to *not* fit in with the film as a whole—to remain an accident, a chance encounter, a dead end. Of course, this is not to say that aesthetic and thematic connections cannot be established between the scorpion sequence and the rest of the film (indeed, Hammond goes so far as to use an intertitle's description of the scorpion's tail as divided into six segments as a rationale for splitting the film into six sections).[6] But as *L'âge d'or* continues, the film's opening makes more and more "sense" as temporal nonsense—the first in a series of assaults on our conventional notions of time's continuity.

"Some hours later" states the intertitle that bridges the scorpion sequence and *L'âge d'or*'s next section, a depiction of hopelessly beleaguered bandits set on attacking a group of Catholic bishops spotted near the seashore. One by one, the marching bandits collapse from old injuries and exhaustion before even reaching the bishops. Time as deadline—a key ingredient for narrative cinema that *The Clock*'s clips revisit again

Figure A.2 *L'âge d'or* (Luis Buñuel, 1930): The ravages of time in a film that ravages our sense of time.

and again—is dismissed here as handily as time's function as the reliable agent of chronology, when "some hours later" turns out to have no relevance whatsoever for the relationship between the scorpions and the bandits. Indeed, when the bandits disappear from the film shortly thereafter and a fleet of new characters land on the same craggy shoreline, the bishops have become desiccated, skeletal remains (fig. A.2). So even though nothing more explicit than a fade-out and fade-in indicate that any time at all has elapsed, apparently long stretches of time have passed.

Since the scorpion and bandit sequences offer no answer to the spectator's question of "When are we?" (let alone specifying a particular golden age), it comes as a relief when these new visitors to the shoreline erect a plaque that names the year as 1930. So we are in the film's present tense after all. The viewer relaxes a bit, finally provided with some temporal bearings to filter the film's onslaught of violent, scatological, hilariously cruel, shockingly blasphemous images. But the relief proves illusory, since Buñuel then reveals that 1930 is the date a city was founded on this spot, and that city was called . . . imperial Rome. Accompanying aerial images place us in an emphatically modern Rome, not its ancient imperial version. And so it goes in *L'âge d'or*, right through the film's final sequence, a tribute to Sade's *The 120 Days of Sodom* led by a Christ figure that leaves us somewhere between the crucifixion of Jesus and the eighteenth century. Not only does *L'âge d'or* refuse to locate or date the golden age promised by its title, but it scrambles our sense of linear time so feverishly that only cinematic time remains. In *L'âge d'or* linear time is subjected to endless surrealist disorientation so that cinematic time emerges poised at an angle of critical possibility to the lived time of the present. The undated golden age may well be that potential instant of Benjamin's flash, when the imprisoning strictures of time and history loosen so that we might glimpse another time, another history, another possibility buried within our own present. *L'âge d'or* offers us that glimpse by conditioning our senses to the surreality of cinematic time.

The same can be said for the examples of cinematic spectatorship collected in *Dreaming of Cinema*. None of the films or digital media analyzed in this book may come close on their own to matching *L'âge d'or*'s stunning insistence on changing the way viewers see, but I hope I have demonstrated how, in the interstices between the surrealist past and the digital present, each of these objects carries the possibility for an expanded sense of cinematic spectatorship. Whether it's a digital clock

made of movies or a surrealist movie that melts clocks, cinema is, was, and always will be an experience for the spectator with a time of its own.

The afterlife of *L'âge d'or* underlines this point. Because it was an early sound film, many movie theaters in 1930 were not yet properly equipped to project it in its intended form. In fact, the film's public premiere in Paris was marred by the malfunctioning of the theater's sound system. A few days later, a group of right-wing demonstrators vandalized the theater that was screening *L'âge d'or*, including damaging an accompanying exhibition of surrealist art in the lobby. Soon the public scandal surrounding the film caused its prints to be impounded, its visa cancelled, and the film itself to nearly vanish from existence for decades.[7] But today *L'âge d'or* is available on Blu-ray, DVD, and streaming video, accessible at a low price and with just a few clicks of a computerized device. Can the film possibly reach and transform viewers now in ways that it simply could not in 1930? Or is *L'âge d'or* condemned to languish as just another forgotten whisper in the digital din of new media?

Perhaps *L'âge d'or*'s golden age of cinematic spectatorship is now. Or yet to come. Or already past. Or all of the above, simultaneously.

Notes

INTRODUCTION: CINEMA AS DIGITAL DREAM MACHINE

1. Some pioneering efforts to think through this problematic include Chun and Keenan, *New Media, Old Media*; Gitelman, *Always Already New*; Gitelman and Pingree, *New Media, 1740–1915*; Hansen, *New Philosophy for New Media*; Manovich, *The Language of New Media*; and Thorburn and Jenkins, *Rethinking Media Change*. All claims stated in this introduction will be supported further, in terms of both argument and bibliographic reference, in the chapters to follow.

2. Of course, this formulation echoes André Bazin's landmark *What Is Cinema?* I will take up Bazin's work in chapters 1 and 4. For a fascinating Bazinian exploration of the idea of cinema see Andrew, *What Cinema Is!*

3. Here and throughout this book I have chosen not to capitalize *surrealism* or *surrealists* in order to indicate my investments in figures either excluded from or at the fringes of the official Surrealist Group.

4. See, e.g., Mulvey, *Death 24x a Second*; and Rodowick, *The Virtual Life of Film*. For an important counterargument see Gunning, "Moving Away from the Index."

5. For an influential version of this narrative see Jenkins, *Convergence Culture*. For a counterargument see Golumbia, *The Cultural Logic of Computation*.

6. Benjamin, "Surrealism," 190. See also Lowenstein, *Shocking Representation*, 18–27.

7. Breton, "Manifesto of Surrealism," 14.

8. For useful overviews of the varied theoretical approaches to cinematic spectatorship see, e.g., Aaron, *Spectatorship*; Brooker and Jermyn, *The Audience Studies Reader*; Plantinga and Smith, *Passionate Views*; Rosen, *Narrative, Apparatus, Ideology*; Thornham, *Feminist Film Theory*; and Williams, *Viewing Positions*.

9. For an excellent study of cinema's movement out of the theater and into the home see Klinger, *Beyond the Multiplex*.

10. McLuhan, *Understanding Media*, 20.

11. I am borrowing these terms from Thussu, "Global Media Flow and Contra-Flow."

12. Hayles, *How We Became Posthuman*, 3.

1. ENLARGED SPECTATORSHIP

1. Bazin, "The Myth of Total Cinema," 21.

2. Barthes, "The Third Meaning," 65. Subsequent citations of this source will be referenced parenthetically in the text proper by the abbreviation TM, followed by the appropriate page number(s).

3. I have chosen the term *intermediated* over the more common term *convergent* to preserve a sense of tension between media layers, as well as between spectators and technologies, that I believe is minimized in accounts like Henry Jenkins's influential description of digital media culture as a "convergence culture." For Jenkins convergence culture is characterized by "the flow of content across multiple media platforms, the cooperation between multiple media industries, and the migratory behavior of media audiences who will go almost anywhere in search of the kind of entertainment experiences

they want." So far, so good. But I ultimately disagree with how Jenkins boils down this definition of convergence culture to a "participatory culture" where "older notions of passive media spectatorship" are replaced by "the work—and play—spectators perform in the new media system." Although Jenkins attends carefully to the complex interchanges between media producers and media consumers, his narrative of the digital age tends to favor depictions of new media that empower the consumer as a producer. For example, he describes the participatory culture of the twenty-first-century digital era as a return to practices closer to nineteenth-century folk culture than twentieth-century mass culture: "The story of American arts in the twenty-first century might be told in terms of the public reemergence of grassroots creativity as everyday people take advantage of new technologies that enable them to archive, annotate, appropriate, and recirculate media content." See Jenkins, *Convergence Culture*, 2, 3, 140.

4. Bazin, "Death Every Afternoon," 30. In the context of the present discussion it is worth noting that "Death Every Afternoon" is a meditation on Pierre Braunberger's *The Bullfight* (*La course de taureaux*, 1949), a documentary that features voice-over commentary written by the surrealist Michel Leiris.

5. Barthes, *Camera Lucida*, 3. Subsequent citations of this source will be referenced parenthetically in the text proper by the abbreviation *CL*, followed by the appropriate page number(s).

6. MacCabe, "Barthes and Bazin," 74, 75.

7. Andrew, "Ontology of a Fetish"; see also Andrew, *André Bazin*, 70.

8. Sartre, *The Imaginary*, 10. Subsequent citations of this source will be referenced parenthetically in the text proper by the abbreviation *TI*, followed by the appropriate page number(s). Sartre's fascinating and frustrating book is overdue for serious consideration by film scholars, not only for its influence on Bazin and Barthes but for its relation to the work of philosopher Henri Bergson. Although Sartre tends to refute Bergson as thoroughly as Gilles Deleuze embraces him later on, particularly in Deleuze's books on cinema, this intellectual genealogy (which also includes Bazin's notable influence on Deleuze) warrants further exploration for film studies. See Deleuze, *Cinema 1*; and Deleuze, *Cinema 2*.

9. Bazin, "Ontology of the Photographic Image," 15. Subsequent citations of this source will be referenced parenthetically in the text proper by the abbreviation OP, followed by the appropriate page number(s).

10. For a discussion of how subjectivity and objectivity are intertwined in Bazin's thought, see Rosen, "History of Image, Image of History."

11. Breton, "Manifesto of Surrealism," 14.

12. The subject of surrealist politics is vast, and I will address it more substantially later, especially in my discussions of Georges Bataille in this chapter and others. For an introduction to the terrain of surrealist politics see Lewis, *The Politics of Surrealism*. For an example of surrealist politics applied to a cinematic context see Lowenstein, *Shocking Representation*, 17–53.

13. Sartre refers to "the structure of the image" as "irrational" (*TI* 24). Formulations such as this one, along with Sartre's thoughtful attention to dreams and various hypnagogic states, give *The Imaginary* a certain proximity to surrealism that Sartre's later work will not share. See, for example, Sartre's searing critique of surrealism in "What Is Literature?" (1948), included in Sartre, *"What Is Literature?" and Other Essays*, esp. 152–58. For a study of Sartre's relation to surrealism see Plank, *Sartre and Surrealism*. On the subject of surrealism, as well as Sartre's importance for Bazin and Barthes, it is worth noting that Sartre comes closest to making an exception to his divisions between perception and imagination when he admits that certain "image-portraits," such as paintings or photographs of actual persons, sometimes seem to offer an "irrational synthesis" of presence and absence for the viewer. See *The Imaginary*, 23; and compare Barthes's related quotation of Sartre in *Camera Lucida* (*CL* 19–20; quoting *TI* 24–25).

14. Cf. *TI* 17.

15. Note how Bazin's formulation here again evokes Sartre in order to challenge him, this time recalling Sartre's refutation of Hippolyte Taine's assertion that "perception is already 'a true hallucination'" (*TI* 148).

16. Krauss, "Photographic Conditions of Surrealism," 29.

17. Andrew, *André Bazin*, 58. Andrew dates Bazin's most intensive involvement with surrealist concepts to the early 1940s, the very same era that Bazin was at work on the ideas that would structure "Ontology of the Photographic Image."

18. Recent developments in film studies suggest, however, an increasing willingness to challenge this conventional reading of Bazin. For illuminating examples of this trend see Andrew, with Joubert-Laurencin, *Opening Bazin*; Morgan, "Rethinking Bazin"; and Keathley, *Cinephilia and History*, 54–81.

19. Bazin, "*Subida al cielo*," 63.

20. Bazin, "Cruelty and Love," 57.

21. Bazin, "*Cabiria*," 88, 89.

22. Bazin, "Science Film," 146–47.

23. See Ungar, "Persistence of the Image," 238–39. For another stimulating critical account of Barthes's work in relation to cinema see Watts, "Roland Barthes's Cold-War Cinema."

24. Barthes, "The Photographic Message," 17.

25. What has been lost, however, in Barthes's transition from "The Photographic Message" to *Camera Lucida* is a willingness to analyze the photograph as a social text. *Camera Lucida* brackets the social in favor of the personal, as explained more fully below in Barthes's distinctions between the studium and the punctum.

26. Barthes, "The Photographic Message," 21.

27. For a valuable account of the influence of Barthes's distinction, particularly in terms of its wide-ranging implications for art history, see Fried, "Barthes's *Punctum*."

28. Breton, "Manifesto of Surrealism," 26, 37, 36.

29. Ferry, "Concerning *King Kong*," 161.

30. Ibid., 164.

31. I will elaborate on surrealist cinematic enlargement below, but for some useful landmarks in the wider critical literature on surrealism and cinema that aid in contextualizing enlargement, see Abel, *French Film Theory*; Caughie and Fotiade, "Surrealism and Cinema"; Harper and Stone, *The Unsilvered Screen*; Kovács, *From Enchantment to Rage*; Kuenzli, *Dada and Surrealist Film*; Kyrou, *Le surréalisme au cinéma*; Matthews, *Surrealism and Film*; Moine, "Surrealist Cinema to Surrealism"; Ray, *How a Film Theory Got Lost*; Richardson, *Surrealism and Cinema*; and Williams, *Figures of Desire*.

32. Surrealist Group, "Toward the Irrational Enlargement," 121.

33. See "Recherches expérimentales." A partial translation can be found in Jean, *The Autobiography of Surrealism*, 298–301.

34. Surrealist Group, "Toward the Irrational Enlargement," 122–27.

35. Ibid., 122–23.

36. Ibid., 121.

37. Breton, "As in a Wood," 73.

38. Ibid., 75.

39. Ibid., 73. It is worth noting, if only in passing, how Breton's account of surrealist spectatorship anticipates certain aspects of the "resistant" or "oppositional" spectator constructed by cultural studies discourse; for a particularly influential example of cultural studies spectatorship see Hall, "Encoding/Decoding." One major difference that distinguishes the two

spectatorship models is that where surrealism favors the shared fantasies forged between spectator and text, cultural studies tends to favor clearly delineated distinctions that separate the text's ideological "encoding" from the spectator's "decoding" of the text's messages.

40. See also Barthes's brief references to Godard, Antonioni, and especially Fellini (*CL* 70, 85, 115–16); these moments underline the extent to which cinema, however marginalized in *Camera Lucida*, is never forgotten.

41. Although the analysis that follows focuses solely on "The Third Meaning," it is also informed by two related essays on cinema written by Barthes during the same period. See Barthes, "Diderot, Brecht, Eisenstein" (1973); and Barthes, "Leaving the Movie Theater" (1975).

42. Unfortunately, Barthes makes no clear distinction between publicity stills and frame enlargements when discussing the "photogram"; distinguishing these two forms may well have altered Barthes's account of "the filmic." I am indebted to John Belton for calling this issue to my attention.

43. Compare Bazin on *Ivan the Terrible*, where he notes the film's "rather static" style but asserts that "it would be wrong to say that the film is nothing more than an album of artistic photographs." Perhaps an inspiration for Barthes's sense of "the filmic"? See Bazin, *"Battle of the Rails,"* 201.

44. Breton, "Manifesto of Surrealism," 26.

45. For a more detailed account of this split within the surrealist movement see Richardson, introduction to *The Absence of Myth*, esp. 1–11.

46. Alexandrian, *Le surréalisme et le rêve*, 456; quoted in Richardson, introduction to *The Absence of Myth*, 6.

47. See, e.g., Bataille, *The Absence of Myth*; and Barthes, "The Surrealists Overlooked the Body," 243–45. It is also worth noting that Barthes, at least intermittently, shared with Bazin a particular admiration for the films of surrealism's most significant director, Luis Buñuel. See Barthes, "On Film," esp. 21–23; and Bazin, *The Cinema of Cruelty*, 51–99.

48. Bataille, "The Big Toe," 20.

49. Ibid., 22.

50. For further examples of Barthes reading Bataille see Barthes, "Outcomes of the Text"; and Barthes, "The Metaphor of the Eye." The former essay examines "The Big Toe," while the latter analyzes Bataille's novel *Story of the Eye* (1928).

51. See Bataille, "Le gros orteil." For a brilliant reading of Bataille's intellectual project that has influenced my own account, see Lastra, "Why Is This Absurd Picture Here?" All fifteen issues of *Documents* (1929–30) have been reprinted in two volumes; see Bataille, *Documents*. For additional contextualization of

Documents see Clifford, "On Ethnographic Surrealism." Translations of select material from *Documents* can be found in *October* 36 (Spring 1986); *October* 60 (Spring 1992); and Brotchie, *Encyclopaedia Acephalica*.

52. Bataille, "The Big Toe," 23.

53. Manovich, *The Language of New Media*, 287, 289. For other noteworthy accounts of cinema in the age of new media that share Manovich's sensitivity in analyzing the continuities between "old" and "new" media, see Belton, "Digital Cinema"; Everett, "Digitextuality and Click Theory"; and Rosen, *Change Mummified*, 301–49.

54. For useful overviews of Egoyan's films see Romney, *Atom Egoyan*; and Wilson, *Atom Egoyan*.

55. For a study of DVD special features see Brereton, *Smart Cinema*.

56. Bazin, "Adaptation," 26.

57. Naremore, "Introduction," 1. See also Elliott, *Rethinking the Novel/Film Debate*; Leitch, *Film Adaptation and Its Discontents*; MacCabe, Murray, and Warner, *True to the Spirit*; and Stam, *Literature Through Film*.

58. Banks, *The Sweet Hereafter*, 1, 34.

59. This sequence can be found on *The Sweet Hereafter* DVD as chapter 11, "That Morning."

60. Banks, *The Sweet Hereafter*, 37.

61. Barthes, *S/Z*, 4–5.

62. Ibid., 12–13.

63. Bataille, quoted in Barthes, *S/Z*, 267; see also 16.

64. Barthes, "The Death of the Author," 144. For additional discussion of the surrealist experiments in collaborative writing see Durozoi, *History of the Surrealist Movement*, 193–96.

65. See *The Sweet Hereafter* DVD, chap. 20, "The Sweet Hereafter."

66. Atom Egoyan, in Banks and Egoyan, "*The Sweet Hereafter*," 35.

67. Ibid., 37.

68. Breton, "As in a Wood," 73 (Breton's emphasis).

2. INTERACTIVE SPECTATORSHIP

1. Belton, "Digital Cinema," 104–5; Lunenfeld, "Myths of Interactive Cinema," 154; Kinder, "Hot Spots, Avatars, and Narrative," 4, 6.

2. I am responding here to a frequent tendency in scholarship on gaming in new media contexts to turn toward narrative as primary. See, e.g., Murray, *Hamlet on the Holodeck*; and Kinder, "Narrative Equivocations." Again, I do

not wish to discount the importance of narrative to gaming in new media but to seek alternate approaches to this phenomenon that do not necessarily begin or end with narrative.

3. See Bordwell, "The Art Cinema"; and Bordwell, *Narration in the Fiction Film*, 205–33. Although Bordwell is not silent on the historical, economic, and cultural aspects of art cinema, these elements have been pursued in more detail by other scholars. See, e.g., Betz, *Beyond the Subtitle*; Galt and Schoonover, *Global Art Cinema*; Kovács, *Screening Modernism*; Neale, "Art Cinema as Institution"; Wasson, *Museum Movies*; and Wilinsky, *Sure Seaters*. The primacy of narrative in Bordwell's account, however, coupled with the influential impact of his claims, means that art cinema's place in film studies has tended to be fixed in a particular way for many years.

4. Bordwell, *Narration in the Fiction Film*, 231.

5. Elsaesser, *European Cinema*, esp. 485–513; and Galt, *The New European Cinema*.

6. Bordwell includes Buñuel in his lists of art cinema auteurs (see "The Art Cinema," 778; and *Narration in the Fiction Film*, 232). For a consideration of Cronenberg's relation to art cinema and Canadian national cinema see Lowenstein, *Shocking Representation*, 145–75.

7. I have placed Galloway's work at the center of this chapter's discussions of video games because his arguments, to my mind, address my particular concerns with unusual sensitivity. This is not to say, however, that Galloway's is the first, last, or only word in video game studies, a field that continues to grow at an impressive pace. See, e.g., Aarseth, *Cybertext*; Bogost, *How to Do Things*; King and Krzywinska, *ScreenPlay*; Perron and Wolf, *Video Game Theory Reader*; and the journal *Game Studies*.

8. Galloway, *Gaming*, 2. I follow Galloway in his use of "video game" as an "umbrella term for all sorts of . . . electronic games" (127n1).

9. Ibid., 3, 128n4.

10. Although Buñuel had not yet joined the Surrealist Group when he and Dalí made *Un chien andalou*, he often pointed out the film's fundamental debts to surrealism: "*Un chien andalou* would not have existed if the movement called surrealist had not existed" (Buñuel, "Notes," 151–52); "Even the poems I published in Spain before I'd heard of the surrealist movement were responses to that call which eventually brought all of us together in Paris. While Dalí and I were making *Un chien andalou* we used a kind of automatic writing. There was indeed something in the air, and my connection with the surrealists in many ways determined the course of my life" (Buñuel, *My Last Breath*, 105). Buñuel joined the Surrealist Group officially in 1929 and broke with them

in 1932. His films and writings, however, right up until his death in 1983, testify to a powerfully sustained investment in surrealism.

11. Buñuel, "Notes," 153. The criticism pertaining to *Un chien andalou* is extensive. For some recent illuminating accounts, in addition to those cited later in this chapter, see Adamowicz, *Un chien andalou*; Short, *The Age of Gold*, 51–101; and Turvey, *The Filming of Modern Life*, 105–34.

12. See Colina and Pérez Turrent, *Objects of Desire*, 15–16.

13. For an overview of surrealist games see Brotchie and Gooding, *Book of Surrealist Games*.

14. Simone Kahn, an associate of the Surrealist Group (and André Breton's first wife), recalls the original exquisite corpse games as insular, with the surrealists putting on "a fantastic drama for ourselves." Even when the first selections of results from the games were published in a 1927 issue of *La révolution surréaliste*, they appeared anonymously. Later examples of the game were signed by the players. See Caws, *Surrealism*, 200, 62.

15. Buñuel, "Notes," 151, 153.

16. See Elsaesser, "Dada/Cinema?" 26.

17. In this way *Un chien andalou* speaks to Buñuel's sense of surrealism as a movement whose aim "was not to establish a glorious place . . . in the annals of art and literature, but to change the world, to transform life itself." Buñuel concludes that surrealism was thus "successful in its details and a failure in its essentials," even though the movement clearly changed his own life. See Buñuel, *My Last Breath*, 123.

18. Bordwell, "The Art Cinema," 779.

19. At the same time it is important not to minimize Dalí's considerable contributions to *Un chien andalou*. According to Buñuel it was Dalí who convinced him to use the title *Un chien andalou* for the film. See Buñuel, "Pessimism," 258. For an extended discussion of Dalí's part in *Un chien andalou* see Finkelstein, "Dalí and *Un chien andalou*."

20. For a fascinating inventory of verbal and visual exchange in *Un chien andalou* see Liebman, "*Un chien andalou*." In the present context Liebman's account is usefully paired with surrealist games that utilize the spoken word in a way that games such as the exquisite corpse focus on written words or visual images—for example, the "game of variants," where one player whispers a sentence in the ear of another and so on until the first and last versions of the sentence are compared. See Brotchie and Gooding, *Book of Surrealist Games*, 32.

21. Galloway, *Gaming*, 11–12.

22. For an excellent introduction to Caillois's career see Frank, introduction to *The Edge of Surrealism*.

23. On the College of Sociology see Hollier, *The College of Sociology (1937–39)*.

24. Caillois, "Surrealism as a World," 334.

25. Caillois, "Testimony (Paul Éluard)," 62.

26. Ibid.

27. Caillois, "Letter to André Breton," 85.

28. Caillois, "Mimicry and Legendary Psychasthenia," 99–100.

29. Caillois, *Man, Play and Games*, 177n5, 12, 19, 21, 54.

30. Ibid., 120.

31. Caillois, *Man and the Sacred*, 162.

32. Caillois, *Man, Play and Games*, 141; see also 55.

33. Ibid., 54.

34. Frank, introduction to *The Edge of Surrealism*, 33.

35. See Richman, *Sacred Revolutions*, esp. 110–54; and Bataille, "The Psychological Structure of Fascism."

36. See Bataille, "The Notion of Expenditure." Bataille develops these arguments further in *The Accursed Share*.

37. Caillois, *Man, Play and Games*, 5–6, 10.

38. Ibid., 196n60, 126. For more of Caillois's views on film see his *L'homme et le sacré*.

39. Another is the issue of community in relation to the masses. For an account of Caillois's oscillations between fearful and hopeful stances toward democracy during the World War II era see Frank, introduction to *The Edge of Surrealism*, 22–37.

40. Caillois, *Man, Play and Games*, 75.

41. Ibid., 135.

42. See Gunning, "The Cinema of Attraction."

43. Caillois, *Man, Play and Games*, 122. Caillois cites Rudolf Valentino and James Dean specifically (see 194–95n57). On Valentino in a related context see Hansen, *Babel and Babylon*, 245–94.

44. Caillois, "Mimicry and Legendary Psychasthenia," 100.

45. For significant examples of this psychoanalytic film theory see the essays by Jean-Louis Baudry, Christian Metz, and Laura Mulvey in Rosen, *Narrative, Apparatus, Ideology*. For an argument about how Lacan's work is misinterpreted in much of this film theory, see Copjec, *Read My Desire*, 15–38.

46. Lacan, "The Mirror Stage," 3–4.

47. Ibid., 4–5.

48. Caillois, "Mimicry and Legendary Psychasthenia," 102.

49. Ibid., 97–98, 103n40.

50. Breton, "Manifesto of Surrealism," 37.

51. See Caillois, "The Image."

52. Caillois does not refer specifically to Dalí's *The Lugubrious Game* in "Mimicry and Legendary Psychasthenia" but to his series of paintings that includes *Invisible Lion, Horse, Sleeping Woman* (1930). Mary Ann Caws has noted how this series demonstrates "Dalí's closeness to cinema . . . in which experiments with multiple images establish links between cinematic techniques, such as dissolves and multiple exposures, and his theory of paranoiac imagery" (Caws, *Surrealism*, 152). For more on Dalí's myriad (but usually unrealized) film projects see King, *Dalí, Surrealism and Cinema*. For Bataille's commentary on *The Lugubrious Game* (which includes references in its footnotes to *Un chien andalou*) see his "The 'Lugubrious Game.'"

53. The fact that Geller later interprets Pikul's actions here as a true desire to assassinate her rather than a simulated one only deepens the problem of agency I have been describing in relation to this scene. The assassination scenario is played out during the film a number of times in a number of different ways, constantly foregrounding questions of who or what is in control of the action (or, to put it in Caillois's terms, what counts as self-abandonment and what counts as self-preservation). When Geller accuses Pikul of being her true assassin near the end of the film, she then kills him and declares triumphantly, "Death to the demon, Ted Pikul!" Afterward, she asks, "Have I won the game?" Of course, there is no answer.

54. Bordwell, "The Art Cinema," 778.

55. Buñuel, *My Last Breath*, 106.

56. Buñuel, "*Un chien andalou*," 162.

57. Breton, "Second Manifesto of Surrealism," 125.

58. Cronenberg, quoted in Scoffield, "An Interview with David Cronenberg," 93.

59. Buñuel, *My Last Breath*, 106.

60. Buñuel's published screenplay, which the film does not always follow faithfully, describes this final couple as "the main character and the young woman," or whom I have been referring to as the dark-suited man and Simone Mareuil. Buñuel adds that they are "blind, their clothes in tatters, devoured by the rays of the sun and by a swarm of insects." See Buñuel, "*Un*

chien andalou," 169. As Linda Williams notes, the nature of the extant prints of *Un chien andalou* make these details hard to decipher at best. See her *Figures of Desire*, 99n45.

61. Caillois, "Mimicry and Legendary Psychasthenia," 99, 100.

62. Barthes, "Metaphor of the Eye," 239, 241.

63. There are a number of remarkable overlaps in theme and content between *Story of the Eye* and *Un chien andalou*. Consider, for example, this passage from *Story of the Eye*: "Upon my asking what the word *urinate* reminded her of, she replied: *terminate*, the eyes, with a razor, something red, the sun. And *egg*? A calf's eye, because of the color of the head (a calf's head) and also because the white of the egg was the white of the eye, and the yolk the eyeball" (Georges Bataille, *Story of the Eye*, 38). The resemblances here to *Un chien andalou* are striking, especially when framed with Bunuel's claim that a calf's eye was used during the filming of *Un chien andalou*'s opening scene and the fact that *Story of the Eye*'s action concludes in Andalusia. See Colina and Pérez Turrent, *Objects of Desire*, 16; and Bataille, *Story of the Eye*, 85. Since *Story of the Eye* was published in 1928, the same year Buñuel and Dalí commenced work on *Un chien andalou*, paired with the fact that Buñuel had already begun living in Paris (off and on) in 1925, there is certainly the possibility of direct influence. For Buñuel on Bataille see Buñuel, *My Last Breath*, 122. For Bataille on Buñuel see Bataille, "Eye." I will return to a more detailed analysis of *Story of the Eye* in chapter 4.

64. Of course, James Cameron's blockbuster film *Avatar* (2009) also exploits the cinema/video game intersection.

65. Caillois, "Mimicry and Legendary Psychasthenia," 102. Paul Young adds an intriguing dimension to the game pod's combination of animate and inanimate matter by reading the pod "as a figure for the contested fetus in an era flush with religious fundamentalism" (Young, *The Cinema Dreams*, 243).

66. My use here of the terms *assaultive* and *reactive* proceeds from Carol J. Clover's important recasting of sadistic and masochistic spectatorship as "the assaultive gaze" and "the reactive gaze." See Clover, *Men, Women, and Chain Saws*, esp. 166–230.

67. Galloway, *Gaming*, 3.

68. Galloway's use of Caillois on matters of play and games reveals similar limitations: Caillois's relevance for video games is considered "confine[d]," and he is described flatly as "a leftist and friends with the likes of Georges Bataille." See Galloway, *Gaming*, 21, 19–20. What this rather broad and

vague characterization of Caillois minimizes is the specific importance of surrealism and mimicry to his intellectual projects.

69. Of course, this temporal discontinuity can also be read as a spatial discontinuity, where the man performing the slashing of the eye is not Buñuel at all. But the persistence of the razor and the vertically striped shirt from previous shots, in addition to the graphic matching between shots, creates a strong impression of spatial continuity despite the missing watch and new tie.

70. The significance of the watch as an object for Buñuel can be seen in his amusing piece "Why I Don't Wear a Watch."

71. Bordwell refers to what Norman Holland calls "puzzling movies" as examples of how "art cinema foregrounds the narrational act by posing enigmas." For Bordwell classical cinema narratives pose questions at the level of story ("who did it?"), while art cinema narratives foreground enigmas at the level of plot ("who is telling this story?"). See Bordwell, "The Art Cinema," 778–79. Where the new "puzzle films" fall with regard to these categorizations is a matter for further debate, but it seems to me that we might begin thinking about them as incorporating enigmas at both story and plot levels. For additional discussion see Buckland, *Puzzle Films*.

72. In fact, the way a film like *Babel* (Alejandro González Iñárritu, 2006) sets out to conjoin the puzzle film with art cinema's trappings of national "authenticity" seems anticipated (and satirized) by the deployment of ostentatiously "diverse" names and accents for many of the characters in *eXistenZ*. In Cronenberg's work performances of national "authenticity" are often distrusted as deceptive rather than embraced as genuine identities. *Babel* displays little to none of this skepticism.

73. See, e.g., Shaw and Weibel, *Future Cinema*.

74. For related discussions of Cronenberg's oeuvre see Lowenstein, "*A Dangerous Method*"; and Lowenstein, "Transforming Horror."

75. For the exhibition catalog see Fogle, *Andy Warhol/Supernova*.

76. Buñuel, *My Last Breath*, 103. For more on Buñuel as a film curator see his "A Night at the Studio des Ursulines."

77. For the exhibition catalog see Stauffacher, *Art in Cinema*.

78. Buñuel, "Notes," 151, 153.

79. For tantalizing hints in this direction consider Buñuel's interactive art project *A Giraffe*, constructed with the collaboration of Alberto Giacometti sometime in the early 1930s but now lost. For Buñuel's descriptions of the project see Buñuel, *My Last Breath*, 118–19; and Buñuel, "A Giraffe." Marsha

Kinder quite rightly points to *A Giraffe* as an important context for discussing Buñuel's legacy for new media. See Kinder, "Hot Spots, Avatars, and Narrative," 3–4.

80. See Drew, *David Cronenberg*, 57.

3. GLOBALIZED SPECTATORSHIP

1. Translations of Murakami's concept of "superflat" sometimes opt for "super flat"; for consistency I have made the former spelling uniform. I have rendered all Japanese names by placing the family name first, with the exception of English-language sources.

2. For valuable reflections on these terms in a cinematic context see Ďurovičová and Newman, *World Cinemas, Transnational Perspectives*.

3. See Andrew, "Atlas of World Cinema"; and Rosenbaum and Martin, *Movie Mutations*.

4. Thussu, "Mapping Global Media Flow," 11.

5. Iwabuchi, "Contra-Flows," 78; see also Iwabuchi, *Recentering Globalization*.

6. Appadurai, *Modernity at Large*, 27, 29.

7. Ibid., 33.

8. Nakata's film is often referred to as *Ringu*, but this is an artificial (and misleading) "Japanizing" of the film's original title, the English word *Ring*. Therefore, I will refer to Nakata's film as *Ring* in this chapter. For an explanation of this usage, as well as a useful introduction to the entire J-Horror phenomenon, see Kalat, *J-Horror*, 25. For more on J-Horror see McRoy, *Nightmare Japan*.

9. See Holden, "'Sportsports.'"

10. For a related discussion of the technological uncanny see Gunning, "Re-Newing Old Technologies."

11. For a fascinating study of film's relation to its photographic substrate that suggests a number of additional implications for this scene (although not referred to explicitly), see Stewart, *Between Film and Screen*.

12. For further discussion see Young, *The Cinema Dreams*.

13. For context on Japanese cultural traditions relevant to these films see Hand, "Aesthetics of Cruelty." For analyses of *Onibaba* in particular on this score see Lowenstein, *Shocking Representation*, 83–109; and McDonald, *Reading a Japanese Film*, 108–21.

14. This list is not meant to be exhaustive; *Ring* is indebted to a number of other American horror films as well. On the influence of *The Exorcist* (William Friedkin, 1973) see Goldberg, "Demons in the Family." Suzuki Koji's novel

Ring mentions a number of American horror films, perhaps as nods of acknowledgment: *The Exorcist, The Legend of Hell House* (John Hough, 1973), *The Omen* (Richard Donner, 1976), and *Friday the 13th* (Sean Cunningham, 1980). See Suzuki, *Ring*, 71–72. David Cronenberg's presence on this list as a Canadian director rather than an American one is important to note, especially since *Videodrome* is saturated with implicit references to fellow Canadian Marshall McLuhan—one character in the film is a McLuhanesque media prophet named "Brian O'Blivion." Cronenberg's films have been remarkably influential for Japanese horror and science fiction cinema, as is apparent in the work of (for example) Tsukamoto Shinya and Miike Takashi. For more on Cronenberg see chapter 2.

15. Nakata Hideo, interview with the author, June 27, 2008, Tokyo; Takahashi Hiroshi, interview with the author, June 19, 2008, Tokyo (trans. Sakano Yuka).

16. Appadurai, *Modernity at Large*, 30.

17. Murakami, "*Superflat* Trilogy," 152.

18. Murakami, "*Little Boy*," 2–3.

19. Okada, Morikawa, and Murakami, "*Otaku* Talk." See also LaMarre, "*Otaku* Movement."

20. Okada, Morikawa, and Murakami, "*Otaku* Talk," 170.

21. McGray, "Japan's Gross National Cool," quoted in Môri, "Subcultural Unconsciousness in Japan," 188.

22. Yoda, "A Roadmap to Millennial Japan," 17.

23. Harootunian and Yoda, introduction to *Japan After Japan*, 1.

24. Murakami, "Superflat Manifesto," 152, 5.

25. Koschmann, "National Subjectivity," 122.

26. Harootunian and Yoda, introduction to *Japan After Japan*, 11–12.

27. Ivy, "Revenge and Recapitation," 197–98.

28. Murakami, "*Superflat* Trilogy," 161.

29. Murakami, "*Little Boy*," 4.

30. See Schimmel, *©Murakami*.

31. Takahashi, interview with the author.

32. For critical reflections on this sort of "electronic presence" see Sconce, *Haunted Media*; and Sobchack, "The Scene of the Screen."

33. Hornyak, "Murder in Lotus Land." Hornyak also discusses a more recent *otaku* murderer, Kato Tomohiro, who in 2008 killed seven people in Akihabara, Tokyo's center for otaku culture. Miyazaki was executed in 2008.

34. Nakata, interview with the author.

35. Takahashi, interview with the author.

36. Ibid.

37. For more on the significance of Aum in this context see Ivy, "Revenge and Recapitation." As Ivy notes, Aum's infamous use of faked photographs to document "miracles," such as Aum leader Asahara Shōkō "levitating while in the full lotus position" (201), have been connected to the craze for spirit photography in Japan. Nakata reveals that such spirit photographs inspired some of *Ring*'s most striking visuals: the distorted faces in photographs of those who have been marked by Sadako's curse, as well as the Miyazaki-like hooded figure on Sadako's videotape. I will return to the subject of spirit photography later in this chapter.

38. Nakata was hit particularly hard by the collapse of Nikkatsu, the studio where he entered the film industry in the mid-1980s. See Mes and Sharp, *The Midnight Eye Guide*, 251–55.

39. Nakata, interview with the author.

40. Sawaragi, "On the Battlefield," 204–5. For an account that argues Sawaragi devotes too little attention to this vacillation, see Môri, "Subcultural Unconsciousness in Japan."

41. It is to the credit of the National Museum of Modern Art that it has been willing to display some of the most violent and disturbing war paintings from its collection. For example, when I visited on June 21, 2008, one of the three war paintings in the gallery was Fujita Tsuguharu's *Fierce Fighting of Kaoru Paratroops After Landing on the Enemy's Position* (1945), which depicts Japanese soldiers beheading the enemy during combat. I was also permitted to study color reproductions of all 153 war paintings in the museum's art library, which is open to the public. I am grateful to Miwa Kenjin and the library staff for their assistance.

42. Sawaragi, "On the Battlefield," 199.

43. Kaido, "Reconstruction," 11. The arrests of Fukuzawa and Takiguchi grew out of long-standing government surveillance of surrealist activities, dating back at least to 1936. See Clark, "Artistic Subjectivity," 48. For additional context on Takiguchi see Sas, *Fault Lines*.

44. Clark, "Artistic Subjectivity," 50.

45. Kaido, "Reconstruction," 11. There is only one war painting by Fukuzawa in the collection at the National Museum of Modern Art: *Shipborne Special Unit Leaves the Base* (1945).

46. Kaido, "Reconstruction," 11. On Fujita's career, including his brief flirtation with surrealism while living in Paris in the late 1920s and early 1930s

and associating with Robert Desnos, see Birnbaum, *Glory in a Line*, 150–59. There are fourteen war paintings by Fujita in the collection at the National Museum of Modern Art, more than any other artist.

47. Suzuki, *Ring*, 193.

48. Eric Cazdyn refers to an event occurring on Japanese television in the late 1980s that may have inspired *Ring*, particularly the novel's (and film's) investments in the past: "At about three or four in the morning, signals would be recircuited and images and audio would appear, flickering like television broadcasts of a bygone era. . . . There were family photographs, old documentary footage of World War II war criminals, and Zengakuren demonstrations . . . but then, before the event could become something, before it could become History, the images . . . stopped" (Cazdyn, "Representation, Reality Culture, and Global Capitalism," 295–96).

49. Takahashi, interview with the author. On the Japanese human experimentation program see Harris, *Factories of Death*.

50. Suzuki, *Ring*, 143.

51. Nakata, interview with the author.

52. Takahashi, e-mail communication with the author, June 26, 2008.

53. Nakata, interview with the author.

54. Takahashi, interview with the author.

55. Buñuel, "Notes," 153.

56. See Fraleigh and Nakamura, *Hijikata Tatsumi*, 24, 100.

57. Klein, *Ankoku butō*, 26; see also Fraleigh and Nakamura, *Hijikata Tatsumi*, 84; and Sas, *Fault Lines*, 161–64.

58. Hijikata's unforgettable presence in the cult horror film *Kyofu kikei ningen* (*Horrors of Malformed Men*, Ishii Teruo, 1969) anticipates Sadako in a number of striking ways: the outcast's thirst for revenge, the spastic movements, the white robe, the long black hair. The fact that Hijikata "began letting his hair grow long in the 1960s in the belief that this act would help his sister [sold into prostitution during Hijikata's impoverished youth] to live on within him" also suggests parallels with Suzuki's Sadako, who is described as androgynous and hermaphroditic. See Klein, *Ankoku butō*, 6. On Hijikata's participation in the avant-garde film scene of the 1960s, including the experimental films *Heso to genbaku* (*Navel and A-Bomb*, Hosoe Eikō, 1960) and *Sacrifice* (Donald Richie, 1959), see London, "X," 286–89. It is worth noting that Hijikata is just one example among several others that point toward rich intersections between Japanese avant-garde film

traditions and Japanese horror film traditions. Consider, for example, the careers of Teshigahara Hiroshi, Wakamatsu Kōji, Tsukamoto Shinya, Sato Hisayasu, and Miike Takashi. See Hunter, *Eros in Hell*; and Standish, *Politics, Porn and Protest*.

59. This globalized network also includes the Korean remake of *Ring*, entitled *The Ring Virus* (Kim Dong-bin, 1999). Space does not permit an analysis of this film here, but its historic status as a Korean-Japanese coproduction is a fascinating instance of global contra-flow and of Japan's recent cultural influence in Asia. For more on these cultural contexts (although neither *Ring* nor *The Ring Virus* is discussed specifically) see Iwabuchi, *Recentering Globalization*.

60. *The Ring*, released not long after the events of September 11, 2001, may well have evoked another Japanese/American historical association commonly mentioned in the American media at that time: the perceived similarity between 9/11 and Pearl Harbor. For more on this connection see Landy, "'America Under Attack'"; and Lowenstein, *Shocking Representation*, 177–84.

61. Lippit, *Atomic Light (Shadow Optics)*, 4. See also Broderick, *Hibakusha Cinema*.

62. I am not suggesting that Lippit is uninterested in national contexts beyond Japan, as he includes, for example, illuminating analyses of *The Invisible Man* (James Whale, 1933) and *X: The Man with the X-Ray Eyes* (Roger Corman, 1963). But *The Ring* is not mentioned at all and *Ring* only in a footnote (Lippit, *Atomic Light*, 193n10). In short, I believe my own chapter can be read usefully alongside Lippit's fine research.

63. See, e.g., Hein and Selden, *Living with the Bomb*.

64. See Tsutsui and Ito, *In Godzilla's Footsteps*.

65. *Curse of the Ring*, www.curseofthering.com/production.php. Directly quoted material from this website appeared originally at *The Ringworld* (www.theringworld.com/production.php), a website that is no longer available. Interested readers will, as of this writing, find the bulk of this material at *Curse of the Ring*, www.curseofthering.com.

66. Of course, this is not meant to suggest that *Curse of the Ring* serves only to open up analytic possibilities for viewers; it is also capable of closing them off. For an illuminating analysis of the conservative aspects of online *Ring* fandom see Hills, "Ringing the Changes."

67. *Curse of the Ring*, "FAQ—The American Films," www.curseofthering.com/faq2.php#curseimages (formerly at www.theringworld.com/faq2.php#curseimages).

68. *Curse of the Ring*, "Factual Basis of *The Ring*," www.curseofthering.com/fact. php (formerly at www.theringworld.com/fact.php).

69. Fukurai, *Clairvoyance and Thoughtography*, 7.

70. Ibid., 164.

71. See *Curse of the Ring*, "Factual Basis of *The Ring*," www.curseofthering.com/ fact.php (formerly at www.theringworld.com/fact.php).

72. *Inteferon's Viral Vestibule*, www.neodymsystems.com/ring/index.shtml.

73. "*The Ring* Images—X-Rays," www.neodymsystems.com/ring/trxray.shtml.

74. Man Ray, *Self Portrait*, 128.

75. Ibid., 129.

76. See, e.g., L'Ecotais, "Man Ray"; and Livingston, "Man Ray and Surrealist Photography."

77. Krauss, "Photography," 24. Krauss also reminds us that Man Ray's photography, along with surrealist photography in general, encompasses many more styles and techniques than just rayography: "solarization, negative printing, *cliché verre*, multiple exposure, photomontage, and photocollage" (25). But for the purposes of this chapter my focus will be on rayography.

78. Man Ray, *Self Portrait*, 278.

79. Ibid., 286–87.

80. Man Ray, "Cinemage," 133.

81. *Curse of the Ring*, "Interview with Gore Verbinski," www.curseofthering.com/ gore.php (formerly at www.theringworld.com/gore.php).

82. See Heiting, *Man Ray, 1890–1976*, 187.

83. See Man Ray, *Self Portrait*, 116.

84. Man Ray, quoted in Krauss, "Photography," 24; see also Man Ray, *Exhibition Rayographs, 1921–1928*.

85. See Man Ray, *Self Portrait*, 128.

86. Ibid., 129.

87. Breton, *Surrealism and Painting*, 32.

88. For more on Breton's relation to photography see Krauss, "Photography," 15; and Ades, "Photography and the Surrealist Text," 161.

89. Breton, quoted in L'Ecotais, "Man Ray," 156.

90. Breton, *Surrealism and Painting*, 70.

91. Bazin, "Ontology of the Photographic Image," 16, 15.

92. Ibid., 15.

93. Nakata, interview with the author.

94. Gunning, "Phantom Images," 42–43.

95. Breton, *Surrealism and Painting*, 30, 32.

96. See Internet Movie Database, www.imdb.com/title/tt0298130/moviecon-nections.

97. Murakami, "*Superflat* Trilogy," 161.

4. POSTHUMAN SPECTATORSHIP

1. Hayles, *How We Became Posthuman*, 3–5.

2. This is not to say that this sort of scholarly investigation would be fruitless; far from it. See, e.g., Badmington, *Alien Chic*; Bukatman, *Terminal Identity*; and Stacey, *Cinematic Life of the Gene*.

3. Wolfe, *What Is Posthumanism?* xviii–xix.

4. For histories and analyses of YouTube see, e.g., Burgess and Green, *YouTube*; and Snickars and Vonderau, *The YouTube Reader*.

5. "Christian the Lion," www.youtube.com/watch?v=zVNTdWbVBgc.

6. See Bourke and Rendall, *A Lion Called Christian*.

7. Daston, "Intelligences," 54.

8. See Haraway, "A Cyborg Manifesto." For an overview of animal studies see Kalof and Fitzgerald, *The Animals Reader*. For valuable contributions to animal studies that are particularly sensitive to cinema, see Burt, *Animals in Film*; and Lippit, *Electric Animal*.

9. Haraway, *When Species Meet*, 31–32, 17.

10. "Christian the Lion—Reunited—From *The View*," www.youtube.com/watch?v=oiGKWoJi5qM.

11. "Christian the Lion Owners—SHOCKING REAL Story," www.youtube.com/watch?v=ViaPc8IuJeM.

12. Haraway, *When Species Meet*, 32.

13. "Me at the Zoo," www.youtube.com/watch?v=jNQXAC9IVRw.

14. Buñuel, quoted in Colina and Pérez Turrent, *Objects of Desire*, 6.

15. Ibid., 34.

16. On Buñuel's Mexican films see Acevedo-Muñoz, *Buñuel and Mexico*; and Strayer, "Ruins and Riots."

17. Bazin, "Cruelty and Love," 52.

18. See Polizzotti, *Los olvidados*, 31–32.

19. Ibid., 71–72.

20. See Colina and Pérez Turrent, *Objects of Desire*, 61.

21. See Polizzotti, *Los olvidados*, 72. For Paz's writings on Buñuel see Paz, *On Poets and Others*, 152–65.

22. See Polizzotti, *Los olvidados*, 75–76.

23. Buñuel, quoted in Colina and Pérez Turrent, *Objects of Desire*, 59.

24. Lastra, "Why Is This Absurd Picture Here?" 209.

25. See Polizzotti, *Los olvidados*, 33; Colina and Pérez Turrent, *Objects of Desire*, 60; and Buñuel, *My Last Breath*, 199.

26. Indeed, the shot of the chicken could be a remnant of a deeper surrealist strategy Buñuel originally wished to pursue in the film but ultimately abandoned: the insertion of "*a priori* unjustified elements, irrational sparks, quick shots" that functioned as "an attempt not to follow the story line to the letter, to achieve a 'photographic' reality" (Buñuel, quoted in Colina and Pérez Turrent, *Objects of Desire*, 63).

27. Haraway, *When Species Meet*, 259. For a relevant sample from *Crittercam* see "Crittercam: Lions," www.youtube.com/watch?v=VpAR4OV-9Ds.

28. Haraway, *When Species Meet*, 251, 255, 257.

29. Ibid., 261.

30. Ibid., 23, 27. See also Derrida, *The Animal*; and Deleuze and Guattari, *A Thousand Plateaus*.

31. See, e.g., Singer, "Animal Liberation"; and Regan, "The Rights of Humans."

32. Haraway, *When Species Meet*, 36.

33. Deleuze and Guattari, *A Thousand Plateaus*, 240.

34. Ibid., 233.

35. Bazin, "Death Every Afternoon," 29.

36. Bataille, *Story of the Eye*, 56–57.

37. Bazin, "Death Every Afternoon," 30.

38. Ibid., 31.

39. Ibid., 30, 31.

40. Bazin, "Ontology of the Photographic Image," 15–16.

41. Bazin, "Death Every Afternoon," 30.

42. Ibid., 29–30.

43. See Daney, "The Screen of Fantasy," esp. 37. For additional commentary on Bazin and animals see Fay, "Seeing/Loving Animals"; and Jeong and Andrew, "Grizzly Ghost."

44. Bazin, "Virtues and Limitations of Montage," 49n.

45. Ibid., 49–50n.

46. Ibid., 50.

47. Bazin "Cruelty and Love," 51, 52, 57.

48. Ibid., 57–58.

49. See Bataille, *The Absence of Myth*, 34–46. Subsequent citations of this source will be referenced parenthetically in the text proper by the abbreviation *AM*, followed by the appropriate page number(s).

50. Bataille's refusal to insist here on the actual killing of animals as the means to reach a poetic awakening in the reader should not be construed as evidence that his thinking can be easily assimilated to an animal rights or animal liberation agenda. There are many instances in Bataille's work where animals, however fascinating or even enviable for "being neither a thing nor a man," prove incapable of reaching the privileged sorts of experience (especially radical negativity) he values as human potentialities. See, e.g., Bataille, *Theory of Religion*, 21; and Bataille, *The Accursed Share*, 27–29. For a relevant commentary on Bataille's resistance to notions of animality advanced by his teacher Alexandre Kojève in his famed lectures on Hegel, see Agamben, *The Open*, 5–12.

51. For a consideration of Prévert's film work in relation to surrealism see Richardson, *Surrealism and Cinema*, 45–59.

52. Bataille, "Eye," 19n1.

53. Breton , "As in a Wood," 73.

54. Ibid., 73–74. It is important to note, however, that Breton does not believe that cinema has lived up to its surrealist potential in its mainstream, commercialized, "controlled" form. The surrealist potential clearly resides primarily with what spectators can do with such films rather than with the films themselves. See ibid., 76–77.

55. Bataille, "Eye," 19n1.

5. COLLABORATIVE SPECTATORSHIP

1. One measure of Cornell's stature is the explosion of art historical scholarship that has been devoted to him in recent years. In addition to the volumes I will refer to later in this chapter see, for example, Caws, *Joseph Cornell's Theater*; Hartigan, *Joseph Cornell*; Hartigan, et al., *Joseph Cornell*; and Waldman, *Joseph Cornell*. The Joseph Cornell Study Center, an important archival resource, was established at the Smithsonian American Art Museum in 1978.

2. For a fascinating record of the Levy Gallery's approach to surrealism (and Cornell's centrality to it) see Levy, *Surrealism*.

3. The story of *Rose Hobart*'s first screening has been recounted numerous times with slight variations in detail, but Dalí's viciousness and Cornell's shock are emphasized in all of the accounts. Another recurring theme is how remarkably long-lasting the traumatic effect of this incident remained with Cornell. See, e.g., Levy, *Memoir of an Art Gallery*, 229–31; Sitney, "Cinematic Gaze of Joseph Cornell," 77; and Solomon, *Utopia Parkway*, 87–89.

4. A number of Dalí's artworks that predate *Rose Hobart* actually do suggest certain general points of resemblance with some aspects of Cornell's film. See, e.g., his collages *The Marriage of Buster Keaton* (1925) and *L'phénomène de l'extase* (1933). The former indicates how Keaton, whom Dalí called "Pure Poetry," may have occupied a similar place in Dalí's imagination as Hobart did in Cornell's. See Gale, "In Darkened Rooms," 53; and Lastra, "Buñuel, Bataille, and Buster." *L'phénomène de l'extase* is discussed in relation to *Rose Hobart* in Hauptman, *Joseph Cornell*, 95–97. There is no doubt that Dalí was an influential figure for Cornell, who apparently even bought a Dalí painting or drawing from the Levy Gallery in 1932. See Solomon, *Utopia Parkway*, 70–71. It is also likely that Cornell attended screenings of *Un chien andalou* and *L'âge d'or* in New York in 1933. See Ades, "The Transcendental Surrealism," 40n15.

5. Cornell, quoted in Hartigan, "Joseph Cornell: A Biography," 103.

6. For an exploration of Cornell's art that focuses on his connection to Christian Science, see Starr, *Joseph Cornell*.

7. Richardson, *Surrealism and Cinema*, 11, 69–70. Another recent example of this disparaging attitude toward Cornell's importance for surrealism can be found in the new introduction to the reprinted edition of Levy's *Surrealism*, where Mark Polizzotti writes that Cornell "is amply—one might say too amply—represented here" (Polizzotti, introduction to *Surrealism*, vii).

8. Sitney, *Visionary Film*, 350.

9. Hoving, *Joseph Cornell and Astronomy*, 61.

10. Sitney, "Cinematic Gaze of Joseph Cornell," 76, 77.

11. Ibid., 76.

12. Indeed, late in his life Cornell would refer to memories from the 1930s as "the 'Chien Andalou' days" (quoted in Hoving, *Joseph Cornell and Astronomy*, 20).

13. Tashjian, *Joseph Cornell*, 17, 18.

14. For fascinating testimony to this process (which is not without its moments of disagreement) see Cornell's letters to Stan Brakhage in the Joseph Cornell Papers at Anthology Film Archives, New York. Incidentally, when Cornell writes to Brakhage about his appreciation of *Umberto D.* (Vittorio

De Sica, 1952) and *La strada* (Federico Fellini, 1954), another pathway opens toward recognizing the surrealism in cinematic realism (as covered in my discussions of Bazin in chapters 1 and 4). See Cornell's letters of Nov. 27, 1955, and October 1956, respectively. I am grateful to Anthology's director of library collections, Robert A. Haller, for pointing me toward Cornell's correspondence with Brakhage. For more recent, posthumous instances of artistic collaboration with Cornell see Foer, *A Convergence of Birds*; and Roche, "Performing Memory."

15. For a touching personal account of Cornell's gift-giving see Michelson, "*Rose Hobart* and *Monsieur Phot*," 47–48. For a less charitable take on Cornell's gifts (he calls Cornell "weird" and "creepy," although not without some admiration) see Gopnik, "Sparkings," 184, 187.

16. It appears that Hobart, who died in 2000 at the age of ninety-four, only learned of Cornell's film in 1982. It was too late for her to meet the filmmaker, but she did watch the film. See Keller, "I Met Rose Hobart"; and Haller, "Joseph Cornell." Both of these publications can be found in the Joseph Cornell Papers at Anthology Film Archives.

17. On these projects see Tashjian, *Joseph Cornell*; and Hauptman, *Joseph Cornell*.

18. Sitney, "Cinematic Gaze of Joseph Cornell," 75.

19. Michelson, "*Rose Hobart* and *Monsieur Phot*," 56.

20. See Hauptman, *Joseph Cornell*, 219n51.

21. See Sitney, "Cinematic Gaze of Joseph Cornell," 77.

22. See Hartigan, "Joseph Cornell," 112. Hartigan also notes that Cornell met Sontag in January 1966 and made "at least one collage, *The Ellipsian* [1966], in her honor" (112).

23. Sontag, "Apocalypse in a Paint Box," 27. Sontag's review includes a wide-ranging genealogy of surrealism that includes the artist Jasper Johns, whom she sees as an "heir to Duchamp and Joseph Cornell" (26).

24. The most extensive account of these relationships can be found in Solomon, *Utopia Parkway*.

25. See Tashjian, *Joseph Cornell*, 42–61. Since Lee Miller appears in Jean Cocteau's *Le sang d'un poète* (*Blood of a Poet*, 1930), it seems worth mentioning that a common antipathy toward Cocteau from within the precincts of surrealism may well include a homophobic dimension, however indirectly expressed. For a stimulating study of how the films of Cocteau and Cornell share certain thematic qualities, see Keller, *The Untutored Eye*.

26. Kuenzli, "Surrealism and Misogyny," 17–18. For ambitious attempts to expand the surrealist canon so that women might occupy a more central role, see

Rosemont, *Surrealist Women*; and Chadwick, *Women Artists*.

27. Hauptman, *Joseph Cornell*, 97.

28. Solomon, *Utopia Parkway*, 87, 70. On Duchamp and Cornell's relationship see also Tashjian, *A Boatload of Madmen*, 239–42; Tomkins, *Duchamp*, 331; and Davidson and Temkin, *Joseph Cornell/Marcel Duchamp*.

29. Tashjian, "'Vous pour moi?'" 37, 38.

30. Among Duchamp's notable contributions to surrealism was his famous design for the web of string that covered the "First Papers of Surrealism" gallery show in New York in 1942; Duchamp's installation came at the invitation of André Breton. See Tomkins, *Duchamp*, 332. See also Breton's glowing appreciation of Duchamp in his *Surrealism and Painting*, 85–99.

31. Tashjian, "'Vous pour moi?'" 44, 45.

32. *Enchanted Wanderer* was originally published in *View*, an American arts journal sympathetic to surrealism. For further analysis see Sitney, "Cinematic Gaze of Joseph Cornell," 73–74; and Hauptman, *Joseph Cornell*, 1–10.

33. Cornell, "'Enchanted Wanderer,'" 206, 208. This reprint does not include Cornell's collage illustration of Lamarr featured in the original publication. For a reproduction of the original see fig. 5.5.

34. Cornell, "'Enchanted Wanderer,'" 208. The importance of music to Cornell's art can scarcely be overestimated. See, e.g., Hussey, "Music in the World."

35. *Mrs. Rock Hudson LOVES Mr. Rock Hudson!!!*, www.youtube.com/user/MrsRock-Hudson. All subsequent quotations from *Mrs. Rock Hudson* can be found at this address.

36. For useful critical overviews of Hudson's career see Klinger, *Melodrama and Meaning*, 97–131; Cohan, *Masked Men*, 264–303; and Meyer, "Rock Hudson's Body." For Hudson's autobiography see Hudson and Davidson, *Rock Hudson*.

37. For an important contextualization of the cultural and political landscape of AIDS within which Hudson's image circulated, see Crimp, *AIDS*.

38. Dyer, "Rock," 162.

39. For a revealing account of this film's genesis see Rappaport, "Mark Rappaport's Notes."

40. See Pratley, *Cinema of John Frankenheimer*, 131–48.

41. Frankenheimer's commentary on this scene is somewhat at odds with the account given of it in Oppenheimer and Vitek, *Idol*, 87–88. Oppenheimer and Vitek assert that the scene had to be shot twice; the first, with Hudson actually drunk, led to Hudson's emotional breakdown on the set, while the second, with Hudson sober, was actually used in the film. Of course, it is possible that footage from both shoots wound up in the final cut. Hudson's

costar, Salome Jens, believes that at the time, Hudson was a high-functioning alcoholic. See Oppenheimer and Vitek, *Idol*, 88.

42. See Oppenheimer and Vitek, *Idol*, 80–92; and Blinder, *"Seconds,"* 212–17.

43. Dyer, too, is alert to the exceptional nature of *Seconds* for Hudson, especially the "queer resonances" of the film's story that "may suggest the idea of the gay Rock making a bid to escape the confines of his straight image" (Dyer, "Rock," 170).

44. Ibid., 172–73.

45. For a brilliant discussion of how such mechanisms of fantasy operate in the public sphere, see Warner, "The Mass Public."

46. See Sitney, "Cinematic Gaze of Joseph Cornell," 77.

47. Sontag, "Notes on 'Camp,'" 277. For more recent investigations of camp that focus particularly on film and visual media, see, for example, Doty, *Making Things Perfectly Queer*; Robertson, *Guilty Pleasures*; and Tinkcom, *Working like a Homosexual*.

48. Dyer, *Heavenly Bodies*, 14.

49. Rappaport, "Mark Rappaport's Notes," 16–17.

50. On the *Seconds* DVD Frankenheimer reports that shooting this scene required multiple replacements of the gurney's leather straps because Hudson kept snapping them; in addition, two professional football players were needed to hold him down while he performed.

51. Frankenheimer, quoted in Oppenheimer and Vitek, *Idol*, 91. On the cult reputation of *Seconds* see also Blinder, *"Seconds,"* 212. For a more expansive consideration of Frankenheimer's career see Pomerance and Palmer, *A Little Solitaire*.

52. Breton, *Surrealism and Painting*, 16. See also Brunius, "Crossing the Bridge," 99–102. Although this excerpt from Brunius's *En marge du cinéma français* (1954) was given its title by Hammond (in an allusion to Breton, presumably), its concerns dovetail with Breton's concept.

53. Breton, *Surrealism and Painting*, 16.

AFTERWORD: MAKING CINEMATIC TIME

1. Benjamin, "Theses on the Philosophy of History," 262, 255; see also Lowenstein, *Shocking Representation*, 12–16. My understanding of Benjamin has always been, and continues to be, shaped by the scholarship of Miriam Bratu Hansen; see, e.g., her *Cinema and Experience*.

2. See Zalewski, "The Hours."

3. Nor is it a Deleuzian film, for that matter, despite the understandable temptation to assimilate *The Clock* into Deleuze's notion of a time-image. But this would ultimately be a misleading literalization of Deleuze, not an illustration of his concept. See Deleuze, *Cinema 2*.

4. See Hammond, "Lost and Found." For a fascinating document that attests to the Surrealist Group's investment in *L'âge d'or*, see their "Manifesto of the Surrealists."

5. See Hammond, *L'âge d'or*, 8.

6. Ibid., 9.

7. See ibid., 60–69.

Bibliography

Aaron, Michele. *Spectatorship: The Power of Looking On*. London: Wallflower, 2007.

Aarseth, Espen. *Cybertext: Perspectives on Ergodic Literature*. Baltimore: Johns Hopkins University Press, 1997.

Abel, Richard, ed. *French Film Theory and Criticism: A History/Anthology*. 2 vols. Princeton, NJ: Princeton University Press, 1988.

Acevedo-Muñoz, Ernesto R. *Buñuel and Mexico: The Crisis of National Cinema*. Berkeley: University of California Press, 2003.

Adamowicz, Elza. *Un chien andalou*. London: I. B. Tauris, 2010.

Ades, Dawn. "Photography and the Surrealist Text." In Krauss and Livingston, *L'amour fou*, 155–91.

——. "The Transcendental Surrealism of Joseph Cornell." In McShine, *Joseph Cornell*, 14–41.

Agamben, Giorgio. *The Open: Man and Animal*. Translated by Kevin Attell. Stanford, CA: Stanford University Press, 2004.

Alexandrian, Sarane. *Le surréalisme et le rêve*. Paris: Gallimard, 1974.

Allen, Matthew, and Rumi Sakamoto, eds. *Popular Culture, Globalization and Japan*. London: Routledge, 2006.

Andrew, Dudley. *André Bazin*. New York: Oxford University Press, 1978.

——. "An Atlas of World Cinema." In *Remapping World Cinema: Identity, Culture and Politics in Film*, edited by Stephanie Dennison and Song Hwee Lim, 19–29. London: Wallflower, 2006.

——. "The Ontology of a Fetish." *Film Quarterly* 61, no. 4 (2008): 62–66.

——. *What Cinema Is! Bazin's Quest and Its Charge*. Oxford: Wiley-Blackwell, 2010.

Andrew, Dudley, with Hervé Joubert-Laurencin, eds. *Opening Bazin: Postwar Film Theory and Its Afterlife*. New York: Oxford University Press, 2011.

Appadurai, Arjun. *Modernity at Large: Cultural Dimensions of Globalization*. Minneapolis: University of Minnesota Press, 1996.

Badmington, Neil. *Alien Chic: Posthumanism and the Other Within*. New York: Routledge, 2004.

Banks, Russell. *The Sweet Hereafter*. New York: HarperPerennial, 1992.

Banks, Russell, and Atom Egoyan. "*The Sweet Hereafter*." In *Subtitles: On the Foreignness of Film*, edited by Atom Egoyan and Ian Balfour, 35–62. Cambridge, MA: MIT Press, 2004.

Barthes, Roland. *Camera Lucida: Reflections on Photography*. 1980. Translated by Richard Howard. New York: Hill and Wang, 1996.

——. "The Death of the Author." 1968. In *Image-Music-Text*, 142–48.

——. "Diderot, Brecht, Eisenstein." 1973. In *Image-Music-Text*, 69–78.

——. *The Grain of the Voice: Interviews, 1962–1980*. Translated by Linda Coverdale. Berkeley: University of California Press, 1991.

——. *Image-Music-Text*. Translated by Stephen Heath. New York: Hill and Wang, 1978.

——. "Leaving the Movie Theater." 1975. In *The Rustle of Language*, 345–49.

——. "The Metaphor of the Eye." 1963. In *Critical Essays*, 239–47. Translated by Richard Howard. Evanston, IL: Northwestern University Press, 1972.

——. "On Film." 1963. In *Grain of the Voice*, 11–24.

——. "Outcomes of the Text." 1972. In *The Rustle of Language*, 238–49.

——. "The Photographic Message." 1961. In *Image-Music-Text*, 15–31.

——. *The Rustle of Language*. Translated by Richard Howard. New York: Hill and Wang, 1986.

——. "The Surrealists Overlooked the Body." 1975. In *Grain of the Voice*, 243–45.

——. *S/Z*. 1970. Translated by Richard Miller. New York: Hill and Wang, 1974.

——. "The Third Meaning: Research Notes on Some Eisenstein Stills." 1970. In *Image-Music-Text*, 52–68.

Bataille, Georges. *The Absence of Myth: Writings on Surrealism*. Edited and translated by Michael Richardson. London: Verso, 1994.

———. *The Accursed Share*. 1967–76. 3 vols. Translated by Robert Hurley. New York: Zone, 1991–93.

———. "The Big Toe." 1929. In *Visions of Excess*, 20–23.

———. *Documents: Doctrines, archéologie, beaux-arts, ethnographie*. 1929–30. 2 vols. Paris: Jean-Michel Place, 1991.

———. "Eye." 1929. In *Visions of Excess*, 17–19.

———. "Le gros orteil." *Documents* 6 (Nov. 1929): 297–302.

———. "The 'Lugubrious Game.'" 1929. In *Visions of Excess*, 24–30.

———. "The Notion of Expenditure." 1933. In *Visions of Excess*, 116–29.

———. "The Psychological Structure of Fascism." 1933–34. In *Visions of Excess*, 137–60.

———. *Story of the Eye*. 1928. Translated by Joachim Neugroschel. San Francisco: City Lights, 1987.

———. *Theory of Religion*. 1973. Translated by Robert Hurley. New York: Zone, 1989.

———. *Visions of Excess: Selected Writings, 1927–1939*. Edited Allan Stoekl. Translated by Allan Stoekl, Carl R. Lovitt, and Donald M. Leslie Jr. Minneapolis: University of Minnesota Press, 1993.

Bazin, André. "Adaptation, or the Cinema as Digest." 1948. Translated by Alain Piette and Bert Cardullo. In Naremore, *Film Adaptation*, 19–27.

———. "*Battle of the Rails* and *Ivan the Terrible*." 1946. In *Bazin at Work: Major Essays and Reviews from the Forties and Fifties*, 197–203. Edited by Bert Cardullo. Translated by Alain Piette and Bert Cardullo. New York: Routledge, 1997.

———. "*Cabiria*: The Voyage to the End of Neorealism." 1957. In *What Is Cinema?* 2:83–92.

———. *The Cinema of Cruelty: From Buñuel to Hitchcock*. Edited by François Truffaut. Translated by Sabine d'Estrée with Tiffany Fliss. New York: Seaver, 1982.

———. "Cruelty and Love in *Los olvidados*." 1951. In *The Cinema of Cruelty*, 51–58.

———. "Death Every Afternoon." 1949. Translated by Mark A. Cohen. In Margulies, *Rites of Realism*, 27–31.

———. "The Myth of Total Cinema." 1946. In *What Is Cinema?* 1:17–22.

———. "The Ontology of the Photographic Image." 1945. In *What Is Cinema?* 1:9–16.

———. "Science Film: Accidental Beauty." 1947. Translated by Jeanine Herman. In *Science Is Fiction: The Films of Jean Painlevé*, edited by Andy Masaki Bellows, Marina McDougall, and Brigitte Berg, 144–47. Cambridge, MA: MIT Press, 2000.

———. "*Subida al cielo*." 1952. In *The Cinema of Cruelty*, 59–63.

——. "The Virtues and Limitations of Montage." 1953/1957. In *What Is Cinema?* 1:41–52.

——. *What Is Cinema?* Edited and translated by Hugh Gray. 2 vols. Berkeley: University of California Press, 2005.

Belton, John. "Digital Cinema: A False Revolution." *October* 100 (Spring 2002): 98–114.

Benjamin, Walter. "Surrealism: The Last Snapshot of the European Intelligentsia." 1929. In *Reflections*, 177–92. Edited by Peter Demetz. Translated by Edmund Jephcott. New York: Schocken, 1986.

——. "Theses on the Philosophy of History." 1940. In *Illuminations*, 253–64. Edited by Hannah Arendt. Translated by Harry Zohn. New York: Schocken, 1969.

Betz, Mark. *Beyond the Subtitle: Remapping European Art Cinema.* Minneapolis: University of Minnesota Press, 2009.

Birnbaum, Phyllis. *Glory in a Line: A Life of Foujita—The Artist Caught Between East and West.* New York: Faber and Faber, 2006.

Blinder, Henry. "*Seconds.*" In *Cult Movies 3: 50 More of the Classics, the Sleepers, the Weird, and the Wonderful,* by Danny Peary, 212–17. New York: Simon and Schuster, 1988.

Bogost, Ian. *How to Do Things with Videogames.* Minneapolis: University of Minnesota Press, 2011.

Bordwell, David. "The Art Cinema as a Mode of Film Practice." 1979. In *Film Theory and Criticism: Introductory Readings,* 6th ed., edited by Leo Braudy and Marshall Cohen, 774–82. New York: Oxford University Press, 2004.

——. *Narration in the Fiction Film.* Madison: University of Wisconsin Press, 1985.

Bourke, Anthony, and John Rendall. *A Lion Called Christian.* New York: Broadway, 2009.

Brereton, Pat. *Smart Cinema, DVD Add-Ons and New Audience Pleasures.* New York: Palgrave Macmillan, 2012.

Breton, André. "As in a Wood." 1951. In Hammond, *The Shadow and Its Shadow,* 72–77.

——. "Manifesto of Surrealism." 1924. In *Manifestoes of Surrealism,* 1–47.

——. *Manifestoes of Surrealism.* Translated by Richard Seaver and Helen R. Lane. Ann Arbor: University of Michigan Press, 1994.

——. "Second Manifesto of Surrealism." 1929. In *Manifestoes of Surrealism,* 119–87.

——. *Surrealism and Painting.* 1928. Translated by Simon Watson Taylor. Boston: MFA, 2002.

Broderick, Mick, ed. *Hibakusha Cinema: Hiroshima, Nagasaki, and the Nuclear Image in Japanese Film.* London: Kegan Paul International, 1996.

Brooker, Will, and Deborah Jermyn, eds. *The Audience Studies Reader*. New York: Routledge, 2003.

Brotchie, Alastair, ed. *Encyclopaedia Acephalica*. London: Atlas, 1995.

Brotchie, Alastair, and Mel Gooding, eds. *A Book of Surrealist Games*. Boston: Shambhala Redstone, 1991.

Brunius, Jacques. "Crossing the Bridge." 1954. In Hammond, *The Shadow and Its Shadow*, 99–102.

Buckland, Warren, ed. *Puzzle Films: Complex Storytelling in Contemporary Cinema*. Oxford: Wiley-Blackwell, 2009.

Bukatman, Scott. *Terminal Identity: The Virtual Subject in Postmodern Science Fiction*. Durham, NC: Duke University Press, 1993.

Buñuel, Luis. "A Giraffe." 1933. In *An Unspeakable Betrayal*, 44–48.

——. *My Last Breath*. 1982. Translated by Abigail Israel. London: Vintage, 1994.

——. "A Night at the Studio des Ursulines." 1927. In *An Unspeakable Betrayal*, 95–98.

——. "Notes on the Making of *Un chien andalou*." 1947. Translated by Grace L. McCann Morley. In *The World of Luis Buñuel: Essays in Criticism*, edited by Joan Mellen, 151–53. New York: Oxford University Press, 1978.

——. "Pessimism." 1980. In *An Unspeakable Betrayal*, 258–63.

——. "*Un chien andalou*." 1929. In *An Unspeakable Betrayal*, 162–69.

——. *An Unspeakable Betrayal: Selected Writings of Luis Buñuel*. Translated by Garrett White. Berkeley: University of California Press, 2002.

——. "Why I Don't Wear a Watch." 1923. In *An Unspeakable Betrayal*, 14–18.

Burgess, Jean, and Joshua Green. *YouTube: Online Video and Participatory Culture*. Cambridge: Polity, 2009.

Burt, Jonathan. *Animals in Film*. London: Reaktion, 2002.

Caillois, Roger. *The Edge of Surrealism: A Roger Caillois Reader*. Edited by Claudine Frank. Translated by Claudine Frank and Camille Nash. Durham, NC: Duke University Press, 2003.

——. "The Image." 1946. In *The Edge of Surrealism*, 317–19.

——. "Letter to André Breton." 1934. In *The Edge of Surrealism*, 84–86.

——. *Man and the Sacred*. 1939. Translated by Meyer Barash. Glencoe, IL: Free Press, 1960. Originally published as *L'homme et le sacré* (Paris: Leroux).

——. *Man, Play and Games*. 1958. Translated by Meyer Barash. Urbana: University of Illinois Press, 2001.

——. "Mimicry and Legendary Psychasthenia." 1935. In *The Edge of Surrealism*, 91–103.

——. "Surrealism as a World of Signs." 1975. In *The Edge of Surrealism*, 327–34.

——. "Testimony (Paul Éluard)." 1973. In *The Edge of Surrealism*, 60–65.

Caughie, John, and Ramona Fotiade, eds. "Surrealism and Cinema." Special issue, *Screen* 39, no. 2 (1998).

Caws, Mary Ann, ed. *Joseph Cornell's Theater of the Mind: Selected Diaries, Letters, and Files*. New York: Thames and Hudson, 1994.

——, ed. *Surrealism*. London: Phaidon, 2004.

Cazdyn, Eric. "Representation, Reality Culture, and Global Capitalism in Japan." In Yoda and Harootunian, *Japan After Japan*, 275–98.

Chadwick, Whitney. *Women Artists and the Surrealist Movement*. New York: Thames and Hudson, 1985.

"Christian the Lion." www.youtube.com/watch?v=zVNTdWbVBgc.

"Christian the Lion Owners—SHOCKING REAL Story." www.youtube.com/watch?v=ViaPc8luJeM.

"Christian the Lion—Reunited—From *The View*." www.youtube.com/watch?v=oiGKWoJi5qM.

Chun, Wendy Hui Kyong, and Thomas Keenan, eds. *New Media, Old Media: A History and Theory Reader*. New York: Routledge, 2006.

Clark, John. "Artistic Subjectivity in the Taisho and Early Showa Avant-Garde." In Munroe, *Japanese Art After 1945*, 41–53.

Clifford, James. "On Ethnographic Surrealism." In *The Predicament of Culture: Twentieth-Century Ethnography, Literature, and Art*, 117–51. Cambridge, MA: Harvard University Press, 1988.

Clover, Carol J. *Men, Women, and Chain Saws: Gender in the Modern Horror Film*. Princeton, NJ: Princeton University Press, 1992.

Cohan, Steven. *Masked Men: Masculinity and the Movies in the Fifties*. Bloomington: Indiana University Press, 1997.

Colina, José de la, and Tomás Pérez Turrent. *Objects of Desire: Conversations with Luis Buñuel*. Edited and translated by Paul Lenti. New York: Marsilio, 1992.

Copjec, Joan. *Read My Desire: Lacan Against the Historicists*. Cambridge, MA: MIT Press, 1994.

Cornell, Joseph. "'Enchanted Wanderer': Excerpt from a Journey Album for Hedy Lamarr." 1941. In Hammond, *The Shadow and Its Shadow*, 206–8.

Crimp, Douglas, ed. *AIDS: Cultural Analysis / Cultural Activism*. Cambridge, MA: MIT Press, 1988.

"Crittercam: Lions." www.youtube.com/watch?v=VpAR4OV-9Ds.

Curse of the Ring. www.curseofthering.com/index.php.

Daney, Serge. "The Screen of Fantasy (Bazin and Animals)." Translated by Mark A. Cohen. In Margulies, *Rites of Realism*, 32–41.

Daston, Lorraine. "Intelligences: Angelic, Animal, Human." In *Thinking with Animals: New Perspectives on Anthropomorphism*, edited by Lorraine Daston and Gregg Mitman, 37–58. New York: Columbia University Press, 2005.

Davidson, Susan, and Ann Temkin. *Joseph Cornell/Marcel Duchamp... In Resonance*. New York: Distributed Art Publishers, 1998.

Deleuze, Gilles. *Cinema 1: The Movement-Image*. Translated by Hugh Tomlinson and Barbara Habberjam. Minneapolis: University of Minnesota Press, 1986.

——. *Cinema 2: The Time-Image*. Translated by Hugh Tomlinson and Robert Galeta. Minneapolis: University of Minnesota Press, 1989.

Deleuze, Gilles, and Félix Guattari. *A Thousand Plateaus: Capitalism and Schizophrenia*. 1980. Translated by Brian Massumi. Minneapolis: University of Minnesota Press, 2002.

Derrida, Jacques. *The Animal That Therefore I Am*. Edited by Marie-Louise Mallet. Translated by David Wills. New York: Fordham University Press, 2008.

Doty, Alexander. *Making Things Perfectly Queer: Interpreting Mass Culture*. Minneapolis: University of Minnesota Press, 1993.

Drew, Wayne, ed. *David Cronenberg*. London: British Film Institute, 1984.

Ďurovičová, Nataša, and Kathleen Newman, eds. *World Cinemas, Transnational Perspectives*. New York: Routledge, 2010.

Durozoi, Gérard. *History of the Surrealist Movement*. Translated by Alison Anderson. Chicago: University of Chicago Press, 2002.

Dyer, Richard. *Heavenly Bodies: Film Stars and Society*. 2nd ed. London: Routledge, 2004.

——. "Rock: The Last Guy You'd Have Figured?" In *The Culture of Queers*, 159–74. London: Routledge, 2002.

Elliott, Kamilla. *Rethinking the Novel/Film Debate*. Cambridge: Cambridge University Press, 2003.

Elsaesser, Thomas. "Dada/Cinema?" In Kuenzli, *Dada and Surrealist Film*, 13–27.

——. *European Cinema: Face to Face with Hollywood*. Amsterdam: Amsterdam University Press, 2005.

Everett, Anna. "Digitextuality and Click Theory: Theses on Convergence Media in the Digital Age." In *New Media: Theories and Practices of Digitextuality*, edited by Anna Everett and John T. Caldwell, 3–28. New York: Routledge, 2003.

Fay, Jennifer. "Seeing/Loving Animals: André Bazin's Posthumanism." *Journal of Visual Culture* 7, no. 1 (2008): 41–64.

Ferry, Jean. "Concerning *King Kong*." 1934. In Hammond, *The Shadow and Its Shadow*, 161–65.

Finkelstein, Haim. "Dalí and *Un chien andalou*: The Nature of a Collaboration." In Kuenzli, *Dada and Surrealist Film*, 128–42.

Foer, Jonathan Safran, ed. *A Convergence of Birds: Original Fiction and Poetry Inspired by the Work of Joseph Cornell*. New York: Distributed Art Publishers, 2001.

Fogle, Douglas. *Andy Warhol/Supernova: Stars, Deaths, and Disasters, 1962–1964*. Minneapolis: Walker Art Center, 2005.

Fraleigh, Sondra, and Tamah Nakamura. *Hijikata Tatsumi and Ohno Kazuo*. New York: Routledge, 2006.

Frank, Claudine. Introduction to *The Edge of Surrealism*, by Roger Caillois, 1–53.

Fried, Michael. "Barthes's *Punctum*." *Critical Inquiry* 31, no. 3 (2005): 539–74.

Fukurai, T. *Clairvoyance and Thoughtography*. London: Rider, 1931.

Gale, Matthew. "In Darkened Rooms." In *Dalí and Film*, edited by Matthew Gale, 52–69. New York: Museum of Modern Art, 2007.

Galloway, Alexander R. *Gaming: Essays on Algorithmic Culture*. Minneapolis: University of Minnesota Press, 2006.

Galt, Rosalind. *The New European Cinema: Redrawing the Map*. New York: Columbia University Press, 2006.

Galt, Rosalind, and Karl Schoonover, eds. *Global Art Cinema: New Theories and Histories*. New York: Oxford University Press, 2010.

Game Studies: The International Journal of Computer Game Research. 2001–13. www.gamestudies.org.

Gitelman, Lisa. *Always Already New: Media, History, and the Data of Culture*. Cambridge, MA: MIT Press, 2006.

Gitelman, Lisa, and Geoffrey B. Pingree, eds. *New Media, 1740–1915*. Cambridge, MA: MIT Press, 2003.

Goldberg, Ruth. "Demons in the Family: Tracking the Japanese 'Uncanny Mother Film' from *A Page of Madness* to *Ringu*." In *Planks of Reason: Essays on the Horror Film*, rev. ed., edited by Barry Keith Grant and Christopher Sharrett, 370–85. Lanham, MD: Scarecrow, 2004.

Golumbia, David. *The Cultural Logic of Computation*. Cambridge, MA: Harvard University Press, 2009.

Gopnik, Adam. "Sparkings." *New Yorker*, Feb. 17 and 24, 2003, 184–89.

Gunning, Tom. "The Cinema of Attraction: Early Film, Its Spectator, and the Avant-Garde." *Wide Angle* 8 (Fall 1986): 63–70.

——. "Moving Away from the Index: Cinema and the Impression of Reality." *differences* 18, no. 1 (2007): 29–52.

——. "Phantom Images and Modern Manifestations: Spirit Photography, Magic Theater, Trick Films, and Photography's Uncanny." In *Fugitive Images: From*

Photography to Video, edited by Patrice Petro, 42–71. Bloomington: Indiana University Press, 1995.

——. "Re-Newing Old Technologies: Astonishment, Second Nature, and the Uncanny in Technology from the Previous Turn-of-the-Century." In Thorburn and Jenkins, *Rethinking Media Change*, 39–60.

Hall, Stuart. "Encoding/Decoding." In *Culture, Media, Language*, edited by Stuart Hall, Dorothy Hobson, Andrew Lowe, and Paul Willis, 128–38. London: Routledge, 1996.

Haller, Robert A. "Joseph Cornell: Enchanted Wanderer." *OCS News*, July 1993, n.p.

Hammond, Paul. *L'âge d'or*. London: British Film Institute, 1997.

——. "Lost and Found: Buñuel, *L'âge d'or*, and Surrealism." In *Luis Buñuel: New Readings*, edited by Peter William Evans and Isabel Santaolalla, 13–26. London: British Film Institute, 2004.

——, ed. and trans. *The Shadow and Its Shadow: Surrealist Writings on the Cinema*. 3rd ed. San Francisco: City Lights, 2000.

Hand, Richard J. "Aesthetics of Cruelty: Traditional Japanese Theatre and the Horror Film." In McRoy, *Japanese Horror Cinema*, 18–28.

Hansen, Mark B. N. *New Philosophy for New Media*. Cambridge, MA: MIT Press, 2004.

Hansen, Miriam. *Babel and Babylon: Spectatorship in American Silent Film*. Cambridge, MA: Harvard University Press, 1991.

Hansen, Miriam Bratu. *Cinema and Experience: Siegfried Kracauer, Walter Benjamin, and Theodor W. Adorno*. Berkeley: University of California Press, 2011.

Haraway, Donna J. "A Cyborg Manifesto: Science, Technology, and Socialist-Feminism in the Late Twentieth Century." In *Simians, Cyborgs, and Women: The Reinvention of Nature*, 149–81. New York: Routledge, 1991.

——. *When Species Meet*. Minneapolis: University of Minnesota Press, 2008.

Harootunian, Harry, and Tomiko Yoda. Introduction to Yoda and Harootunian, *Japan After Japan*, 1–15.

Harper, Graeme, and Rob Stone, eds. *The Unsilvered Screen: Surrealism on Film*. London: Wallflower, 2007.

Harries, Dan, ed. *The New Media Book*. London: British Film Institute, 2002.

Harris, Sheldon H. *Factories of Death: Japanese Biological Warfare, 1932–1945, and the American Cover-Up*. Rev. ed. New York: Routledge, 2002.

Hartigan, Lynda Roscoe. "Joseph Cornell: A Biography." In McShine, *Joseph Cornell*, 90–119.

——. *Joseph Cornell: Navigating the Imagination*. Salem, MA, and New Haven, CT: Peabody Essex Museum and Yale University Press, 2007.

Hartigan, Lynda Roscoe, Richard Vine, Robert Lehrman, and Walter Hopps. *Joseph Cornell: Shadowplay ... Eterniday*. New York: Thames and Hudson, 2003.

Hauptman, Jodi. *Joseph Cornell: Stargazing in the Cinema*. New Haven, CT: Yale University Press, 1999.

Hayles, N. Katherine. *How We Became Posthuman: Virtual Bodies in Cybernetics, Literature, and Informatics*. Chicago: University of Chicago Press, 1999.

Hein, Laura, and Mark Selden, eds. *Living with the Bomb: American and Japanese Cultural Conflicts in the Nuclear Age*. Armonk, NY: M. E. Sharpe, 1997.

Heiting, Manfred, ed. *Man Ray, 1890–1976*. Köln: Taschen, 2004.

Hills, Matt. "Ringing the Changes: Cult Distinctions and Cultural Differences in US Fans' Readings of Japanese Horror Cinema." In McRoy, *Japanese Horror Cinema*, 161–74.

Holden, T. J. M. "'Sportsports': Cultural Exports and Imports in Japan's Contemporary Globalization Career." In Allen and Sakamoto, *Popular Culture, Globalization and Japan*, 117–36.

Hollier, Denis, ed. *The College of Sociology (1937–39)*. Translated by Betsy Wing. Minneapolis: University of Minnesota Press, 1988.

Hornyak, Tim. "Murder in Lotus Land." *Metropolis* (Tokyo), June 20, 2008, 62.

Hoving, Kirsten. *Joseph Cornell and Astronomy: A Case for the Stars*. Princeton, NJ: Princeton University Press, 2009.

Hudson, Rock, and Sara Davidson. *Rock Hudson: His Story*. New York: William Morrow, 1986.

Hunter, Jack. *Eros in Hell: Sex, Blood and Madness in Japanese Cinema*. London: Creation Books, 1998.

Hussey, Howard. "Music in the World of Joseph Cornell." *Keynote* 3, no. 3 (1979): 7–12.

Inteferon's Viral Vestibule. www.neodymsystems.com/ring/index.shtml.

Iwabuchi, Koichi. "Contra-Flows or the Cultural Logic of Uneven Globalization? Japanese Media in the Global Agora." In Thussu, *Media on the Move*, 67–83.

——. *Recentering Globalization: Popular Culture and Japanese Transnationalism*. Durham, NC: Duke University Press, 2002.

Ivy, Marilyn. "Revenge and Recapitation in Recessionary Japan." In Yoda and Harootunian, *Japan After Japan*, 195–215.

Jean, Marcel, ed. *The Autobiography of Surrealism*. New York: Viking, 1980.

Jenkins, Henry. *Convergence Culture: Where Old and New Media Collide*. New York: New York University Press, 2006.

Jeong, Seung-Hoon, and Dudley Andrew. "Grizzly Ghost: Herzog, Bazin and the Cinematic Animal." *Screen* 49, no. 1 (2008): 1–12.

Joseph Cornell Papers, Anthology Film Archives, New York.

Kaido, Kazu. "Reconstruction: The Role of the Avant-Garde in Post-war Japan."
In *Reconstructions: Avant-Garde Art in Japan, 1945–1965*, edited by David Elliott
and Kazu Kaido, 11–22. Oxford: Museum of Modern Art, 1985.

Kalat, David. *J-Horror: The Definitive Guide to "The Ring," "The Grudge" and Beyond*.
New York: Vertical, 2007.

Kalof, Linda, and Amy Fitzgerald, eds. *The Animals Reader: The Essential Classic and
Contemporary Writings*. Oxford: Berg, 2007.

Keathley, Christian. *Cinephilia and History, or The Wind in the Trees*. Bloomington:
Indiana University Press, 2006.

Keller, Marjorie. "I Met Rose Hobart." *Working Papers* 4 (St. Paul, MN: Film in the
Cities, March 1983): 20–25.

———. *The Untutored Eye: Childhood in the Films of Cocteau, Cornell, and Brakhage*.
Rutherford, NJ: Fairleigh Dickinson University Press, 1986.

Kinder, Marsha. "Hot Spots, Avatars, and Narrative Fields Forever: Buñuel's
Legacy for New Digital Media and Interactive Database Narrative." *Film
Quarterly* 55, no. 4 (2002): 2–15.

———. "Narrative Equivocations Between Movies and Games." In Harries, *The
New Media Book*, 119–32.

King, Elliott H. *Dalí, Surrealism and Cinema*. Herts, UK: Kamera, 2007.

King, Geoff, and Tanya Krzywinska, eds. *ScreenPlay: Cinema/Videogames/Interfaces*.
London: Wallflower, 2002.

Klein, Susan Blakeley. *Ankoku butō: The Premodern and Postmodern Influences on the
Dance of Utter Darkness*. Ithaca, NY: Cornell University East Asia Program,
1993.

Klinger, Barbara. *Beyond the Multiplex: Cinema, New Technologies, and the Home*.
Berkeley: University of California Press, 2006.

———. *Melodrama and Meaning: History, Culture, and the Films of Douglas Sirk*. Bloom-
ington: Indiana University Press, 1994.

Koschmann, J. Victor. "National Subjectivity and the Uses of Atonement in the
Age of Recession." In Yoda and Harootunian, *Japan After Japan*, 122–41.

Kovács, András Bálint. *Screening Modernism: European Art Cinema, 1950–1980*. Chi-
cago: University of Chicago Press, 2007.

Kovács, Steven. *From Enchantment to Rage: The Story of Surrealist Cinema*. Ruther-
ford, NJ: Fairleigh Dickinson University Press, 1980.

Krauss, Rosalind. "The Photographic Conditions of Surrealism." *October* 19
(Winter 1981): 3–34.

———. "Photography in the Service of Surrealism." In Krauss and Livingston,
L'amour fou, 15–53.

Krauss, Rosalind, and Jane Livingston, eds. *L'amour fou: Photography and Surrealism*. Washington, DC, and New York: Corcoran Gallery of Art and Abbeville Press, 1985.

Kuenzli, Rudolf E., ed. *Dada and Surrealist Film*. Cambridge, MA: MIT Press, 1996.

——. "Surrealism and Misogyny." In *Surrealism and Women*, edited by Mary Ann Caws, Rudolf Kuenzli, and Gwen Raaberg, 17–25. Cambridge, MA: MIT Press, 1991.

Kyrou, Ado. *Le surréalisme au cinéma*. 1953. Paris: Ramsay, 2005.

Lacan, Jacques. "The Mirror Stage as Formative of the Function of the I as Revealed in Psychoanalytic Experience." 1949. In *Écrits: A Selection*, 1–7. Translated by Alan Sheridan. New York: Norton, 1977.

LaMarre, Thomas. "*Otaku* Movement." In Yoda and Harootunian, *Japan After Japan*, 358–94.

Landy, Marcia. "'America Under Attack': Pearl Harbor, 9/11, and History in the Media." In *Film and Television After 9/11*, edited by Wheeler Winston Dixon, 79–100. Carbondale: Southern Illinois University Press, 2004.

Lastra, James. "Buñuel, Bataille, and Buster, or, the Surrealist Life of Things." *Critical Quarterly* 51, no. 2 (2009): 16–38.

——. "Why Is This Absurd Picture Here? Ethnology/Heterology/Buñuel." In Margulies, *Rites of Realism*, 185–214.

L'Ecotais, Emmanuelle de. "Man Ray, Creator of Surrealist Photography." In Heiting, *Man Ray, 1890–1976*, 149–59.

Leitch, Thomas M. *Film Adaptation and Its Discontents: From "Gone With the Wind" to "The Passion of the Christ."* Baltimore: Johns Hopkins University Press, 2007.

Levy, Julien. *Memoir of an Art Gallery*. New York: G. P. Putnam's Sons, 1977.

——. *Surrealism*. 1936. New York: Da Capo, 1995.

Lewis, Helena. *The Politics of Surrealism*. New York: Paragon House, 1988.

Liebman, Stuart. "*Un chien andalou*: The Talking Cure." In Kuenzli, *Dada and Surrealist Film*, 143–58.

Lippit, Akira Mizuta. *Atomic Light (Shadow Optics)*. Minneapolis: University of Minnesota Press, 2005.

——. *Electric Animal: Toward a Rhetoric of Wildlife*. Minneapolis: University of Minnesota Press, 2000.

Livingston, Jane. "Man Ray and Surrealist Photography." In Krauss and Livingston, *L'amour fou*, 115–51.

London, Barbara. "X: Experimental Film and Video." In Munroe, *Japanese Art After 1945*, 285–305.

Lowenstein, Adam. "*A Dangerous Method*: Sight Unseen." *Film Quarterly* 65, no. 3 (2012): 24–32.

——. *Shocking Representation: Historical Trauma, National Cinema, and the Modern Horror Film*. New York: Columbia University Press, 2005.

——. "Transforming Horror: David Cronenberg's Cinematic Gestures After 9/11." In *Horror After 9/11: World of Fear, Cinema of Terror*, edited by Aviva Briefel and Sam J. Miller, 62–80. Austin: University of Texas Press, 2011.

Lunenfeld, Peter. "The Myths of Interactive Cinema." In Harries, *The New Media Book*, 144–54.

MacCabe, Colin. "Barthes and Bazin: The Ontology of the Image." In *Writing the Image After Roland Barthes*, edited by Jean-Michel Rabaté, 71–76. Philadelphia: University of Pennsylvania Press, 1997.

MacCabe, Colin, Kathleen Murray, and Rick Warner, eds. *True to the Spirit: Film Adaptation and the Question of Fidelity*. New York: Oxford University Press, 2011.

Manovich, Lev. *The Language of New Media*. Cambridge, MA: MIT Press, 2002.

Man Ray. "Cinemage." 1951. In Hammond, *The Shadow and Its Shadow*, 133–34.

——. *Exhibition Rayographs, 1921–1928*. Stuttgart: LGA, 1963.

——. *Self Portrait*. London: Andre Deutsch, 1963.

Margulies, Ivone, ed. *Rites of Realism: Essays on Corporeal Cinema*. Durham, NC: Duke University Press, 2002.

Matthews, J. H. *Surrealism and Film*. Ann Arbor: University of Michigan Press, 1971.

McDonald, Keiko I. *Reading a Japanese Film: Cinema in Context*. Honolulu: University of Hawai'i Press, 2006.

McGray, Douglas. "Japan's Gross National Cool." *Foreign Policy* 130 (May 2002): 44–54.

McLuhan, Marshall. *Understanding Media: The Extensions of Man*. New York: Signet, 1964.

McRoy, Jay, ed. *Japanese Horror Cinema*. Honolulu: University of Hawai'i Press, 2005.

——. *Nightmare Japan: Contemporary Japanese Horror Cinema*. Amsterdam: Rodopi, 2007.

McShine, Kynaston, ed. *Joseph Cornell*. New York: Museum of Modern Art, 1980.

"Me at the Zoo." www.youtube.com/watch?v=jNQXAC9IVRw.

Mes, Tom, and Jasper Sharp. *The Midnight Eye Guide to New Japanese Film*. Berkeley: Stone Bridge Press, 2005.

Meyer, Richard. "Rock Hudson's Body." In *Inside/Out: Lesbian Theories, Gay Theories*, edited by Diana Fuss, 258–88. New York: Routledge, 1991.

Michelson, Annette. "*Rose Hobart* and *Monsieur Phot*: Early Films from Utopia Parkway." *Artforum* 11, no. 10 (1973): 47–57.

Moine, Raphaëlle. "From Surrealist Cinema to Surrealism in Cinema: Does a Surrealist Genre Exist in Film?" *Yale French Studies* 109 (2006): 98–144.

Morgan, Daniel. "Rethinking Bazin: Ontology and Realist Aesthetics." *Critical Inquiry* 32, no. 3 (2006): 443–81.

Môri, Yoshitaka. "Subcultural Unconsciousness in Japan: The War and Japanese Contemporary Artists." In Allen and Sakamoto, *Popular Culture, Globalization and Japan*, 174–91.

Mrs. Rock Hudson LOVES Mr. Rock Hudson!!! www.youtube.com/user/MrsRock-Hudson.

Mulvey, Laura. *Death 24x a Second: Stillness and the Moving Image*. London: Reaktion, 2006.

Munroe, Alexandra, ed. *Japanese Art After 1945: Scream Against the Sky*. New York: Harry N. Abrams, 1994.

Murakami Takashi, ed. *Little Boy: The Arts of Japan's Exploding Subculture*. New York and New Haven, CT: Japan Society and Yale University Press, 2005.

——, ed. "*Little Boy*: Plates and Entries." In Murakami, *Little Boy*, 1–95.

——. "The Superflat Manifesto." In *Superflat*, 4–5. Tokyo: MADRA, 2000.

——. "*Superflat* Trilogy: Greetings, You Are Alive." In Murakami, *Little Boy*, 150–63. Translated by Office Miyazaki.

Murray, Janet H. *Hamlet on the Holodeck: The Future of Narrative in Cyberspace*. New York: Free Press, 1997.

Nakata Hideo. Interview with the author. June 27, 2008, Tokyo.

Naremore, James. "Introduction: Film and the Reign of Adaptation." In Naremore, *Film Adaptation*, 1–16.

——, ed. *Film Adaptation*. New Brunswick, NJ: Rutgers University Press, 2000.

Neale, Steve. "Art Cinema as Institution." *Screen* 22, no. 1 (1981): 11–39.

Okada Toshio, Morikawa Kaichirō, and Murakami Takashi. "*Otaku* Talk." Translated by Reiko Tomii. In Murakami, *Little Boy*, 164–85.

Oppenheimer, Jerry, and Jack Vitek. *Idol: Rock Hudson, the True Story of an American Film Hero*. New York: Villard, 1986.

Paz, Octavio. *On Poets and Others*. Translated by Michael Schmidt. New York: Seaver, 1986.

Perron, Bernard, and Mark J. P. Wolf, eds. *The Video Game Theory Reader 2*. London: Routledge, 2008.

Plank, William. *Sartre and Surrealism*. Ann Arbor, MI: UMI Research Press, 1981.

Plantinga, Carl, and Greg M. Smith, eds. *Passionate Views: Film, Cognition, and Emotion*. Baltimore: Johns Hopkins University Press, 1999.

Polizzotti, Mark. Introduction to *Surrealism*, by Julien Levy, v–viii.

——. *Los olvidados*. London: British Film Institute, 2006.

Pomerance, Murray, and R. Barton Palmer, eds. *A Little Solitaire: John Franken-heimer and American Film*. New Brunswick, NJ: Rutgers University Press, 2011.

Pratley, Gerald. *The Cinema of John Frankenheimer*. London: A. Zwemmer, 1969.

Rappaport, Mark. "Mark Rappaport's Notes on *Rock Hudson's Home Movies*." *Film Quarterly* 49, no. 4 (1996): 16–22.

Ray, Robert B. *How a Film Theory Got Lost and Other Mysteries in Cultural Studies*. Bloomington: Indiana University Press, 2001.

"Recherches expérimentales." *Le surréalisme au service de la révolution* 6 (May 1933): 10–24.

Regan, Tom. "The Rights of Humans and Other Animals." In Kalof and Fitzger-ald, *The Animals Reader*, 23–29.

Richardson, Michael. Introduction to *The Absence of Myth: Writings on Surrealism*, by Georges Bataille, 1–27.

——. *Surrealism and Cinema*. Oxford: Berg, 2006.

Richman, Michèle H. *Sacred Revolutions: Durkheim and the Collège de Sociologie*. Min-neapolis: University of Minnesota Press, 2002.

The Ringworld. www.theringworld.com (site discontinued).

Robertson, Pamela. *Guilty Pleasures: Feminist Camp from Mae West to Madonna*. Durham, NC: Duke University Press, 1996.

Roche, Joanna. "Performing Memory in *Moon in a Tree*: Carolee Schneemann Recollects Joseph Cornell." *Art Journal* 60, no. 4 (2001): 7–15.

Rodowick, D. N. *The Virtual Life of Film*. Cambridge, MA: Harvard University Press, 2007.

Romney, Jonathan. *Atom Egoyan*. London: British Film Institute, 2003.

Rosemont, Penelope, ed. *Surrealist Women: An International Anthology*. Austin: University of Texas Press, 1998.

Rosen, Philip. *Change Mummified: Cinema, Historicity, Theory*. Minneapolis: Uni-versity of Minnesota Press, 2001.

——. "History of Image, Image of History: Subject and Ontology in Bazin." In Margulies, *Rites of Realism*, 42–79.

——, ed. *Narrative, Apparatus, Ideology: A Film Theory Reader*. New York: Columbia University Press, 1986.

Rosenbaum, Jonathan, and Adrian Martin, eds. *Movie Mutations: The Changing Face of World Cinephilia*. London: British Film Institute, 2003.

Sartre, Jean-Paul. *The Imaginary: A Phenomenological Psychology of the Imagination*. 1940. Translated by Jonathan Webber. London: Routledge, 2004.

——. "What Is Literature?" 1948. In *"What Is Literature?" and Other Essays*, 21–245.

Translated by Bernard Frechtman. Cambridge, MA: Harvard University Press, 1988.

Sas, Miryam. *Fault Lines: Cultural Memory and Japanese Surrealism*. Stanford, CA: Stanford University Press, 1999.

Sawaragi, Noi. "On the Battlefield of 'Superflat': Subculture and Art in Postwar Japan." Translated by Linda Hoaglund. In Murakami, *Little Boy*, 186–207.

Schimmel, Paul, ed. *©Murakami*. Los Angeles and New York: Museum of Contemporary Art and Rizzoli International Publications, 2008.

Scoffield, Sean. "An Interview with David Cronenberg." In *David Cronenberg's "eXistenZ": A Graphic Novel*, 93–107. Toronto: Key Porter Books, 1999.

Sconce, Jeffrey. *Haunted Media: Electronic Presence from Telegraphy to Television*. Durham, NC: Duke University Press, 2000.

Shaw, Jeffrey, and Peter Weibel, eds. *Future Cinema: The Cinematic Imaginary After Film*. Cambridge, MA: MIT Press, 2003.

Short, Robert. *The Age of Gold: Surrealist Cinema*. London: Creation Books, 2003.

Singer, Peter. "Animal Liberation or Animal Rights?" In Kalof and Fitzgerald, *The Animals Reader*, 14–22.

Sitney, P. Adams. "The Cinematic Gaze of Joseph Cornell." In McShine, *Joseph Cornell*, 68–89.

——. *Visionary Film: The American Avant-Garde*. 2nd ed. New York: Oxford University Press, 1979.

Snickars, Pelle, and Patrick Vonderau, eds. *The YouTube Reader*. Stockholm: National Library of Sweden, 2009.

Sobchack, Vivian. "The Scene of the Screen: Envisioning Photographic, Cinematic, and Electronic 'Presence.'" In *Carnal Thoughts: Embodiment and Moving Image Culture*, 135–62. Berkeley: University of California Press, 2004.

Solomon, Deborah. *Utopia Parkway: The Life and Work of Joseph Cornell*. Boston: MFA, 1997.

Sontag, Susan. "Apocalypse in a Paint Box." *Washington Post Book Week*, Nov. 21, 1965, 4, 26–27.

——. "Notes on 'Camp.'" 1964. In *Against Interpretation and Other Essays*, 275–92. New York: Picador, 1966.

Stacey, Jackie. *The Cinematic Life of the Gene*. Durham, NC: Duke University Press, 2010.

Stam, Robert. *Literature Through Film: Realism, Magic, and the Art of Adaptation*. Oxford: Blackwell, 2004.

Standish, Isolde. *Politics, Porn and Protest: Japanese Avant-Garde Film in the 1960s and 1970s*. New York: Continuum, 2011.

Starr, Sandra Leonard. *Joseph Cornell: Art and Metaphysics*. New York: Castelli,

Feigen, Corcoran, 1982.

Stauffacher, Frank, ed. *Art in Cinema: A Symposium on the Avant-Garde Film*. San Francisco: San Francisco Museum of Art, 1947.

Stewart, Garrett. *Between Film and Screen: Modernism's Photo Synthesis*. Chicago: University of Chicago Press, 1999.

Strayer, Kirsten. "Ruins and Riots: Transnational Currents in Mexican Cinema." PhD diss., University of Pittsburgh, 2009.

Surrealist Group. "Data Toward the Irrational Enlargement of a Film: *The Shanghai Gesture*." 1951. In Hammond, *The Shadow and Its Shadow*, 121–29.

——. "Manifesto of the Surrealists Concerning *L'âge d'or*." 1930. In Hammond, *The Shadow and Its Shadow*, 182–89.

Suzuki Koji. *Ring*. 1991. Translated by Robert B. Rohmer and Glynne Walley. New York: Vertical, 2004.

Takahashi Hiroshi. E-mail communication with the author. June 26, 2008.

——. Interview with the author. June 19, 2008, Tokyo. Translated by Sakano Yuka.

Tashjian, Dickran. *A Boatload of Madmen: Surrealism and the American Avant-Garde, 1920–1950*. New York: Thames and Hudson, 1995.

——. *Joseph Cornell: Gifts of Desire*. Miami Beach, FL: Grassfield Press, 1992.

——. "'Vous pour moi?': Marcel Duchamp and Transgender Coupling." In *Mirror Images: Women, Surrealism, and Self-Representation*, edited by Whitney Chadwick, 36–65. Cambridge, MA: MIT Press, 1998.

Thorburn, David, and Henry Jenkins, eds. *Rethinking Media Change: The Aesthetics of Transition*. Cambridge, MA: MIT Press, 2003.

Thornham, Sue, ed. *Feminist Film Theory: A Reader*. New York: New York University Press, 1999.

Thussu, Daya Kishan. "Mapping Global Media Flow and Contra-Flow." In Thussu, *Media on the Move*, 11–32.

——, ed. *Media on the Move: Global Flow and Contra-Flow*. London: Routledge, 2007.

Tinkcom, Matthew. *Working like a Homosexual: Camp, Capital, Cinema*. Durham, NC: Duke University Press, 2002.

Tomkins, Calvin. *Duchamp: A Biography*. New York: Henry Holt, 1996.

Tsutsui, William M., and Michiko Ito, eds. *In Godzilla's Footsteps: Japanese Pop Culture Icons on the Global Stage*. New York: Palgrave Macmillan, 2006.

Turvey, Malcolm. *The Filming of Modern Life: European Avant-Garde Film of the 1920s*. Cambridge, MA: MIT Press, 2011.

Ungar, Steven. "Persistence of the Image: Barthes, Photography, and the Resistance to Film." In *Critical Essays on Roland Barthes*, edited by Diana Knight, 236–49. New York: G. K. Hall, 2000.

Waldman, Diane. *Joseph Cornell: Master of Dreams*. New York: Harry N. Abrams,

2002.

Warner, Michael. "The Mass Public and the Mass Subject." In *The Phantom Public Sphere*, edited by Bruce Robbins, 234–56. Minneapolis: University of Minnesota Press, 1993.

Wasson, Haidee. *Museum Movies: The Museum of Modern Art and the Birth of Art Cinema*. Berkeley: University of California Press, 2005.

Watts, Philip. "Roland Barthes's Cold-War Cinema." *SubStance* 34, no. 3 (2005): 17–32.

Wilinsky, Barbara. *Sure Seaters: The Emergence of Art House Cinema*. Minneapolis: University of Minnesota Press, 2001.

Williams, Linda. *Figures of Desire: A Theory and Analysis of Surrealist Film*. Berkeley: University of California Press, 1992.

——, ed. *Viewing Positions: Ways of Seeing Film*. New Brunswick, NJ: Rutgers University Press, 1995.

Wilson, Emma. *Atom Egoyan*. Champaign: University of Illinois Press, 2009.

Wolfe, Cary. *What Is Posthumanism?* Minneapolis: University of Minnesota Press, 2010.

Yoda, Tomiko. "A Roadmap to Millennial Japan." In Yoda and Harootunian, *Japan After Japan*, 16–53.

Yoda, Tomiko, and Harry Harootunian, eds. *Japan After Japan: Social and Cultural Life from the Recessionary 1990s to the Present*. Durham, NC: Duke University Press, 2006.

Young, Paul. *The Cinema Dreams Its Rivals: Media Fantasy Films from Radio to the Internet*. Minneapolis: University of Minnesota Press, 2006.

Zalewski, Daniel. "The Hours." *New Yorker*, March 12, 2012, www.newyorker.com/reporting/2012/03/12/120312fa_fact_zalewski.

Index

Film and Culture

A series of Columbia University Press

Edited by John Belton

Laughing Hysterically: American Screen Comedy of the 1950s
ED SIKOV

Primitive Passions: Visuality, Sexuality, Ethnography, and Contemporary Chinese Cinema
REY CHOW

The Cinema of Max Ophuls: Magisterial Vision and the Figure of Woman
SUSAN M. WHITE

Black Women as Cultural Readers
JACQUELINE BOBO

Picturing Japaneseness: Monumental Style, National Identity, Japanese Film
DARRELL WILLIAM DAVIS

Attack of the Leading Ladies: Gender, Sexuality, and Spectatorship in Classic Horror Cinema
RHONA J. BERENSTEIN

This Mad Masquerade: Stardom and Masculinity in the Jazz Age
GAYLYN STUDLAR

Sexual Politics and Narrative Film: Hollywood and Beyond
ROBIN WOOD

The Sounds of Commerce: Marketing Popular Film Music
JEFF SMITH

Orson Welles, Shakespeare, and Popular Culture
MICHAEL ANDEREGG

Pre-Code Hollywood: Sex, Immorality, and Insurrection in American Cinema, 1930–1934
THOMAS DOHERTY

Sound Technology and the American Cinema: Perception, Representation, Modernity
JAMES LASTRA

Melodrama and Modernity: Early Sensational Cinema and Its Contexts
BEN SINGER

Wondrous Difference: Cinema, Anthropology, and Turn-of-the-Century Visual Culture
ALISON GRIFFITHS

Hearst Over Hollywood: Power, Passion, and Propaganda in the Movies
LOUIS PIZZITOLA

Film and Stereotype: A Challenge for Cinema and Theory
JÖRG SCHWEINITZ

Chinese Women's Cinema: Transnational Contexts
EDITED BY LINGZHEN WANG

Hideous Progeny: Disability, Eugenics, and Classic Horror Cinema
ANGELA M. SMITH

Hollywood's Copyright Wars: From Edison to the Internet
PETER DECHERNEY

Electric Dreamland: Amusement Parks, Movies, and American Modernity
LAUREN RABINOVITZ

Where Film Meets Philosophy: Godard, Resnais, and Experiments in Cinematic Thinking
HUNTER VAUGHAN

The Utopia of Film: Cinema and Its Futures in Godard, Kluge, and Tahimik
CHRISTOPHER PAVSEK

Hollywood and Hitler, 1933–1939
THOMAS DOHERTY

Cinematic Appeals: The Experience of New Movie Technologies
ARIEL ROGERS

Continental Strangers: German Exile Cinema, 1933–1951
GERD GEMÜNDEN

Deathwatch: American Film, Technology, and the End of Life
C. SCOTT COMBS

After the Silents: Hollywood Film Music in the Early Sound Era, 1926–1934
MICHAEL SLOWIK

"It's the Pictures That Got Small": Charles Brackett on Billy Wilder and Hollywood's Golden Age
EDITED BY ANTHONY SLIDE

CPSIA information can be obtained
at www.ICGtesting.com
Printed in the USA
LVOW07s0833291017
554009LV00008B/12/P